The Marketing Edge for Filmmakers

Written for working and aspiring filmmakers, directors, producers and screenwriters, *The Marketing Edge for Filmmakers* walks through every stage of the marketing process – from concept to post-production – and illustrates how creative decisions at each stage will impact the marketability of a film.

In this book, marketing experts Schwartz and MacDonald welcome you behind the curtain into the inner workings of Marketing departments at both the studios and independents. They also track films of different budgets (studio, genre, independent and documentary) through the marketing process, examining how each discipline will approach your film. Featuring interviews with both marketers and filmmakers throughout, an extensive glossary and end-of-chapter exercises, *The Marketing Edge for Filmmakers* offers a unique introduction to film marketing and a practical guide for understanding the impact of marketing on your film.

Russell Schwartz is Associate Professor at the Dodge College of Film and Media in Chapman University where he is the lead marketing professor in the Creative Producing Program. He is also Co-Principal of Pandemic Marketing, which provides strategic consulting to the motion picture industry which oversees marketing and awards campaigns for a select group of films and independents every year, including the recent politically divisive film *Chappaquiddick*. Prior to that, he was President of Worldwide Marketing for Relativity Media and was formerly President of Marketing at New Line Cinema, where he created and managed the marketing campaigns for over 70 films including the *Lord of the Rings Trilogy*, *Wedding Crashers*, *Elf*, *Hairspray* and *The Notebook*.

Katherine MacDonald is Senior Vice President of Paramount Animation. In this role, she oversees all marketing efforts for the Animation group. Prior to this, she has been the liaison between the Production and Marketing teams at Paramount and Vice President of Worldwide Research. Previously, she was Head of Research at MGM and Director of Market Research at Lionsgate. She has also worked in both Distribution and Marketing at New Line Cinema. During her career, Katherine has worked on a variety of both large and more targeted films such as *Wedding Crashers*, *World War Z*, the *Saw*, *Star Trek* and *Transformers* franchises, the *SpongeBob Squarepants* animated movies and *The Big Short*. Katherine has an MFA in Screenwriting from the University of California-Riverside, Low Residency Program, and a BFA in Film Production from the University of Wisconsin-Milwaukee.

The Marketing Edge for Filmmakers

Developing a Marketing Mindset from Concept to Release

Russell Schwartz and Katherine MacDonald

Routledge
Taylor & Francis Group

NEW YORK AND LONDON

First published 2020
by Routledge
52 Vanderbilt Avenue, New York, NY 10017

and by Routledge
2 Park Square, Milton Park, Abingdon, Oxon, OX14 4RN

Routledge is an imprint of the Taylor & Francis Group, an informa business

© 2020 Taylor & Francis

Library of Congress Cataloging-in-Publication Data
A catalog record for this book has been requested

ISBN: 978-1-138-08891-7 (hbk)
ISBN: 978-1-138-08892-4 (pbk)
ISBN: 978-1-315-10956-5 (ebk)

Typeset in Bembo
by Apex CoVantage, LLC

Contents

Contents

Acknowledgements

This book is the sum total of many years of marketing in the trenches on behalf of both the independents and the studios. By living and breathing in these two very distinct, yet related, worlds, we have had the good fortune to meet and work with a wide variety of industry folks and incredible filmmakers.

This list does not begin to illustrate the impact so many have had on our careers, but these contributors hold a special place in our hearts, and for this we can't thank them enough:

Catherine and Angela Paura – two women who have had extensive careers in the market research, branding and studio worlds both as proprietors of their own businesses and as studio execs. Everything you need to know about the industry is right here between the two of them.

Kevin Goetz – whose knowledge of focus groups, research screenings, and deep dive analysis of what is working and isn't in a movie is beyond compare.

Zanne Devine – an independent producer who has been in both the studio (Universal) and independent worlds (Miramax Films) and currently has her own production company working in the feature, television and digital worlds. Her body of work is highlighted by strong female roles in unique situations.

Kellye Carnahan – her original story idea and title of *K2TOG* gave us the perfect movie to illustrate both the challenges and opportunities of marketing independent films.

Mark Ciardi and Campbell McInnes – have created a very unique brand as independent producers, a great example for producers who are navigating the simultaneous worlds of theatrical, streaming and television.

Tom Grane, Mitchell Rubinstein and Chris Miller at Mobscene – major innovators in the world of location shoots and original content, and along the way, they created a new business model that supports the studios and independents in a variety of ways from theatrical through home video and everything in between.

Joe Whitmore – the studio side of the original content generator who has done remarkable things at New Line Cinema, Paramount and now with new gig as co-head of Marketing at Sony Screen Gems.

Richard Gladstein – producer extraordinaire, who was wonderfully helpful in describing the world from the opposite point of view – how producers navigate Marketing departments.

Megan Crawford – a stalwart at the Creative Artists Agency, who every day places herself between the studios and the talent CAA represents and performs subtle miracles of cooperation and problem solving.

Doug Sack – one of the emerging breed of digital analysts making an impact inside the larger studio Marketing departments.

Jason Pritchett – without a doubt one of the smartest guys in the room when it comes to data analysis, audience habits, tracking studies, box office projections and generally great opinions.

Brad Johnson and Ethan Archer – have created a terrific boutique that stays in its lane of print and digital advertising and every day they wisely go with their strengths resulting in amazingly wonderful campaigns.

David Schneiderman – who, for over 25 years has churned out trailers, television spots and digital content earning a host of loyal clients from small indies to the major studios, no small feat.

Mark Woollen – who runs one of the most consistently sought out boutique trailer houses for auteur and special interest titles and the non-blockbuster studio titles. Always comes through.

Elissa Greer – only from the heart and mind of a publicist were we able to fashion such a comprehensive chapter on publicity. Elissa brought us a world of help.

David Gross – a research and marketing guru who has created some of the most interesting critical review websites we've seen. His new venture of research screenings with critics bodes well for independents looking to get a fix on their movies before they enter public scrutiny.

Kymn Goldstein – was very instrumental in charting the evolution of field and grass roots marketing from 20 years ago to the new 360 marketing paradigm that defines that world today.

Nicole Butte – a digital specialist and responsible for some of the most successful independent online campaigns in recent years was enormously helpful in fashioning our digital chapter into bite-sized concepts understandable by all.

Amy Spalding – a multi-hyphenate digital advertising executive and published author, Amy's approach to all things in the digital media buying world never ceases to amaze us for its originality of concept.

Gail Heaney – her background as a media executive working on huge campaigns like *Twilight* and a host of smaller ones has given us a perspective on our media chapter that we would not have gotten from anyone else.

Tom Donatelli – another great contributor to our media chapter, Tom's work with the independents has provided great insight into the world of not so large budgets.

Ted Mundorff – the person you can personally thank for bringing so many great movies to American audiences through his ongoing term as President of Landmark Theaters. Ted started with all the old school exhibitors and is now on the leading edge of exhibition.

Steve Buck – of Rentrak/Comcast for providing keen box office analysis and stats as we crafted our distribution chapter. He has helped steer the world of exhibition from the traditional to digital for many years.

David Spiegelman – who understands the world of windows, ancillary sales and television like no one else we have met. If David has one mantra, it's "there are no rules."

Chris Horton from the Sundance Institute for allowing us to highlight the work they are doing as they forge new directions for producers to take control of their own destinies in the exploitation of their own features.

Guilia Caruso and Danielle Renfrew Behrens – producers of *Columbus*, for showing us how the Sundance Distribution model can work, and work successfully.

Jim Cummings – who was about to embark on self-distribution of his feature length version of his original short, *Thunder Road*, and we can only assume this force of nature producer/director/actor will continue to blaze new trails.

Gail Brounstein – one of the most seasoned awards consultants whose insights, knowledge and sense of humor, can only come from toiling in the cutthroat yet always exciting world of the awards season.

Richard Rushfield whose blog, The Ankler, has become one the most widely read digital posts in Hollywood. Afraid of nothing and opinionated about everything, he makes sense of the business in more unique ways than anyone else we have ever read.

Sean Seguin – a research and industry seer whose thoughts about the business and future of entertainment, never fail to leave our mouths agape.

Avery Blake – not the only millennial we spoke with, but one whose insights into a business he has only been in for a few years, shows us he is indeed the future.

Renata Jackson, who created our index in a fashion we never dreamed possible.

A special thanks to Gabi Goodman, undergraduate student extraordinaire, who created the Glossary and oversaw a ton of details for the book.

And to LAMill Coffee and Cliff's Edge Restaurant in Silver Lake, California, for providing the environments where ideas flourish.

Prologue: In a Research Screening, No One Can Hear You Scream

As our Marketing team has done many times before, we all sit in the dark with an audience of moviegoers watching a movie for the first time. The movie is not finished yet, but it's close. The last touches are just being applied. An agency specializing in research screenings has recruited the audience and they are likely getting a free movie ticket in exchange for their willingness to attend tonight. The movie won't come out for another six months, but this evening we are here to evaluate how well it will play with audiences and how easy it will be to market. As you will learn in the course of this book, those are two very different things.

Marketing watches the movie from a very different perspective than the audience or the filmmakers. The audience is there to sit back and enjoy the story, while the filmmakers are usually scattered throughout the theater with wide open ears and eyes scanning and listening for any signs from the audience that will indicate how their movie is playing. Sometimes the Marketing team sits up, sometimes we lean back in our seats, and sometimes we slump deep into our seats.

Tonight, this audience is totally into the movie. Not a pin drop or cough. *Why does the Marketing team start to squirm?* The storyline has grabbed the crowd. *Is that a creeping sense of panic spreading over the Marketing group's faces?* No one is leaving the theater. *Why does our Marketing team sense doom ahead?* Because the way that we approach movies is distinctly different and that is what this book is about.

The screening ends with applause and as Marketing gets up to leave, we glance over at the filmmakers and production execs still sitting in their seats. They all look happily satisfied, digesting the screening experience – one of pure relief and elation – but all we feel is apprehension.

Everyone comes into the lobby and huddles in small groups as we wait for the audience to fill out the research comment cards. The filmmakers are totally engaged and they talk amongst themselves excitedly about any small editorial changes they plan to make. The studio production execs come over and congratulate them on how well the film played and all breathe a collective sigh of relief.

While this post-screening dance plays out, our Marketing team, which usually includes the research person, the creative advertising exec who is working on the film and a producer from a creative agency, all wander over to another corner – and we have a very different conversation. Who do we think the primary, secondary and tertiary audiences are for this? Is it clear? What's in the movie for each of them? What's the central marketing hook going to be? Can we get the content on TV during primetime? Is the cast available for publicity? Can anyone think of what the poster image will be? What are the best trailer moments? Digital content?

Eventually, we walk over and join the filmmakers and production execs. We make small talk about the film and ideas for the trailer. But they eye us warily, something is off and they know it. No words need be spoken – this movie is going to be trouble for Marketing.

After about a half hour, we all dutifully file back into the theater and sit a few rows behind the focus group. We listen to these 20 general moviegoers talk about what they liked, favorite characters, the pacing, the ending, etc. The focus group tonight is enthusiastic, effusively offering up compliments about the merits of the film. The filmmakers smile and flash each other thumbs up. But then, the question is asked, "would you recommend this to your friends?" and the focus group hesitates. One person raises their hand and says "To some of my friends, but not to all of them." The Marketing department trades a worried glance. This is bad. Real bad.

The group wraps up and we all stand around and wait for the scores. This is the total from the comment cards that the audience filled out. How much did they really like the movie? How likely are they to recommend it? This is always the longest and most agonizing period for the filmmakers as they await the results from what they just spent the past several years of their lives working on. Soon the numbers come in and they are very good!

Everyone is thrilled and the studio Production execs and filmmakers all backslap and high-five each other. Congratulations all around. All the hard work, all the arguments, the editorial decisions, and the tireless efforts of everyone from production designer to the composer to the cast to the director – it was all worth it!

And soon enough, all eyes turn expectantly toward Marketing and we smile even though chills creep up our spines. We review the numbers with the research company and they too glance at us with a pained expression. They also know!

The head Production exec comes over and says how great she thinks these numbers are, that this should be a slam dunk marketing job and we should be able to open this film well above expectations. No problem. She gives us that look we know all too well: "I did my job, so now you better do yours." We look at each other and quickly nod, "Very doable number. Let's try to get there."

Everyone leaves the theater to head home. Our team walks together, heads up high, and once we get into the cover of darkness we all turn and look at each other: Wow – this is going to be a tough one!

Why are we reacting this way? Everything seemed like it went swimmingly. Nothing is wrong with the movie and, at the same time, nothing is wrong with our

response. We knew the movie was good and at the same time we fully understood how difficult it will be to market.

The research screening that we just went through is a perfect example of one of the great marketing challenges for both independent and studio Marketing teams: The classic battle between:

- **Playability:** How well a film actually *plays to an audience* and how much they say they enjoyed it *after they have seen the film.*
- **Marketability:** How easy it is to get that audience *to commit to seeing your film to begin with.*

The research screening showed that the film plays to an audience, but what it does not indicate is whether we can get that audience into the theater in the first place. That is Marketing's job, which relies on a whole different set of factors.

Ideally, you want both – strong word of mouth and strong marketing hooks – for a successful commercial release and yet the truth is that one does not necessarily guarantee the other.

In this particular case, the film holding the research screening tonight is called *Philosophy of War*, and it is a political/war drama involving the choices a soldier must make between adapting to a new life at home and the pull of going back into battle, the place where he feels most comfortable. We'll be digging into this film in detail in Part Two of this book as one of our four case studies.

But, the headline is that the marketability issues of *Philosophy of War* are challenging. As we saw at the research screening, the movie plays well to an audience and the testing numbers were strong – *after they have seen the movie.* One could also argue that research audiences tend to score a movie like this higher because of its subject matter than, say, a comedy. They feel it would be wrong to criticize it too harshly because the message is so strong.

But, this will not necessarily translate to the real world of paying customers who could be much more critical. Trying to get them in to see a movie with a challenging subject matter is difficult because it does not guarantee an entertaining evening on a Saturday night. Furthermore, that one comment from the focus group member drives deep – he will only recommend it to "some of his friends." So who are they? Is that what everyone feels? How much smaller of a subset is that audience?

This is the job of Marketing: to peel away the layers of a film and attack each as a marketing strength or a marketing challenge. The underlying premise of this book is that marketing must be integrated into the filmmaking process. You are not just screenwriters, producers and directors but also collaborators in the marketing process. For filmmakers, often times a simple choice that still preserves the quality of the film, can make a huge difference when it comes time to selling the movie.

Our book is for producers, screenwriters, directors, students and anyone interested in how the marketing process functions before, during, and after the filmmaking stage. We will show you what happened after the research screening of *Philosophy of War* and how Marketing was watching the movie differently and *why*

it will be a marketing challenge. We'll show you how some of the big marketing challenges of the movie could have been identified, addressed or avoided entirely in the earliest stages of the film.

This book will help you:

- Create a strong vision for the marketing plan, which is a great sales tool for the movie.
- Define the marketing landscape and terminology at the earliest stage of the movie so you can engage in and participate with the marketing team to help realize your joint vision.
- Get the "yes" vote from the marketing or acquisitions teams who sit on the greenlight committee (the committee that decides whether or not your movie moves forward at a studio).
- Avoid expensive reshoots.
- Give the movie a major leg up to succeed.

The Marketing Edge applies to both independent and studio productions. Everything laid out here is applicable to all kinds of movies, whether they are $500K budgets or $100M. It all comes down to what you can afford, integrate, access, promote and negotiate on behalf of your movie. This book is divided into three parts:

Part One will show how every decision you make in the creation of a film, beginning with your idea and through post-production, will impact marketing.

Part Two will take you behind the scenes and inside of a studio marketing department to understand all of the disciplines and functions, utilizing many of the ideas and concepts set up in Part One.

Part Three dives into some marketing specialties to show how campaigns vary for animation and awards contenders.

We will utilize four "case study" movies in Part Two, including *Philosophy of War*. These movies are fictional, but each is inspired by assets and challenges that we see all the time in marketing. We used these fictional movies so that we can be brutally honest about the "good, the bad and the ugly" of each title without offending any hardworking marketing team.

Each movie is distinctly different, each with its own set of strengths and challenges, and we will discuss how each will impact marketing, from production right through the execution of a marketing plan based on the finished product.

WHAT THIS BOOK IS NOT

Now that we've explained everything that this book is, we should also explain what this book is *not*.

This book is in no way:

- A guide to directing, screenwriting or producing. There are plenty of excellent books about these subjects already!

- A how-to on the mechanics of physical production.
- A legal perspective on the business of production though we do cover the business aspects of marketing.
- A prescription for how to make a movie. Filmmakers should pursue their vision and make the best film.

The bottom line is this, the information presented in this book comes from our direct experience and from interviews with specialists in the field of theatrical marketing. We have lived most of the points in this book and our reporting is based on what we know to be true. At the same time, we are open to dissenting opinions. This is not a typical academic text full of citations and extensive research – though nothing against those books! Rather, this book is written by people who have been in the trenches. We've marketed great movies that were deeply challenging, we've marketed not-so-great movies that were very successful in the end. The goal of this book is to share "the good, the bad, and the ugly" from what we've learned so that you can deliver the most marketable version of your film!

IS EVERY FILM MARKETABLE?

The simple answer is yes, because every film has *something,* and identifying what that is and exploiting it is the job of the Marketing department. But the more elements a Marketing department has to work with, the more inspired the campaign. Movies that have inherent hooks or angles create boundless opportunities for exploitation. Movies that are difficult to market because of content, title, cast indifference, critical response or difficult structure can create obstacles to creative thinking which often results in a "by-the-numbers" type of sell.

This book follows the stages of creating a film and illustrates where marketing comes in to help amplify, not alter, the process, regardless of the type of film you want to make.

Marketing looks for the right elements, which can be a lot like pushing a rock up a hill to a successful campaign. You, the filmmaker, can help determine where on the hill marketing gets to start.

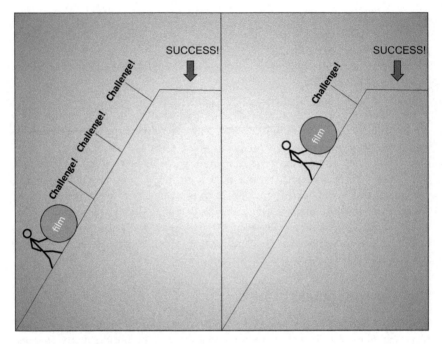

Figure 0.1 The marketing challenge

PART I
WHAT YOU WILL CONTRIBUTE TO MARKETING

1

Marketing Defined

What You Need to Know

As you embark on your film project, at whatever stage you decide to jump in – original idea, screenplay or book option, newspaper or magazine option, stage play, non-fiction story – it will be important to recognize the signposts and stages of marketing as your project advances up the production ladder. Equally important is to understand the terminology associated with the marketing discipline and how marketing first and foremost is an extension of your creative efforts. However, it has not always been that way if we look at the evolution of movie marketing.

WHICH CAME FIRST – THE BUSINESS OR THE ART?

It can be said that the business of marketing goes back hundreds of years beginning with the invention of the printing press in 1440, but for our purposes we will just say movie marketing began somewhat more recently.

"I went into the business for money, and the art grew out of it," Charles Chaplin said towards the end of his life. "If people are disillusioned by that remark, I can't help it. It's the truth."[1]

Chaplin was not alone. In fact, he followed the path of the great entrepreneurs from the pre-studio days. Arguably, none of these founding fathers of the movie business went into it solely for the art. It was always partially or mostly motivated by business and the marketing of the business. In the early 1900s, when American was flooded with a wave of immigration and silent films were starting to make their ways into the penny nickelodeons, many of these short films came from Europe. This was to be the only era in U.S. film history in which movie distributors from a foreign country, predominately France, were dominant in the American market.[2]

Thomas Edison, who is mainly credited as a forerunner of the movie distribution system with the invention of the movie projector, was more interested in licensing

and selling his projectors to the thousands of Nickelodeons that were springing up everywhere across the country and less concerned with what they were going to project.

Originally, these Nickelodeon operators purchased their "content" from a Sears Roebuck or Montgomery Ward catalogue and they would buy it by the foot. The showman who ran the vaudeville theater would spend approximately $50 on a really popular movie and run it until patrons lost interest, or until the celluloid print was in such tatters that it could no longer be run.[3]

This was the original "distribution" network – a catalogue that held no importance to time or place or subject, simply pieces of content available through mail order the same way one could buy clothes or tractors.

The origins of the motion picture business, then, started with the hardware, and not the story driven "software," that we have come to associate with the industry. And Chaplin was just one of many who contributed to these short films. Only a few years later, in 1914, in a Keystone Comedy, *Kid Auto Races at Venice*, did he introduce his classic Tramp character, which turned him into a name talent and helped focus the industry from technological advancement to star and story. For 20 years, Chaplin played The Tramp, until he retired it in 1936 in *Modern Times*. It can still be said that Chaplin's marketing of his character that manifested itself not only in his movies, but through numerous dolls and paraphernalia associated with the time is still one of the great marketing and branding feats in the annals of moviedom.

During this time, one of Chaplin's comedic peers, Harold Lloyd, began pioneering the idea of test screenings with his invention of a laugh-o-meter, when in 1928, he charted audience laughs for his movie, *Speedy*.[4]

These early comedians would even use a comedic scene that was a work in progress for an upcoming movie and attach it to a movie currently playing in a theater. They would advertise it as a "coming attraction" and while it helped bring in patrons, it was really a way of testing the scene in front of a regular audience.

From these rudimentary beginnings, marketing has evolved into a smooth running machine – a mix of business, culture, technology and creativity – all finely tuned to define, understand and engage audiences.

CORE MARKETING PRINCIPLES

There are a number of applications that every Marketing department utilizes as the foundations for their work. They may vary in emphasis and methodology but movies have to be sold and these functions are essential to understanding marketing, but remember the success of your movie lies in what elements you have identified in your project that allow for the "marketing edge."

DEFINING YOUR AUDIENCE

First and foremost, marketing identifies the audience for your movie and this most important area of research and understanding is known as **Demography.**

The Merriam-Webster dictionary defines this as: "The statistical study of human populations especially with reference to size and density, distribution, and vital statistics."

Demographics sits inside Demography and refers to findings and characteristics of certain segments of the population. Demographics breaks down further into audience subgroups which allows the Marketing team to focus its advertising campaign on specific audience groups who are likely to respond to the story, stars, or content. Demographics refers to age, ethnicity, education, etc. These are specifically:

- The **Target** or **Primary** Audience is the most important subgroup to whom the Marketing team must initially appeal. This is the core audience that will ignite the box office and hopefully spread the word on the movie.
- The **Secondary** Audience is the group that may have interest in certain elements of the movie or they come as the companion of someone in the primary audience.
- The **Tertiary** Audience is the larger, initially uncommitted audience, which eventually comes to the movie when it breaks out and becomes a commercial hit.

Psychographics is another important marketing approach in defining the audience as it speaks to lifestyle, income, political inclination, shopping interests, and a host of other factors. The objective in a psychographic audience analysis is to find people with similar interests regardless of age, geography or ethnicity. For example, with the film *Twilight*, the psychographic profile of the audience was not only young females, but readers of the book, and mothers and grandmothers who were drawn to the subject matter and the romantic elements. It even became a mother–daughter "date" movie.

ENGAGING YOUR AUDIENCE

Marketing has two main functions: To generate **Audience Awareness** and **Audience Interest**. While the methodologies are quite different, these two elements are the twin pillars of a successful marketing campaign. They are quite interdependent on each other and deciding on what kind of movie you are making, whether it be one that appeals to a small specialized audience or to a wide commercial one, will determine the levels of awareness and interest that marketing will consider necessary to insure success. However, none of this is easy anymore.

Awareness is generated through:

- Media (such as television, digital advertising, outdoor billboards, radio, stunts)
- Publicity (talent appearances, subject interest, promotions, influencers, print and editorial, etc.)
- Distribution (in theater trailers, lobby displays, exhibition of the film, etc.)

Interest is generated through:

- Creative advertising (trailers, posters, original content)
- Social media (identifying and appealing to like-minded communities usually through online methods)
- Word of mouth (friends and family)

We live in a very cluttered media world, one that offers a myriad amount of content, from movies to games to television to streaming, and available on a variety of screens and platforms. This creates enormous challenges to marketing when it comes to creating awareness and interest. Understanding this issue and how the marketing elements you incorporate into your film can help marketing is probably the most important take-away from reading this book.

THE THREE TYPES OF MEDIA

As we stated above, media helps create awareness and anything that helps promote awareness is media in one form or another. Media functions in a number of different ways, some of which marketing can control, some of which it can't. All of the different types of media are effective in their own particular way.

Paid Media

Paid media is generated through the licensing of advertising slots such as they are available in traditional television, online or outdoor venues. Marketing has complete control over the when, where, how and what is put out there to the public. Examples of paid media are 30-second television spots, outdoor billboards, bus stop shelters, Facebook and Instagram posts (and even "likes"), banner advertising on key web portals and sponsored online content including streaming, story and pre-roll and forced view short form content.

Owned Media

Content that has been created either during your production (i.e., behind the scenes footage, interviews with cast and director) or in the period leading up to release (original television or web specials of varying lengths, content themed to a specific character). Owned media is story and subject driven and is placed in both traditional and digital environments in a passive way where you come upon it as you are watching or surfing the web.

Earned Media

If the ultimate goal of marketing is to make audiences aware of and interested in seeing your film, then the best way to do this is through content that people

discover, talk about and share. Content that is shared earns the highest form of credibility as it is vouched for by a trusted source, your friend or family, and not the studio or some advertising agency. Content that is shared can lead to the ideal result: Awareness, definite interest and commitment.

As you conceive of your project, it is vitally important to consider how the subject you are choosing will translate into something people will actually *want* to see and how a Marketing team can make that happen. In Part Two of this book, we will see how these two important principles of awareness and interest impact the campaigns of our four case study movies.

Whether the primary audience for your film is smaller and specific or big and broad, you will still need to achieve awareness and interest. For a lower-budget, indie film you may employ **Targeted Marketing.** This refers to a campaign directed at an audience with a specific interest in the film. For example, Latinx and African American audiences are very specific targets for subjects or cast that are appealing to them. Horror or sci-fi fans are also a loyal and specific audience that can be marketed to directly. Arthouse audiences are another specific audience that can be strategically targeted.

Conversely, if you are making a big budget, high-spectacle movie based on known IP, you may use **360 Degree or Integrated Marketing.** This type of marketing campaign encompasses all of the media options discussed above and includes gaming, merchandise and product promotions, soundtrack, and, where applicable, theme park tie-ins. They call it 360 marketing because anywhere a moviegoer turns, she encounters a promotion for the film. The campaign literally creates a 360-degree circle around the consumers.

UNDERSTANDING YOUR AUDIENCE

Once marketing identifies the audience, the next step is to figure out what they want and how to convince them to fork over money for a ticket. To do that, we use **Marketing Research.** This refers to the quantitative (numbers) and qualitative (feelings) study of a movie's potential at different points in its life cycle. The methodologies used measure the impact on the target audience and help devise the most effective creative advertising.

Kevin Goetz, the founder of Screen Engine LLC, defines the Market Research process as a series of "abilities" which, when utilized correctly and at the proper time, all work together to create a very effective marketing strategy. Mr. Goetz also discusses this idea in Jason E. Squire's excellent, *The Movie Business Book.* We're going to delve deeply into the different tools and approaches to Market Research in Chapter 10, but for now, here is how Mr. Goetz breaks down the marketing abilities:

Capability: How well can this move do? What's the ultimate potential? In research, this is learned by conducting "Positioning and Brand Studies."

Playability: How well does the movie play with audiences? Research addresses this with "Recruited Research Screenings."

Marketability: How easy or difficult is this film to sell? Research explores this question with "Creative Advertising testing" and "Theatrical Tracking."

Buzzability: Will people talk about this movie? Will they share content on social media and recommend it to their friends? Research investigates this with "social media analytics" and "exit polling."

To Kevin's spot-on analysis, we would also add:

Theatricality: How likely are people to pay to see this film *in a theater* (as opposed to at home by renting or streaming). What is the draw to experience this film on the big screen? This is measured by employing all of the above research tools.

MARKETING'S FUNCTION DURING PRODUCTION

You might wonder who are all those people who interact with your film during the production process and once it is delivered. The Marketing departments, be they big studio teams of 75–200 people or smaller indie groups of 5–10, all have the same goals in common, and that is to bring out the best that your film has to offer to an audience defined by what elements you have incorporated. During the production process, the people you will likely have the most direct contact with are:

Brand Manager

There is often one person assigned inside the studio who acts as the point person between marketing and production. This job function is extremely important as they maintain ongoing dialogue between both departments and help coordinate schedules and resolve any conflicts that may arise during the production process.

Publicity

In most cases the publicity people will handle all public pronouncements about your film, as well as manage any problematic issues that may come up during production. We will show how publicity works its magic leading up to release in Part Two of this book, but during the production process, publicity manages the release of publicity stills, behind the scenes clips, press set visits, talent issues, special photo shoots for poster and magazine cover art, dealing with special interest groups who may have an issue with the content of the film and/or one of its stars and generally keeping the press coverage of your movie positive and proactive.

Consumer Products and Licensing

With films of any budget, these folks will be very anxious to create opportunities in your film for product placement, special promotional content and advertiser tie-ins.

Distribution

In order to stir up interest when it comes to dating your film in theaters, your distributor may ask for a set visit for some of their high-end exhibition people. They will also work to find the best, most competitive date for your movie.

Creative Advertising

Even while you are still shooting the movie, this group will be thinking about advertising ideas for your poster and trailer, both teaser and long form. They'll be watching dailies, cutting trailer explorations and strategizing with market research about audience and positioning. They will also very likely arrange for a photo shoot for print needs. The best time to do this is during the production when the actors are completely into their character, in costume, make-up and hair and will be most amenable. Often, when a production wraps and the talent scatters, it is very difficult to corral them back for any type of advertising shoots.

CONCLUSION: MARKETING IS THE SUM OF DIRECT AND INDIRECT APPLICATIONS

In this chapter we have seen how marketing utilizes a specific set of tools to help filmmakers achieve their goal of harnessing audience eyeballs and this is done purposefully through direct and indirect methods. Marketing purposefully drives awareness by finding, targeting and spending against an audience and indirectly drives interest through creative content placement digital engagement and publicity.

This is a great way to sum up this chapter: **21ST CENTURY MARKETING IS ABOUT CREATING AN ECOSYSTEM.** It is no longer a matter of checking off all the marketing boxes to make sure you are doing everything you can, but the marketing efforts have to become part of the DNA of the movie, where every marketing tool becomes a contributor to helping audiences see the overall essence of what the movie is.

We got this idea from industry veterans Catherine and Angela Paura, formerly co-heads of Marketing for Alcon Pictures, Among their more recent films were *The Blind Side*, *Blade Runner 2019* and *12 Strong*. Prior to Alcon, Angela was President and COO of Capstone Global Marketing, a strategic marketing consultancy. She is currently Associate Professor of Public Relations and Advertising at Chapman University in the Dodge College of Film and Media Arts. Catherine co-founded the pioneering research film The National Research Group (NRG) where she served as CEO for 25 years and what she contributed to the development of tracking has remained a mainstay of the industry. Currently she is Director of Screen Engine/ASI Turbine specializing in global research and consulting.

Catherine: When I think about marketing in today's world in the twenty-first century, I think about each movie having to create its own ecosystem.

9

It has its own marketing ecosystem. So if you think about what does that mean because we have to decide who's the audience, how large is that audience, what are they going to like about this movie, what's the essence of this movie, what can I sell?

Angela: What's the value in this movie?

Catherine: The added value, right? What's the value proposition?

Angela: Value proposition, wish fulfillment, what wish are we fulfilling?

Catherine: What are we selling, and then we have to make sure that what we think we're selling via research is appealing to those people we think we're going to be selling it to. I think also when you think about marketing today, you have to think about where does my audience live in terms of getting messages about my movie, because …

Angela: You don't mean like physically live …

Catherine: No, no, no. I mean live in a marketing space, what do I need to develop? I know that I need TV. And I also know that TV doesn't work the way that it did 10 years ago even, forget 20 years ago. So where are they? Are they online? Where are they online? How do I get to them online? So, therefore I have to think about components of the marketing campaign do I need to develop. I know that I need to develop some kind of outdoor or print, but from an AV point of view now, not only do I need a trailer, not only do I need TV commercials, but I also need additional content. We used to call them featurettes, but they're not really featurettes anymore. I need to develop a way to sell to millennials that makes it look like I'm not selling to them, so that in and of itself needs to be an entertainment. And then I also need to pray that I get a great Rotten Tomatoes score because Rotten Tomatoes scores impact opening weekend box office.

EXERCISES

1. Pick a movie that came out recently and make a list of anything you can find about it online, in newspapers, on TV, etc. Then organize those pieces about the movie into owned, earned and paid media.

2. In your own words, write a page defining the concepts of awareness and interest. Why are they so important? How are they different?

NOTES

1 Bosley Crowther obit in the *New York Times*, Dec 26, 1977.
2 *George Lucas's "Blockbusting,"* page 15, edited by Alex Ben Block and Lucy Autrey Wilson, New York, IT Books, 2010.
3 *Blockbusting*, page 14.
4 Park, Ed (April 12, 2005). "Freshman Orientation." *Village Voice*.

2
So You Have a Movie Idea ...
Marketing Starts Here

Let's start at the beginning. You've just come up with a great idea for a movie. Congratulations! This is the first monumental challenge in the road to making, marketing and releasing a film. It's time to either sit down and start working on the outline or to hire a writer, right? Not so fast. We know, you're already thinking about who you should try to pitch or sell it to, who would be great in the starring roles, what directors you want to meet with, etc. All of that will come, but first there is one absolutely crucial question you need to ask yourself:

WHO IS THE AUDIENCE FOR MY MOVIE?

Don't say "everyone," or "women" or "men." Even in our current age of superhero blockbusters, there are very few movies that draw in absolutely all audiences or fit every age group in a gender. Most films are inherently appealing to a specific group of people. For example, the western genre traditionally appeals most to older males and those films tend to struggle to gain traction with a female audience. That's not to say that you can't write a western that breaks the paradigm, but it's important to know which audience your genre typically attracts. The executives that you pitch will know and so will the marketing people that read the script and weigh in.

We know what you're probably thinking: Isn't my job just to tell a great story? That's definitely true, but knowing who your audience is will make your story even better. It not only informs how you treat your subject, but also gives you a specific audience to write for. An audience that you know would appreciate your idea but who also assume certain conventions of plot, specific characters, tone and settings. Furthermore, "who is this movie for?" is the first question that Marketing asks when it assesses a film. It dictates everything in their process and it is monumentally important to a movie's success.

So how do you identify your future audience? First, it's important to understand the many different ways that the film industry looks at moviegoers. Understanding

whom the movie is for and how to target that audience is the first step in creating a release strategy and there are a number of different techniques for accomplishing this objective.

YOUR AUDIENCE TIERS

As you think through the idea for your story, it will be important to understand your *primary, secondary* and *tertiary* audiences. These are the terms that marketing uses to identify who they can reach and convince to see your film. The media department will have a big say in this conversation, and their plans will be built around the audiences that are identified here.

Your **primary** audience is your target audience. That is the audience you feel will most readily respond to your material. It is essential that you have the confidence in your story to attract at least this core audience component. Without a primary audience, you will be hard pressed to explain your story to any investor or distributor. Your primary audience may be based on age, gender or types of films they normally like. For example, you could say that your primary audience will be 13–34-year-old females who are fans of supernatural thrillers.

Your **secondary** audience is an equally important subset as it indicates a very possible additional group of moviegoers who could be drawn to see your film. They may need a little more convincing, but they should be inclined to buy a ticket if they are delivered the right marketing message.

Lastly, your **tertiary** audience is the reach group. They might not be white hot for the material at first glance, but they can possibly be convinced by marketing, critical reviews and word of mouth.

DIFFERENT WAYS TO IDENTIFY YOUR AUDIENCE

Demographics

Hollywood traditionally divides moviegoers into four groups, which we call "quadrants": Males over 25 years old, males under 25, females over 25 and females under 25. If you've ever heard the expression, "a four quad movie" that refers to one of those rare, aforementioned titles that appeal to everyone across the four quadrants. Even though these demarcations are now considered too general for many films, they are still the industry standard and important to understand.

The four-quadrant system came into practice in 1986 when Joe Farrell and Catherine Paura of the National Research Group (NRG) created theatrical tracking. We'll talk a lot about this incredibly important tool later on, but for now what's important to know is that theatrical tracking is a report that is delivered to all of the film studios three times a week. It tracks which films moviegoers are aware of and how interested they are in buying a ticket. Theatrical tracking analyzes moviegoers by quadrant, so that method of identifying audiences is still a big part of conversation in studio boardrooms.

Catherine Paura (co-founder of National Research Group) explains the origin of the four quadrant system:

In 1986, all of the studios were conducting their own theatrical tracking but they decided it would be beneficial to have one central report that everyone could see. We signed each of the six major studios to an exclusive contract and began conducting telephone surveys three times a week that measured moviegoers' awareness and interest in upcoming movies. When Joe and I were designing this, we looked a lot at demographic data and specifically at the composition of moviegoers. At this time the oldest baby boomers were about 41 and the youngest baby boomers were about 21. So the US population divided evenly at 25 years old. Now, the average age of the US population is much older. The average age is about 35. So, really, the tracking should break audiences at 30 years old to be more accurate. But, everyone in Hollywood is used to the quads at 25, so that's what we all stick with.

Incidentally, you might hear some people say that a true blockbuster nowadays is actually a "six quad movie." That would be the four traditional quads, plus parents and kids, really a sextet. But the point is that family appeal is a big factor to consider when you are identifying your audience. Could your idea appeal to kids and is it therefore worth considering toning down the content somewhat to reach that audience?

Another area of demographic interest is ethnicity. Certain films, subject matters, directors or stars may have particularly strong appeal among African Americans, Latinx, Asian Americans or any other specific audience. This is only a plus and important to be aware of when pitching and setting up your film.

Psychographics

This is a more detailed way that marketing often looks at moviegoers to efficiently target them. Here you would think about the character traits of your audience – everything from their education, their background, their taste in clothing, type of movie they would like, food they like, faith, all of which hones in on a more direct and effective sell.

A great example of this is the *xXx* franchise (*xXx*, *xXx: State of the Union* and *xXx: Return of Xander Cage*). These movies center around an elite group of extreme athletes who are engaged in spy games. In terms of psychographics, moviegoers with an interest in these extreme sports or the X-games are likely an excellent target for the movie.

13

Geotargeting

This is a little deeper dive and looks at moviegoers by region of the country. It is certainly true that certain films play better in different areas. For example, arthouse movies would most likely release first and perform best in major movie markets like Los Angeles and New York. Meanwhile, faith-based films often excel in the southern and central United States.

Movie marketers use all of this information to break the audience down into "subsets." This is one of the most important audience indicators as it takes into account a wide range of indicators from ethnicity, to people who like a particular type of film, families, married, divorced, with children, without children, single and by age, fans of animated films, etc.

INTELLECTUAL PROPERTY VS. ORIGINAL CONTENT

When it comes to your movie idea, it is also important to consider where it came from and what implications this may have down the road. Legally speaking, Intellectual Property, also known as IP, is anything created that can be trademarked, copyrighted, patented or registered in some official capacity with any number of organizations from the US Government Copyright and Patent Office to entertainment guilds like the Writers Guild of America. Registering IP gives the owner or creator protection against the infringement of the rights granted to the owner based on the uniqueness of the property. Without going into any of the legal ramifications here, suffice it to say that once you have written your project or licensed the rights of an existing IP, it is essential that you protect yourself. But make sure that you license and option properties according to acceptable entertainment law guidelines.

In the entertainment business and in particular in the studio world, when they refer to "IP" they are generally talking about material adapted from something that already exists and has a built-in awareness, i.e. a book, play, graphic novel, theme ride, etc. When they speak of something created that does not have a legacy background, they call it "original."

As a filmmaker and a creator you know that great ideas can come from anywhere. Anything can inspire your next movie: An article, a place, a culture, or a story your great-grandfather shares at a family reunion. These sources of inspiration are not only great fodder for ideas, they can also be extremely powerful marketing assets later on. For example, Neil Moritz, the producer of the wildly successful *Fast & The Furious* franchise, was originally inspired by an article called "Racer X" in *Vibe Magazine*, which centered on illegal street racing in New York City.[1] Ultimately, this not only spawned an eight (and counting) movie franchise but the car racing culture was also a significant marketing hook for the movie.

GENRE IMPLICATIONS

Of course, as soon as you hatched the idea for your movie, you also determined the genre for that film. The setting, the concept and the promise of the story all dictate

the primary genre. When you sit down to write, or when you hire a writer to commence, you will, of course, consider the rules and expectations for the genre. These rules are deeply ingrained in anyone who works in movies and loves to watch them. A successful horror film must deliver scares, a strong romantic comedy will probably end with a tear-filled, impossibly romantic union between the two leads and an action movie will feature a number of high adrenaline set pieces. Therefore, it is important to satisfy the *audience* expectations as well as your own.

However, when marketing looks at genres they see their own list of implications because, for them, it's about how the movie will translate into a campaign. Movie marketers understand that each genre offers its own particular hooks and challenges. As filmmakers, it's vital to understand these characteristics so that you can best work with marketing to highlight the assets of the genre and minimize the challenges.

The following are widely held truths about the various genres. It's important to note that this does not mean that these are unequivocally true in every single case. It just means they often tend to be true. Every movie is different and there are all sorts of examples of films that broke the paradigm and surprised everyone, but, as you are developing your idea and selecting your genre it is important to consider how marketing will likely view your genre.

COMEDY

Audience

One of the most broadly appealing genres in film. Audience is often determined by the subgenre. For example, romantic comedies skew female, R-rated raunchy comedy plays younger and family comedies can draw in kids as well as adults.

Marketing Considerations

The campaign has to sell one primary thing above all else: This movie is going to make you laugh. A lot. Therefore, marketing will be looking at your idea, the one you are coming up with right now, and they will prefer that it is inherently funny. That means that when you tell people your idea for a comedy, they laugh, or at least smile, right away. If you have to explain why it will be funny, it will mean that down the road marketing will also have to explain to people why this is funny, which is an extra hurtle for them. *The 40-Year-Old Virgin* is immediately funny right in the title and you can see the comedic promise right away.

Marketing will also want an idea that promises to be funny for the entire movie, rather than just a one-off joke. Ideally, the premise will make people think of all sorts of funny situations that could arise from the comedic situation. In marketing comedies, it's ideal when there are a variety of different types of jokes (physical, verbal, scatological, pop culture, sight gags, etc.). This helps attract the broadest group of comedy fans because some people might find it absolutely hilarious when a character falls over, while others might prefer witty banter. If your comedy

idea has room for different brands of humor, all the better. This is especially important if your movie is going to be an R-rated, raunchy comedy. There will be a great deal of the jokes that won't be allowed in the regular trailer or in TV spots. So, it's important that there are some clean jokes mixed in there because they will be leaned on heavily in the campaign. Finally, marketing will need to distill your idea and the promise of the humor into :30 second and :15 second TV spots. They will be scouring the movie, looking for quick and effective jokes that fit into television and digital spots. If most of the humor in the movie is based on running gags or requires a long set-up that will not work for commercials either on television or online.

ACTION

Audience

This genre can appeal to both teens and adults. However, if the movie will be R-rated, that will obviously rule out moviegoers under 18 years old. Fans of this genre often skew male, but there are certainly examples of female-appealing action movies like *Salt* and *Lucy*. If the movie is particularly violent, that may potentially turn off some females and older audiences. As we mentioned earlier, the western subgenre traditionally struggles to attract female audiences.

Marketing Considerations

Just like comedy, it's not only about promising heart-pounding action, but also a variety of different types of action. Fans of this genre love fight sequences and car chases (or boats or planes or trains or anything that you can drive, really). Spectacle is ideal, like things blowing up and cars flipping over and the like. But, there are plenty of cool, low-budget action movies that manage to create suspenseful thrills without any expensive spectacle. For example, Robert Rodriguez's *El Mariachi* was made for $7,000 dollars and is still considered an action-thriller classic.[2]

The spy movie subgenre will ideally feature some very cool, high-tech gadgetry. Showcasing all of these elements in the marketing will be key. Marketing will also love to see a strong hero in this genre who has some very specific and unique talents. As the hero of the *Taken* franchise famously put it, "I have a particular set of skills." We can base a lot of the campaign on the personality and charm of this hero. Take a look at the movie poster for the original *Taken* movie. It's simply a picture of Liam Neeson and the text of his character's famous speech.

When marketing the action genre, it is especially important to have a very clearly defined problem for the hero with high stakes and an urgent need to solve it. We don't want to spend very long setting up the premise in the marketing materials because we want to leave lots of time for all that unique, exciting and high spectacle action.

MYSTERY AND SUSPENSE THRILLERS

Audience

These movies tend to appeal to adult audiences, and they can draw in both males and females in equal measure. Sometimes these movies are very specifically aimed at female audiences, but that is largely dependent on the subject matter.

Marketing Considerations

The marketing for this genre is all about the big questions: Whodunnit? What are these people hiding? Will they catch the killer? Most likely, the campaign will center around setting up that big question and telling audiences that if they want to find out the answer, they have to buy a ticket. The marketing will promise lots of surprises, twists and turns and an ending that audiences will never guess. If your movie idea is in this genre, try pitching just the concept to people you trust and ask them to guess the answer to the big question. If everyone guesses correctly, then you have a predictable outcome on your hands, and that is not what you want in this genre. That will mean when audiences see the trailer, instead of saying, "I have to go see that to find out," they will say "I can already tell how that ends. No need to pay for it!" Movies like *Gone Girl* are perfect examples of this genre as it serves as a mystery, thriller and is based on well-known IP.

Furthermore, as the genre name suggests, these movies are all about suspense. That slowly building tension as the movie heads toward its climax. Conveying sustained tension is difficult in a few minutes or seconds of marketing material, so these campaigns also rely on review quotes to tell the audience that they are in for a fun ride.

HORROR

Audience

Fans of horror tend to skew a little younger and the subgenre often determines the dominant gender. Younger females typically drive box office on supernatural thriller movies while younger males drive slasher and gory horror. An R-rating will exclude teens, so if your idea features teenage characters in a high school setting, it's worth considering making it a PG-13 execution (no pun intended).

Marketing Considerations

The primary job of the horror marketing campaign is to promise a truly frightening and fun experience. Simple and unique concepts are usually incredibly helpful in this regard. A ghost haunting the house might not be enough. But a ghost

haunting the house and it can only get you when the lights are off, like in *Lights Out*, is a $149M idea. Marketing is going to want to sell the promise of suspense, jump scares, creepy moments and clever kills (if it's that kind of horror movie). They will want the audience to feel like this could happen to them. They might employ other tactics like TV commercials that show the audience watching the movie and reacting. These are called audience reaction spots and we'll talk about them in detail in Part Two. The key marketing element for your horror idea might very well be the idea itself and how effectively it raises goosebumps on the arms of anyone who hears it.

Another kind of horror movie has come into vogue of late – the hybrid horror. Look at a film like *Get Out* – it is part drama, part social commentary, part fantasy and part horror. The budget for *Get Out* was $5M and it went on to gross $255M worldwide. These types of horror films are coming from directors, like Jordan Peele, who are interested in their messaging but using a conventional and accessible genre to do this.

DRAMA

Audience

The audience for drama movies has a lot to do with the source of the drama in the story. For example, if the drama is coming from a married couple struggling through a divorce, that's most likely going to appeal to moviegoers in a similar life stage. However, two teenagers falling in love and living with cancer (*The Fault in Our Stars*) was directly appealing to the teen audience. Conversely, there are historical period dramas such as *The English Patient* or *Room with a View* that can be immensely successful by drawing in an older audience. Take a look at the central cause of drama in your movie idea and think about what ages would relate the strongest. If you are striving to reach younger audiences, the drama should be relatable to them.

Marketing Considerations

The campaigns for drama movies are probably the most story-driven of all the genres. It is a sort of implied contract with the audience that the drama movie will draw some tears in the theater, so while the campaign will promise that emotion, it is more about selling the experience of the story. Marketing must show that the movie will feature complex characters that audiences will care about and that the story will engage them and affect them deeply. This genre is often based on books as source material and in that case, the campaign will lean on the popularity of the book. Critical response to the movie can have a bigger impact in this genre as well. Marketing will be hoping for strong press screenings and great quotes from critics that they can use in marketing materials. Another big consideration in this genre is "theatricality." Is this a movie that people really need to pay to see in a theater? If the movie features lots of people sitting around and talking, that can be a marketing challenge.

TENTPOLES

Audience

These movies are very, very, *very* expensive to produce and in order to recoup the investment they need to appeal to as many people as possible. That means the afore-mentioned four quads, plus parents and kids and not just in the United States, but worldwide. This genre is all about being as widely appealing as possible.

Marketing Considerations

The pressure is on with these movies, and the marketing will need to reach far and wide. Audiences are going to look for huge, big-screen spectacle and in many cases, brands and characters that they recognize. In other words, this is the genre where IP really thrives. The campaign will serve up a balance of action and comedy. The international markets will get custom materials that play to their individual tastes. These movies are about offering something for everyone: Male and female charac-ters of multiple races and nationalities, worldwide settings, comedy, action, emotion and spectacle. At the same time, selling tentpoles is also about downplaying anything that might turn off an audience. It has to seem safe for parents to take their kids. It can't be "too American" for foreign audiences and if it is based on an existing prop-erty like a comic book, it has to make fans happy while also remaining accessible to people who are not at all familiar with the brand.

FAMILY

Audience

For live action family movies the audience is typically kids and parents (frequently moms). The content will usually determine the ages of the kids that parents are will-ing to bring. If you are working in the family space, it is important to know that kids are very sensitive to the ages of the characters in the film and they generally aspire older. In other words, if your main characters are seven years old, then nine-year-olds will often think the movie is "too young" for them. Conversely, if the movie has some scary elements or older themes, parents will generally keep their younger children away. On the other hand, animated films should appeal to families as well as a broad general audience. CG animated movies are very expensive to produce and, therefore, they carry many of the same pressures as tentpole movies. That is, these movies need to appeal to as many people as possible: Families, tweens, teens, general audiences and grandparents. Furthermore, these films are designed with a global audience in mind.

Marketing Considerations

The adage in marketing family films is "nag or drag." It means, will kids nag their parents to take them or will parents have to drag their kids? "Nag" films appeal to

kids strongly while "drag" films are titles that parents really think their kids should see (due to nostalgia or a positive message). For the most part, "nag" films work much better than "drag" films. In other words, your family film should appeal strongly to children. That generally means it will be fun, funny, relatable *to them* and wish-fulfilling. Parents will still look for positive messages and clean content and it's important to keep them happy too. Above all, these movies need to be funny.

SCIENCE FICTION

Audience

The primary audience for this genre is often older males, with a secondary audience of older females. If the science fiction is coupled with big spectacle and action, these movies can appeal to a broad audience (à la *Star Wars*). This genre also can play strongly in regions of the country with large tech sectors like Austin, Texas and Silicon Valley in Northern California. Newer, low budget sci-fi movies have come of age lately as well, and such titles as *Ex Machina* have proven to be enormously successful with millennials as well.

Marketing Considerations

This genre can easily get very "heady." In other words, it can involve a lot of people standing around and talking about science. While that intellectualism is part of the draw for these movies, the marketing will generally lean on the action and the amazing things that no one has ever seen before. This genre often presents a view of our future that includes really cool gadgets, technology and worlds and these will be key for marketing.

There is also a social commentary element in this genre and many of these films touch on political or societal notions about our current world and show us a future that has either suffered because of it or has evolved beyond it. This smart, social commentary can also be exploited in the marketing.

ANALYZING YOUR IDEA

Okay, so at this point you have your idea, you have identified your likely audience, you understand the marketing implications of your genre and you understand if you are working with existing IP or original content. Down the road, when you start to interact with marketing they may propose a research study that will identify the audiences that are responding most strongly to your idea (this will either confirm your assumptions about who the movie is for, or it might illuminate a new audience). The research will also measure the response of audiences to see if the idea and the story deliver on the promise of the genre. Finally, the research will help marketing determine what may be the strongest "hooks" for selling your idea to moviegoers. But remember, research *is a tool and not a rule*, and there is no amount

of research that is the definitive answer to either story or audience. It is a guideline, but an important one.

THE IMPORTANCE OF YOUR TITLE

It must be said at this point that not all titles are created equal and coming up with one that would immediately translate into "What a great title!" is really challenging. Even the legendary producer Samuel Goldwyn Sr., when asked what he thought was a great title for a movie, demurred, and said "A hit."

To come up with a good title for your movie, you must take yourself out of the equation and assume you are now part of the audience. Here are some ideas for helping you to formulate the best title:

- **"Two tickets for … (insert your title here)."** This technique is a great way to test out a title. When you say it out loud does it roll off your tongue? Is it too long? Do you have to pause to remember it? The point is you want to make it easy for people to say they want two tickets to your movie.
- **"Party chatter."** You are at a party and someone asks you if you saw any good films lately. You say yes and mention the title of your movie. Try to imagine how they would react? Would they say "what?" Would they ask what it's about? Do you think they will remember next weekend when they decide to go to the movies?
- **"The text test."** Try texting the title to your friends but don't tell them anything else about your idea. Ask them to respond with what kind of move they think it is – if the responses don't line up with your genre and content, you need to rethink your title.

Remember – the most important function of a title is to begin a relationship with your audience.

One of the biggest challenges facing any content today is how to bust through all the media clutter and sound original. Shows premiering on Netflix or Amazon with odd titles for example, have a different luxury than movies do because as you become more familiar with the show, the title gains relevance. "Orange is the New Black" has a whole lot of meaning now that we are familiar with the concept of the show.

Movies have to sound and feel "cinematic" from the point the marketing process begins and the title you as filmmakers give to your project becomes the first line of attack for your Marketing team.

Strong Titles

- Succinctly explain what the movie is about: *Gladiator, Titanic.*
- Convey genre and tone: *Sinister, Get Hard, The Terminator, 12 Years a Slave.*
- Are tied directly to the content by using the easy to remember name of the subject: *Forrest Gump, ET, Rocky, Sharknado.*

- Are attention grabbing and clever but not alienating: *The Dead Poets Society.*
- Provocative but not inappropriate: *Sausage Party.*
- Promise an experience (but must deliver): *Snakes on a Plane, Tower Heist.*

Great titles are "sticky" in that they stick with audiences and make an impact; weak titles are "slippery" because they are easy to forget and lack a meaningful connection to the subject matter of the movie.

Challenging Titles

It's worth noting that just because a title is "challenging" doesn't mean that it's bad. It just means that marketing probably will have some work to get around it. Our examples below include some very successful movies, so a challenging title can clearly be overcome. But if you can avoid it, do so!

- Words that are uncommon or lack inherent meaning: *Syriana, Anthropoid.*
- Titles that are not easily linked to the subject matter of the movie: *Every Which Way but Loose.*
- Long titles that are difficult to remember and fit into TV spots: *The Best Exotic Marigold Hotel.*
- Titles that evoke an immediate reaction regardless of whether the movie is good or bad: *A History of Violence.*

So the title is tricky, so what? It is actually a pretty significant issue for marketing. The repercussions of a troubled title mean that there will be difficulty building awareness for the film. You can say a difficult title over and over and it still may not "stick" with audiences. It also hampers word of mouth. How can people recommend your movie to others if they can't remember what it's called?

Sequel Titles

Marketing people used to think that putting a #2 or #3 was a detriment to creating audience interest and the best title for a sequel was something brand new with a smaller subtitle referencing the original. Now, that thinking has actually flip-flopped where marketing believes that a clear connection to the original is better. Now you see the original title firmly in place with a sequel number next to it and a subtitle that implies a new adventure.

Here are some examples:

The Hangover
The Hangover Part II
The Hangover Part III
Ted
Ted 2

Lord of the Rings: The Fellowship of the Ring
Lord of the Rings: The Two Towers
Lord of the Rings: The Return of the King

Ironically with all its extraordinary success, the *Star Wars* franchise has had a title roller coaster. They just keep changing it up:

Star Wars
The Empire Strikes Back
Return of the Jedi
Star Wars: Episode I: The Phantom Menace
Star Wars Episode II: The Attack of the Clones
Star Wars Episode III: Revenge of the Sith
Star Wars: The Clone Wars
Star Wars: The Force Awakens
Star Wars: The Last Jedi
Rogue One: A Star Wars Story
Solo: A Star Wars Story

In conclusion, never underestimate the importance of the movie title! These can give marketing a big leg up or a hurtle to overcome. We'll show you even more how and why in Part Two of this book.

Title Research

Studios and the larger independents actually do title research and hire companies to help in this process. But title research often ends up in a mixed bag of results – people can react too quickly in a cold environment where no other information is given. Consider these movie titles:

This Is the End
End of the World
Seeking a Friend at the End of the World
It's Only the End of the World
Encounters at the End of the World
A Home at the End of the World

If you didn't know anything about these movies, could you identify which was the serious drama, the comedy, the documentary, the family movie and the real cataclysmic story? If you had to think for a few seconds as to which was which and then pick one favorite, well, you can see the issue.

Ideally, you the filmmaker, with your intimate knowledge of the story will arrive on a clear, evocative, easy to remember title that conveys the genre of your movie.

THE NEED FOR ORIGINALITY

This may seem like an obvious point, but sometimes writers get more involved in the plotting of their stories rather than thinking about whether their story is unique to its genre and therefore has a better chance of attracting an audience. As you are formulating your movie idea, this will be a very important factor to keep in mind.

We live in a cluttered world where movie and television shows not only compete against each other, but when you consider all the other distractions available to an audience seeking entertainment, the options are so great that it is no wonder that many shows and movies fail simply because they struggled to find an audience in the short amount of time they were given. The TV shows and movies that we call breakouts are often deeply original and fresh concepts.

In a time when the major studios are under great pressure to protect their downside, they are frequently producing films that draw on known properties, brands, characters or titles from their library. But as filmmakers, sometimes huge budgets, advertising, IP sourcing and A-list cast access are not to be had, which means you will have to differentiate by pursuing original and intriguing subject matter. In this era of super clutter, the content that breaks through is sticky, original and capable of creating strong word-of-mouth among audiences. Originality is also a great asset for marketing because they will be striving to differentiate your film from everything in the marketplace.

So what are some things that marketing people consider "original" when it comes to mid-range and low budget movies?

- A true story that hasn't been told before: *The King's Speech, Elizabeth, The Big Short.*
- Completely original and innovative ideas: *Don't Breathe, Wedding Crashers, A Quiet Place.*
- Characters or creative voices that audiences find unique and engaging: *Bad Moms, Little Miss Sunshine, Trainwreck.*
- A story that takes place in an unusual or exotic location: *Slumdog Millionaire, The Martian.*
- Stories based on real world events that tell the story in an entirely new way: *The Hurt Locker, Saving Private Ryan.*
- Stories that show us a new angle on everyday things: *The Secret Life of Pets, Elf.*

As a writer/director/producer working in the low to mid budget range, you have much more license to create stories that can be filmed without too much stress on their commercial potential. You are also in a great position to find and utilize emerging talent. Both of these coupled with a movie that gets strong critical support becomes the "trifecta" for marketing people as this asset list is a key component of their selling process.

EXERCISES

Now it's time to take a look at your own movie idea and to apply these processes.

1. **Audience:** What is your primary, secondary and tertiary audience and why? What does your audience look like in terms of psychographics and geography?
2. **IP vs. Original:** Are you working with Intellectual Property or Original content?
3. **Genre:** What is your movie's genre? What audience does that typically garner? Does that audience match with your target above? What are the marketing implications of your genre and how will you address them in your script?
4. **Analyzing Your Idea:** What is your research plan to vet your idea?
5. **Title:** Is your title strong or challenging? Can you find a title that is simple, easy to remember, is tied to the subject matter and conveys your genre?
6. **Originality:** Create a list of comparable films and TV shows that are working in the same space as your idea. Is your concept original enough? How will it stand out from the pack?

NOTES

1 "Fast & Furious: the true story of the street racer who inspired a billion-dollar movie franchise" *The Telegraph*, April 12, 2017
2 "10 low-budget thrillers that could teach Hollywood blockbusters a thing or two" – Den of Geek, September 5, 2011.

3

The Screenplay Stage
Every Choice Impacts Marketing

As you move into the screenwriting stage, of course your focus will be on crafting a strong story, creating exciting conflict, developing strong characters and building your world. But, there is something very important to know at this stage:

Every major decision you make in your screenplay will have an impact on marketing.

The marketing campaign might feel like a million miles away from the screenplay; the movie isn't even filmed yet! But the decisions you make now will directly impact how the movie is sold down the road. To be clear, this book is not here to tell you to change your script to suit marketing, but knowing how your choices will affect the campaign is a powerful tool for planning, especially if you are producing this film or planning to market it yourself.

Right now, you don't need to worry about the specifics of how the film will be sold, but there are certain aspects that are worth considering so you can enhance the *marketability* of your project. Remember from chapter one that "marketability" refers to how easy or challenging it will be to sell your film to audiences. The goal at this stage is to consider the key ingredients in your story and to understand their impact on marketability.

IDENTIFY THE CENTRAL IMAGE

What is the one, evocative, summarizing image for your movie? Think about your story, your hook, and the hero's journey and try to picture what the one image would be for your film. This is the DNA of your film and it should be crystal clear. This image would be the movie poster that would grab the attention of audiences and tell them everything they need to know about the idea of the movie. For example, on the poster for *Ted* we see a teddy bear using a urinal and we immediately know the entire concept of the movie as well as its genre (raunchy comedy and attitude).

If you are at a loss to wrestle your movie idea down into a single, concise image, it might indicate that you have not yet identified the clean central concept of your film – which will prove to be a challenge down the road for marketing as well.

We're going to talk later about how marketing identifies a central idea and communication about the film for their campaign, something they often call the "positioning." But, the important take-away at this point is that your story should definitely have a clear central idea that can be easily communicated. In writing, we often talk about this in terms of the "logline." That one sentence lays out the protagonist, the obstacles, the conflict and the world of the film. Even projects that do not adhere to a traditional structure still have a central *idea*.

As you brainstorm your central poster image, maybe you will sketch it out or create a mock-up. Perhaps you will simply close your eyes and see it in your mind. Either way, hang your real or imaginary poster on the wall above your workstation and remember it throughout your writing.

KNOW YOUR THEMES

Every successful screenplay explores a theme. This subject is well covered in the many excellent screenwriting books out there, so we won't elaborate here. But the essence is that "theme" is different from "story." Story is what happens in your script, theme is what the movie is actually about.

Clearly identifying your theme and weaving it throughout your script is a very important aspect of storytelling, but it also becomes a central tool for marketing as well. Audiences buy tickets for movies in order to be entertained, but they also seek substance. They don't want just empty spectacle; they also want to feel something. Marketing will be tasked with promising both experiences in their campaign: The entertainment and the deeper layer of emotional meaning.

Even movies that fall squarely in the blockbuster action category still riff on powerful themes: Sacrifice for a greater good (*Rogue One: A Star Wars Story*), identity (the *Bourne Identity* series) or loyalty (*Captain America: Civil War*). The clearer and more resonant your theme, the easier it will be for marketing to communicate it to audiences.

Let's look at the campaign for David Fincher's *The Social Network* (screenplay by Aaron Sorkin, based on a book by Ben Mezrich). The movie deals with the theme of loyalty and betrayal in the name of ambition and the campaign emphasized these themes as well.

One of the posters prominently featured the tagline: "You don't get to 500 million friends without making a few enemies." Another poster labeled the protagonist: "Punk, Genius, Traitor, Billionaire."

The trailer begins by reminding us how Facebook revolutionized social networking. Then we get a hint why the protagonist, Mark Zuckerberg, wanted to create it to begin with: He wanted access to social clubs that excluded him, he felt like an outsider. We see how the site is taking off, but then the conflict begins and the themes of betrayal become foreground. Allegations surface that the idea for the site was stolen, tension heightens and relationships are severed all while Mark

is seduced into more power. One character suggests to him, "a million dollars isn't cool, you know what's cool? A billion dollars." The central tagline for the campaign re-appears: "You don't get to 500 million friends, without making a few enemies." Finally, we hear "your best friend is suing you for six hundred million dollars," which cements the central hook of the campaign and the movie: Come see how Mark Zuckerberg created Facebook, possibly stole the idea and was willing to alienate everyone, even his best friend, to achieve success.

TRAILER MOMENTS

You've probably heard the expression that a script needs to have "trailer moments," but what does that really mean? It refers to moments in the film that are obviously perfect for the trailer. These are often great one-liners, triumphant hero moments, epic action or great physical comedy beats.

The following are some common moments and techniques that show up in trailers frequently, regardless of genre. You can look for these in any screenplay you are writing, or any project that you are producing or making yourself.

Central Conflict

Narrative movies all revolve around some sort of central conflict. The hero wants something and there are numerous, almost insurmountable obstacles in her way. In the screenplay this conflict is often established in the "inciting incident" and set in motion during the "act one break." Similarly, the trailer will usually use several scenes or lines of dialogue to let audiences know what the conflict or quest will be for the movie. In other words, in this movie we're going to watch A fight B, or the hero will try to find this special thing, or this problem will need to be solved, etc.

Escalation

In your script, once you've established your central problem, it becomes rather boring if things don't get increasingly worse for your hero. This raises the stakes and increases suspense as audiences wonder how the hero will possibly overcome these mounting obstacles. There are likely scenes in your script where things go from bad to worse for the hero. This is true even in a comedy – it's just that in those films when things get worse, it only gets funnier. The marketing campaign will also use escalation within the materials and throughout the campaign. This tells moviegoers that they will have to come to the theater to see how it all gets resolved.

Thematic Question

Earlier we talked about how the themes explored within the script will also be part of the campaign. The big ideas and central questions that you pose in your screenplay will often become the heart of the trailer. The question is posed to the audience

so they will want to see the movie to learn the answer. If your theme is clear, it can be very clear in the campaign as well.

Turning Point

This is a moment where your hero does something unexpected or something surprising happens to the characters. It sets new conflict in motion and raises the stakes. Your script will likely have a number of these throughout the story. Trailers use these moments from the script all the time because it indicates to audiences that there will be surprises and "twists and turns," in the plot. That just when they think they've figured out where the story is going, there will be an interesting development. These moments are sometimes called "reversals" in screenwriting.

Plot Tease

This is a moment in a trailer that hints at a big plot point. In your screenplay it will simply be an explosive moment, a huge revelation, the death of a character, etc. But since the trailer will not want to give everything away, sometimes they use just a quick image or a suggestion of this plot point. Audiences will get a hint that something big and dramatic will happen in the film.

Cliffhanger Moment

This moment usually comes at the end of the trailer and is designed to leave audiences asking, "What will happen next?" It will be a moment in your script that has huge implications for the characters and the story. However, in your script this may happen much earlier in the story whereas the trailer will use it near the end. It makes sense, because in a script you are presenting a big interesting cliffhanger early to lure in the audience (readers and eventually moviegoers) to stick around and see what happens. Marketing uses that cliffhanger toward the end of the trailer as a motivation to get people to buy tickets and come find out what happens next. Marketing will use the beat to tease moviegoers but not answer the question of what actually happens. If they answer the question, there's much less urgency to see the whole film!

Promise of the Genre

As you are writing your script, watch trailers for movies in your genre. Look at those key moments the show up across the trailers. These are the genre goods and you'll want to make sure your script has a number of them:

- **Action movies:** Usually feature a variety of different action types, an adrenaline buffet, if you will. You'll see fistfights, car chases, explosions, espionage, gunplay, etc. These trailers are meant to get your heart pounding.

- **Comedies:** Similarly, these trailers usually feature a range of humor from verbal to physical. You get a taste of the type of comedy the movie will have to offer. These trailers are meant to make you laugh.
- **Dramas:** These trailers often set up the primary conflict and then show a range of emotional moments that are the result of that conflict. These trailers are meant to make you cry.
- **Horror:** Just like the genres above, horror trailers set up the source of the fear in the movie (ghost, demon, serial killer, etc.) and show a variety of frightening moments. These trailers are meant to scare you.

The thing to take away from this exercise is that you want to make sure that your script has a healthy selection of these "trailer moments." It's not a bad idea to grab a highlighter and go find them in the screenplay. This is something the marketing execs will likely do when they're asked to read your script and weigh in on its marketability. If they can only find a scant few trailer moments in the genre, you can bet they will give you a low grade on marketability. They will know that the moments are not present in the film and will need to be constructed in the campaign (or "cheated" as they call it).

Let's deconstruct the first official trailer for *Captain America: Civil War* to break down these trailer moments:

- The trailer begins with Captain America addressing his old friend, Bucky, and asking: "do you remember me?" Bucky replies with memories from their childhood and Cap tells him, "You're a wanted man." Right off the bat, this scene establishes the **central conflict** in this movie: Captain America's childhood friend is a wanted man. Will the Captain turn him in or defy his other friends (The Avengers) to protect him?
- Next, there is a big explosion, showing **the promise of the genre.**
- The exchange continues between Captain America and his old friend and we learn that people are coming to kill Bucky. We see armed enforcers rappelling in and kicking down doors – **escalation.**
- The next scene features The Avengers together while a man explains, "Captain, while a great many people see you as a hero, there are some who would prefer the word vigilante. You've operated with unlimited power and no supervision, that's something the world can no longer tolerate." Here we have another **escalation.** It's not just that Captain America will be in trouble for protecting his friend, his entire character and freedom is in question. Not only that, but also this scene presents a **thematic question.** How much unlimited freedom should superheroes have? What happens if they use their powers for their own designs rather than to help other people? This thematic question is explored throughout this film.
- Next, we hear a conversation between Captain America and Black Widow where she warns him to stay out of this. He responds, "Are you saying you'll arrest me?" This is a **turning point** in the trailer, where we get a taste of how the

conflict will play out in the film. We can see that loyalty will be questioned and some of Captain America's closest friends may turn on him. We can answer the question posed in the beginning, it seems that Captain America will choose to protect his childhood friend and there will be consequences with (some of) the other Avengers for this decision. The promise of the movie is getting to watch that conflict play out.

- There are a series of quick shots of guns and Captain America donning his suit: **Promise of the genre.**
- Now we have a direct conflict between Captain America and Iron Man. We learn here that these two heroes have opposing views on the thematic question. Iron Man says, "If we can't accept limitations, we're no better than the bad guys" and Captain replies, "that's not the way I see it."
- Next, a montage of action shots, showing off explosions, fight sequences and some of the uniforms of the Avengers (like Falcon flying off a building with metal wings). More **promise of the genre.**
- Captain America declares, "We fight" and in another **escalation,** we see the two camps of Avengers go head-to-head in a battle that is sure to be epic.
- There is **plot tease** that cuts in quickly where we see Iron Man kneeling next to a fallen War Machine. We don't know if this character is alive or dead.
- The trailer ends with an emotional **cliffhanger moment** where Captain America says, "I'm sorry Tony, but he's my friend" and Iron Man replies sadly, "so was I." The scene struck a huge chord with fans and suggested a possibly permanent rift between these two beloved characters.

When constructing trailers, the marketing execs labor meticulously over the decision of every single shot included – actually, every single frame included. Particularly for films with a rabid fan base like the Marvel universe, where they know that the entire trailer will be analyzed and parsed for clues. But even for a family movie or a comedy, marketing execs know that one carefully chosen trailer moment can make or break the efficacy of the sell. The "he's my friend/so was I" moment that elevates the *Civil War* trailer from exciting and interesting to a must-see movie. Again, audiences are not just looking for exciting spectacle they want to feel something too. Seeing their favorite characters torn apart by divided loyalties is an emotional hook to complement the bigger action.

Surely, you have seen a trailer where you can immediately tell that the movie doesn't have the goods. One of those trailers that uses fancy cutting, exciting music and lots of text or voiceover to hide the fact that there really isn't that much action or substance. That's the evidence of a marketing department making the best with what they had, but as a filmmaker you can do better. Remember, marketing only gets to cook with the ingredients you give them. They can create custom content (more on that later) and employ other methods to round out a campaign, but today's sophisticated audiences can tell right away if the movie delivers on the promise of the genre. The trailer moments are the proof that it does.

BUDGET

The budget of the film is determined by the content in the screenplay. When the production department at a studio evaluates what a movie will cost to make, they hire experts to go through the script and estimate cost. They look for things like number of locations, how many and how global? Are there a lot of special effects? Is there weather? Rain and snow usually have to be manufactured or added digitally which can increase costs quickly. In other words, every time you write "the building explodes," or "she stood outside in the rain," your budget goes up considerably. As a writer, your primary job is make the screenplay the best it can be, whatever that entails. If the scene absolutely works the best on a ship in the middle of a hurricane, then so be it. The problem arises when the budget of the script does not match with the size of the potential audience.

The producers, directors, stars and decision-makers are all obviously very focused on what a movie will cost. It's often the difference between being able to get the film made or not. But, marketing is also very focused on budget. First of all, it's directly tied to the size of their marketing spend (called the P&A budget for "Print & Advertising"). The budget sets the expectation for what the movie must earn in order to be profitable. Since marketing's job is to sell this thing, that obviously matters a great deal.

Referring back to Chapter 1, when we talked about the target (primary) audience and how this is usually the first question marketing asks: Who is this movie for? This ties directly to the budget of the film. If the size of the audience (and therefore the potential box office) is smaller than the money it will cost to make the movie, that is a significant issue. For example, if you are writing a young adult story with an all-teen cast and themes around coming-of-age, that's perfectly fine. But if that same film also takes place on a space station with big budget battle sequences, that potentially creates a situation where you have a limited target audience (teens) on a movie with a budget level that necessitates big, broad appeal. There are certainly examples of films that break out beyond their likely primary audiences, but these are generally the exception and not the rule. In order to give your script the best chance to get made and succeed in the marketplace, it is worth looking closely at the alignment between audience and budget level.

EXERCISES

1. Make a list of movies in your favorite genre and find the posters for those movies. In one sentence, write the central idea of each film communicated their poster image.
2. Now look at your own project. Can you think of a single image that encapsulates your film? What central idea does that image convey? Can you write it down in one sentence?
3. Read the script for a recent film and make a list of one to three themes that the story is exploring. Next, go watch the trailer for that movie and look for how those same themes are use in the marketing as well.

4. Find the script for a recent movie you love online and then watch the trailer. Find each moment used in the trailer in the actual script and mark down if the moments were:
 a. Central conflict
 b. Escalation
 c. Thematic question
 d. Turning point
 e. Plot tease
 f. Cliffhanger moment
 g. Promise of the genre
5. Analyze your own script, one you are writing, directing or producing. Mark down the possible trailer moments throughout. Are there plenty of these trailer moments within the screenplay? Are there places where you could add more?
6. Look at your project through a budgeting lens and write down a ballpark range for how much you think that film would cost. You can simply decide if it would be:
 a. Micro budget (under $1M)
 b. Low-budget ($2–15M)
 c. Moderate budget ($16–30M)
 d. Mid-budget ($31–50M)
 e. High-budget ($51–100M)
 f. Blockbuster ($100M+)
7. Next, use what you learned in Chapter 1 to identify the primary and secondary audience for the film. Does the size (and box office potential) of your audience align with the potential cost of the film?

If there *is* a disconnect, think about ways you could either reduce the budget for the film (without hurting the project) or ways that you could expand the script to draw in more potential audience. For example, does it have to be R-rated? Could you preserve the quality of the film but still achieve a more inclusive MPAA rating?

4

Packaging and Casting
Building the Most Marketable Team

Once the script is complete (or at least in solid shape), the next stage in the filmmaking process is called Packaging. This is where you will attach talent, producers and a director. There are all sorts of ways that this comes together, generally determined by what makes the most sense for the film financially, who is involved and where it is in terms of distribution. The following are types of packages you might see form around a script:

FESTIVAL PRE-SALE PACKAGES

Sometimes producers and film financiers will come together around a script or even a treatment and they will assemble a package with key cast and a director. They will take this to festivals or a market such as The American Film Market (AFM) to try to find a distributor. This process is detailed in Chapter 5, "Financing and Greenlight."

When a package is assembled for pre-sale, filmmakers and actors are attaching themselves to a movie that is not guaranteed and that means they are assuming some level of risk. You may find yourself in this position in your film career, especially for more independent and arthouse movies. By committing to the movie, you'll need to keep your schedule available for that time period in case the movie becomes reality – which means you may have to turn down other opportunities. If the package fails to sell, it's back to square one. Consequently, this generally happens with movies that have something very compelling to offer the director and cast such as great visual promise, artistic merit, appealing roles or Oscar potential. Most movies that are sold as packages happen at the independent/foreign sales level where the key cast elements are put to together with a director and producing team. One can see examples of packaged movies when you look at some of the 2017 Academy Award nominated films like *I, Tonya*, and *Three Billboards outside Ebbing, Missouri*.

These movies were packaged by the producers with the help of various talent agencies and were then shopped to all those distributors who the producers felt would respond to the material and cast. Fox Searchlight bought the North American rights to *Three Billboards*[1] and the new Miramax, under its previous management, bought the North American rights to "I, Tonya."[2] When the new management changed their business direction, *Tonya* was shown at the Toronto Film Festival where it was acquired by another company, Neon,[3] who went on to release the film to great success in the US.[4]

There are also a number of Talent Agencies in Hollywood that represent directors, writers, producers and actors. They will take a script written by one of their screenwriter clients and attach other clients to it – such as a director or cast. Then the agency will take the package around town and shop it to studios and production companies. This happens quite frequently and it benefits the agency, the talent and the studio because they get a big splashy package. Or, when one of their clients finds a script or wants to become attached to one, the agency takes the lead in putting the rest of the elements together. Recently, this practice of packaging has come into question from the WGA (Writers Guild of America). The agencies are locked in a tense battle with the guild to determine the best business practices.

The major agencies in Hollywood are:

* William Morris Endeavor (WME)
* Creative Artists Agency (CAA)
* United Talent Agency (UTA)
* International Creative Management (ICM)
* Paradigm Talent Agency
* The Gersh Agency

STUDIO-CREATED PACKAGES

Another common way that movies come together is within the studio internally. Writers or directors frequently come into the studio, through their agents or managers, with a pitch for a movie or a complete screenplay (a submission). A development executive from the studio will hear the pitch or read the script and decide if it's something worth pursuing for the studio. When a project is acquired by the studio in this way, they immediately set about creating a package for the movie. This process will be driven by the development executive who will create lists of additional writers and available directors to pursue. They will work closely with the studio's casting department to find the right actors and get them attached. Outside of very rare occasions, it is only once the package is assembled and the budget run that a studio can bring a film to Greenlight. We'll talk in detail about the Greenlight process in Chapter 5, but for now it's just important to know that this is the "okay" from the head of the studio to go ahead and make the movie. So, this process is very important in the early stages of a movie's life.

TALENT-DRIVEN PACKAGES

Major actors, directors and producers commonly have their own production companies who hunt for ideal material. For example, Leonardo DiCaprio has Appian Way, which looks for scripts, books, pitches, etc. for the actor to either star in or produce. These production companies usually have a "first look deal" with the major studios. This means that the studio will finance these acquisitions in exchange for the right to take a look at whatever is acquired and be able to say yes or no before it goes to any other studio. At the time of this writing, Appian Way has a first look deal with Paramount Pictures. In this case, the talent is essentially packaging themselves with a property and then looking for a partner to make the movie.

No matter how the packages come together, all movies need actors, producers and at least one director in order to get made and this part of the process has big ramifications for marketing. Even though this all happens before the movie is even filmed and long before the campaign kicks off, the decisions you make in this stage will come into play later and this chapter is going to show you how.

Zanne Devine was Executive Producer of the recent *Halloween* remake, the Oscar winning *I, Tonya*, *Mr. Holmes* and *Southside with You*. Currently, Zanne is president of Montana North Media, a development and production company, and Pacific Northwest Pictures (PNP), a Canadian distribution company. Previously, Zanne was EVP of Film & Television at Miramax, and has held leadership positions at several studios and production companies, including The Kennedy Company, Beacon Pictures, PolyGram Filmed Entertainment, and Universal Pictures. Her recent credits include: Producer of the upcoming films *The Grizzlies*, *Kim Possible*, and *Needle in a Timestack*.

How Do You Approach a Script?

Zanne: One of the most important things is to think about is, "What will the best version of this movie be, and is it going to live in the marketplace?" Whatever the genre, I have to believe:
a. I can cast it properly
b. The role will have depth that an actor may consider awards worthy
c. I am presenting material to an actor who has never been offered such a role, but guessing that the audience may be interested in seeing the actor doing that role.

For example, offering Allison Janney the part of Tonya Harding's mother believing how committed and dedicated she could be, and how only she could play this role. And hope that she is going to hit the bullseye and that will give my friends in marketing something great to work with.

Offering actors roles against type is a fascinating approach to casting – even accepting Margot Robbie in the role of Harding – that is a very different trend from what it used to be where audiences would rarely support an actor who played a character out of their comfort zone.

ZD: Now that is changing dramatically with talent wanting to cross over from mainstream to indie movies and back again. Even the tentpoles being made at the studios are attracting indie talent and that affects the actors of these mainstream movies and how they now are attracted to indie movies so there is a whole creative cross pollination going on now.

So is your selection of an actor now, really an example of marketing?

ZD: I think so and will this actor choice also help sell the movie to the people who influence the publicity of a movie – journalists, writers, television hosts, what are the talking points of this movie? Will it resonate on talk shows? And how is the social media presence of the actor going to help sell the movie?

When you consider material, do you think about where the movie should be presented? What determines whether a movie should premiere in a theater or on a streaming service?

ZD: If you look at every original movie that premiered on Netflix this year, a number of them could have opened in a theater and conversely, if you look at some of the movies that are in theaters, the question is why? Could they not have lived just as happily on another platform?

Many filmmakers say I want my movie to stay in the conversation, and to me that is the difference. When things land on Netflix, they are in and out quickly and the cultural conversation doesn't happen to the same degree when something plays in a theater over a number of weeks

You have also recently entered the area of short form content and are working with a major platform set to launch a number of original content series. How has that made you, as a traditional storyteller and producer, rethink what you are bringing to the table?

ZD: It is still about storytelling, but at a different pace and that is fascinating. We are creating content for a young generation, primarily 16–22, who are all click-click-tap-tap. And we have to give them stories that happen really fast and even on multiple screens at the same time.

That is the challenge – to integrate all the different ways we use our devices – split screen, quad screen – with story points happening in each one of them and distilling those story points into something fast moving and comprehensible involving both story and character.

CASTING IMPACT ON MARKETING

The first and most important objective in casting your film is obviously to find the very best and most talented people to embody the roles. As we've said repeatedly,

your job as a filmmaker is to make the best film you possibly can and the cast plays a huge role in that. However, it is very important to consider that your casting choices will have a significant impact on marketing activities down the road in some obvious, and perhaps, some surprising ways.

Popularity and Bookability

Of course, the star power of your cast will impact the profile of the film. An A-list star will immediately generate publicity and attention and they generally bring along a built-in fan base that is eager to see them in just about any film. But, only a scant handful of films will feature the biggest stars, while the majority of movies made every year are cast with lesser-known or unknown actors. There is not a thing wrong with this from a filmmaking perspective. Indeed, many of the most celebrated breakout films from the festivals each year feature brand new faces. However, when it comes to marketing, a big component of the campaign will be generating publicity and this leads to the question of "bookability." In other words, will your cast be able to get booked on talk shows? Will magazines and newspapers want to interview them for features? Will press attend a junket or a premiere? This doesn't just come down to how famous or popular the actors are, it's also about how interesting they are. This is especially true when we're talking about more modest and locally based marketing campaigns.

If you are making and marketing your film by yourself, then you will likely have a very modest marketing budget. Your premiere might be at local art cinema to kick off a limited run at that theater. But, you'll still want publicity and that requires the interest and the attention of the press. Let's say you're making an independent film about public school teachers in your community. If you also cast some real teachers, or actors who were formerly teachers, that makes for a great story! That's a hook that you can pitch to local press to try and generate coverage.

For a slightly larger budget film, you might opt for one actor that has name recognition surrounded by a cast of relative newcomers. We see this frequently with independent films on the film festival circuit and there's a reason. Sure, you could save the money and cast all unknowns, but that one name might prove to be the very best investment. Not only are they likely to be strong actors (they have a name for a reason) but they are also bookable. They can generate interest and coverage from press, especially locally. It's a big deal when a relatively well-known actor travels with a film to smaller markets outside of the usual New York, Los Angeles, Chicago circuit. Both local press and college newspapers will want to interview that actor and review the film.

For studio level movies, most titles feature relatively popular actors, but it's not always the case. Particularly in the horror genre, there are movies every year with budgets in the millions and nobody with name recognition, so what counts is originality of concept and story. In these cases, publicity can be tricky and usually involves a process of breaking the cast in and introducing them to the world long before the movie comes out. Publicity is capable of creating stars and does so all the

time. We'll cover this process in detail in part two of this book. But for now, the key takeaway is that whether you are making a micro-budget film or a bigger studio movie, be aware of your cast's ability to help you sell the movie.

Availability

This is a big factor that is overlooked much more often than you might realize. What is the schedule for your cast when your film will be in the marketing stage? Are they going to be available to attend festivals, do interviews and attend your premiere? If they will be off filming another movie in Australia while you are desperately trying to generate press for your launch in Chicago, that will be a hindrance. Actors obviously strive to work and they frequently line up several projects in a row. In the studios, the contracts for the cast often stipulate that they make themselves available for marketing efforts. But, on smaller or independent movies, this may not always be a matter of course. It's important to consider and to discuss with your cast early on in the process.

Social Presence

An actor or actress with a large social media following can be a huge asset for marketing. Talent that engages with their fans and creates an active, loyal online fanbase is a great thing for the campaign. An excellent example of this is Dwayne "The Rock" Johnson. At the time of writing, he has 57 million followers on Facebook, 13.1 million followers on Twitter and 119 million followers on Instagram. He posts regularly, lets fans see a glimpse of his life, shares fitness inspiration and jokes around with other celebrities. When he's promoting a movie (which is often), he posts behind-the-scenes pics from the set, updates on the production and sneak peeks at the footage. When it's time to debut the trailer, it's frequently Johnson that will release it first to his huge fan community to give them the chance to see it before anyone else. They will in turn share it on all of their social channels and this gives the trailer a big boost in viewership as soon as it goes online. Johnson is building early awareness and his fans feel like part of the movie, long before it ever hits theaters. The studio, of course, is completely in synch with him on these posts and it's a great thing for them as well.

It's still a good idea to take a look at the social presence of your cast and director. Even though their followers may not number in the millions, if they do engage with fans online, this is a great tool that you can use later to help promote your film. And for those cast members with no social following, the job of your producer and publicity person is to get that going on behalf of the reluctant cast member.

International Appeal

Another factor to consider in the packaging stage is the international appeal of your cast. Whether you are distributing the movie through a studio or planning to

sell the foreign rights at a film market, international marketability is a big plus. The international box office on a major movie often accounts for 60–65 percent of a film's worldwide gross and the studios, who are acutely aware of this, will frequently cast some of the secondary roles with actors that are well-known in foreign markets. Though they may not be as recognizable in the United States, they have huge fan bases in their country that are eager to see the movie. No matter the budget or scope of your film, if the package that you put together has international appeal, that will only help the marketing efforts down the road.

Consultation Rights

The right to marketing consultation generally applies only to the more A-list stars and directors, but it's important to be aware as a filmmaker. What it means is that, contractually, certain stars and directors get to review and approve all marketing using their likeness. It's common for talent (at every level) to get sign-off on photos and film stills that will be used in publicity. But, the next level of this is when marketing is required to show the cast and director any piece of marketing material they create (posters, trailers, TV spots, clips, online ads, etc.) When this happens, the talent has a strong influence over the direction of the campaign.

For example, Director and Producer J.J. Abrams is famously secretive about his projects and the marketing campaigns are likewise more of a tease than a full meal. Here are his thoughts on the matter from a 2013 interview with *Entertainment Weekly*:

> "I will sit in a meeting before a movie with 80-some people, heads of departments, and literally say that all I ask is that we preserve the experience for the viewer," Abrams says. "Every choice we make, every costume fitting, every pad of makeup, every set that's built — all that stuff becomes less magical if it's discussed and revealed and pictures are posted online. I just want to make sure that when somebody sees something in a movie they didn't watch a 60-minute behind-the-scene that came out two months before."[5]

There is no right or wrong answer on how much to show in a campaign and filmmakers have different points of view about the issue. Some filmmakers are happy to stay back and let the marketing department sell the film however they think is best, while other filmmakers are incredibly hands-on in the process. In either case, it is vital to understand the process and be confident enough to engage in the conversation with the marketing team as necessary.

EXERCISES

1. If you are working on a film, create a dream cast list for your characters. This means what living actors would be your dream to cast in each role. Next, create a report of the cast's social media presence. Do they have accounts on

Facebook, Instagram, Snapchat, Twitter, Musical.ly, etc.? How many followers? Do they post? Do they promote their films? It may be eye opening to see which celebrities excel at social media and which ones eschew it. If you are in a class, compare your reports and see who's dream cast has the highest level of social media presence.

2. Pick five movies that came out recently that you liked. Use the trades (*Variety*, *Hollywood Reporter* and Deadline.com) to research how they were packaged. Were they put together by an agency, developed at a studio or bought at a festival?

NOTES

1 http://www.channel4.com/info/press/news/film4-fox-searchlight-pictures-co-finance-film-by-martin-mcdonagh

2 https://www.screendaily.com/distribution/miramax-acquires-us-rights-to-i-tonya/5112156.article

3 https://deadline.com/2017/09/i-tonya-neon-30west-tonya-harding-margot-robbie-toronto-film-festival-allison-janney-craig-gillespie-1202164919/

4 https://www.indiewire.com/2018/03/tom-quinn-neon-i-tonya-netflix-1201943238/

5 https://ew.com/article/2013/01/06/jj-abrams-secrecy/

5

Financing and the Greenlight Committee

Marketing Moves the Money

There is no truer a lament when it comes to financing your project than what Jerry Maguire shouted throughout his office while on the phone with his client. Of course you can't demand it like Jerry did, but understanding the process of the financing of your movie is a vital part of getting it made and we will talk about how marketing has evolved as a force in the Greenlight process and what tools you, as filmmakers, can make available to them.

The "greenlighting" of your movie, meaning you are finally moving into production, can happen in a number of different ways, which we will discuss here. It can be on the micro level with a small group of investors, in the independent world with investment from financiers and the packaging and world-wide sales of distribution rights, or on the studio level, through the greenlight "committees" that comprise representatives from divisions of the studio, each of whom is responsible for their share of the revenue projections.

The purpose of this chapter is not meant to be an in-depth study of the options and rigors of production finance, nor will we argue about the benefits of selling outright to companies like Netflix, but, rather, to illustrate how three very specific "greenlight" scenarios play out at multiple budget levels and where marketing sits inside these processes.

At this point, you have developed your screenplay into a strong, original story capable of attracting talent and/or a director who can bring talent onboard. You will likely have already begun to package and cast your film. You are now ready for the finance phase and your circle of influencers has become considerably larger, as your goal is to move your project forward towards production.

MICRO BUDGET – SELF-FINANCING

If you decide to raise the money for your ultra-low budget film, then you will most likely pursue all the options available for indie financing including crowd-funding,

equity investments, friends and family donations and the like. You will most probably not be able to presell any of the distribution rights to your film, including theatrical or television rights, given that you likely have an unknown cast and subject matter that may not seem readily commercial to the seasoned eye, or perhaps you are making a documentary. The most important part of your sales pitch to raise the financing will be your passion and your ability to place your project in some meaningful context where people can say "Yes, I'm interested in funding that," or if talking to a distributor, "Yes, I can sell that."

Particularly at this level, where we can assume everyone involved in the project is an unknown, marketing can have a profound influence on the potential of your film. By creating the group of materials discussed below, you define your project before it becomes real. Whether you are putting your project up on a crowdfunding site or making individual pitches to investors or a combination of both, you will need a set of marketing tools:

Social media platforms to support your message. Every film needs a home where people can go for more information – this can be a website with its own URL, a Facebook page, Tumblr if more appropriate, or even some of the newer tools available on Instagram and Snapchat. You are selling a story through a visual medium and beginning to build your community is an important step.

A version of a poster. Already you can see how important visualizing a single image in your head can become as we discussed in Chapter 3. It's very helpful for potential financiers as well.

A conversational video pitch by the director and or producer to send to investors. Here the filmmakers will explain their inspiration and vision for the film.

A sizzle piece. You could try cutting together a trailer using scenes from other films that reflect your storyline or the mood you are going after. This is called a "rip-o-matic" or a "sizzle reel."

A teaser trailer you can shoot with your talent, even a single scene to give a flavor of the film. This is becoming increasingly common in self-financed movies and these single scenes or first few minutes of the movie are called "proof of concept" pieces. They are often quite successful in generating investor interest or crowd-funding support.

Rewards deck. Every micro budget film needs a rewards deck based on the levels of investment you are seeking and what your investors can expect in terms of repayment.

Most importantly, you have to stay with it. Tenacity has no better friend than a movie that needs dollars.

So what is the "greenlight" factor here? Mostly intangibles, as your backers probably come from very different places and are supporting you for a variety of reasons. Your job at this point is to position your project into a coherent package that

interested investors can follow, digest and, hopefully, embrace with an eye towards profitability. Your film is greenlit to proceed with production when people donate or invest money and you reach your financial benchmarks.

INDEPENDENT FILM

If your budget crosses the seven figure mark, you will find yourself knocking on the doors of production companies, talent agencies, and independent distributors, all obligatory visits on the path to production financing. And as your marketing tool kit starts to expand, the decision-making process shifts from supporting the individual to a project's potential and finance-ability.

At this level, it is rare that first-time filmmakers will be able to sell their projects directly to a distributor, but it is nonetheless very important to have the basic building blocks of your project in hand prior to going out into the world with it. A producer needs a script, a first-time director needs a producer with some sort of track record, an actor with a production company needs credible representation, an agent needs to package, etc.

In addition to whatever attachments filmmakers bring to their pitch, many directors and producers include a "look book," which is usually a compendium of images, words, and even designs, that speak to the mood, place, relationships and tone of their project and usually incorporate images from a wide variety of sources. This is a very effective tool and "leave behind" after a production or distribution company pitch meeting.

The independent greenlight committees usually comprise a small group inside a distribution company that look at projects submitted to them through their own in-house acquisition or development staffs, agencies, producers, and more recently, from foreign sales companies. Most of these projects taken under consideration consist of developed scripts with the majority of elements attached and a vetted production budget.

They evaluate measures based on the company's relationships with, or interest in, the filmmakers, the marketing potential of the project to a core audience including advertising costs and box office scenarios, and the financial models which project expenses. These models include production or acquisition and marketing costs, and revenues brought in across all windows or platforms usually over an initial ten-year period.

Profit & Loss Report (P&L)

While the specific terminology inside each company may be different, this report is generally called a "P&L." It shows financial models for low, medium and high case scenarios of box office success. The P&L factors in a combination of all sources of revenue that the movie could bring in including theatrical, television, home video/streaming, and any merchandising. This is all put against all the expenses including

the cost of production and the dollars needed to properly promote and distribute the film. The P&L shows the studio or production company how much the movie needs to earn in the box office in order to break even and where they will start seeing some real profit.

Figure 5.1 is a mock-up of a typical independent movie P&L report. In this case the movie does not turn a profit in the mid-case (average) scenario and therefore, this would be considered a problematic situation. This sample P&L suggests that the movie would have to over-perform (high-case) in order to be profitable. That would give a studio, production company or distributor pause.

Of specific note, we assume the budget for the movie is $5M and the international revenue is just 30 percent of domestic. While this is almost the opposite case with many tentpole movies where international accounts for 60–70 percent of the gross revenues, independent movies do not come close to that. Also, we have discounted any marketing costs that may be spent oversees as well. While we can say

		Low	Medium	High
P&A		$4,000	$8,000	$12,000
U.S. Box Office		$3,000	$14,000	25,000
Income				
Theatrical Box Office Rentals (45%)		$1,350	$6.300	$11.250
U.S. Non-Theatrical (2%)		60	280	500
Digital Sales (25%)		750	3.500	6.250
Video on Demand		1.000	2.000	2.500
Free TV (5% subject dependent)		150	700	1.250
Pay Television 15%)		450	2.100	3.750
Total Receipts		**$3.360**	**$14,880**	**$25,500**
Expenses				
U.S. Prints and Advertising		$4,000	$8.000	$12.000
Misc. Expenses		1.000	1.500	2.500
Total Expenses		**$4.500**	**$9.500**	**$14.500**
Distribution Fees (domestic)				
Theatrical Rental	20%	$270	$1.350	$2.250
Non-Theatrical	15%	9	45	75
Digital Sales	15%	112.5	562	937.5
Video on Demand	15%	125	133	141
Pay Television	20%	250	400	4,000
Total Distribution Fees		**$2,531**	**$2,648**	**$6,559**
Total Expenses and Distribution Fees		**$7.031**	**$11.148**	**$18.003**

Figure 5.1 INDEPENDENT MOVIE

NET PROFIT	$ (3.671)	$3.732	$7.497
INTERNATIONAL +30%	(2.570)	4.851	$9.746
FILM BUDGET	$(5.000)	($5.000)	($5.000)
NET NET	$(7.570)	$(149)	$4.746

Figure 5.2

Charts created by the authors

NOTE: The percentages and income statements are shown as examples only and do not represent a fully fleshed out P/L. There are many variables to each deal and each phase of release, based on existing arrangements your distributor may have in place.

for sure that none of these predictions are real and no matter how finely tuned you may want your P/L to be, these statements are only a guide and it is still up to you and your financers to determine how much risk you all are willing to take.

Ideally, you expect that the movie starts to show a return on investment at a mid-range of box office performance and based on that performance it drives all the subsequent revenue streams as the movie plays out in the ancillary world of home video, streaming and television.

The low-case scenario for box office illustrates a worst case scenario, so there is no expected profit there, actually a loss, which is indicated by the parenthesis "(xx)." The high-case scenario is if the movie exceeds expectations and over-performs. You expect to get a profit at that level. The mid-range scenario is what the movie is expected to gross and at that level, it will return investment back in to the company. When a P&L is run and it shows that a movie would need to over-perform to create a profit, that's a big red flag and will often lead to a pass on investing.

Of course there are exceptions to this rule; a company may really want to be in business with a particular actor, director or producer and are willing to take a greater risk for the value of building a relationship. In more cases than not, however, it is the financial model that determines whether a project is "greenlit."

SELLING FOREIGN RIGHTS TO FINANCE THE MOVIE

In addition to talent agencies like CAA, WME, ICM, UTA and the Gersch Agency, there are many independent producers who are now sourcing a lot of independent product. They are either directly involved as financers or help to raise the initial funding necessary to develop and package their movies. These producers also usually work hand-in-hand with foreign sales companies.

The new breed of foreign sales companies brings great value to independent distributors and their internal greenlight committees. Here's how it works. When you and your producer have managed to put together a few attractive elements such as a strong script and are able to attach a name talent or director, you start to have

many options in this world. While foreign sales companies have been around for over 30 years and many continue to function in much the same way over that time (which we will get to), this new group has emerged as credible suppliers only over the past five years.

Foreign Sales Companies

Independent companies who will broker the distribution rights for your movie to each international market (UK, Australia, Mexico, etc.) and will use that financial commitment to fund the production of the film. This is called "foreign pre-sales."

How do they work? Simply put, they are in the business of pre-selling territories to upcoming productions and securing a financial commitment to be paid upon delivery. These companies then put together rather elegant financing plans that include these pre-sales, tax credits based on location, equity and bank loans against these commitments. The studios and the independent companies then acquire these movies well into their production phase, or by committing to acquire domestic rights prior to production. In many cases the commitment to US distribution by an accredited indie or studio allows the foreign sales companies to finalize their international sales throughout multiple territories. These companies tend to do most of their domestic business with Fox Searchlight, Focus, A24, Sony Pictures Classics and some of the newer companies like Annapurna, Bleecker Street Media, 1091 Media and Neon.

In other words, here is a simple version:

1. You, the filmmaker, have a script.
2. You either create a package yourself or with an agency (attaching talent, director, etc.) OR you will work with a foreign sales company to do that.
3. The foreign sales company will then bring your script and package to a film market or festival and attempt to pre-sell the right to distribute to each international market.
4. You then take the foreign sales estimates that the sales company is confident they will get based on a small percentage up front and the balance to be paid on delivery, and go to a bank or lending institution to secure a discounted loan against those rights.
5. The money that you receive from the lending institution will fund the production of your film.
6. At this point a number of other issues usually pop up – you are short of cash for your production and you either have to cut your budget, cut your salaries, or go another lender to secure the difference. This secondary lender usually charges a significantly higher fee for the use of their money.
7. Hopefully all goes well and you are off to start making the movie.
8. Once you are further along and have more materials to show, a studio/distribution company will screen the work-in-progress and acquire the movie for domestic distribution.

The exception to this order of events is that it is not uncommon for a studio/ distribution company to get involved before you even shoot a frame of film. If you have a particularly appealing script and package assembled, they will acquire domestic rights early in the process.

So, this all sounds pretty exciting for an independent film. It's a great way to finance your production and to make the movie knowing that it's going to be seen in theaters worldwide. But, the bad news is that not every film will be attractive to the foreign sales companies. They are, after all, looking to make a profit themselves. Therefore, when a foreign sales company assesses a project to take on, it's important to know what they are looking for. If you guessed that *marketability* is going to play a major role here, you are correct!

The script: It all starts with your script and from there a marketing template is drawn. Just like we showed you in Chapter 3, these companies are going to be looking at your script to assess how easy or difficult this movie will be to sell internationally.

Who is the audience? Marketing's favorite question is also hugely important here. Is there a defined target audience, whether it be in France, Germany, Korea or the US? How large is that audience relative to the size of the budget and cost to market and release the movie?

Poster, sizzle reel or trailer: Depending on how deep into production the film is, you will likely create some marketing materials to try to woo the foreign sales agents. You are going to want to show them just how marketable your movie is by mocking up a poster, cutting a sizzle reel or shooting a proof of concept trailer.

Genre: Much consideration is given to this factor and it can make or break interest from the companies. Specifically, will the genre of the film work in the majority of international territories? The markets each have their unique tastes and box office patterns. For example, American comedies do not typically travel very well because humor is so country-specific. Horror plays well in many countries, especially Latin America. But, supernatural horror is traditionally much easier to sell than hyper-violent/slasher horror. Dramas can work in many markets (especially with an A-list cast attached), but they are very subject matter specific. A drama about the US military, for example, is not going to be easy to sell overseas. But, a drama about something universally relatable could have very strong reach.

Offensive content. Are there questionable or offensive scenes, or subject matter, that would impact a country's cultural traditions? Foreign sales companies are experts on the do's and don'ts by market and they will be looking for anything that might offend or turn off international moviegoers.

Cast: The foreign appeal of the cast is another significant factor. Are your actors well known around the world or are they only beloved in America? One of the things that makes A-list stars, A-list, is their ability to draw audiences worldwide. For example, actors like Tom Cruise, Brad Pitt, George Clooney,

Meryl Streep and Charlize Theron are popular around the world and therefore highly desirable for foreign sales companies and studios.

Local talent: If there are several roles in the movie that could be cast with actors that are popular in their respective markets, that can be a big plus. For example, we might see this in an action movie where an ensemble cast is assembled that features major stars from multiple countries.

Market relationships: What are the target distributors in each key market and what types of films are they looking for? Maintaining relationships with the same companies in each territory is an essential part of the sales technique. If they deliver one good film that earns the local distributor a profit, the more likely are they to sell to these companies in the future. Those individual companies in the market will be filling a specific slate and the foreign sales companies will look for titles to slot in.

These foreign sales companies regularly attend the bigger sales markets like the American Film Market and the Berlin and Cannes Film Festivals. These festivals each offer a strong sales marketplace that exists alongside the regular festival programing. These foreign sales companies are primarily known for representing genre specific films – teen, horror, action, etc. If the film is already finished, then to represent the sales of the film on behalf of the producers. These companies usually put a dollar value on each territory as a percentage of the film's budget and negotiate territory-by-territory. It is a gargantuan business as evidenced by the 2017 American Film Market where over 8000+ industry professionals attended, over 2000 new films and projects were for sale, 1000 production companies were represented, 400 distributors were looking to acquire content, and there were over 700+ screenings of sizzle reels and finished films.[1]

These companies not only package, they acquire rights, develop and ultimately produce a wide variety of movies and in doing so have essentially created a new production pipeline for the type of movie that the studios have moved away from. A foreign sales company can become a significant option for your project if you want to make a film with the right elements and about subjects that could engage international audiences.

The agencies have divisions that handle foreign sales as well and you will often see a line like this in an article: "The movie will be distributed domestically by Warner Brothers and foreign sales are being repped by CAA."

This remains a very strong staple for that certain kind of film. Even if lower budget, genre fare has progressively seen less life as theatrical releases in theaters worldwide, there are many new content platforms currently available for distribution, both in the broadcast and digital arenas. The foreign sales companies will push to get a movie in theaters worldwide with distribution commitments from the markets.

Over the past ten years, as the studios have focused more on their tentpole and IP-driven titles, they have moved away from the mid-range budget, dramatic and low concept story driven ideas.[2]

This has opened a huge gap in the marketplace for producers to help put these kinds of films together. For sure, it is not the audiences that have disappeared; it is the profit margin for making these films on the studio level, where it simply isn't worth it for them to produce.

If it can be said that the success ratio for films over $100M budgets is far greater than that of films under $100M, one only has to look at the conglomerate/studio axis at Disney to fully understand this.

According to Bruce Nash of Nash Information Services and publisher of The-Numbers.com, "Approximately 70% of movies budgeted over $100M are profitable, while 70–80% of independently made movies under that number lose money."

New, emerging and name directors are more than willing to take on a project with edgier material. Talent loves being challenged by these types of projects and producers who operate on the international stage are all attracted to these types of movies, some of which have recently dominated the awards cycle and turned considerable profits as well. A lot of these movies have been packaged by this new breed of foreign sales companies including FilmNation, Bloom, Sierra Affinity and Good Universe. Most of the 2016 Oscar Best Picture nominees had foreign sales companies involved with their financing including *Arrival*, which was put together by FilmNation, who sold the domestic rights to Paramount at a later date.[3] The same will be said for any number of future awards contending movies. In 2017, *I, Tonya*, *The Shape of Water* and *Three Billboards Outside Ebbing, Missouri* were financed with the help of foreign sales companies.

One note of caution: The world of international pre-sales is a very cyclical one. Many independent distributors have lost loads of money by pre-buying movies that didn't work in their own market for one reason or another. Many of the established international independent distributors are now more willing to wait and see how the movie comes out and would rather enter a competitive bidding situation at a festival because at least they are seeing what they are buying. The same theory applies to domestic distribution companies, which is why the festival circuit remains such a hot place to buy.

So what does this business look like today? We spoke to Camela Galano who is currently an international sales consultant and Executive Producer/Head of World-wide Sales & Distribution at Good Films Collective. She previously held executive jobs as President of International at New Line Cinema and Relativity Media. In addition, she was President of International Acquisitions at Warner Brothers.

How important is the idea of pre sales territory by territory?

Camela Galano: Independent films still rely heavily on international sales. However, the pre-sale business has become much more challenging. Ideally, a producer wants to have many presales done prior to production. These presales are generally done at one of the major film festivals – Berlin, Cannes, Toronto to an extent, and the American Film Market.

Producers use presales at three different phases of a production: Phase One is based on the package alone. It is highly unusual for a film to be 100% pre sold just based on a package of elements (cast and filmmaker) and before it starts production.

Phase Two would be, if it is not pre sold at the first festival cycle, then the producer of the film would put a promotional reel together which is shown at the next festival cycle and hopefully picks up more presales.

Phase Three is when a finished film screens either at a festival or a private screening at a market or if the sales company goes territory-to-territory screening the film. Phase Three is the least preferable way of doing it, as it is no longer a pre-sale and the film must speak for itself. Ideally you want to make as many presales as you can in the Phase One. This actually used to happen at close to 100% levels, but now it is much more challenging. Another big challenge in terms of preselling in Phase One is across the world people are consuming a lot of content so, just like there is in the domestic marketplace, you have television and all the streaming services competing for those movies.

When does marketing come into play with international sales?

CG: Marketing mostly comes into play during Phase Two when there is something to show, and the company makes a promo reel, which, by the way, is very different from a trailer. A promo reel can show whole scenes, including the ending. Remember the people who are seeing this footage are the buyers who are making a decision about the entire movie and have already read the script.

Part of this marketing conversation in Phase Two also relates to what are the domestic plans for the film in the States. Of course if there is no domestic sale yet, it is harder, but the important thing is to engage with the local distributor and hear their take on how they are going to release the movie. Also, it is good to share one country's thoughts, say the French, with another country, say the Germans, on how they are going to release it and market it.

Does international follow the US campaign?

CG: Yes, and generally when it is a high profile movie. But there are many instances where a local distributor will adjust a campaign geared to the local needs.

What would drive that decision?

CG: Let's say there is an actor who is known in the US but means nothing internationally. Assuming that actor is not contractually

obligated to be on the international poster, the distributor may alter the image. In France for example, there is no television advertising for movies, so the image is much more important and they may opt to take out an actor and replace it with something more original. Or there may be an actor who is known in one country but not the other and that would be a determining factor as well.

How does the domestic release commitment impact international?

CG: When a movie is greenlit, the international numbers would be based on a specific domestic release commitment. So if a movie was greenlit and sold worldwide as a 3000 screen release, but only opens on 300 in the US, the original international numbers will definitely change,

Do the studios still invest in local productions?

CG: Yes, they do that a lot and now the independents have started doing that as well. It can make more sense for both types of companies. Here's the options – let's take Germany again – if a local distributor has to choose between pre-buying a movie for $5M and taking that money and just making their own local movie they may well opt for the production over the pre-buy. They own it for the world, they can sell it to other territories, they have a lot of options. Another factor is local distributors have gotten burned over the years – they have been paying big advances for independently produced films and sometimes they just don't come out well but the local distributor is stuck with the overpayment.

Any advice for young filmmakers in the international marketplace?

CG: It is certainly important to work with a company that knows the world as they really should not attempt to do it themselves.

STUDIO GREENLIGHT AND FINANCING

While both the ultra-low budget and independent greenlight models involve some version of a decision-making group that ultimately says "yes" to a production, this concept is most conspicuous at studio level where the phrase "Greenlight Committee" came into being.

Decades ago, when the studios were run by powerful, if somewhat larger than life moguls, the decision to make a film pretty much rested with this one person, usually in consort with a few of his close executives. Their decisions were mostly made by gut instincts (when is the last time you heard that?!) based on their belief in a director or producer with strong talent attached. In some cases, these decisions resulted in ground breaking films, as can be seen in the glorious and highly innovative decade of the 1970s, the last pre-conglomerate decade.

When the corporations started taking over the studios, beginning in the 1980s, it completely changed the dynamic of the decision making process and "greenlighting" went from gut to minimizing risk and unpredictability. After all, the shareholders rule. One can only imagine how the moguls of the 1960s and 70s felt about suddenly being surrounded by a bunch of executives from the corporate parent and the ancillary divisions of their own studios. Today, Warner Brothers is owned by AT&T, Paramount is owned by Viacom (which is owned by National Amusements), Universal is owned by Comcast and Disney and Fox are in the process of merging into a massive corporation of their own.

As these businesses grew, it became more incumbent on the studio to be able to forecast profitability. The marketing departments soon had a strong voice in the process, followed by the home video and ancillary groups (TV sales, Consumer Products, etc.) and more recently the international team which can represent a large portion of a film's revenue stream.

So, the "new" greenlight committee is a mix of production, marketing, international and ancillary people, all of whom are responsible for owning their share of the anticipated expense and revenue stream.

Normally, the process entails the committee becoming acquainted with the script and potential cast and director elements prior to the meeting. They will also have a budget in hand and the aforementioned P&L (profit & loss report).

The P&L Report at a Film Studio

Before everyone meets to discuss the movie, each of the various departments will have submitted their estimates for what they expect to spend and make. Marketing will submit the approximate cost to sell the movie domestically and internationally.

This is a P&A budget, which means "print and advertising." Home Entertainment will submit their costs to market as well as projections for revenue through DVD and Blu-ray sales and through renting and streaming. Television will provide numbers for foreign TV rights sales. The production team, the marketing team and the distribution team will all provide their own sets of comp titles. This is short for comparable titles and it means films that they think have a lot in common with the movie up for greenlight and could predict box office. It is interesting to note that the comps that come from Production are often much more optimistic and high grossing than those that come in from the other departments. Everyone is managing their risks and upsides. It is left to the finance team take all of these various numbers and create the report which breaks down potential low, medium and high box office scenarios and shows that after everything is spent and received, when the movie will become profitable. At a studio there will many different forecasted tiers of box office and the P&Ls have scenarios like: Low-low, low-medium, medium, medium-high, high, etc. This is the more mathematical and exact version of the concept we discussed earlier: Size of potential audience vs. cost of film.

The Greenlight Meeting

Before everyone gathers, the key stakeholders across the studio will have been given the script, information about attachments (director, cast, writer, etc.) and sometimes additional material like pre-visualization art or a pitch deck. The meeting usually begins with the executive who is the production advocate laying out their vision of the film and why it has commercial potential. This then opens up the dialogue as each department weighs in with their own issues and concerns whether it be casting, story through line, audience target, budget issues, and the like. The debate can be cordial … or not. Each department is working to protect their interests, but the group also understands the greater needs of the studio as a whole.

If production is passionate about a movie, but marketing feels strongly that it will be incredibly difficult to sell, there is going to be a debate. This isn't a bad thing; it helps ensure that movies that are greenlit meet a certain level of financial responsibility and still deliver on the artistic and commercial promise that everyone is looking for.

It's also worth noting that the greenlight committees are there to weigh in and their considerations are taken very seriously. But, at many of the major studios the final greenlight power still rests with the Chairman or Chairwoman.[4]

At the end of the meeting, one of three courses of action is usually taken:

No greenlight, back to the drawing board: A determination that the movie needs further development by the production team, or a rethink of budget, talent or even director. This isn't necessarily the death nail for the movie, but it doesn't bode well. Many movies that get uniformly shot down in greenlight end up falling apart before they can make it back to the table. Talent moves onto to other projects, tastes change, etc. That said, this outcome should be rare if a studio's greenlight system is working well. A project that makes it to the table for greenlight should have been vetted well in advance by the stakeholders and early concerns would have been addressed during development.

Table the greenlight: A decision that more research needs to be done in terms of positioning concepts, audience demographics, box office potential. Sometimes, the P&L looks unfavorable and so the production team will go and find a partner to co-finance the film. This will mean less exposure for the studio and therefore less risk. In these cases, the greenlight is tabled until more information is gathered or until the P&L can be improved.

Greenlight! The film is signed off and is now clear to move from development budget to production spending. It is very unusual for a greenlit movie to not get made, so this generally means the movie is a go. Filmmakers are not in the room for the greenlight meeting, so you will likely be waiting on pins and needles to hear how it went. The "we're greenlit!" call is one of the most exciting things that a filmmaker can experience. It means the studio believes in your film and they are ready to invest in it and work to make it a success.

Note on the process from Russell Schwartz:

I was President of Gramercy Pictures, an independent distributor in the 1990s. It served as the marketing and distribution arm for a group of fiercely independent production companies all of whom developed and submitted projects for greenlight to our corporate parent, PolyGram Films, I was more of a red light kind of guy since I had no real authority to greenlight. My arguments against a film going into production were solely based on its marketability and over time our production company friends started to take notice. When I was head of Marketing at New Line Cinema, it was always a more raucous conversation since everyone was quite passionate about their projects and many times the production executives were at odds with the international folks since a lot of New Line's biggest hits were comedies, many of which did not travel very well.

At the studios, the marketing team is on equal footing with production and international in determining a project's viability. Recently, with the domestic and international marketing functions more or less combined into one entity in most of the studios, it can be said that it has become the most important element of this new group of associates as they can advocate for, or against, the production of a film.

When marketing evaluates a film for greenlight, they employ many of the same tools that we have discussed already in this book. This, again, underscores how important it is for filmmakers to have a grasp of how marketing looks at a film. A greenlight vote of yes or no from marketing should come as no surprise to you if you are aware of the assets and challenges in your film. Marketing will ask the following questions:

- Who is the target (primary) audience? Is there a secondary and tertiary audience? How big is the potential audience for this movie?
- Does the story have definable elements and a clear storyline that can be used to explain it in short bites (i.e. 30 second ads)?
- Is the movie theatrical? In other words, is it something that audiences will want to experience in a movie theater or is it something they will be happy to wait for on streaming and home entertainment?
- Are the cast and director known commodities? Can we book them on talk shows? Do they have fanbases who will loyally come out to see their work?
- Is the cast identifiable to audiences and what those audiences have come to expect from them? In other words, a red flag could go up with a comedian cast in a dramatic film.
- Depending on the type of film, the impact of social media can be profound. Does the cast have a social media following? Do they engage in social and if not can we set up and handle their accounts?
- What are the advertising expenses and box office projections based on the budget?

- Is the story rooted in some sort of recognizable IP? In other words, is there any sort of built-in audience or are we starting from scratch?
- Where does the film sit in the digital world? Would targeted and created communities that would support it or be early advocates of it?
- Are there any competing films like it in the pipeline at other studios?
- Does it have to be released at any particular time of the year, i.e. Christmas themed?
- What is the international potential? Are there any roadblocks to a worldwide release?
- How much of the film's production costs are offset by international? In other words, what does the film have to gross domestically?
- What opportunities are there for Consumer Products and Licensing?

As we mentioned, you as a filmmaker, will not take a seat on the greenlight committee. But, the meetings you will have had with the production, and in some cases the marketing teams beforehand, will have served as the forum for your vision of the film which is hopefully distilled at the greenlight meeting with the proper advocacy. Understanding and being able to pitch the marketing elements to the studio can go a long way.

THE VALUE OF IP

The greenlighting of a project that has a significant IP (IP = a project based on a well-known source) attached to it utilizes a different value system when it comes to marketing. In this kind of greenlight meeting, all eyes are on the marketing team to deliver on what is expected to be a very high profile and costly film, sometimes with major stars attached. Many times this process does include the filmmakers attending a pre-greenlight meeting to present their own marketing visions.

This is where brand marketing comes into play. When a property that has an inherent value is up for consideration, be it a comic book, a bestselling novel, part of an ongoing deal with a production company, a reimagining of an existing property, a videogame headed to the big screen, etc. the marketing team has to look at this project through a 360-degree lens.

THE INDEPENDENT PRODUCER

Select Films is an independent production company whose mission statement is: "Bringing aspirational stories from the world to you." We sat down with principal, Mark Ciardi, and his senior producer, Campbell McInnes, to discuss independent development, content and financing.

Before Select, Mark Ciardi was a producer for the Walt Disney Company and his credits include just about every successful sports movie over the last ten years – *The Rookie*, *Secretariat*, *McFarland*, *The Miracle Season*, *Invincible* and the much beloved

The Miracle about the underdog US hockey team's win over the formidable Russian team in the 1980 Winter Olympics.

Maybe it was in Mark's blood, as for a brief eight months he was a Major League baseball pitcher for the Milwaukee Brewers until a shoulder injury sidelined his career. But whatever the reasons, he has built a successful business on telling stories about people overcoming the odds to success and made most of these films at the Walt Disney company.

Five years ago, Mark decided to go the independent producer route and formed Select Films with the idea of turning to real life experiences as a source for a number of their projects and in the process they have created their own unique brand. Most recently they produced *Chappaquiddick*, the Ted Kennedy story about the death of a young woman when Kennedy inadvertently drove his car off a bridge on the island of Chappaquiddick. Hardly a sports story, but one that stayed true to the company's sourcing.

Campbell was a former production executive at New Line Cinema and over the years he has been involved with a unique slate of films including the YA (young adult) adaption, *Fallen*, the Liam Neeson thriller *The Grey*, and the Andrew Dominik film *Killing Them Softly* among others. He is the head of production at Select Films and produced with founder Mark Ciardi, *Chappaquiddick* and *The Miracle Season*, both released in the Spring of 2018.

Was the idea of the company something you set out to do or did it evolve over time?

Mark Ciardi: Something I always had in my mind for the past five or six years before I left (Disney). I always knew that would be the progression if what I wanted to do – raise private equity and get into the independent space – and bridge the financing of studio and independent movies. Make if more proactive on how movies get made. At a studio, you have to wait for that greenlight, but if you can raise money or find the money, you have much better chance of making a film that you feel can be successful.

Did you get a lot of rejections while at Disney?

MC: This business is mostly about rejection – mostly about no. Interestingly, we have a few scripts that we have had for almost ten years, and which are active again. You just have to be tenacious.

What's your process to a decision?

MC: Something comes in, it works its way up – the idea is to find those little gems, those diamonds – that's what *Chappaquiddick* was. Scripts come in two ways – you can develop internally or you can get projects that come in – one that has a kernel of an idea that needs work, or rarely you get a great script that needs little work. You just have to figure out what works best for the company.

Campbell McInness: Development can be endless so the further you are along in terms of where the screenplay is, the more serious we get. We also try to understand if there is a market for this film, for example, if may not be a four quad wide release movie, but can you make it for a price that makes sense for the market. There are some great movies that become untenable because of its market value, but for us a lot of it is gut. We read something that we feel is good and then you dip your line in the water – and movies have a way of coming together or not.

You actually looked at *Chappaquiddick* very early on and felt there was an audience for it, and that was a more conservative or right leaning one ...

CM: The question was whether the people on the left were going to buy into it. From the DNA of the screenplay we knew it was not going to be a hit job on the Kennedys but still appeal to that audience because of the subject matter. The key with all these movies is to define the target and from there expand your audience if you can. Look at *Get Out*, I doubt anyone had an idea, or read the tea leaves on what that movie was going to do what it did.

Have your assistants or support cast ever brought stuff in?

CM: Yes, they are the first level of readers. Our assistant, Kyle, was the first one to read *Chappaquiddick* and then we did and felt that no studio was going to make this movie but we should.

MC: We thought it would be a brave choice and the conservatives never felt that Kennedy was properly taken to task about the event. The big thing I got from the conservatives was "I can't believe Hollywood made this movie" But it was also very fair – the conservatives also thanked us for making a movie that was not catering to the conservative audience and that it
was fair, but they all still loved it. It appealed ultimately to both sides because of its objectivity.

There was a lot of press around the movie – did you enjoy doing all that press yourself?

MC: When you know something and can speak about it that's what you have to do for a film – It's obviously an acquired skill that every producer and filmmaker should learn – I think they should be able to talk eloquently about whatever film they are doing. You have to sell it – to the financiers, to the cast and crew, to the public. They have to learn that and how to do it.

So the idea of theatricality is not a prime decision factor with your company as you have many places to sell your movies to, beyond the traditional movie theater scenario.

CM: We found that price point where your salvage value – the worst case scenario for your movie – is within a few hundred thousand dollars of your investment. As long as you execute properly of course.

MC: For the Toronto Film Festival, our plan was to sell it there, even though we knew it was a long shot to get a Fall release, but that was the hope. We missed the other festivals and felt Toronto was the best market.

Do your backers need distribution in place? Your backers do not really participate in production financing.

MC: We can make small bets that they will cover. With bigger movies, they will partner or we will raise the money through other investors. By having equity available to us, we can make our own decisions on how we want to make the movie. Maybe in a perfect world we would have a co-financing arrangement with a studio but still have the ability to make a movie any way we want.

CM: I much prefer the proactive idea of building a movie piece by piece rather than the endless development.

MC: I just want to convert – have a good batting average. It's important to stay focused on less projects or you spend a lot of time with each film and the day is over and you didn't always work on the one that had the best chance of being made.

For young filmmakers what are the three most important things they should be thinking about?

MC: You just have to get in the game – you can work at a studio, at a management company, a producer, an agency, wherever there is a deal flow and stuff is coming in and out.
There is real value at being at an agency because you can see from that side how all the material is generated and how. That's the heartbeat – dealing with writers, putting the movie with this and that – that's where stuff gets sent out.

CM: Make yourself valuable – that's the biggest thing – and proximity to the action.

ACQUISITIONS: WHEN MARKETING SELLS TO YOU

We have spent a lot of time discussing the evolution and mechanics of the financing and greenlight process. In each situation, you as a filmmaker were on the sales end: Pitching, developing, redeveloping, negotiating, working and reworking your buyers. But there is a time and a place where the situation is reversed and you are the one who has to be sold.

Welcome to the world of acquisitions.

Let's assume you have finished your low budget film and it earns a slot in a coveted film festival like Sundance, Cannes, Telluride or the Toronto Film Festival. Each

of these festivals is populated by film lovers, press, bloggers, entertainment outlets both traditional and online and buyers looking to acquire movies.

Let's further assume that your film receives a standing ovation at the end, the word of mouth coming out of the screening is strong, the press are the first to report the reaction shortly followed by the critics and bloggers who start writing about it almost immediately.

One of the first rules in going to a film festival is to "represent up" whether that be by a lawyer, producer representative, agent, plus a publicity firm who can help steer you through the publicity demands of a film festival and navigate the offers you may receive. Suddenly, the phone calls and texts start rolling into your representatives from interested distributors and from the press who anxiously want to interview you and your cast. With some of the high profile acquisitions a lot of the press is arranged beforehand, but the distributor interest peaks after that first screening. If everything goes according to plan, there is more than one interested buyer, both domestic and international rights are sold and the next two days become madness and deliriously fun and intense.

For once, you are in the driver's seat and it is your representatives' job to keep all the balls juggling in the air and for your publicity team to keep you in the spotlight for as long as possible. And to keep your investors aware of what is going on as they are the ones who are quite possibly breathing down your neck the most with visions of profitability.

At your post screening party, you are inundated with press and distributors anxious to express their feelings about the film all of whom you trying to pay attention to while not really hearing everything they are saying given the decibel level in the room. Over the next few hours and even up to a few days, you patiently wait while your agent and/or lawyer analyzes and sorts through the competing offers, sometimes but not always based on an initial asking price. When the group is whittled down to a chosen few, you begin the process of meeting with each distribution company and their marketing people and listen to their vision of how they want to sell your movie.

While it is true that most films are usually sold to the highest bidder, this is not always the case. The savvy filmmaker and their reps have to walk the fine line between the pressure to get the highest price in order to offer your investors the best return for their money, (and your agency, if you have one, which is looking for their highest fee payout) and which company can do the best marketing job for you based on their vision and previous experience. At the 2016 Sundance Film Festival, *The Birth of a Nation*, which was a lightning rod in the bidding wars, went to Fox Searchlight for less money than was offered by Netflix and indie distributor Entertainment Studios (Byron Allen),[5] mostly because Searchlight promised a traditional theatrical campaign with an awards run. Netflix, on the other hand, utilizes a different business model where the theatrical piece was not as important to them as it was to the filmmakers, nor did they have much of a history with awards at the time (that's changing now), which was equally on the minds of the filmmakers.

During this process you will hear many different types of marketing plans but below are some of the most important things to keep in mind. You will notice that

this is very similar to the list of things that foreign sales companies and studio green-light committees are looking for when they assess films. Everyone is looking for maximum marketability. If you are in the catbird seat of being courted by multiple distribution companies, be sure to consider the following:

- **Marketing vision:** What is their overall marketing vision of the film? How are they going to position it in the marketplace? What are the most important themes that they plan to highlight? Do these align with your feelings about the theme of your film?
- **Target audience:** What is the audience they seem most confident in reaching?
- **Social and digital media strength:** How are they going to engage that audience – what traditional and digital ideas do they have?
- **Release strategy:** How are they planning to release the film? Slowly through a platform scenario or wide release or somewhere in between?
- **Time of release and competitive schedule:** When do they see as the right time to release the film? If you have a timeframe in mind now is the time to share that. What other films are they planning to release around the same time?
- **Awards plan (Oscars, Globes, Bafta, etc.):** Do they see the movie as awards friendly? (show me a filmmaker who doesn't think theirs isn't!)
- **P&A budget:** How much money are they prepared to spend in advertising costs? This is not a number normally thrown out. It usually is part of the fine point negotiating. Note that studios will usually promise a guaranteed P&A (print & advertising) level, while indies usually won't.
- **Filmmaker input:** How do they plan to position you in the campaign? How much voice do they usually allow directors in their process? This is your career and it's perfectly acceptable to advocate for yourself. Selling the film should be the first priority, but selling you – the filmmaker – is important as well.
- **Comp titles:** You should also be prepared to talk about other films they have released which may be similar to yours.
- **Innovation:** What is new and different and exciting in their approach?

Being "wanted" is unique place to be and you should revel in the moment – but don't take off your marketing hat!

As you can see there are many different ways that movies find their way to funding and release. We have covered self-financing and fundraising, independent film, foreign pre-sales, studio greenlight and acquisitions, but these are only the major categories – there are myriad other ways to get a movie made. There is no set path for a movie and every filmmaker must be proactive and make the best decisions for their films. The one thing we can say with certainty is that marketing is going to play a role in this process. The gatekeepers with the money will be looking at this closely and you, the filmmaker, will have a much stronger chance if you understand and anticipate marketing's reaction. The good news is that this book in your hands is determined to make sure that is the case!

EXERCISES

1. Research online and find an example of a strong campaign for a crowd-funded independent film. Write about the steps the filmmakers are taking to self-market their film and ramp up donations. Why are they effective? Is anything missing?

2. Pick a recently released movie. Now, pretend that you are the Chairman or Chairwoman of the studio that made it. Your greenlight committee is in deep debate about whether or not to make the movie. Write an essay that lays out the arguments for or against this film that would be discussed by the greenlight committee. In the end, recommend whether you would send the movie back to development, table it or greenlight it.

3. If you using this book in a classroom, divide up into two teams. Half of you will be an acquisition company and the other half will be filmmakers. For the purpose of this exercise, pick a recent movie that played the festival circuit and (using what you learned in this chapter), it is the job of the acquisition team to convince the filmmakers to sell them the movie. Filmmakers, make sure you ask all the questions listed above.

NOTES

1 americanfilmmarket.com AFM By The Numbers.
2 https://www.huffingtonpost.com/entry/hollywood-sequels-will-they-ever-end_us_575813f8e4b00f97fba6b1e3
3 http://www.latimes.com/entertainment/movies/la-fi-ct-film-nation-oscars-20170222-story.html
4 https://www.hollywoodreporter.com/news/new-power-yes-who-actually-has-green light-authority-at-movie-studios-976236
5 https://www.indiewire.com/2016/01/fox-searchlight-takes-nate-parkers-birth-of-a-nation-in-17−5-million-deal-after-electrifying-sundance-premiere-update-byron-allen-made-a-20-million- bid-158631/

6

Pre-production

Planning for the Toolbox

Your script is done, you've hired the director and attached the cast and you have either secured financing or achieved studio greenlight – congratulations! It's time to get to work on making the movie. Marketing can take a back seat here for a while, right? Wrong! They are about to become your partners in each step along the way.

During this period, filmmakers will be very busy scouting locations, hiring crew, renting equipment, scheduling the shoot and rehearsing. But, what you might not realize is that marketing also kicks in at this point in the process. There is a misconception among some filmmakers that marketing only begins when the finished movie is handed over, but that is far from true. The actual making of the movie is a significant tool in the marketing toolbox.

This chapter is going to walk through how marketing should be ramping up right alongside the movie. Regardless of whether you're planning to self-market the film, release through an indie distributor or through a studio, it's important to consider marketing needs during each step in this stage of the process.

HOW MARKETING WILL INTERACT WITH PRE-PRODUCTION

Location Scouting

As you get ready to film the movie, you're likely searching for locations to shoot. Where you make the movie might be dictated by the story or perhaps by the most attractive rebates and financial incentives. Nevertheless, the locations you select will have some effect on the marketing.

If you film in a major city, that means greater proximity to press. It will be easier to get them to come to cover the filming and do a set-visit. Conversely, if you're filming out in the middle of a swamp in Florida, that might be more of a challenge.

But sometimes, a high-profile shooting location can be a challenge. If you are making a film with a lot of fan buzz and interest, it's easy for people to snap pictures or take video of the actors, costumes and scenes. These things end up leaked online and can be very frustrating for filmmakers. We've all seen the fan-captured pictures revealing superhero costumes, cameos that were supposed to be a surprise or even plot spoilers. If you are making a movie with this level of audience scrutiny, it's imperative to be in lock-step with the Publicity team to minimize leaks and to respond quickly if they occur. This is why it's common to see directors or actors release their own pictures and video from the set. By doing this, they are feeding the appetites of the fans while also controlling the message. All of that is usually coordinated in advance with the Marketing department.

If you are shooting in international locations, this is also a valuable marketing angle. Not only can the global nature of the film be promoted, but the countries where you shot the film may likely be more inclined to support the movie. For example, China has become a significant movie market and it is no coincidence that so many movies now feature sequences shot in that country.

Furthermore, sometimes the locations themselves can be marketing assets. For example, let's say you are making a self-financed super low-budget horror movie and you are the very first crew to be granted access to shoot in the allegedly haunted, abandoned prison outside of town.

That is a cool and creepy detail that you can certainly exploit in your marketing.

Set Building

If you are shooting a bigger budget production on a set or soundstage, you are likely building custom sets at this point in the filmmaking process. These sets are actually very valuable assets to marketing and can be used in a variety of different ways in the campaign:

1. The Digital Marketing team may take a Lidar scan of the set, which creates a 360 degree, 3D picture. They can later use this for a digital walk-through online, a gaming execution or a VR experience.
2. If you are self-marketing, set visits can be an enticing prize for your top donors.
3. The Creative team may want to come and shoot the set before everyone arrives so they can use it as backgrounds for posters and digital banner ads.

It's very important to get the most out of the sets you are spending the money to build and to keep marketing updated on when they will be broken down. All too often, a set is destroyed before marketing had a chance to utilize it and this leads to expensive rebuilds or digital reconstructions that are completely avoidable.

Shooting Schedule

This is a very important piece of information for the marketing group. They will use the overall shooting schedule as well as a document called "day-of-days" that

tells them when each actor will be on set. As we'll see in the next chapter, marketing activity will pick up considerably during filming and the schedule is a key part of their planning.

Publicity is going to want to look at the shooting schedule to see when the most exciting shooting days are and when most of the cast will be together on set. Those are ideal days to schedule on-set publicity. Conversely, they will also look for days that would be a bad idea to bring any outside visitors to set. For example, days where you're shooting big plot reveals or highly emotional scenes. When actors are shooting those types of scenes, it's important to protect them by creating a safe space for that vulnerability. Having a group of reporters gawking at them and taking pictures while they are shooting an emotional scene would be both distracting and unprofessional.

The Creative group will likely need to shoot the print campaign on set when the cast is in costume. They will peruse the schedule to find the best day when everyone is there and the filming schedule is not too intense.

Budgeting and Staffing Up

The budget and the crew can also be marketing assets. We read all the time about breakout films with low budgets and huge box office performance. It's both inspiring and impressive when filmmakers pull this off.

Also, the crew you hire can generate some marketing as well. If you bring on a noteworthy Director of Photography, for example, that might earn coverage in *American Cinematographer* or other trade publications. Or, perhaps you hired women for all of your key, department head positions. That's definitely something to proudly publicize.

Even on very low budget, independent films, you should never overlook the marketing value of the people you are collaborating with. Your key positions may likely have built-in fanbases or networks of their own. Maybe your make-up artist has a YouTube channel, or perhaps your sound engineer also works with popular local bands – you can use these connections to get the word out about your movie. After all, that is half the task of marketing.

Get the word out and start building awareness so you can then generate interest.

Table Reads

As you gear up for shooting, you might arrange for a table read with the cast. This is a sort of rehearsal where all of the key cast sit with the filmmakers, writers and producers and perform the screenplay, start-to-finish. This helps everyone because it lets the cast work out details of their performance, it lets the writers hear the flow of the dialogue and pacing so they can make adjustments and it helps the editor get a sense of pacing and laugh moments.

But, the table read is also a great marketing asset. You can film it as ancillary material for the DVD/Blu-ray release or for behind-the-scenes content. At the very

least, if you have marketing execs attending the reading, they can watch to get a sense of the key dramatic or comedic moments. The table read tends to bring the script to life in a way which can stimulate a lot of inspiration for the creatives who will be selling your movie.

Production Art and Storyboards

In the pre-production process you will likely create art for visual development and storyboards. These are obviously important tools for planning the look and feel of the movie, but they can also be marketing assets. Making-of and behind-the-scenes featurettes are great tools to use to promote a movie. Audiences enjoy seeing the process for how a scene was constructed and the creative decisions that went into the film. These pieces can be edited into a featurette or featured as bonus material on the DVD. They can be a sales tool at the film markets or used as incentives for crowd sourced funding contributors. We even see these assets used as part of a greenlight presentation at the studios.

If you are self-marketing your film, you can begin the process now by creating an online presence and keeping fans and supporters updated on the filmmaking process. Moviegoers love seeing how the film is made and it makes them feel included in the production. As you create art, storyboards, location scouting reels, etc. you can post these assets to keep people talking about your upcoming film and engaged with the content.

Planting a Flag

It's time to plant your flag in the marketplace. Once there's a title for the movie, it's a good idea to stake out the URL online and the handle on Twitter, Facebook, Instagram, Snapchat, etc. Eventually, marketing will use all of these avenues to reach audiences online. Once the website name for the film is secured, they usually put up a landing page which is just a logo for the film and a note such as, "more coming soon."

Studios will usually create a press release called "start of production" that lets outlets know that filming has begun on a film. This statement often includes some key details like title, anticipated release window, cast and a brief summary.

Additionally, if you are making your movie with a studio or an indie distributor, the distribution team will want to stake out a release date. The release schedule fills up quickly and it's important to "plant your flag," as they say. For many years now, the keeper of studio release schedules has been a company formerly called "Rentrak" and now owned by ComScore and called "Box Office Essentials."[1]

The studios report their release date announcements and changes into this service and in turn, Rentrak generates a comprehensive release schedule that everyone can access. Locking down a set release date is an important step, because it stakes out the best weekend for the film but also kicks off marketing planning in terms of media strategy and key date benchmarks.

Early Messaging

At this point in the process, publicity is already working on talking-points for the filmmakers and the cast based on the overall marketing positioning of the movie. This is key because, as we'll see in the next chapter, there is often press coverage around a movie shoot (local or national media) and reporters may come to set to interview the cast and crew. It's a good idea to have a plan for how everyone is going to discuss the film to best position it in the marketplace. For example, you don't want some of your cast referring to the movie as horror and others saying comedy because those are two completely different audiences. Even if you are making a horror comedy, it's often a good idea to lean into one or the other dominate genre (ex. "it's a comedy with some horror elements"). Additionally, there may be plot twists and details that the filmmakers would like to keep under-wraps and therefore the talking points list would include instructions to avoid certain subjects or details about the film.

The pre-production period is a very important time for both the film and for the marketing. The documents, materials and decisions you make during this time are all useful tools and resources for marketing.

EXERCISES

1. Pick a film released recently and create a report showing how marketing used and promoted the following (if applicable):

 * Locations
 * Sets/set visits
 * Noteworthy crew
 * Table reads
 * Production art
 * Storyboards

2. If you are currently making a film, write out an early marketing plan that details how you will use the stages in pre-production to promote the movie. What assets will you collect during this period (storyboards, art, set photographs, video of the table read, etc.)? What elements can you promote (notable crew, unusual or international locations, etc.) Finally, write out how you will "plant your flag" and write up key talking points for your cast and crew.

3. Visit the website of a key trade magazine such as *American Cinematographer, Script Magazine* or *Film Comment*. Research how they are highlighting noteworthy members of the crew and creative team on upcoming films.

NOTE

1 https://www.comscore.com/

7
Production
When Marketing Begins to Execute

Roll sound… speed… marker… action!

You're now in production and completely focused on making the best possible movie on time and on budget. This is a very intense, high-pressure period for filmmakers and marketing is probably not on the forefront of your mind. That's perfectly okay! If you are making your movie with a studio, there will be a team of people focusing on this task and all you need to do is make room for them to do it. If you are going to try to sell the film to a distributor or self-market, then some advance planning will allow you to collect marketing assets during filming to bank for later.

Sometimes production companies hire a marketing consultant whose job is to make sure that everything that is possible to secure during the production process is achieved. The marketing consultant can usually stay with the production right through the theatrical release of the film and interact with the distributor to insure that the movie is properly released.

The most important thing to know is that while you are in the process of making your film, the Marketing department is kicking off too. On many films, they are going to need your help (and the cast too) to start selling the movie right now. The more open and collaborative the filmmakers and cast are at this point, the better the head start for the marketing campaign.

SET VISITS

The studio might look to arrange a set visit for press, partners or internal execs. This can be a little stressful for filmmakers and some refuse it. It's ultimately your choice, but our advice is to embrace the set visit! If publicity is bringing reporters to set, they are likely to be "friendlies" who are going to show up with already positive feelings about your film. Indulge them and charm them and it could mean a glowing article for you down the road.

Depending on the content of your film, there may also be set visits from advocates like spiritual and faith leaders for a film with religious themes or representatives from the LGBTQI community for themes with that subject matter. These visits can a very positive experience that create goodwill with the community.

The exhibitor relations team (the group that coordinates with theater owners and oversees in-theater marketing) may want to bring some key people to set. These might be the top execs at the major theater chains and the idea here is to generate early excitement, so they are more inclined to play and promote the film.

There may be a requested visit for international partners. We'll delve more into this in Part Two of the book, but in a studio there are a huge number of international territories who are going to be crafting custom marketing campaigns for your film. Bringing their key people to set can help energize the global Marketing team.

Finally, the Home Entertainment group may request to bring representatives from the major retailers to set. Everyone is competing for promotion and placement in the retailers like Target, Walmart and Best Buy. Getting those companies excited about the film early on can help set up the movie for success down the road.

If you are going to self-market your movie, you may still want to consider arranging a set-visit. Perhaps you'll invite a local film reporter to visit or the pastor of your town's biggest church. If you're the director, you'll be too busy to coordinate this, but a producer can assist. The bottom line is that people are fascinated by the making of movies. A film set is an exciting place and a visit from someone with a built-in audience can be an asset to put your film on the radar.

PRODUCT PLACEMENT

Filmmakers have a range of feelings about this issue. Some embrace it because they know it's a lucrative revenue stream and that these partnerships often come with a promise of guaranteed media spend. Some filmmakers accept these promotions begrudgingly and only if they are as discreet as possible. Finally, there are many filmmakers who refuse to allow product placement in their films at all. Wherever you fall on this issue, it's important to be aware that this is a consideration that you may have to address. If you're making a bigger budget film with a studio, they may insist on some level of product integration.

The *James Bond* franchise is known for its car chases and Aston Martin has become synonymous with the brand. In *Guardians of the Galaxy Vol. 2*, Dairy Queen makes two appearances in the film – in a flashback and in the present-day time frame of the movie. In *World War Z*, Brad Pitt's Gerry Lane stops for a soda in the middle of a zombie attack, which made for a great laugh in the movie.

The product integrations are spearheaded by the Consumer Products and Licensing group and they are big asset for marketing down the road. Not only will these companies donate assets to the production like cars, computers, etc. but they will create ads that integrate movie footage closer to release. These ads and all the views they generate will only help get the movie out there more above and beyond the studios paid media campaign.

Even for independent filmmakers, there can be partnerships of this nature between local businesses and your film. For example, perhaps you are shooting scenes at a local restaurant and their signage is visible in the background. You might also arrange with the business to hang up posters for your movie or to host a cast and crew dinner there after the movie wraps.

CREATIVE CONTENT

If you are distributing your movie through a studio, they will likely ask for a "special shoot" at some point during or shortly after production.

The major distributors regularly partner with networks and cable channels to cross-promote the movie. The basic idea is that the media team negotiates integrations with shows and networks.

For example, there was an episode of the singing competition *The Voice* where the contestants appeared in a music video with the cast of *Pitch Perfect 3*. *The Voice* airs on NBC, which is a sister company of the *Pitch Perfect* studio, Universal. This integration was negotiated well in advance of this episode airing and that music video was shot in a special shoot. This is a win-win for all parties because the audience for *The Voice* and *Pitch Perfect* are perfectly aligned. The show benefits because they can promote an appearance by the movie's stars and the movie benefits because they reach a huge audience viewing *The Voice* and promote their film.

All this to say, that at some point during shooting if the cast needs a few hours to step away and participate in a special shoot, it's a good thing in the long run and worth tolerating the interruption. You and the actors will be informed exactly what they are looking to capture in the shoot so everyone is on the same page. The cast will likely be asked to read greetings tailored to different movie chains, for example: "Welcome to AMC theaters, please enjoy this special behind-the-scenes peek at my new film." You've surely seen these intros during the pre-show at your local movie theater and these were often gathered while the actor was in costume and on-set.

The cast may also call out greetings for the International markets, such as "Happy Boxing Day to all of our fans in the United Kingdom!" These greetings can be used across social channels during the respective local holidays.

Whatever the content and goals of the special shoot, it is important to know that the Creative Content team will gather a great deal of assets for the campaign in a short amount of time. Actors and filmmakers that are game to participate in this sort of thing are a dream for marketing.

If you are making an independent film, you may still set aside a little time to shoot greetings from your cast for a local independent cinema that will play your film or a special "thank you" from the cast for your crowdfund backers.

CREATIVE MARKETING

Another department that will likely ask for time with the cast on set is Creative Marketing. They will have already worked with their print vendors to create books

of poster ideas and will have selected a few favorites. They will work with a producer to find a good day on set when all of the cast are present so they can send a photographer to shoot the actors for this poster. Because actors very often move quickly from movie to movie, once you wrap they may no longer be available. On top of that, actors commonly change their appearance between shoots, so it's important to photograph them during production when they are in costume with the same hair and make-up they have in your movie. It would be strange if your movie poster showed the cast with completely different looks than they have in the trailer!

If you are making a movie independently, it's still a good idea to set aside some time to photograph your cast on set. Many smaller budget movies will use a still from the film as the poster image and that works great as well. But professional shots of the cast are still very useful for your publicity and promotion efforts. Actors generally appreciate it too, as these photos are useful for their websites and social channels.

The Creative group will also ask for access to your dailies (the raw footage of everything you shot that day) while you are filming, which they will use to start assembling the trailer. It's not unusual for word to come from the studio that Marketing is asking you to cover a few extra lines while you're filming. As they start to put the trailer together they're aiming to present the big idea of the movie in a concise and clean way. Sometimes a few lines of dialogue are needed to get the idea across quickly to audiences. The trailer vendor will write these and you'll be asked to pick them up while shooting.

A common ask is to have someone in the cast say the name of the movie in context, especially if you have a tricky title. It's always great to connect the title to the movie in the marketing materials. If that doesn't exist in the script, you might be asked to shoot it. The extra lines are only for the marketing campaign and are not expected to appear in the film.

PHOTO DEPARTMENT

The photo department reports to Marketing and will also be on hand during production to cover the shoot. They will hire a unit photographer who is a specialist at getting the best behind-the-scenes shots and cast photos without intruding on the filmmaking process. Many directors will request a unit photographer that they feel comfortable with and have worked with before.

These shots of the filmmaking process and the actors will be used in the publicity campaign to run in magazines, online features and newspaper profiles. You'll often see these shots as part of a print publication's "first look" feature. These behind-the-scenes shots can also become part of the movies DVD/Blu-ray features. The director and cast usually have full approval over which images are released to the press.

Additionally, the photo department will request access to the dailies so they can pull still frames or "stills," which will also be used in the publicity campaign. They will look for the moments that best capture the promise and tone of the film. When photo pulls a still they will work with the studio's production executives to identify

every person in the shot. They will seek approval from the key filmmakers and cast before releasing any images.

These photos are another important tool for marketing and very valuable to acquire while you're in production. Every movie, from the smallest to highest budget, should hire someone to come to set and take pictures to document the shooting process. There is no question that these photos will become an important part of your toolkit in marketing, publicity and promotion.

DIGITAL MARKETING

The Digital Marketing team focuses on content created for the web, mobile devices and virtual and augmented reality platforms. This team will also want to come to set to collect assets for their campaign. They will want to shoot fun and funny videos of the cast, behind-the-scenes content, videos of the cast in make-up or breakdowns of how a shot was constructed. Anything and everything in the filmmaking process is fair game and can be turned into a piece of compelling marketing down the road.

The digital team will also want access to your shooting schedule so they know when you will be using and then breaking down (destroying) sets. They will usually want to get in to the set after hours when it's empty and take a Lidar scan, which is a 360-degree scan of the entire set. This can be used later to construct virtual walk-throughs online or gaming experiences.

PUBLICITY

On your set, publicity incorporates a lot of activities and each activity contributes to the marketing toolbox in anticipation of distribution. The only question is how much of this you can afford. This is an extremely important area that sets the tone for the movie at a very early stage. When your production is greenlit and the director and the key cast are set, the independent or studio publicity department will announce this to the public usually through the industry trade press like *Deadline*, *Variety* or *The Hollywood Reporter*. From there, it is picked up by bloggers and syndication agencies depending on how important or interesting the news is. For example, the next Marvel character spinoff becomes newsworthy when talent and/or a director are attached. In the independent world, this type of announcement would come through a publicity agency attached either to the production or the producing entity.

Depending on the scope of the production, publicity engages in your film in many different ways. These first two are more geared to bigger budget situations:

1. "Start of Production" press release, which could include some late cast adds, new locations or the addition of some new special effects companies.
2. Release date announcement from a distribution company or a streaming company like Netflix or Hulu.

THE UNIT PUBLICIST

The unit publicist is a must for any and every production. Whether you have someone on set for a few days or for the entire shoot, the material the unit person can gather is indispensable. This person is the set representative who coordinates all press interviews and deals with any on set crises that may occur (particularly, if it could leak). But they spend most of their time protecting the set from any kind of incursion, whether it be paparazzi hanging around, way too curious public or local press, and the like. It is their job to oversee everyone involved in the making of the film and ferreting out who may be leaking photos or talking to outside press without a filter.

The unit publicist is also responsible for securing and writing press notes on the making of the film including interviews with the major talent and production people, a synopsis, and anything technically or location unique to the production. They also coordinate on-set visits with video crews, bloggers, and persons of special interest like exclusive writers.

On-set interviews are a very important item. During the shoot a limited amount of key press people are invited to the set for a few days to witness the shoot and meet and do interviews with your cast, director and producers. This not only affords a sense of exclusivity to the press member, but allows for a tightly controlled amount of information to be disseminated on behalf of the production. It also allows some of these key press people, whether they are print/digital or television to "bank" pieces for later use. The morning television shows like the *Today Show*, or shows like *Extra*, do this a lot and release these pieces in conjunction with a live cast interview close to release.

In conjunction with this, publicity usually puts an embargo with a certain date when any press can be released from these set visits. This is negotiated before the press arrives on set and can be a tricky back and forth. For publicity, this is all about controlling the messaging and not allowing someone to "scoop" the set, which will inflame a lot of other press. For the press visitor, the need to put this out first only strengthens their credibility in the entertainment community.

If your production has a profile, meaning there is recognizable talent, you would be wise to arrange for another key press group that makes the rounds to most productions: The Hollywood Foreign Press Association. This is a group of 95 international press people who put on the Golden Globes Awards, which is usually the first awards show of the season. We will talk extensively about this group and the influence they have in Chapter 18 on Awards Marketing.

Unfortunately, with low and micro budget films, the unit publicity job tends to be dropped because of budgetary reasons. If this becomes the case with your film, then at least be sure to have someone – an assistant – grab as much content as they can even with a smartphone. You will never get the chance again. You may end up writing up small pieces and announcements yourself, dispatched from the set. Particularly if you have crowdfunded your film, it's a good idea to keep your backers updated on the shooting progress.

BEHIND-THE-SCENES CONTENT

The use of video crews to shoot behind the scenes content (also known as "BTS") has become an increasingly important component of on-set publicity given the extraordinary demand for content that can be placed both online and offline. For many years, the EPK, or "Electronic Press Kit" was the only way to secure behind the scenes footage, which was then intercut with interviews from the producer, director and key cast to create a ten-minute short form video that was made available to television and cable stations to use as part of their coverage of the movie. Now, these crews do a whole lot more, including shooting promotional videos for any corporate branding partners who have come on board, creating a vault of shots and scenes that can be tailored to a specific media partner's needs, and coming up with "first look" scenes that publicity can put out there as teasers for what's to come.

Mob Scene is one of the premiere content production companies in Los Angeles. We sat down with Tom Grane, CEO, Mitchell Rubinstein, COO, and their senior producer, Chris Miller, to talk about the issues of shooting behind the scenes footage on set:

Mitchell Rubinstein: "A good unit publicist will keep the production's needs in mind but also will help us try to get the materials we need, "oh, we need to do this with Ben Affleck." Well, okay we've got *People Magazine* coming tomorrow so this week's not going to be a good, and they will come up with ideas to help figure that out. A lot of times these shoots happen internationally, so, on those bigger jobs, we have to hire shooters that we trust that know what we need and will work with the unit publicist to accomplish what needs to get done when one of our producers can't be on set.

So what do you do with an actor and doesn't want to deal with you at all, and yet you still have your job to do?

MR: That's the art of it. We need to work with Production and talent who are all killing themselves to make the movie. While key players are usually contractually obligated to give us interviews, a lot of times, it's at the end of a very long day. We have to ingratiate ourselves and get what we need very efficiently in a limited amount of time ...

Chris Miller: Even though they may wait until the week before the movie comes out.

MR: And sometimes it's not their fault, it's just that their schedule is too demanding or they're working on another film so they don't have the time to give. A lot of times, too, depending on the situation, the unit publicist has to balance the demands of the production, other publicity needs, and with helping us get what we need so sometimes the ask is

never made, and then when the talent find out it's like, "oh, I would have loved to have done something. That sounds like fun." So, you deal with it, and sometimes they'll barely show up in any of the marketing materials because we were only able to get a very small amount of time to sit with talent. We just do with it what we can. There are a lot of moving parts and sometimes we get lucky and sometimes we don't. Everyone is very accommodating, but sometimes we aren't always the priority.

We also spoke about the challenges of Virtual Reality, a recent marketing staple, and the difficulty of getting it done – particularly during production.

Tom Grane: We pitched the studio to do this VR experience for a big tentpole film and nobody knew what to do with it, nobody knew what department it was going to go through. So we literally got on the phone with home entertainment, theatrical advertising, theatrical publicity, and theatrical digital advertising, and said we need some dollars to do R&D to develop this special VR rig that the actors could wear. Plus, if we can get main cast to shoot this, then we need production money to shoot.

MR: We had to do things in stages because during production of the film, when we had to capture the footage, no one knew how VR would work into the marketing campaign of the film. While the film was in post it sat for months and, we didn't know if we were ever going to finish this piece. Finally, at the last minute, the studio greenlit the project to great success. Other VR projects have been shot, but never finished.

Do you pitch content ideas to the studios?

TG: I think we do pitch a lot of unique stuff, and I think Chris mentioned it earlier, a lot of the times whether it's budget issues or just some studios that want big ideas, and then they just wind up doing the tried and true ideas. But we've been able to pull of some really unique and interesting things that I think in the long run have a much bigger marketing potential.

The independents, of course, do not have the money to afford a crew on set all the time. How do you make it work with some of these lower budget movies? Is the talent approached differently?

MR: I don't think the talent changes that much because a lot of those people will do an indie movie for themselves and then they'll do a bigger marketed one, so they get it either way. They know it's all about selling the movie.

TG: You tend to schedule an independent more around talent availability than the best days to cover because of the budget. So you kind of end up with whatever B-roll you get. You can't

be as strategic because the most important thing for them is to get the interviews so that you have those interviews with the talent. These films don't have the budget to capture just days of B-roll. The most important things on these films, are the interviews.

MR: And the problem is half the time you're spending the whole day doing the interviews and end up getting very little B-roll.

So, the innovation that you guys love doing in terms of expanding your own product base really is at the studio level. It's more difficult to do it independently.

TG: Yes, but the independents provide all sorts of opportunities that the studios don't offer particularly when it comes to fresh ideas and just trying new kinds of content. These films have smaller marketing budgets so they are always looking for ideas that will get exposure and are willing to try new things.

SOCIAL MEDIA TEAM

Finally, social media will be (and should be!) a big part of your shooting process. You, the filmmaker, should have a social presence already and even though you are neck-deep in making the film, it's imperative to interact with your fans and supporters online. Take pictures or short videos of the filming and post them to your site and the movie's handle, which you have pre-registered. Update your investors and followers and make them feel like part of the shooting process.

The major directors and producers generally have a social media manager who does this for them. If you are just starting out, you'll have to do it for yourself. As we discussed, if you have cast anyone with a local following, use that asset and have them post.

The expression is: "No press is bad press," and that is true in social media as well. The more noise you can make and the more people who become aware of your movie, the better. The major studios generally cast the best people for the roles in their movies, but they also look at social following. If someone has a major, loyal, online fanbase that is a huge asset to the Marketing team and will factor into casting. If that actress posts a selfie from set of herself in make-up, it could generate a significant volume of views and pick-up from other media sources. All of that works toward spreading awareness about your film, which is a positive.

If you are making your movie with a studio, they will have people in the Marketing department that will work with you on feeding the social channels. They will help create and curate content to keep the fans happy and to engage new audiences. Your movie will have a Facebook page, an Instagram profile, a Twitter handle, a Snapchat account, a presence on Weibo (China's Twitter), etc. If you have actors with a significant social following, they will be skilled at posting and maintaining a relationship with that audience. But, if you are making a low budget movie with a relatively unknown cast, then the social media aspect is an important area to

remember. You might even assign a PA to manage everything on this front and, with your approval, feed these social channels with content.

The main lesson of this chapter is that the entire shooting process is a valuable time for marketing the movie. Even though you, the filmmaker, will be extremely focused on making the movie, it's important to support the marketing. Whether you are working with a studio or self-marketing the movie, you'll want to facilitate the following:

- Arrange set visits for special interest groups, journalists, theater chains, international territories and home entertainment.
- Accommodate product placement from the studio or from local companies willing to support your movie.
- Take photographs of the cast while they are in costumes and make-up.
- Collect behind-the-scenes photography from the shoot.
- Shoot funny behind-the-scenes videos and extra content with your cast.
- Post from the set to feed the social media channels and keep the fans engaged.

EXERCISES

1. Pick a recent film and create a report detailing the behind-the-scenes content they released as well as social media posts. Indicate which pieces were generated during the filming process.
2. Create a plan for your own film for what you will collect on set to aid in the marketing of the film.

PART II
WELCOME TO THE MARKETING DEPARTMENT

8

Welcome to the Marketing Department
Behind the Curtain

You have now completed your film and have been lucky enough to have produced your movie either inside the studio system or out there in the world of independent financing and production. But the good news is you are here with a marketing and distribution partner who is passionate about your project and ready to commit all their resources to your success, led by a very capable Head of Marketing.

But what exactly is this department you are about to deal with and what is the real function of the marketing executive?

The definition of any executive is to have the necessary knowledge base to do the job correctly. Marketing, in particular, is a multi-layered discipline with many functions and while the president, or Head of Marketing, is in charge of every area, the really good ones don't take ownership of any particular one. Their job is to make things happen, solve problems, and ultimately take responsibility for the success, or failure, of the entire campaign.

At the same time, marketing people have to be capable specialists in every area that they oversee. They must be able to "walk the talk" as their job is to command respect on every aspect that marketing touches and be able to guide, influence, and embrace contributions from every specialist who works under them including outside vendors who work on projects for the company in various capacities.

As we move through Part Two of this book, we're going to spend time meeting each of the various disciplines that make up the Marketing department. Each chapter in this section of the book will dive deeply into a different discipline and show you how these groups will work to market your film, how you will interact with them and how you can best help them succeed.

In a small studio, only one or two people may represent each of these disciplines whereas in a large studio each discipline will include dozens of people. The

Marketing department in a major studio will be over a hundred people based on the home base in Los Angeles and hundreds of others around the world.

If you are self-marketing your film than you, the filmmaker, will at some point wear all of these hats yourself.

RESEARCH

This group uses various methodologies to determine who the audience is and how to find and connect with them on a specific film. Some of these methods include positioning studies, materials testing, and tracking, all of which we will explain throughout this book.

CONSUMER PRODUCTS AND LICENSING

Most of the departments in the marketing group spend money to try to promote the film, but one group actually *makes* money: CP & Licensing. These experts look for partners they can place in the actual film to generate advertising and revenue down the road. They license the movie brand for toys, t-shirts, bed sheets, books and shot glasses. They turn each movie into a property and that work continues long after the release when the movie transitions into being part of the studio's library.

PUBLICITY

This group knows how to deal with the myriad of personalities that inhabit a movie production including cast, filmmakers and press. They design and control the coverage of the movie to keep it as positive as possible. Their job is to generate press coverage for the film – on television, in print and in digital media. Publicity execs also need to know how to pivot when things go wrong and to jump in and control the coverage.

SOCIAL MEDIA AND DIGITAL MARKETING

This team focuses on all marketing that occurs online, which includes viral stunt videos, digital ads, exclusive clips and online trailer releases. They also manage the studio's social media presence as well as the individual movies. They work with the talent in the film to capitalize on their social footprint as well.

CREATIVE ADVERTISING

This department is in charge of cracking the creative direction of the marketing campaign. They will determine the positioning, the particular shots, the language and even the colors that will define the film in the marketplace. They have a command of the elements that go into creating compelling advertising campaigns including posters, trailers and digital content.

MEDIA PLANNING AND PROMOTIONS

Once the creative department generates all of their "materials," TV spots, trailers, special content and sneak peeks – it's up to the media department to get all of that in front of consumers' eyeballs. The media group plans ahead to buy all of the slots on the shows which will reach the right audiences and get the word out about the movie. They also place newspaper and magazine ads, outdoor ads like billboards and ads that run before the movies in the theater. The promotions group within the media department creates all sorts of special programming and cross- promotions with different networks and programs.

DISTRIBUTION

This group doesn't report to marketing but they do work closely alongside the department. They pick release dates, determine print count and plan how wide the film will open. Marketing will generally have a big say in the release dates for the movie because those other films in the marketplace are going to be the direct competition.

In addition to all of this, a Head of Marketing will also need to excel in many other areas as she works to promote the film.

PRODUCTION

A marketing head will need to have an ability to analyze a script and find the core marketing nuggets inside and to make sure all the content is properly mined and created. Also, she must know how to grab all of the available assets during production so nothing is wasted or lost (all of those marketing assets are detailed in Part One of this book).

OPTIMIST AND CHEERLEADER

The Head of Marketing must keep her team motivated and focused, even through crushing openings or stressful projects. This is sometimes the most difficult part of the job – when a movie is not going well or it looks like it will not work, it is essential to keep your staff focused on the result, no matter how grim or hopeless it may look.

HUMAN RESOURCES

Staff members come and go in this highly competitive field. Marketing heads are responsible for recruiting top talent and then retaining them.

MANAGING DOWN – AND UP!

Any good executive does this, but marketing executives in particular, have to not only manage their superiors but the heads of some of the other departments,

particularly production and home entertainment. The more these other department heads feel they are part of the marketing process, the better for the company as a whole as it fosters a more collegial atmosphere.

And lastly, she must be a sort of **brewmaster** – yes, you are creating a stew of data, personalities and events all geared toward a successful opening.

And consider this: The average tenure of a CMO (Chief Marketing Officer) is a little under four years. In the entertainment business, it is probably about the same, though certainly more volatile at the studio level.[1]

A marketing executive's biggest challenge is accountability. Take production, for example – every aspect of the production process is a combination of group interaction and compromise. By the time we're ready to market the movie, everyone's job on the production is more or less done, and marketing is the final phase in putting a movie out into the public square. In many ways, then, it is the most visible, highly scrutinized, criticized, and analyzed art form, where everyone has an opinion but very few ever know the whole picture behind a campaign.

For many decades there was the prevailing idea that marketing could "steal" a weekend by creating a campaign that was far superior to the movie. The theory that any movie is salvageable with the correct kind of marketing campaign has become a myth in the age of the internet and social media where opinions and word of mouth travel so fast that a marketing campaign, no matter how flashy, can no longer camouflage a troubled movie. In the past, a movie could play for a whole weekend before news would travel around the water cooler on Monday that the film was disappointing. The second weekend would then drop sharply, but the studio had already collected a good opening result. Now, word travels straight out of the first set of shows on Thursday nights. Audiences will even pull out their phones during the film (despite that being frowned upon) and tweet, text or post their flash review. In a matter of hours, a movie's word-of-mouth can be so damaged that the Saturday and Sunday grosses take a nosedive.

Audiences have also reached a historical level of sophistication. They are so inundated with advertising in their daily lives, that they inherently know when a campaign is covering up shortcomings in a film. Depending on which source you believe, experts estimate that the average US adult is exposed to between 4000–10,000 ads *every day*.[2] It means that consumers have become extremely marketing savvy and they recognize the machinations of the campaign.

When Dorothy and her friends discover who the real Wizard of Oz is in the movie, they are told to "pay no attention to that man behind the curtain!" In Hollywood studios, it may be a man or a woman behind that curtain, but they can no longer remain completely hidden.

Moviegoers are watching and watching closely.

So when one can say the marketing campaign was a success, that means that everyone did their job as directed by the marketing executive. At the same time, they had the freedom to bring their own ideas and solutions to the marketing tasks at hand.

Marketing is a cross platform opportunity. What has evolved over the years are distribution mediums and new methodologies for measuring and communicating with your audience but the basic and essential function of marketing has not changed – to identify your audience, make sure you create the content to reach and engage them, solidify their interest, and figure out the best ways to deliver your film to that target audience. As we said in the very beginning of this book, marketing has two essential jobs: Build awareness and generate interest.

YOUR FIRST MARKETING DEPARTMENT MEETING

So, your movie is "in the can" (done filming) and working its way through Post Production. The time has come and you are invited to your first marketing meeting! The entire team – large or small – is going to present their strategic plan for the release of your film. When you walk into the studio, the room is usually very long with a rectangular conference table that can seat up to 50 or more people. It can feel staggering. This group not only includes the theatrical marketing people, but also, production execs, distribution, a business affairs person and some key representatives from the home video/ancillary sales side.

The meeting covers many aspects of your release with the more difficult parts, like creative advertising, usually saved for last since these garner the most discussion and opinions. In no particular order, here's a sample agenda:

1. The distribution executives will kick things off. Looming along one of the long walls of the room is an electronic board, capable of being programmed off a portable console.

 What is on the board? – the release schedule for a four-to-six month period from every studio and for every independent movie that is opening. This is the domain of the distribution executive who goes through this schedule, film by film, by genre, by star, by date. The idea here is to identify the best release date for your film from a competitive and seasonal standpoint and present their reasons for picking it. You may or may not love the date they choose, but rest assured the decision was arrived at with a great deal of strategy and consideration.

 Publicity goes next and weighs in as there are a lot of important dates to cover: The press tour, premiere, national junket, any international scheduling conflicts, etc. Subtly but warily, the publicity team wants to how much the talent is going to support the movie and all the appearances that are being scheduled. While you, the filmmaker, cannot make any real promises other than confirming your wholehearted support of the picture, the message is loud and clear – the PR team will be circling back to the filmmakers if there is any push back from the cast on doing publicity – whether it be a specific show, live web chat, stunt for the home video people, or whatever.

They need you to be a partner to help get the cast out there as much as possible.

2. The next part of the meeting is a bit of show and tell – where the consumer products, licensing or merchandising people usually get to show their prototypes in support of marketing. While this certainly won't happen at every meeting, particularly at a smaller indie studio, it's a good area to explore as you never know what partnerships can be put together, even with a small clothing boutique in your town.

3. The media buying team will now weigh in here – to review the media plan on television, radio, outdoor and digital: What shows and websites are being bought, how is the media weight being allocated over a six-week period leading up to release, etc. They will highlight big stunt buys like show finales, major sporting events and awards ceremonies.

4. The digital team is up next – and they usually command a lot of attention these days as the social aspect for every movie has become increasingly important. Besides laying out some great digital promotional ideas themed to your movie, the digital folks also need to know how the cast will handle their own social media including Facebook, Instagram and Twitter, and how willing are they to participate in some crazy digital stunting with YouTubers and the like. This is a rather long part of the meeting as there is a lot to cover if the digital team is on board.

5. Creative Advertising comes last and represents the "wow" part of the presentation. This is where the studios excel with their highly creative teams and outside vendors who have spent months cutting and testing numerous versions of posters, digital ad units, and teaser trailer until they are ready to present. Of course, your feedback as a filmmaker is more than welcome and all ideas are encouraged – to a point.

Of course, this sequence of events is not always the case, but regardless of the presentation order, most of the same ground is covered in all of these meetings whether they are held at an indie studio or a major. The meetings are sometimes more presentational and other times more fluid with everyone contributing ideas and thoughts. It all depends on the team, the company and the needs of the film.

SAMPLE MARKETING BUDGET

Now that you understand all the categories, take a look at how a typical marketing budget for a spend of $18M based on a 2500 screen release is broken down by those categories.

This example details every budget category for every budget level. The only difference between a $500K and a $35M budget being how much is allocated to each category and differentiated based on how wide the movie is going out and what audience is being targeted.

THEATRICAL DISTRIBUTION
DCP/Hard Drive and shipping, in theater promo costs, post production expenses, delivery,

TOTAL DISTRIBUTION
$3,528,250

PUBLICITY
Press Kits, Electronic Press Kit Shoot, Special photo shoots, National press screenings, field press screenings, screening security, outside national publicists, outside regional publicists, speciality publicists, press junket, press days, Personal Appearance tours and travel, Premieres, Special events, Satellites (television and radio), misc. $1,333,500

DIGITAL MARKETING
Social media outreach, digital publicists, website design, digital ad creation, digital content and asset production, social influencer marketing, social research, web hosting, newspaper and magazine creative
$500,000

CREATIVE ADVERTISING (PRINT)
Teaser and final poster design, printing, outside vendor design fees, printing, misc print materials postcards, outdoor billboard design, in theater standees banner design and printing,

CREATIVE (AV)
Teaser and final trailers, outside agency fees, graphics, music license fees, narration/voice over, additional footage shot during production, copy writing, finishing fees, television, and radio spots

TOTAL CREATIVE ADVERTISING $1,128,000

RESEARCH
Test screenings, advertising materials testing, tracking studies, positioning and concept tests. Exit surveys, digital listening, focus groups
$165,000

LEGAL, FINANCE
MPAA rating, clearances, contracts, etc.
$175,000

MEDIA
Print
Newspaper, magazine, flyers, postcards, etc. Television

Broadcast, cable, syndication Out of Home
Billboards, in theater, bus and bus stop shelters, subway, digital billboards
Digital
All online paid media opportunities
Misc
Awards campaign, International campaign, contingency **$11,155,230**

TOTAL BUDGET **$17,999,980**

STRATEGIC POSITIONING

The very first thing your Marketing department will try to understand is to define your audience and how they are going to sell your movie to that audience. It is very important you partake in this dialogue as you will have been guided by some marketing principles as you made your film, and it is now time to share them with your distribution partner so they can mold a sales strategy that will ensure the greatest chance of success.

WHAT IS A POSITIONING STATEMENT?

Inside your Marketing department, it can be said that strategic positioning has many parents. The Head of Marketing in conjunction with the research department will have a direction, the creative team, in consort with the vendors working on the campaign, will have their own direction, and the publicity team will be aware of all the strengths and pitfalls of the movie from their perspective. The end result is usually a combination of all vectors boiled down to a few sentences, and that becomes the unified direction for selling your movie.

Sometimes people confuse positioning with synopsis. A movie's synopsis is a straight- ahead description of the storyline and plot as it unfolds in your movie but it does not include the underlying themes that help sell your movie.

A typical positioning statement would define what type of film it is by genre, i.e. horror, romantic comedy, dramedy, etc. It will highlight themes, identify the primary and secondary audiences and the inherent allure that the film represents which will hopefully be embraced by those audiences.

The final positioning is then shared with all the other departments working on the film including digital, media buying, publicity, corporate relations, and creative advertising, and of course the producer, director and talent. The positioning statement is crucial because:

1. It defines a shorthand strategy for the movie so the digital and media buying agencies know what kind of programming to buy.
2. It gives the creative people specific directions to explore for print and trailer ideas.

3. If there are any other areas like branding and promotions that could get involved, positioning helps establish talking points with potential partners.
4. From positioning, talking points are then put together by the publicity team that are very important for the talent to have as they do their interviews with the press about the film.
5. These subject areas are then put forth to the press and editorial people to broaden their perspective on the movie in their pieces when they write about the film: What kind of film it is, which are the primary and secondary audiences, and what are the essential elements for success.
6. Finally, it gets everybody on the same page. This is the way we are going to present this film to the marketplace. A good campaign is cohesive and every department should be working from the same blueprint.

When a movie is positioned properly, it successfully embraces all the reasons an audience would *want* to see your film.

In the Case Studies section below, you will see examples of positioning statements for the films we discuss.

If you are self-marketing your film, this is still a very useful tool for you to create and share with your cast and crew as well as potential marketing partners. It's very important that all messaging about your film is consistent and the positioning statement helps keep everyone on the same track.

CASE STUDIES

To best illustrate how a marketing department works, and to give you a sense of an adaptable template for your own project, we have created four movies to illustrate how the Marketing department works. While our four example movies are fictional, they fall into specific genres with each having their own set of identifiable issues. Hopefully you will be able to recognize similarities with these films and your own.

Why are these movies fictional, instead of real examples? It's because we want to be completely honest about the strengths and pitfalls of these films, with the freedom to be critical. These movies have both hooks for marketing as well as some rather major issues. There were some decisions made by the filmmakers on these case study movies that are going to cause big hurtles down the road and we want to be able to break them down honestly for this book. A good marketer never speaks badly in public about a film they are working on as every single movie is equally important and it's our job to sell every one of them – no matter how challenging!

Throughout Part Two of this book, we will look at each of these four films to explore how marketing would practically approach each one. These are specifically designed to cover a gamut of marketing spends and approaches:

- *The Tunnels*: A lower budget, smaller studio horror movie
- *Philosophy of War*: A mid-range budget passion project for A-list stars. Released by a major studio with awards potential.

- **K2TOG:** A low budget indie film hitting the festival circuit and up for sale to distributors
- **Sugar:** A self-financed, self-marketed documentary

The Tunnels

Positioning

This PG-13 horror movie traffics in claustrophobia and the occult, creating a truly terrifying experience. This movie is aimed at younger females (girls 13–24) and secondarily, younger males. This movie is unique and very, very scary with shocking twists and turns. Fans will want to see this opening weekend to avoid spoilers.

Genre: PG-13 Horror/Thriller
Budget: Production costs $10M, marketing around $18M. Wide release.

Summary

When a 6-year-old boy goes missing, an extensive tunnel system is discovered under a rural American town. The boy reappears a few days later, but something is definitely *off* with the child. He talks to things that aren't there, starts creating strange drawings and wanders out at night to stand at the Tunnel entrance. Authorities are quick to dismiss his behavior as shock, but his much older sister (23 years old) suspects something more sinister. She and her friends decide to investigate the tunnels for themselves. They discover that the tunnels lead to a Pagan shrine where the townspeople worshiped demonic forces in the past. As the girl and her friends continue to dig into the mystery, they discover shocking evidence that the worship is still very much alive in the town. Soon her friends are acting strangely just like her little brother. As events unfold, the girl realizes that her own life is in grave danger.

Cast

The female main character is not a movie star, but recognizable from a popular TV role. She is very active on social media, with a strong follower count. The rest of the cast are attractive unknowns. There is one cameo role from a recognizable actor in the horror genre. Also, one of the characters is Latinx and the actor playing him is Mexican and well known in that country.

The cast is eager to work and support the film.

Title

Strong. Easy to remember, suggests genre and tied directly to the subject matter of the film.

Marketing Strengths

Touches on a few popular horror genres: Demonic possession and the supernatural. The story promises intense claustrophobic scares. The possession subject matter is also very popular in Mexico and South America. Concept is clean and easy to communicate. Cast is all 20-somethings which ages it up, but PG-13 rating and female lead helps draw in teen girls. The cameo role is sellable and lends credibility for horror fans. The Mexican actor is very popular in the country and can travel to do aggressive local press. The main actress has a following from her TV career. Tunnels and claustrophobia are fun hooks for marketing stunts.

Marketing Challenges

Main actress's TV show fanship does not completely cross over with horror audience. Mostly unknown cast domestically is difficult to book on talk shows. The parts of the movie filmed in tunnels are dark and small (not theatrical); shots outside that show scope are crucial for this movie and there are not many of them to use in the campaign.

Demonic possession genre is often R-rated, so this feels a bit "soft" for true horror fans. Title could be misconstrued as something other than horror, i.e. it could be a story about drug smuggling. However, once the poster and trailer elements kick in, the title becomes very clear.

Philosophy of War

Positioning

This intense, heart-wrenching drama is an important and timely study about the cost of war. The primary audience are older, arthouse movie fans. But, the film's honest and unflinching look at PTSD could also be appealing to veterans and military families. This movie promises a realistic view of life after combat and features amazing performances from A-list stars. This also has significant award potential.

Genre: R-rated Political/War Drama
Budget: Production costs around $50M, marketing around $30M. Wide release.

Summary

A hard-hitting and gritty drama about a soldier who returns home from war in the Middle East to a life he's not yet ready for. The main character is suffering from PTSD, coping with being a "civilian" and feeling a strong pull to return overseas. All of that is overshadowed, however, when his wife and young son are involved in a serious car accident that threatens both of their lives. Now, he must choose between the war at home or the war abroad.

Cast

Both the main character and his wife are major, A-list movie stars. Significant domestic fanbase and international appeal in certain markets. However, while this is a passion project for both of them, their availability for marketing and PR is limited due to commitments on their other tentpole projects. Also, while they have large fanbases, they are not active on social media.

Title

Challenging. More difficult to remember, more abstractly tied to the subject matter and suggests action genre when this is drama. Will require some lifting from marketing.

Marketing Strengths

A-list stars that are very bookable on talk shows and can easily secure magazine covers and features. Significant awards appeal for the film. Military tie-in. Possible religious angle.

Marketing Challenges

Very challenging subject matter, asking audiences to go through a difficult experience rather than an escapist one. Middle East subject matter is political and polarizing, very tricky to navigate a neutral position. Important not to paint a soldier and war hero in a negative light. Settings are smaller and static. The movie involves lots of talking, and minimal action – more reminiscent of a stage play than theatrical experience.

Consultants

Military, awards, religious and political (both sides).

K2TOG

Positioning

This quirky indie dramedy touches on sibling rivalry, best-friendship, grief and healing through hand-made crafts. The primary audience are art-house fans, but there's significant potential to expand to all 25+ females who are active in the crafting space. This movie promises both laughter and a good, cathartic cry with a feel-good conclusion.

Genre: R-rated, indie comedy.
Budget: $3M Production budget, $5M marketing. Platform release (this title is for sale to distributors and the marketing budget is a minimum commitment)

Summary

Identical twins Marley and Mandy live together in New York City more out of necessity, than anything else. Though they look exactly the same, their personalities could not be more different – Marley, the quieter, meeker one, and Mandy the loud, brash one – and a resulting rift in their sisterhood–friendship has started to settle in. When their grandmother in Texas suddenly passes away, the pair find themselves inheriting the little, old yarn shop that's been in the family for generations. Marley jumps at the opportunity to move back, to take over the store, Mandy returns only begrudgingly. But when they arrive, the financial situation of the quaint little boutique is dire, teetering on the edge of shutting down, as the younger generation is not interested in an "old person" hobby. Marley begs her sister to stay and help her keep the shop from closing, and the two work together to find a way to make knitting into a cool, hip pastime, before the bank closes in and sells off the family store.

Cast

Newcomer twin comediennes. Unknown on a national level but definitely have developed an avid fan following through their popular web series and clips of their stand-up online. Available and willing to work for marketing.

Title

Extremely challenging. Very difficult to remember, doesn't mean anything inherently, doesn't suggest genre. Will need to be changed by buying Distributor (likely through a title test).

Marketing Strengths

Knitting! Universal hobby with stores, magazines, blogs, groups and built-in grassroots efforts. The stars are funny and bookable as stand-up acts on talk shows, if not guests. Themes of family, small business, loyalty and aging are all very appealing. Great potential with sites like Pinterest and Etsy.

Marketing Challenges

Small story, not necessary to see in a theater. Very review driven. Audience is likely primarily older female, with some younger female potential. Very challenging to get males. Tone of the movie doesn't suggest an R-rating and that may turn off some older audiences.

Sugar

Positioning

This is a super feel-good story that is relatable to everyone. This documentary is about community and food and culture. But, also about how it's never too late to

pursue your dreams. Primary audience are older with potential to draw in the large 65+ crowd that aren't frequent moviegoers. With a strategic platform release, this could potentially expand to a broader audience due to charm and comedy. As a self-financed doc, the end goal is for purchase by a distributor or streaming platform to reach a wider audience.

Genre: Indie-documentary.
Budget: Production budget of $500,000, marketing budget of $50,000.

Summary

A group of plucky, charming, multi-cultural senior ladies get together to start their own neighborhood bakery/patisserie in Detroit. They bring their own histories, stories and cultures to the recipes they all make with love. The leader of the effort is 80-year-old Lucy, also known as "Sugar." The bakery is located downtown, in a neighborhood currently going through an economic resurgence.

Title

Good, ties in with the subject matter and has a nice variety of layers to play with in the marketing. It also suggests a sweet experience, which this movie definitely delivers.

Marketing Strengths

This film is self-marketed so the campaign will be entirely field and grassroots marketing. With a limited-run engagement in Detroit, the filmmakers are concentrating their efforts on local moviegoers. The true story and local hero aspect is a big hook as are the elements in the film: Baking, senior citizen empowerment, anti-ageism and multi-culturalism.

Challenges

There is such a low amount of money earmarked for marketing, the filmmakers will have to be incredibly strategic with their choices. Most of the media and exposure will be earned rather than bought.

THE PRODUCER'S VIEWPOINT ABOUT MARKETING

Richard Gladstein has twice been nominated for a Best Picture Oscar® – for *The Cider House Rules* and *Finding Neverland*. Richard's other produced films include *The Bourne Identity*, *Hurlyburly*, *Mr. Magorium's Wonder Emporium*, *The Nanny Diaries* and *She's All That*, among many others. His films have received 25 Academy Award® nominations and five wins.

He enjoys a long and fruitful collaboration with Quentin Tarantino – most recently producing Tarantino's *The Hateful Eight*, and prior to that, executive-producing *Reservoir Dogs*, *Pulp Fiction* and *Jackie Brown*.

Richard is the Founder and President of Los Angeles-based motion picture production company FilmColony. Prior to the formation of FilmColony, he was Miramax's Executive Vice President and Head of Production, supervising the company's development and production activities.

As a producer, how do you see your role in dealing with Marketing departments?

RG: As my films are being released, I believe it is mandatory that the producer participate and aid in the process of a film's release – and to secure buy-in and participation from the director and the cast. The only way to have a successful film is for the public to be asked to come see the movie. I think it would be crazy for me to make a movie and then immediately think about the next one. I work very hard making these movies and I have to consider how it is being treated and released ... understand the feelings people have when they look at the poster and watch the trailer.

The filmmakers have to consider if the marketing accurately reflects the film. Or, is it a manipulation of the film's message? It may be OK if it's not entirely accurate, the movie's message is in the movie and the marketing message may be slightly different, but it is incumbent upon us, as producers, to work with the distributor to come up with the materials and messaging. We have our idea of what the film is about and then we discuss what their idea of the film is about, and you usually meet somewhere in between.

How important is it to get the cast to buy-in? Is it about getting them to do publicity?

RG: When you talk to actors about doing publicity, they usually bow their heads and say how much they hate it, but in reality they love it. And if you leave them out of a trip, or interview, they call to complain. They usually want to do more than even you want them to do it's just how you ask them, and when you ask them.

But there are actors who just won't do anything – I did a movie with Jack Nicholson and the studio called me, wanted me to ask Jack to do some talk shows. Now, if they are asking me to ask Jack, they have likely already asked him (through his agent or publicist) and he has said no. So, they failed and now it become my job to convince Jack because I have the relationship with him and his reops and supposedly I could get Jack to do publicity.

So, I called his manager and said "I know you have already been asked but I want to ask again and would really like Jack to do some talk shows." The manager asked me "Have you ever seen Jack do a talk show?" I thought about it for a moment and said "No." At which point the manager said, "That's because he will not do them." And it wasn't about what the movie is, or whether he had a good experience or not, it is always a "No." I understood he doesn't do movie publicity because he doesn't want to speak as himself because he wants the audience to see him in the character he plays in each film, and not see "Jack."

Have you found any differences between working with a big studio Marketing department or a smaller indie? Is your voice heard louder in either case?

RG: The studios generally have more resources, so they can do more, but it can also be generic. However, with a big movie, the studios, with their vast Marketing departments, are very skilled at releasing films to a broad audience. Big studios are also better able to secure better screens and for a longer period of time.

When I produce a smaller film, I find the indies may have more original ideas but, as a producer, you have to do more to augment their marketing. The indies have less resources to capture all the behind the scenes stuff, interviews, etc. so whether they ask me or not, I'm going to do it. And I am happy to corral everyone into what are the good ideas and nix the bad ones. Because nixing the bad ones is really important.

How much into the weeds of a marketing campaign do you go? Creative advertising? Release date? Marketing spend and media mix? Do you take separate meetings with the publicity department? Do you visit the company who is making your trailer?

RG: I get to know the publicity team as we are shooting, and that relationship continues into and marketing distribution. As to the trailer house, I have requested to go sit with the editors and creative directors and sometimes I am allowed to, but more often the studio wants to be point. They have fear of them becoming "influenced" by the producer. I understand that, but I do believe no one knows the movie better than me and the director and the actors – we've seen all the dailies, every cut, so after I see the creative materials I can be useful by saying we have these out-takes which may help tell the advertising narrative, we have actors saying these exposition lines that you have never heard, and you can use these here and there in the trailer or television spots.

So, in general I abide by the philosophy we (director, producer etc.) get to decide what we want to do when we make the movie ... and then marketing decides what they want to do with the release. We are the professional filmmakers and they are the professional marketeers.

With the first batch of materials for *The Cider House Rules*, I thought the movie looked like *The Notebook*, a romantic sentimental movie. This movie was about people making important choices with life changing ramifications, and the Marketing department was not selling the movie with gravitas and I really believed that no one was going to see it. So, I argued to completely redo the campaign. When you argue, you get as much as you can get, and sometimes it ends up being much better, as was the case with *Cider House*, or sometimes the campaign ends up as a soup of unclear ideas and messages or a compromise.

Any advice for young filmmakers?

RG: The key, I think, is to read a lot, including screenplays, and figure out what are the stories that you want to tell, and being able to express your view and

giving that to a director or screenwriter. If you can do that, then you have a point of view and you can mine a story for its thematic relevance, that is the key to being a filmmaker.

For example, we made *Finding Neverland* with a point of view of an adult story told through a child's perspective and people cried at the end. And believe me, there is no greater reward than watching someone cry over something you made. We did a research screening of *Finding Neverland* and the first screening went well and tested really high, but the studio said go screen this in the middle of nowhere and see if they like it.

So, we went to the middle of nowhere and during the screening I sat next to a real salt of the earth, "blue collar" kind of guy. And here he is watching a movie about the man who wrote *Peter Pan* and how a woman and her kids inspired him to create a play. When the movie ended, I looked over and this guy was weeping, and I said to myself "I'm done." I didn't have to hear anything from the focus group or do a thing – if I achieve that kind of emotional response, then we are done.

Any directors you worked with that didn't like the research process?

RG: Quentin Tarantino will go to a research screening, he will watch it with the audience, but he never allows the studio to do research cards (this is where people write their responses to a number of questions about the movie). He says he will not review data, but will listen, and watch them react to his film, however the studio cannot break his movie down into data.

Which leads me to the first screening we had on *Pulp Fiction*. Before the movie began, Quentin points to an empty seat and says to me "I am going to sit over here after I introduce the movie." And I said you can't do that, you can't introduce the movie, and he asked, "Why not?" I said because if they know you are here, you will be getting them all excited and we won't get a real reaction from the audience. And don't we want a real reaction?" So, he said "What's the matter – are you afraid they are going to like the movie?"

Remember by this time Quentin had already achieved a measure of notoriety from *Reservoir Dogs* and he had become a bit of a celebrity particularly from the talk shows he'd done, so many members of the audience recognized him when they were coming into the screening and yelled over to him.

In the middle of this discussion with Quentin Bob Weinstein wandered into the conversation and asks what we're talking about. I try to say it's nothing, but Quentin said "No, let's tell him" and Quentin says that Richard doesn't want me to introduce the movie because he thinks it will color the audience reaction. And Bob said, "Oh, go ahead and introduce the movie."

So, Quentin goes to the front of the audience and sure enough the audience erupts like it's Woodstock. The first thing he asks is "How many people here have seen *Reservoir Dogs*?' The majority raise their hand and cheers. "How many have seen *True Romance*?" (he wrote that) and about three-quarters raise their hand and howl in delight. "How many of you want to see my next movie?" Everyone raises their hand, whooping.

Then he asks one last question "How many of you have seen *Remains of the Day?*" And one person meekly raises his hand and Quentin looks at him and says: "Get the f★★k out of here! Let's start the movie!"

It was a party.

AN AGENCY'S VIEW ABOUT MARKETING AND REPRESENTING THEIR CLIENTS

Megan Crawford oversees the Motion Picture Marketing Department for Creative Artists Agency (CAA). Her background in marketing was something the CAA partners realized was a part of their business that they were missing – someone who can talk to the studios and independents on behalf of their clients about marketing and distribution. We spoke to Megan about how she handles her very unique job, the filmmakers, and some insights from her special perspective.

Megan Crawford: No other agency has a Motion Picture Marketing Department. We advise clients on anything that has to do with marketing or distribution. So that can be anything from "what does the release date that the studio has proposed say about the way they feel about my movie" to understanding release patterns, reading tracking and looking at media plans. We often smooth out wrinkles. There's a fair amount of diplomacy to this job.

I think that the partners wanted to be sensitive about the way that questions land with Marketing departments. They wanted a dedicated department who would be able to position the conversations in a way that was more productive, and also it saves agents time, right? Like if I'm dedicated to marketing and spending time on the specific challenges and opportunities on a particular campaign, then they can be busy getting the client their next job.

Russell: **When I was at New Line Cinema, you and I had a number of on-the-record and off-the-record conversations about the movies New Line was releasing on any given day. For example, when tracking came out on a movie and it didn't look good, it was time to speak to Megan.**

MC: I think it is about having an honest dialogue, and maybe because I was also a marketer you felt like we could have the off-the-record conversation before we had the on-the-record conversation. We could try to address it so that by the time we are each getting phone calls from filmmakers, agents, managers and publicists the first conversation is "I spoke to Russell at New Line this morning, he didn't like the tracking either. So here's

what he's doing about it: X, Y, and Z." Then everyone feels like it's proactive, and that's super important, and it's really important to have partners on tough tracking days. And I think that the agency very much wants to be the studio's partners throughout marketing and distribution.

How knowledgeable are your filmmakers about marketing?

MC: There are certain clients that are really experienced and I find that clients who have done it over and over again have a little bit more of a keen understanding, it is a sensitive moment for any client.

With all the new methodologies in place is there any trend that your filmmakers are looking most towards?

MC: I think for the longest time we were treating digital like it was television. It's a completely different medium. And I think that as young marketers are coming up they are starting to work in the medium without being mentally hung up on the way that we did things in television.

Amazon, Netflix, and Hulu are taking over film festivals and spending way too much money in terms of a competitive situation, so how do these companies that we've grown up with, like Fox Searchlight, Focus Pictures and Sony Classics compete going into this world?

MC: Well, fortunately, we still have a great art house movie-going audience. Because awards-driven material is still an event for older moviegoers, we still have that audience. Boomers in particular grew up feeling that movie-going itself was a really good value in terms of money to social value so I think there's still real opportunity for movies that aren't necessarily SearchLight but skew towards older adults.

One of the thesis statements of our book, which we're open to debate on, was this argument that it would behoove filmmakers to think in terms of marketing, not that they are marketers, but that they should consider marketing from the very beginning. Can you speak to that?

MC: Well for me it all goes to positioning, right? Positioning is the most important part of any campaign and having filmmakers and marketers – not saying that a positioning can't evolve – but really speaking in the same language about a movie from the very beginning is super important. Marketers are a part of the green light process, so it's not that marketing hasn't been considered, but making sure all parties are on the same page on what we are selling is super important. If you have a great positioning statement on a movie, it makes it easier for materials because you can look at a piece of art and say does this serve the positioning? If not, move on.

When you come up with some ideas for the marketing people, do they listen?

MC: They might think I'm nuts, or may not agree, but I find that studio marketing heads are just trying to do their very best for the movie, and so a good marketing head does not care where an idea comes from if it can be something that helps. It may be the way that I position things so it doesn't feel like, "you need to try a TV spot blah blah," but I think in general, people want things to go smoothly and want everything to be a success.

One of the things that's great about this job is that almost every time I walk into a marketing meeting, a studio marketing meeting, and I go to a lot of them, very, very frequently, I hear something that nobody has ever done before. And that is super cool.

You mean an idea, an execution?

MC: An idea, an execution, a new partner, something like that. That is inspiring. Because marketers in this town are so smart, and they are so creative and there are so many cool things that people do that have never been done before, and I love being here and seeing the opportunity that people do that. The other thing I love about being here is that I get to see young talented marketers coming up. So the first or second time you see them present in a meeting and you're like who's that kid? You know, because their boss is gone and so they've brought the director level into the meeting to present or something, and then you can track them and help them along the way. It's an unbelievable privilege to work with the caliber of filmmakers that I get to work with every day. I can't tell you how incredibly lucky I feel.

Do you have any advice for young filmmakers? You know they're on their first big movie, it's their first big shot in town. What would you say if you could sit them down?

MC: I am going to quote *Wonder*, the book and the movie, which is when given the choice between being right and being kind, choose kind. Having an open, honest and respectful relationship between filmmakers and marketers is the way that you set a campaign forward in a positive way. And that would be my advice.

With that, let's dive into the various disciplines in movie marketing. Whether the studio department has over 125 people or you are working with a small indie company and a marketing department of ten, the primary marketing functions pretty much remain the same as we will see in the following chapters. Size is all about the extent of execution which is why studios need big tentpole films so their multitiered Marketing departments can exploit all the things that big budget movies offer

including brand, promotions, music, books, etc. Independents, on the other hand, don't have the luxury of body count and, in reality, they lust after a different type of film – one where passion rules the endeavor, not the scope of work to be done.

Marketing departments then are scaled to the type of movies the company is releasing, and that varies from a huge department to a few well-chosen consultants if you decide to distribute the film yourself.

EXERCISES

1. Think of three recent movies and write the positioning statement for them. Try to pick at least one that was less successful and a challenge to market.
2. Set up a binder with sections for each of the marketing disciplines discussed above. As we move through Part Two if this book, you will add notes and strategy for how you are going to execute each of these marketing needs on your own film. When you're finished, you'll have a complete marketing plan in that binder!
3. Imagine you are at your first marketing movie with your film. Prepare opening remarks that you would give to the Marketing department where you talk about the film, your vision and how you think it should be sold

NOTES

1 https://blogs.wsj.com/cmo/2014/03/23/cmos-work-lifespan-improves-still-half-that-of-ceos-study/
2 https://www.forbes.com/sites/forbesagencycouncil/2017/08/25/finding-brand-success-in-the-digital-world/#780c10f1626e

9

Market Research
The Numbers that Rule the Town

The Market Research team is the one department in the studio that will likely interact with your movie from its inception all the way through production, marketing and release. This team is there to provide insights and guidance throughout the entire lifecycle of your movie. Filmmakers sometimes find the research process daunting, but it needn't be. The purpose of research is not to hamper your creativity, but rather to help ensure that the movie is as satisfying as possible for audiences and that the marketing campaign is successful at generating interest because if the movie opens well, then everybody wins. Bottom line, research should be a guideline, not a rule.

This chapter is going to look at the various ways that research will interact with your movie and show you how the process varies depending on the scale of the film you are making. Whether you're making a massive, branded tentpole or a micro-budget documentary, research can be invaluable to the process.

SOCIAL MEDIA VS. TRADITIONAL RESEARCH

First things first, let's break down the two major categories in theatrical market research. The first big camp is research conducted using digital tools, often called "social listening." There are a large number of major digital platforms that track what audiences are saying online and create reports about content and sentiment for the marketing department. Two of these are "Crimson Hexagon" and "Way to Blue." These tools gather public comments from moviegoers across multiple sources like social media accounts, Twitter, YouTube comments, blog posts and article comments and create detailed metrics to assess how people feel about films. Marketers can look at a dashboard that concisely shows them all of these measures in one place.

This is called "passive research" because you are merely observing how moviegoers are reacting to your film and campaign – but not engaging with them or asking

them questions directly. Though you might not have the budget to purchase access to one of the major social listening tools, there are plenty of affordable or even free ways to harness the information available online. Google Analytics can run reports on search terms and you can get other metrics once you build a website for your movie. You also can monitor comments and feedback when you post trailers or material for your movie online.

Doug Sack has been in the digital space for his entire career beginning at CitizenNet where he was one of the founding partners. Presently he is head of digital research. We talked about how digital has evolved as a measuring tool and how he interacts with the rest of the company

What companies do the studios and the independents use for their digital research?

Douglas Sack: Two of the better known companies are: ListenFirst – they are an aggregator of digital metrics for both past and present movies. They do precisely what their name says – listen to all the conversation on the web and distill it down into relevant information that would be useful for a particular movie.

Crimson Hexagon performs many functions but they are primarily a social media analytics company. They passively and organically perform competitive analysis, including what share of voice the social conversations about our product means. They give us real-time response, which allows us to react very quickly if a television spot, for example, is not engaging with our target audience.

We also use a variety of smaller digital platforms like Survey Monkey if we are looking for answers to a specific question or smaller item."

What are some of the methods of digital testing currently being used?

DS: We use Facebook a lot as it is still the most robust platform out there. We can draw a psychographically targeted audience. For example, we could focus on a 35–50 age subset, which would be used against a creative launch. "Dark posting" involves putting a post on Facebook, Twitter or Instagram but one which is not visible to everyone. In fact, it is never really published and people only see it if we promote a buy against them. This allows us to see if an ad is working for its intended audience only at which point we would decide if it is worth putting on Facebook to be shared organically.

The headline of these posts is very important as it is part of the positioning statement of the content and helps dictate what is below it. So we have to make sure the message at top is the best it can be which will help our audience continue watching.

Which is more powerful – a View, a Like, or a Share?

DS: It all depends on which stage of the campaign you are in. A "View" helps capture an audience early on and puts them in a bucket. Views also help us gauge the competition based on how many people are watching. A "Like" is pure vanity and can be bought but is not an effective measure of interest. A "Share" is a much better indication of interest because we do not control it – it happens organically. And then there is the "Retweet," which gives us a lot of information: The viewer understands the material and by retweeting the material they are saying they want people to know that this piece of content is something they relate to. It also defines a person's own perception of themselves in a meaningful way.

What are some of the challenges in your digital research?

DS: Clutter, being able to define and test content that resonates in the present zeitgeist, which, of course, is constantly evolving. And competition, which is finding people who want to go to a movie theater and not to just see a Marvel movie.

TRADITIONAL RESEARCH

Once you go out and specifically ask people questions and engage in a dialogue about the film and the marketing this becomes "traditional research." There are all sorts of products, tools and techniques available for this kind of research, which we will look at closely in this chapter.

Of course, the line between social and traditional research has blurred considerably in recent years. As marketing campaigns and research moves increasingly online it all becomes one big ecosystem to tap into for information.

THE BRAND STUDY

This research is primarily used when your idea comes from IP if you are adapting something that exists in a different form already. The term "brand" has become very popular these days.

Entertainment conglomerates like Disney consider themselves a brand, so do popular sports teams like Manchester United and individual sports figures like LeBron James and Stephen Curry. In actuality, every one of us is a brand as we all have distinct properties that could be wrapped up into a sales package and marketed. However as relates to the movie business, a brand is more specific.

In the entertainment world, examples of IP where you would consider a brand study would be comic book franchises, a popular book series like *Harry Potter*, *The Lord of the Rings* or a current best seller, or a successful play you are thinking of adapting to the screen. Brand refers to the belief that the property has already established itself in the zeitgeist of popular culture and when mentioned, it elicits a response of familiarity. Of course, a movie can become a brand after its success as well. Many original movies spawn sequels or character spinoffs, such as *The*

Conjuring, which has both sequels and spinoffs with the Annabelle doll and the Nun character. This is what a brand study does for marketing:

- Can help gauge awareness and interest in the underlying brand worldwide and will identify the appetite for a film adaption. Furthermore, brand studies are commonly conducted globally and can help determine international appeal by market.
- Identify the biggest advocates for the brand (super fans) and what they hope for in a movie and conversely help pinpoint potential trouble spots. When Peter Jackson was writing the initial draft of *The Fellowship of the Ring*, the first part of *The Lord of the Rings* Trilogy, he took great pains to engage in online dialogue with the super fans of the original book and told them early on that he was eliminating certain characters or scenes. Despite some initial howls of "how could you?" by engaging these avid fans early on in the process, he was able to keep their allegiance as they felt they were part of the process.
- Brand studies can do a "heat check" on the cast and director. Sometimes research can help identify actors that would be incredibly exciting in key roles or cameos.
- Help identify which international elements could be attractive in foreign markets without hindering the domestic sell, for example, casting an international star in a supporting role rather than an unknown one.
- Assess the health of the IP brand. For example, we would look at how an author's books have held up in the public eye and whether it is wise to continue to produce material based on them.
 - o Robert Ludlum is still a strong contender for adaptations based on the success of the *Jason Bourne* movies.
 - o Nicholas Sparks' movies, which have been enormously successful over the 11 movies adapted from his material, have seen a decline in box office for the more recent films but at the same time his works are still beloved by audiences and will resonate in other mediums.
- Measure the changing audience demographic.
- Identify key story elements and challenges.
- Develop the optimal positioning and messaging of the story.
- Help identify which characters audiences are most looking forward to seeing: The good guy or the bad guy, Batman or The Joker?

THE CONCEPT TEST

A concept test differs from a brand study in that here we are looking for the most interesting elements of your story to market rather than assessing the strength of the underlying brand.

Marketing approaches movies like sound mixing: Certain elements of your story get dialed up in the campaign and some get modulated down. A concept test can

help identify which is the best approach. Additionally, they help marketing identify the following:

- Who the primary and secondary audiences could be for the movie.
- What MPAA rating might be ideal (R, PG-13, PG or G).
- Are there any confusions that can be easily cleared up now?
- How would your casting be impacted based on audience interest in response to the characters?

Concept tests are usually done with a market research company and the idea is to present different ways of looking at the story to increase the interest with the primary audience as well as identifying how to attract secondary and tertiary audiences.

If you don't have the funds for either a brand or concept test, you should still do the research. There are all sorts of free online tools for surveys where you can set up questionnaires and ask people to weigh in. If you are making your own independent film, you can still perform a concept test for how best to position the film.

You should sit down and make a list of all the elements in the film: The location, the subject matter, the theme, the genre, the cast, etc. You can then write different loglines for your movie where each of these elements is front and center. Then take the different loglines and put them in a survey and see which one people respond to the most. At the very minimum you can do your own, on-the-ground research, by pitching your movie to your friends, family and colleagues. Get feedback from them on what they liked about the pitch or what confused them and then tailor the message. The version you land on will probably end up being what you use to sell the film to the world when you are ready to release.

RESEARCH SCREENINGS

Okay, don't panic. Research screenings are part of life in Hollywood. If you make your movie with a studio or even with a smaller production company, it's probably going to happen. Usually the purpose of the screening is simply to measure audience enjoyment in the film and to see if there's anything that can be repaired that may heighten that further. But sometimes, research screenings are also used to determine how wide the print count will be for the release, the marketing budget or to justify reshoots. These bigger pressures can sometimes make this process daunting for filmmakers. But, know this: The executives at the research screening want the movie to score well just as badly as you do. Their jobs are also directly linked to this success, so everyone is rooting for a strong screening. Remember how happy the executives were in our opening prologue? A great screening is great for everyone. Here's how they work, so you know what to expect.

- **What is a research screening?** This is a special screening of your movie where the studio or producers (or sometimes even the director) will invite regular,

non-film industry, moviegoers to watch the movie before it is finished to get their feedback. Everyone in the audience will fill out a questionnaire and some people will also participate in a focus group.

- **The recruit:** The studio will write up a description of the movie and designate whom they want in the audience. They will determine what ages the audience should be, the ethnic make-up, the gender split and even how many of them are fans of the genre. They will hire a research vendor to find people to attend the screening through invitations, online groups and emails.

- **The recruit ratio:** You may hear this term bandied about when discussing your screening. It means the ratio of people who were offered an invitation to attend a free screening of your film versus the number of people who accepted. Marketing often looks closely at this measure, because it gives them a nice sneak peek into how easy or challenging it might be to draw people into a theater. If the recruit ratio is 4-to-1 or under that is considered an "easy" recruit and bodes well for the movie. Anything between 5-to-1 and 10-to-1 is broadly called a "moderate recruit" and this is not a cause for alarm but also doesn't signify things will be easy. If it takes more than ten invitations for every one acceptance that is considered a "difficult" recruit and might suggest that the core audience for your film is more modest. Nothing wrong with that if you are making an art house film, but probably a red flag if this is a broader studio release with a big budget.

- **The questionnaire:** Everyone that attends the research screening will be asked to stay in their seats after the movie and fill out a two-sided questionnaire about the film (these are often referred to as the "cards.") The audience will rate how much they enjoyed the film and how much they would recommend it. Audiences will also rate the characters, and the elements of the film, and they will indicate if there were any issues with pacing or confusion. As you can see, a ton of useful information is gathered at these screenings and it is everyone's intention to help make the movie as satisfying as possible.
 - o It's worth noting that as we write this book, research companies are already experimenting with foregoing the traditional "comment cards" and handing digital tablets to the audience after the film. This technology would create scores in real time and allow filmmakers and executives to immediately access the feedback to the film.

- **The focus group:** Once the audience is finished filling out their cards, a handful of moviegoers will be asked to stay back and participate in a focus group. The studio executives and filmmakers will watch this together to get the first sense of what the audience felt about the movie. This will be a discussion about the movie moderated by a professional research executive. The group will be asked about why they marked down what they did on their questionnaires, how they will talk about the movie and what they would have changed.

- **The scores:** After the focus group is over, someone from the studio (usually the head of research) will come in with the scores. This is a grid that shows the percentage of people who loved and liked your film and how many of them

will definitely recommend it to others. Because all of the studios do research screenings and have been doing them for many years there are robust averages for these scores – called the "norms." Above norm is good, while a score at or below norm means there's still work to do on the movie. The studio will also look at your movie scores against comparable titles from their own history. They will see you if are testing in the same range as big hits in the genre or more in the range of movies that performed less robustly. The scores usually prompt the most anxiety for filmmakers, because it can feel like a grade. Did the film perform above norm? Did we match or exceed the right comps? But rest assured, the scores are not the ultimate predictor of a film's success and they can always go up!

- **The post-mortem:** The day after the screening the studio executives and the filmmakers will often meet for what is morbidly called the "post-mortem" meeting. As dark as it sounds, it really is designed as an opportunity to hear from research about what people loved in the film and what might need to be addressed. As difficult as it can sometimes be to hear negative feedback, try to remember that everyone sitting around the table wants the movie to work just as badly as you do.

MATERIALS TESTING

When the studio or distributor starts cutting marketing materials for your movie (trailers and television spots), they will turn to research to see how well those advertisements connect with audiences. Most of the time this testing is done online but sometimes people are polled in shopping malls around the country.

In materials testing, moviegoers are shown the trailer or TV spot and asked to rate how likely they are to go see that movie in a theater. That metric is called "the definite interest score" and just like the research screenings, it is measured against the norms and comparable titles. A bigger studio will keep cutting and testing the trailers and TV spots until they achieve the scores they want. Sometimes, ten (or more) different trailers will get tested along with dozens of TV commercials. It's a complicated and expensive process to find the perfect messaging for a movie!

As a filmmaker, you may never be exposed to the details of the research on the marketing materials. However, when the Marketing team shows you the finished trailer, it's very probable that they'll mention that it "scored well!" They probably won't elaborate beyond that, but now you'll know that they mean they found a version that generated enough definite interest to make them happy with the direction.

When interviewed by the *New York Times*, Steven Soderbergh commented, "It's very difficult once you get into studio testing to push back."[1] This is not to say that research is wrong, or necessarily always right, but the results are what frames the dialogue between marketing and filmmaker and in those cases where there is disagreement, Marketing usually wins. Compromise is not the best answer in testing because the numbers are hard and cold. At the same time, it is the weak Marketing department that will only use the numbers to put forth their agenda. From your perspective as filmmakers, it is your right to challenge this.

These are the primary types of materials testing that happen at studios:

- **Trailer testing:** Most of the bigger movies will have at least two trailers, usually a teaser piece and then a longer payoff trailer. A major tentpole may have three to five different trailers released over time. The teaser is exactly what it sounds like, a tease. It usually doesn't pay to test these pieces because they are only meant to whet the audience's appetite. However, the payoff trailer can benefit from testing to make sure that it is enticing the right audience and giving people just enough information to lure them in, but not so much that they feel like they've already seen the film.

- **TV testing**: Studios and larger distributors will often test their television commercials for the movie and this has a lot to do with the "rotation." We'll get much more in detail on this topic in Chapter 14 on media planning, but for now, this refers to how the TV spots are served up to audiences. Studios will cut certain TV commercials that are designed to appeal to everyone – called the "workhorse" spots. They will also cut targeted spots that are aimed at specific audience segments like younger males or moms. The research will make it clear which spots work best for which audiences and the media department can serve them up on the ideal programming to reach those people.

- **Materials focus groups**: Another way to gauge the efficacy of marketing materials is to hold some focus groups. In this exercise, moviegoers are recruited to sit in a room for an hour and talk about the movie marketing. A moderator will guide the discussion, usually showing them a range of TV spots and trailers. This isn't about scores, but rather about "getting under the hood" to find out why people are or are not responding to the marketing. Executives from marketing usually watch these focus groups from the other side of a two-way mirror or via webcam. These groups can be incredibly illuminating for marketers and often expose unknown issues in the messaging.

 o It's worth noting that anyone can pull together a focus group to go through a movie campaign. The best plan is to recruit people who are not close friends and not associated with the film (i.e. you want to talk to impartial people with no skin in the game). Get a friend to moderate the discussion and have it videotaped. You should not be in the room because you don't want to influence the group in any way. You'll definitely learn a lot about how people perceive your film and whether your marketing materials are connecting or not.

As marketing people, your authors have been on many different sides when it comes to deciding which is the right cut to use. In many cases, a filmmaker will cut his own trailer and argue extensively why it is a better version than the one we just spent thousands of dollars on. The only solution to this is either a long conversation about how we know our job better than they do and to trust us (sometimes this works, but not often), or what unfortunately has become all too routine, is to do a research bake-off with the two trailers to see which one tests better.

This is not dissimilar to what your distributor may feel about the final cut of your film when they disagree with, for example, your ending – to test your cut of the film and the distributor's cut of the film in the same night with two different audiences but in the same theater – to see which comes out better. If the results are statistically far enough apart – say at least five to ten points – then the conversation is over. If they are still close, then the conversation continues. Of course, when you work yourself up to having "final cut" status, then this whole conversation is moot.

Another difficult place to be is when we are creating materials and have hit a wall with the testing process where the numbers just don't go up. This is not necessarily because of bad cutting, but more about the subject matter or genre of the movie and that it simply appeals to a very defined audience and nothing more.

The goal of trailer and television spot testing is to hit the "Top 10%" of the historical averages of testing for a particular type of film. When the spots hit this number, everyone is thrilled and end of conversation. When the numbers don't get there, that wonderful thing called "trust your gut" comes into play and usually this is the best version possible anyway.

Jason Pritchett is a former executive at the National Research Group (NRG) and has had extensive experience with the testing of advertising materials. While the testing process itself is very proprietary to the companies they work with, Jason sat down with us and offered great insight into the testing process.

The testing methodology has dramatically changed over the past ten years. In the past, your teams of researchers would intercept people in a shopping mall and show them trailers in a back room inside the mall. Now, all of this is done online. What has accounted for this dramatic change and have the numbers changed from live mall to online?

Jason Pritchett:　　The shift from mall-based testing to online occurred because we wanted to reach consumers where they are on a day-to-day basis. The percentage of people who regularly go to malls has dropped dramatically in recent years, and experts have recently estimated that 25 percent of existing malls could close within the next five years. Mall traffic is also typically very low during the week, forcing testing to occur only on weekends. On the other hand, the prevalence of mobile phones, laptops, and tablets has continued to increase, as the vast majority of the US population has regular access to broadband internet and smartphones.

How many people are asked about the material? And how do you break them up demographically? Is it by the content of the film and material?

JP:　　Our typical sample size is 400 people per piece of material being tested. The sample composition varies widely, and is largely dependent on the content of the film. We try not to be too "templated" in how we design a study and its sample composition, as each film

has a unique identity, and we want our study to be customized to its individual needs. We will frequently do oversamples, as well, to dig deeper into what various segments of the population might feel about a film. These oversamples include groups such as kids and parents, ethnic oversamples, geographic oversamples (e.g., oversampling in a particular city or state if the location of the film's setting plays a prominent role in its appeal), political groupings/ ideologies, and religious groups. [Note: an "oversample" is when you target a specific audience and you make sure to test to a group of them above and beyond the regular materials testing.]

When NRG analyzes a trailer, you start with a question asking about interest based on the title and the stars only. This is before any material is shown to the respondents. The response is a number that is compared to a baseline number that has been established over years of quantitative analysis. With big studio films, the initial interest number is usually at or considerably above the baseline. But what about the more independent movies that don't have the title recognition or star quotient to hit those numbers? What do you tell the marketing teams? Are they automatically in trouble?

JP: The title-and-stars interest (also known as "pre-interest") is certainly an important measure, as it's a quick and easy way to assess the appeal of the most basic components of a film – but it's not impossible to overcome a soft title-and-stars number if you have an appealing premise and effective marketing materials. It's true that some independent or smaller-scale movies start off at a disadvantage due to having lesser-known cast members or a title that isn't linked to a brand or franchise. In those cases, we might place more emphasis on "conversion," which is a measure of how many people converted to being interested in seeing the film after they're exposed to the marketing materials.

For example, a film with a catchy title and well-known stars might have high title-and-stars interest, but the interest levels after seeing the marketing material might not increase much for various reasons (e.g., the concept isn't a good match for the stars, the tone/ genre of the movie isn't what respondents thought it was going to be based on the title and stars, etc.).

On the flipside, a film with lesser-known stars and a title that isn't as catchy might have low title-and-stars interest, but after seeing the materials, quite a few respondents are interested due to a catchy premise, impressive performances, etc. While the resulting interest numbers after seeing the materials still might not be as high for the latter film, it's "converting" people at a higher rate than the former film. This can be a sign that with increased awareness driven by

well-placed marketing, even a smaller, more "independent" movie can still succeed.

After you show the trailer, you then get another number – interest based on the content. What is the importance in the difference between these two numbers?

JP: Interest in seeing a film is still an important measure when evaluating the effectiveness of a piece of advertising, but it shouldn't be the only determinant of success. It's not uncommon to see only small differences in interest across various materials for the same film, thus making it difficult to justify making a decision on which piece is "better" solely on a one- or two-point difference. Looking at multiple measures gives a fuller, more well-rounded picture of how a piece is performing, as well as informing the overall strategy that should be used in a creative campaign. We now look at measures that assess what makes a film stand out from others, what makes a film relatable, and what increases urgency to see the film.

Can you talk about how you analyze a trailer demographically and what signs spell trouble?

JP: Defining a core audience is key for most films, as only a lucky few each year have true mass appeal. To some degree, our demographic analysis of trailers stems from past experience and attendance patterns for certain genres of films. For example, if we're testing trailers for a romantic drama, and younger males are more enthusiastic than older females, that's going to be a red flag, since the expected core audience isn't as engaged as they should be. We would focus first on determining what's turning off older females and what's needed to fully bring them on board, and then assess what's causing a rise with younger males to see if there's an unforeseen opportunity to tap into a secondary audience.

It's also worth noting that being "broad" isn't always a sign of success. If all demographic segments are responding to a piece of advertising in a similar fashion, but none stand out against norms or comparative titles, that could also be a red flag—a sign that the film in question doesn't yet have a clearly defined audience that will advocate for it and show up on opening weekend.

Identifying a core audience may go beyond typical demographic profiles, as well. We also look at psychographic data such as religious and political beliefs, media consumption habits, and lifestyle choices that help us create a more robust and nuanced picture of who to target.

One of your most powerful contributions to the testing process is a section called "Moving Forward". How does this work with the marketing team?

JP: The "Moving Forward" section of a creative testing report helps give strategic and creative direction based on the findings from the research. It goes beyond simply regurgitating numbers pulled from the dataset or restating findings, and instead becomes a roadmap for how to make the existing advertising materials better, as well as suggesting entirely new approaches and directions based on findings from the research. Research and marketing teams at the studios partner with their research vendors to communicate this strategic roadmap to their internal creative executives. The creative executives then tweak the materials or create entirely new pieces based on our suggestions, before coming back to test the materials again to see if audiences respond more positively to them.

For young filmmakers who are just getting their first feature done and want the feedback but can't really afford NRG, is there any advice you have on how they can do their own "self-testing"? There are, of course, two parts to this question – the movie itself and then if they want to cut their own trailers, to see how they stack up as well.

JP: For testing the film itself: For young filmmakers who want feedback, but don't have the budget for traditional testing methods, a "friends-and-family" screening can be an effective tool. The key to success in such a situation is ensuring that you're inviting people who will give you their open and honest opinions about the film, despite their potential personal connections to the filmmakers. After viewing the film, request that all people in attendance fill out a comment card that asks questions such as rating (Excellent, Very Good, etc.), whether they'd recommend the film to others, which elements they liked/disliked, which scenes stood out to them, and other questions that could help them refine the film.

For testing marketing materials: For young filmmakers who want feedback, but don't have the budget for traditional testing methods, it's possible to run relatively low-cost tests on Facebook and other social media. Ideally, you'd need to create multiple pieces of advertising, then run each on Facebook or a similar platform to see which pieces received the best response, as measured by how many people watched the entire ad and how they otherwise engaged with it which provides some directional guidance regarding how to market and position your film.

TITLE TESTS

As we talked about earlier, the title of your movie is supremely important. Now is a good time to warn you that the studio or distributor may very likely change the title

of your movie. If it's called something that creates challenges for marketing, they'll likely push for something easier to sell.

It's a little controversial whether or not title tests actually work, but studios love to have data before they make big creative decisions. Sometimes a title test is as simple as giving moviegoers a description of the movie and a list of possible titles to pick from. Occasionally, the studio will mock-up posters or cut different trailers using the various titles and test them against each other.

The way this will impact you is if the studio lands on a higher testing title that they'd like to go forward with. It can be difficult to embrace a new title when you've lived with another one for so long on your project. But, know that there is usually some data and research behind these decisions.

TRACKING

It cannot be overstated how important tracking is to the movie business. This is a report that comes out three times a week (Mondays, Tuesdays and Thursdays) that polls nine hundred moviegoers nationwide about what movies they're aware of and interested in seeing. Any film getting a wide release (600 screens or more) will show up on the report starting three weeks from release. There are a number of research companies that offer tracking, but the gold standard has always been the report from NRG (National Research Group).

All of the major studios and distribution companies subscribe to the NRG tracking and read it ravenously each week. The agencies, production companies and individual filmmakers are not allowed to buy a tracking subscription; somehow they still get their hands on it each week, regardless. It's pretty much the report card for the upcoming films and it can cause jubilant Monday morning staff meetings or send the marketing department into crises mode trying to redirect the campaign in time for opening. The tracking companies use their reports to generate box office predictions that you might read about in *Variety* or the *Hollywood Reporter*.

So, the bottom line is: Buckle up. When your movie finally hits tracking it will probably lead to some of the most intense weeks of your life. We're going to give you a little primer here on how tracking works so you when everyone is talking about it, you'll know what they mean. There are four important measures on the tracking report, each with its own predictive quality.

- **Unaided awareness:** This measure tells us how many people are aware of your movie without any prompting. They are so aware of it that when asked what's coming out in theaters soon, they can type it into a blank box. Unaided is often referred to as the "top of mind" measurement because it tells us what films are on the forefront in attention for moviegoers. This is also the most predictive measure on tracking.
- **Total awareness:** This is the percentage of moviegoers that are aware of your movie either unprompted or prompted when they selected it from a list of possible titles. Remember, we've been saying all along that marketing campaigns

must always begin by building awareness. You have to let people know a movie is coming out before you can get them interested in it. This measure on tracking shows how well that endeavor is going.

- **Definite interest:** All of the people on the tracking survey that say they are aware of your movie are then asked how interested they are in seeing the movie in a theater. This is the percentage of aware audiences that are also expressing definite interest in seeing your film in a theater. You want this number to be robust and to see it grow over the course of the campaign. As we have also said, the second task of marketing is to generate interest and this measure is crucially important.
- **First Choice:** For this measure, the moviegoers are given a list of all titles on tracking and asked to pick which one would be their first choice to see in a theater. This measure is said to indicate "commitment." When a movie has strong first choice, even from one dedicated audience segment (like teen girls for *Pitch Perfect*), that bodes very well for the film.

EXIT POLLS

After the movie opens, studios and distributors will often want to know who came out to see the film and what they thought about it. This is especially important if the movie has any potential for a sequel or spinoff. Despite all of the advances in audience measurement technology, it remains incredibly difficult to get an absolute sense of who actually came out to see a movie.

The movie theater chains have data on ticket sales from their loyalty card programs, but they don't offer that up to studios. If you buy a movie ticket online, you can be tracked as the credit card you used is tied to information about your gender, age, income level, residence, etc. But again, this data is controlled by the website selling the tickets (Fandango, etc.) and the credit card companies themselves. Movie distributors know how much money they made and how many tickets they sold, but more granular detail on who exactly bought those tickets is still elusive. For now, there are a few ways of getting a sense of the audience, some have been around a long time and one is very new:

- **Cinemascore:** This company has been around since 1979 and they offer a service to studios where they collect demographic data about who attended the opening weekend and how much they liked it. Studios pay a yearly subscription fee for the service and to get access to historical data as well. Cinemascore hands out cards at movie theaters every Friday and asks people exiting the theater to indicate their gender, age and response to the film. This data is all collected and rolled up into the Cinemascore. If you read the industry trades (*Variety, Hollywood Reporter*) and blogs like Deadline.com you'll often see a line like this: "Opening weekend audiences skewed female at 58% of the audience and they liked the film, awarding an A– Cinemascore."
- **Kiosks:** Several research companies have partnered with theater chains to set up electronic kiosks in busy movie theaters. As people move through the lobby, they

are prompted to use the kiosk to fill out a brief survey about what move they came to see and who they are. In exchange they get a reward of some kind, like a discount on their next movie ticket. This method allows for a very robust sample of people across the country, but it also only measures people who took the time to stop at the kiosk and fill out the information – you're not getting everyone.

- **Face scanning**: A new technology is emerging now that mounts cameras on the entrance to the theater showing a film. As people walk out after the movie, the camera scans their faces and determines their gender, ethnicity and approximate age. This obviously raises strong questions about the ability of a computer to determine these attributes objectively and also the ethics of such a practice. Nonetheless, this technology is already used by large retailers and other companies to collect consumer data.

CASE STUDIES

The Tunnels

The first interaction with research on this title is the recruited audience screening while the movie is in post-production. Things aren't locked yet and the cast is available if any small reshoots are needed. The team in production calls the research department and tells them it's the right time to put the film in front of moviegoers and get their reaction.

The recruit is going to be very important on this movie because horror is such a specific and polarizing genre. The studio will want to make sure that the theater is full of horror fans so they assess the movie on its own merits instead of just rejecting the genre. The research team will write a recruiting paragraph that clearly indicates what kind of movie this is (horror aimed at teens). Furthermore, they will set the screening in a location where horror fans are more likely to be. Most research screenings happen in and around Los Angeles because executives and filmmakers prefer to be there in person. If they do screen out of town, popular spots are: Paramus, New Jersey, the suburbs of Las Vegas and Phoenix, Arizona.

The screening is all set and the research team gets a call from the research vendor who are recruiting the audience. They say the ratio is about 8:1 (eight invitations for every one accepted). While that might seem on the high side, research isn't worried. Horror fans are a smaller subset of moviegoers and finding them can take more invitations. Furthermore, there's no big stars in the movie and no advertising materials in the marketplace yet. However, the research vendor adds that the reason people are giving for passing on the invitation to screen the film is, "it doesn't feel like a theater movie." Now, this is a red flag. The claustrophobic, underground settings for the film have the potential to make the movie feel "small." Research makes a note of this as it will have to be addressed in the campaign.

The screening itself goes wonderfully with the audience engaged and screaming the whole time – which is a good thing in a horror movie preview, but only there! The studio also set up night vision cameras to film the audience as they watch the

movie. They will use this footage to measure out the scares and make adjustments in editing to maximize suspense. The footage might also be used in a TV spot to show moviegoers how much fun they will have in the film.

These are called "Audience Reaction" spots and they used to be incredibly popular with studios. However, they became a bit overused and audiences are more skeptical of them now.

The scores for the movie come in strong, but there is one very important finding. The cut that was screened that night would absolutely earn an R-rating from the MPAA. However, the strongest scores in the audience are coming from teen girls, followed by teen boys. The studio knows this is going to be a debate with filmmakers who would prefer to keep the film harder horror. But, there's no way the studio will leave that teen money on the table, so – spoiler – the studio is going to win this one in the end and the film will release as a pushing-the-envelope PG-13. By the way, this situation could have been avoided if the filmmakers had asked themselves early on who the most likely audience for the movie would be.

The post-mortem for the screening is jovial as most of the news was excellent. Research brings up the theatricality issue and the ratings discussion and then leaves the room to allow the development team and the filmmakers to hash it out. They decide that no reshoots are needed, they will make the appropriate cuts to get the PG-13 rating and screen one more time to make sure audiences are still on board.

As the movie finishes up, marketing starts to meet to figure out how they will sell this film. There are actually a number of rich elements in the concept that they could exploit – the filmmakers have done a great job giving marketing plenty to work with! Marketing decides they will do a concept test with horror fans to determine the best direction. They will cut three different trailers, each one selling the movie in a slightly different way:

- **Trailer one:** Will focus on the little boy and the terrifying ways that he has changed since emerging from the tunnels.
- **Trailer two:** Will tell the girl's story as she investigates the tunnels and uncovers the mystery of what happened down there.
- **Trailer three:** Will highlight the demonic worshipping history of the town and the lengths they will go to keep it hidden.

All three of these stories are part of the film, but marketing needs to know which one resonates with the most amount of people. The results come back and the winner is "trailer three demonic possession." It makes sense because this history and conspiracy makes the movie feel bigger and more theatrical. The campaign as a whole will now lean heavily into this angle.

International will follow suit as they know demonic themes tend to do very well in South America and Mexico – both extremely key for horror movies.

We're now about six months from release and the studio has started cutting versions of the demon worshipping trailer and testing them. They will do multiple

rounds of this, swapping in and out different scares to find the perfect cocktail of suspense, fear, plot and fun.

Once the trailer is released in theaters and online, the digital research team jumps into action. They create reports on how well it's doing by measure views, shares, retweets and comments. They will run these figures against similar movies to benchmark the performance. The feedback collected by the team will help inform the TV campaign.

Marketing wants to make sure they keep teen girls interested in the film, but they also want to get teen boys and older horror fans. They will cut different spots that dial up or down various elements in the film to appeal to different groups. For example, in the trailer test they learned that teen girls loved scenes with the lead girl and her boyfriend in the film. However, teen boys were less interested in that subplot. Spots will be created that either push that or hide it. When the TV spot scores come back from the research vendor, the media group will make sure those spots are seen by the ideal audience.

There is no discussion about title testing on this movie as everyone agrees *The Tunnels* is a great title. It's short, easy to remember, suggests horror and is tied directly to the content of the movie.

Three weeks out from release *The Tunnels* hits tracking. The numbers are soft and the filmmakers start to panic. How could this be? The movie screened brilliantly! Marketing gets on the phone to reassure them. First of all, tracking polls all moviegoers, not just horror fans. The screening, meanwhile, was filled with people inclined to love the genre. Second, horror movies often come on tracking softer and then spike in the end. It's a real nail-biting genre for filmmakers. Marketing reassures the filmmakers that the marketing campaign is "back-loaded." This means the marketing budget is smaller so the studio will be focusing most of the activity toward the week of release so they can make as much noise as possible. By the way, this is very common for horror movies and partly the reason they don't always come on tracking with huge numbers.

Because the movie plays so well, the publicity team has a robust screening plan. They're going to be holding free, word-of-mouth screenings on college campuses all over the country and banking on the fact that these moviegoers will tell their friends and get on social media to praise the film. It's always a gamble to do this because there's no guarantee that audiences will match the reaction of the research screening. But, in this case it works. The buzz around *The Tunnels* is getting huge and the tracking is moving up. The rest of the marketing department is incredibly busy during this time and in the coming chapters we'll show you everything they are up to in order to promote the movie globally.

Finally, its opening weekend. The exit polls come back on Saturday morning and reveal that the audience skewed toward teen girls and boys, just as the screening predicted. Good thing the studio pushed for that PG-13! Interestingly, audiences only give the movie a B– Cinemascore which rattles the filmmakers. They worry that without an A score, maybe the studio won't want to make a sequel. But Research

explains to them that exit polls tend to be lower on horror movies, a B– is actually not bad and won't be held against the film.

Philosophy of War

This movie is being released by a major studio with Academy Award aspirations. It has an A-list cast and a moderately sizeable budget. Research will begin by conducting a concept test to determine which genre to lean into for the movie. In actuality, this film is a melodrama, but marketing wants to confirm that's the way to go.

The concept test will present three scenarios:

- **Drama**: The strained family relationship of a soldier suffering from PTSD.
- **Thriller**: A soldier works to uncover the cause of a mysterious car accident that has threatened the lives of his family.
- **Action**: A soldier returning from war and struggling with wanting to go back to the battlefield or rehabilitate himself back into society.

The results come back definitively: Audiences prefer this movie sold as a drama but with some mystery and thriller elements. There are not enough action sequences in the film to convincingly sell the movie in that genre.

The research screening for this film will be held at an upscale arthouse cinema and geared toward a crowd that likes specialty films. Scores will be extremely important here as dramas like this live and die by reviews and audience response.

There is an early warning sign on the movie in that the recruit is a very difficult 15-to-1. Audiences are hesitant about a film that will be challenging and not necessarily "fun" to watch. Marketing will have to offset the challenging subject matter by highlighting the emotional journey, the performances and the themes of the film.

The research screening on this movie is a very interesting one – in fact, it's the screening we talked about in the very beginning of this book in the prologue chapter. The movie scores exceptionally well and the filmmakers and everyone in production are celebrating. However, Marketing are slumping in their seats because they can see this film is going to be extremely difficult to market. There's another warning sign in the scores for the movie: the "excellent" ratings for the film are very high, but the ratings for "definite recommend" are lower. People in the focus group praise the "important" story about war, but would only recommend to "some" of their friends. Filmmakers and marketing hear great numbers and a positive focus group.

Marketing, however, suspects the film is having a "halo effect." This means that people are scoring the movie highly not so much because they loved it, but because they feel compelled to praise the subject matter of the film. This is a tricky situation, because you can't tell from the scores alone what is happening and marketing needs to feel like they are on the same team as the rest of the filmmakers and executives at their studio. The pressure will be on for publicity on this film, as making this a success will deeply depend on the critical response and awards.

The creative team will be strategic with their spending on this title and they will cut and test only a few trailers and a handful of TV spots. The campaign will mostly focus on reviews and highlighting the dramatic performances. Testing for the trailers and spots is also done judiciously and the scores come back "at norm" but not above. Marketing's worries are confirmed as audiences are difficult to persuade to see this film in a theater.

The tracking, similarly starts out soft, but once award buzz starts to circulate around the film and the A-list cast agrees to do some appearances, the numbers improve and the studio is feeling better about the opening.

Finally, the movie opens and exit polling shows that audience was, as expected, older arthouse fans. However, marketing also managed to draw in some younger males due to their push toward military households.

K2TOG

Even once this film sells at festival to an indie distributor, the research budget for this movie is very low. There won't be any funds for a positioning test, but the distributor will pay for testing one trailer. They know this one piece of marketing content is immensely important on this film as there won't be very much budget for TV spots. The trailer test will seek to identify the best way to reach arthouse fans and also to expand the audience to include younger females and fans of arts and crafts.

The filmmakers are very attached to their title and Marketing knows it is a huge issue. They debate back and forth for some time before Marketing agrees to pay for a title test. They create a mock-up of the poster and test it to three different groups of moviegoers with three titles. One of them is the original, K2TOG. The title stands for *Knit Together* so this is also a title that is tested and it earns the highest response from audiences! The filmmakers are shown the results and the hard numbers and they relent and agree to this modified title. Marketing is relieved because this has removed one significant hurtle in the campaign.

This film is going to release as a platform release so it will not appear on tracking at first. This means that it will only open in a handful of theaters at first (New York and Los Angeles) and then expand a bit at a time over a period of weeks. The only movies that are on tracking are those with wide releases. However, once the platform release is successful and the film does expand wide, it will hit tracking. At this point, the filmmakers anxiously wait to hear how the film looks on the report. They will get an analysis from the research head at the distributor and their agents. The tracking looks solid and the audience is primarily older females. Younger females are soft, which means that marketing needs to do more to connect with them.

Finally, the film opens wide and it is a success. The Cinemascore shows that the audience was mainly older females and moviegoers really liked the movie, awarding it an "A" grade. The distributor will use this in their sustain campaign (money spent after opening to support the second and third weeks of release).

Sugar

There is no research budget for this self-marketed film but the filmmakers will be savvy and find ways to work with what they have. First, as they are moving through post-production (before the film is finished), they host a screening at a small, local theater and invite about 50 people who are not connected to the movie. The filmmakers create a questionnaire that asks the audience to answer questions about their reaction to the film. From this research they learn that one of their secondary characters is incredibly well liked in the film and audiences crave more. The filmmakers respond by adding more footage of this character to the final cut.

There will be no research budget for materials, but the filmmakers cut a trailer and post it on the website for their film. They use Google Analytics to measure the views and response. They also do a small test with Facebook to see how the response is to their ads on the platform.

This movie will never appear on tracking because it's a limited local release. The local opening is a great success and the filmmakers work with the local theater chain to create comment cards the audience can fill out on leaving. From this, they learn their audience was broader than just older, arthouse fans and they got a robust crowd of college students and young professionals. They use this data and the strong responses to the film to add to their sales packet when they seek wider distribution.

EXERCISES

1. Search the industry trades and blogs and collect five examples of exit polling reporting, Cinemascore, audience make-up or audience response.
2. For your own film, write three different positioning statements for the movie, highlighting different aspects of the story and poll friends, classmates and coworkers on their preferred version and why. Use the results to craft an ideal positioning statement for your film.
3. Write a questionnaire that you will use to poll audiences on your film when it is ready to screen.

NOTE

1 *NY Times*, With *Logan Lucky*, Soderbergh Hopes to Change Film's Business Model, July 31, 2017.

10

Creative Advertising – Print
The Campaign in Images

THE ANATOMY OF A PRINT CAMPAIGN

Strategic Positioning

The creative team puts enormous responsibility into strategic positioning. As we have seen earlier, advertising is about interest and if the campaign is not positioned properly then the messaging is off and there is a risk of alienating the core audience. To make matters worse, it is very difficult to course correct online, which is where materials live forever. When audience response to a trailer or poster is negative, you can never really "take it down," so you will try to replace it quickly; however, the offending piece of material will still hang around. This is why research testing is so important – to give the creative people the best chance of putting out the correct message.

Things that a creative marketing executive will consider as they determine positioning:

- Are there well-known stars or a director to highlight?
- Will the fans of these stars or the director go see the film on opening weekend?
- Is this the kind of film the audience associates with the stars who are in it?
- Is it an arthouse film driven by critics or a mass-market film?
- Does the title clearly communicate the essence of the film (*Snakes on a Plane*, *The Conjuring*)?
- What are the legal requirements in terms of cast, likeness, sequential billing, size of credits

Prepping for Production

The creative marketing executive working on your movie will hire an agency who will work to produce various looks that are the basis for potential advertising

campaigns. These ideas can be everything from pencil sketches featuring the cast and some key element from the movie, photo montage ideas to give an idea of the look, feel and genre of the campaign sourced from magazines, or even pieces of other campaign's websites and frame grabs stitched together. The main purpose of these early explorations is to look at every option, be able to narrow down a small number of directions which will then be worked on further, and make sure that the materials needed for execution are realized.

Production

On set, the unit photographer covers every scene in the film, but sometimes this is not enough to help marketing realize a particular look. Remember, the unit photographer is working with the publicity group to capture stills from the movie with the cast. These photographs have a very different purpose than photos the creative group might need in order to create a poster. In most cases, budget permitting, a special photographer is hired to do posed set-ups that also serve as the basis for a poster, teaser posters, the online campaign or for additional publicity. This shoot usually happens on the day the cast is not shooting and thousands of images are usually banked.

It is very important that these shoots happen during filming because the cast members are all in hair, make-up and costume. Many actors change their appearance radically between movies, so it's crucial to catch them here. If the cast is shot against green screen in various poses, they can be editing into any poster background or a still of one of the sets.

During this period, the creative team is looking through the unit photography for other ideas that work including mixing and matching unit photography and the staged photo shoot. Selects of up to hundreds of shots are made and circulated to talent and their agents for approval. Usually they can only disapprove 50 percent of what is offered. In many cases, the talent has a second option to approve the final photo used in the poster. This can take weeks to negotiate even if the shot has already been approved.

Many independent and self-marketed films end up using a still from the film for their poster image. This is generally cheaper and easier than creating something composited with Photoshop. Nonetheless, it's not a bad idea to get photographer friend to grab pictures of your cast in character, these images can have all sorts of helpful uses later.

Post-production

During the post-production period, the creative team is hard at work realizing a number of advertising **comps** that they get ready for presentation. Comps means composites and these are rough versions of the poster ideas that will be presented to the President of Marketing.

The marketing team will first create what is called a "teaser" poster. The teaser poster ideas might be character looks, high concept art or design, etc. They will roll

out into the marketplace up to one year before opening and they are meant to simply tease the tone of the film and announce the title. They do not necessarily have to incorporate the cast likenesses or give much information about the film.

Here are some excellent examples of teaser posters that merely teased the idea of a movie (and the key elements) without too much information.

- *Django Unchained*: This poster is created in a vintage style (reminiscent of Tarantino's films) and doesn't even include the movie title. A graphic suggests, "unchained." The copy says simply – "The new film by Quentin Tarantino." This is enough to tease fans.
- *The Dark Knight*: The classic line from The Joker says it all and simultaneously sets up the tone of the movie.
- *Star Trek: Into Darkness*: This poster simply shows the villain standing over the wreckage of a city. The outline in the building is the iconic *Star Trek* logo. This poster referenced the brand in a subtle and organic way.

The Presentation

Once a broad range of poster comps are produced, the dialogue begins between the creative execs, their bosses who run the studio, the producers and director and last, but certainly not least, the cast and their agents and handlers. This process could include creating hundreds and hundreds of looks, some of them radically different from each other, others simply a different type face or repositioning of logo. It can be a significant challenge to settle on a final poster look, because you are trying to please so many different people with different agendas while also attempting to preserve some version of artistic integrity and originality. Often, the studios might hire three to four separate companies to work on the posters and trailers and digital content. Once a poster is decided upon it is broken down and disseminated through all the marketing outlets – digital, publicity, outdoor, in theater, social, etc.

The Image

Take a look through some movie posters for your favorite films, particularly films in the same genre as yours. This poster, called "the one sheet" by marketing is a 27×41 static image and, at its best, it gives you a comprehensive message of the film. As we said, the marketing department has likely hired an agency to create that poster, selected it from several hundred possible concepts and revised it in great detail. They settled on this one final image to represent the film. Even if you knew nothing about the movie, a strong poster will tell you everything: The genre, the idea of the movie and the tone. A few things to look for:

- **Key image:** The posters will likely have a key image that conveys the entire idea of the film. In one picture, this poster will visually represent the logline and hook of the film.

- **Color palette:** The palette will tell audiences what kind of movie it is.
- **The title treatment:** The size, choice of fonts or letters, and the design of the title treatment will enhance the messaging of the central image and color palette.

INTERNATIONAL POSTERS

This will vary depending on the size of the movie and the studio distributing it. But for a larger tentpole, the international marketing team at a studio will create their own set of posters for the global markets. They will usually maintain the same color palette and tone of the domestic print look but will dial up or down certain aspects. For example, if there is an actress in the movie that is more popular abroad, she will be featured more prominently. The individual markets may want a more action-driven sell or some markets may want to dial up the love story. Generally, a range of posters are produced and the international markets can give notes, conduct research and weigh on which will work best for them.

For some markets, print is exceptionally important. In France, for example, US studios cannot buy television ads to promote their films so print and outdoor is the primary means of advertising the film in that country. In the UK with their incredibly populated underground train line, print ads in the tube stations are an extraordinarily important way to reach consumers.

Let's look at some posters from well-known films and break down how the studios that made them successfully conveyed genre, tone and idea:

The Conjuring poster tells us so much with its one simple image. Dark clouds gather over an isolated house; there is no one around for miles and miles. An otherworldly mist floats across the ground. A dead tree in the foreground holds a noose. If you look closely, you will see the shadow of a woman hanging from the noose on the ground. This suggests something supernatural is afoot. The color palette is muted and tinted sepia, like an old photograph. This hints that the movie takes place in the past. From this one image we get all of the following: This is a period horror movie and it's about a haunted house with a violent history.

The poster for *Taken* similarly communicates the essence of its film. It features a serious Liam Neeson, partially shrouded in the shadows. He wears a suit, which indicates that he's a professional and he holds a gun, which tells us what his profession might be. The text over the picture is an excerpt from the famous speech that kicks off the film "I will find you and I will kill you." This poster images tells us that this is a serious action film, with a seriously formidable and professional hero who is going to rescue his daughter and punish her kidnappers.

Ted is a raucous comedy with a high-concept hook about a teddy bear that comes to life as a foul-mouthed, best friend to Mark Wahlberg's character. The poster image illustrates exactly that. The colors are light and bright, suggesting fun. The bromance of the two main characters is obvious and the incongruity of a teddy bear holding a beer is immediately funny and irreverent – clearly conveying genre.

The poster for the original *Harry Potter* film is very different from the other examples, but also neatly conveys the idea of the film. It shows a large cast of

characters, some human, some animal and some magical. The fantastical Hogwarts looms in the background and we can see Quidditch players on their brooms in the upper corner. The blue and golden colors suggest good versus evil and a fantasy tone. The poster has a special quality in that it looks like a drawing rather than a picture, which evokes the *Harry Potter* book covers. The young cast featured in the foreground tell us this is for families and adults. This poster suggests an invitation to an entire magical world and that is exactly the promise of the movie.

Meanwhile, *Bridge of Spies* is a serious, star-driven drama and this poster image sums that up succinctly. We see a serious and conflicted Tom Hanks in the center of two flags, the United States and Russia. We can tell this will be a movie about conflict between those nations with Hanks' character in the middle. He's in black and white, which tells us that this is a period piece. Hank's expression makes it very clear that this a drama with high personal stakes for the hero.

Wedding Crashers, one of the first ultra-successful "R" rated comedies, conveys a very clear message of humor with the body poses of Vince Vaughn and Owen Wilson. This is further enhanced by the title treatment, which uses big and clean letters the bold colors – red and white – which are all classic comedic visual signposts. Of course the title is a perfect description of the movie's main characters and the copy line further enhances the experience of seeing this movie.

The Fault in Our Stars campaign has a title treatment that is identical to the font of the best-selling book title so the thread from novel to movie is maintained. Adding the two young stars further enhances the romantic sell and the overhead photo and unique placement give the film a different look quite different than the traditional love story. And the title itself is a terrific in that it speaks to the larger issues of the story. This is arguably one of the best campaigns in the past decade.

The Notebook, a romantic drama that goes back almost 15 years still deserves a place here for its super-sexy look where the stars are not really featured as personalities rather than simply involved in their passionate kiss. This movie launched the careers of Ryan Gosling and Rachel McAdams, and was one of the movies that started the teen young adult series of movies, which went on to include *Twilight* and countless others. The letter font shows its own distinct personality through the elegant treatment. The film is also based on a well-known book by Nicolas Sparks whose credits include 11 films based on his writings.

To summarize then, here are how different genres are usually defined through their posters:

- Comedy – one or two word titles, very descriptive, big, bold title treatments and simple primary colors like red, white and black. Also, these posters are inherently funny. They either feature a visual gag or their comedic stars posing in a funny way. If a comedy movie poster doesn't make you smile or laugh, it's not working.
- Romance – usually a more unique title treatment, the cast is prominently featured, but the look is clean and focused. Generally suggests passion or the promise of love. Frequently softer colors, idyllic settings and some form of physical contact between the leads.

- Drama – design elements are key here. Colors are either darker and more muted or stark and contrasting. Cast prominence is important as well since this is usually one of the key selling elements for the genre.
- Horror/suspense – small scary elements in a bigger canvas, foreboding sense of fear, broken up or fractured title treatments, dark colors and many times monochromatic.
- Tentpole adventure – usually very busy as there is a lot to sell here and promise. Grandiose title treatments.
- Animated – bright and colorful, characters usually featured in a key sequence from the film that is played out in the trailers, TV and online spots. Has to appeal to two audiences simultaneously – children and parents – so clean bold lines usually backed by some smart copylines. Heavily supported by outdoor billboard campaigns.

There is also a sort of "indie" look. Like the movies these posters represent, they have greater artistic and design flair. Many times these films do not have a major star and with movies that lack star potential the best way to give a sense of story is through an icon, a landscape or some interesting play with the characters.

Sideways: A striking green background with a simple graphic featuring two men trapped in a wine bottle. This succinctly captures this gist of the movie.

Moonlight: This movie tells the story of one man at three different stages in his life. Similarly, the poster creates one face from the three different actors and colors the slices in moonlight tones. There is a suggestion of broken glass, which conveys the drama in the film.

Fargo: Very cleverly uses a cross stitch motif to display a violent murder. This speaks to the movie's intersection of small town Midwestern culture and murder. The tone is black comedy on this print and that aligns with the film.

Little Miss Sunshine: The yellow poster suggests "sunshine" and references the yellow bus. We see a family holding hands and rushing to the vehicle, which hints at the plot of the movie. The negative space in the poster is used for critical accolades and awards.

12 Years a Slave: This poster places all copy and billing inside of the silhouette of the lead actor running. The background is intentionally a stark white as this places all focus on the actor. The title treatment mixes a historical script with more modern letters.

LIVING ONE SHEETS

Another now very common practice is to take the finished poster for a film and to animate some portion of it so it moves. A flock of birds may fly through and reveal the title or the characters on the poster might move and turn toward the viewer. These very short, about ten-second, gifs are called "living one sheets" and they are used to further increase the reach of the poster when it is launched online.

THE IMPORTANCE OF TITLES (AND WHAT HAPPENS WHEN MARKETING WANTS TO CHANGE IT!)

As we have seen earlier, the most important function a title can have is to establish a relationship with your audience. Most of the time the marketing department, having lived with your title through the greenlight and production process, is good with it.

However, there may come a time where the marketing department feels a change of title is important – either the original one is misleading, too generic, based on a lengthy book title that was not a best seller, or just too quirky. These discussions can happen on both the studio and independent level and they do not always net out with a satisfactory conclusion. Further, you, as the filmmaker and originator of the existing title, are very tied to it having lived with it for a long period of time.

When a marketing department does decide to explore a title change, they may order up hundreds of different titles from a vendor. The top tier of these titles is usually tested through a title test as we discussed in the research chapter. Nonetheless, as a participant in the Marketing department, you should not fight this process too hard as it may very well turn up with a title that even you can embrace.

We can conclude this chapter with a short interview with Brad Johnson, who with his business partner, Ethan Archer, has spent his entire career creating key art for the entertainment industry. They partnered in 2007 to start ARSONAL, a collaborative agency of people that share their passion for design and advertising. ARSONAL primarily focuses on print and digital solutions for studios, networks and brands.

ARSONAL has been behind some of the most eye-catching campaigns in their field, and they have been recognized as a leader in entertainment advertising with clients that include, 20th Century Fox, A&E, ABC, Amazon, Bravo, Cinemax, Fandango, Focus Features, Fox, FX Networks, HBO, History Channel, Hulu, IFC, Nat Geo, NBC, Netflix, Showtime, Sony, Starz, TBS, The CW, TNT, TruTV, Universal and Warner Bros.

Is the poster still the most important element for a movie campaign?

Brad Johnson: I think that depends on the campaign. Certain times a poster can't do all the story-telling that a film needs to get sold and the poster is used more as an influencer that makes audiences want to get more engaged and learn more about the movie through the trailer, social media, etc. The poster is important though because it is the piece of creative that lives on after the initial campaign and typically becomes the identity of the film.

Has the digital universe impacted how you approach a campaign for a movie?

BJ: In developing key art our approach stays pretty consistent unless we're specifically asked for a 360 campaign that covers digital.

Digital does allow for more of the art we create to be seen since clients sometimes use alternative pieces for their digital and social campaigns.

We have found that sometimes producers and directors obsess way more over the one sheet than they do over a trailer. Why do you think that is?

BJ: When you live with a film for as long as producers and directors do, the obsession comes when you believe in the product and the key art usually becomes the identity of the movie. For producers and directors, they want a piece that they're proud of because they will be seeing it for the life of that film and beyond.

Since a poster elicits a very personal response from the viewer, do you think that testing posters is really effective in the same way a trailer is tested?

BJ: Having never been involved in the process of testing, I can't definitively comment on its effectiveness. However, I will say that the posters we get the most positive reaction from people on are usually the ones where the client went with their gut on what worked.

When you approach a campaign what are the key elements you feel it should have in terms of representing the movie? Positioning? Target audience? Cast? Design? Graphics? Color palette?

BJ: Our primary goal has always been to create a piece that will illicit an immediate emotion or response. If we can't do that, then none of the other stuff matters.

Do you usually get a lot of direction from the studios, or do they allow you to come up with your own visions? Is it any different with some of the independents you have worked with?

BJ: Regardless of whether it's a studio or an independent, every client is different. Some allow us to just go off and do what we do with very little direction, while others are extensive in their initial brief. We are very open to whatever approach works for the client because in the end we're always going to deliver the vision that the client has in addition to alternatives that we feel are right for the project.

While the amount of content that is being created now has opened many doors of opportunity for your company, do you find the pressure to stand out or be more original is even greater?

BJ: The pressure to stand out has been and will always be a part of this job. It's what drives us.

11

Creative Advertising – Audio Visual

The Campaign in Video

The general moviegoer's opinion is that studios such as Warner Brothers, Disney and Paramount have their own in-house teams who create trailers from start to finish – but, in fact, there's an entire network of vendors, developers, and post production houses that all contribute to the creation and distribution of motion picture advertising.

For this section we were very fortunate to secure interviews with the heads of two of the most innovative and creative trailer-making companies currently working in the entertainment business: David Schneiderman from Seismic Productions, and Mark Woollen from Mark Woollen and Associates. Between the two of them, they handle the full gamut of movies from mainstream commercial comedies to the most auteur driven art films.

David works with both major and independent studios on movies of all genres – comedies, dramas, action-adventures, and animation. He has run his own trailer company, Seismic Productions, for over 28 years, and continues to offer each and every client his undivided personal attention. Seismic has staked a claim in the industry with campaigns such as *Fargo, Four Weddings and a Funeral, Brokeback Mountain* and *Les Misérables,* as well as more recent campaigns like *La La Land, Beauty and the Beast, Hotel Transylvania 3, Crazy Rich Asians* and almost every Will Ferrell, Tyler Perry and Kevin Hart movie ever made.

Mark is the go-to vendor for unique and specialized directors usually working at the top of their game. He tends to be attracted to those movies that come out in the Fall rather than the summer (Oscar movies vs. Popcorn flicks). His respect for the creative input from directors is legendary and many of them request his services time and time again.

TRAILER COMPANY WORKFLOW

Before we get into the conversation with David and Mark however, Karla Ravandi, Seismic's senior producer, gave us a look at the Seismic Productions workflow below.

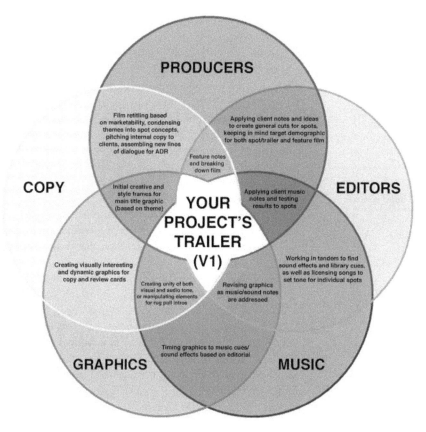

(Chart courtesy of Seismic Productions © 2018)

The most important thing to understand here is how each department contributes to the creation of a trailer and that they overlap each other in function and time. The elements are:

- **Producers:** Lead in-house creative efforts on specific projects and shepherd them from the first meeting with the client to the final finish.
- **Copywriters:** Work on the messages inherent to the movie to distill the story into multiple narrative cards or voiceover narration that becomes the framework for editing.
- **Editors:** Analyze films, then piece together scenes, dialogue, and individual shots, while integrating copy, music, and graphics, and adhering to client notes to create trailers and television spots.
- **Music:** Work in tandem with the editors to find the appropriate licensed artists, songs, or original music that sets the tone for the trailers and TV spots.

- **Graphics:** Create dynamic fonts and visual styles for the main title and cards that enhance the look of the trailer.

What makes a trailer great?

David Schneiderman:	I'm always excited when I get a call from a client asking us to cut a trailer. I love all films and, just because a film isn't amazing, doesn't mean we can't make a great trailer. Trailers require several important elements to be considered great – music, graphics, pacing and, of course, story. Trailers need to have a compelling story and, if the film doesn't provide it, we have to make one.
Mark Woollen:	We work with a lot of original voices so the trailers that we are making have to reflect that as much as possible. It would not make any sense to take their movie and put it into a conventional box and it is important that they recognize that.

One of the challenges sometimes is we are dealing with directors who are at the top of their game and you have to really break the code of the film and understand what they are doing. We try to take the movie apart, try to understand what creates this feeling – I call it a film autopsy – and what are the moments through dialogue, images, sound and music that they were able to create the feeling of the film. I have to understand that and be able to take it apart and reposition it in a way and harness that feeling in a shorter form. We spend a lot of time dissecting the film bit by bit, beat by beat, how it is constructed and then how can we deconstruct it and put it back together again in shorter form, in two minutes.

THE CREATIVE AV PROCESS

Scripts

The process leading up to production process involves a wide variety of approaches to telling the story. Usually the vendor who is hired specializes in audio visual advertising which includes trailer, teaser trailer, and web content.

Most agencies come up with scripts that give a good sense of how a teaser or trailer might be cut together. When a trailer is mapped out using lines and moments from the script, this is often referred to as a "paper cut." Sometimes, the trailer houses will also create storyboards to begin envisioning the trailer before the footage is available. These storyboards also act as good explorations for a special shoot teaser trailer. These scripts are then presented to the creative marketing team and a lively dialogue ensues hopefully resulting in specific directions to be shot.

The Production Rough Cut

One of the trickiest issues for the creative team is to be able to see the film as it is being cut together before the director signs off which is usually at the end of the editorial process. You can imagine how difficult this would be to create materials if you had to start so late – i.e. 10 to 15 weeks after completion of principal photography. What most agencies will do, in consort with the creative advertising exec, is take what they consider the best take from each scene and "cold cut" a version of the film based on the shooting script. This, of course, will not be the final version of the film, but at least it allows for a narrative to be built from which to cut ideas. The heads of the studio and even the head of marketing will be none the wiser, or at least not be allowed to screen this version lest it taint their opinion about the final director's cut.

This is also the time when any special shoots should happen – usually the execution of a unique teaser idea with the cast or involving the sets, or grabbing any lines of dialogue that would help propel the story in a two minute trailer.

The Exploration

Your marketing department will sit with outside trailer agencies and discuss and explore the many different directions an advertising campaign can take. These would include:

1. How to tell the story. Every movie has a direct narrative but sometimes the movie story is different than the trailer story. The scenes may be inserted at different points than where they would sit in the movie's timeline, and certainly lines of dialogue are used wherever they propel the narrative
2. Through whose eyes should we tell the story: The protagonist, the antagonist, or a secondary party witnessing the events unfold?
3. Is the story, the cast or the special effects the most important element? Different genres demand different story telling elements.
4. The role of the teaser trailer in setting up the story – usually the first piece of content released online and obviously the most important as it sets the tone for whatever content comes after it. What to focus on? The cast? A story beat that will stand out and will set the tone for what is to come?
5. The plan for the final trailers – #1 and #2. With all the media outlets available now, there can never be enough content. The only problem is that content travels, is shared fast and can dissipate quickly, so new content has to keep coming to keep the interest levels up. The agencies are tasked to not only deliver on the first impression, but to make sure the second, third, and fourth impressions are as good if not better to continue to amp up the anticipation. This can unveil itself over a one year period in the case of big tentpole movies, and even with the independent releases, releasing content can happen as early as six months out.

Creative marketing is a problem-solving industry. The amount of cut-around-editing, additional dialogue recording, and other tricks of the trade that go into cutting the trailer for your film can be staggering — and sometimes are easily prevented by your actions on set and the pre-production work from your team.

A few examples of some common problems and solutions can be found in the chart below – but there are often other ways of achieving solutions, such as reshoots, additional shoots from content, or additional talent recording. This is how Seismic approaches some problems:

Problem	Creative Solution	How You Can Help
We've got a great line we want to use, but it contains profanity	Cheat the line (if possible) through ADR sound-alikes or other instances of similar dialogue in the film	Shoot safe takes on set of comedic/dramatic moments with clean language
We need establishing shots of the locations of your film to establish locations in our TV spots	Source stock footage of similar locations, which are usually not 100 percent accurate or true to your film's visual language	Shoot multiple-angle coverage of establishing shots for major scene locations.
Need shot of a character for a cut, but dialogue is unusable/line necessary for the shot isn't said	Cut the shot entirely or use dailies that were left on the cutting room floor	Get coverage of actors not talking/wider shots of actors within a scene
The most common issue: we're lacking a line of dialogue or two that concisely sum up the premise of your film	Chop up lines and scenes to cheat the premise film in a few sentences	Shoot summed up version/ elevator pitch dialogue — even if it's cut from the film, marketing can use it to help sell

Courtesy: Seismic Productions © 2018

HOW SCREENWRITERS CAN CONTRIBUTE TO THE TRAILER PROCESS

So, when you read a script I'm sure you have your highlighter and you circle a moment in the script. I know it's very subjective, and varies by script but is there anything you can say to screenwriting students, when they are looking through their own screenplay, to look for what makes that trailer moment?

David Schneiderman: Dear screenwriters, please write at least one line that has impact. That's so critical when you're selling a drama. For

example, in *The Last of the Mohicans*, Daniel Day-Lewis' character famously declares: "You stay alive … you survive … you stay alive no matter what occurs. I will find you no matter how long it takes, no matter how far … I will find you!"

You want a moment in which your protagonist, your hero, is saying something noble or powerful, or where he or she is feeling some kind of conflicted emotion.

For a comedy, obviously, you want the screenwriter to write a hilarious joke or create a situation that's really funny. When I meet a comedy screenwriter, I always suggest that they give their lead characters the punch line. You'd be surprised how many times screenwriters will give the joke to a supporting character. And for trailers, we really need to keep the stars of the film front and center.

Mark Woollen: In terms of the trailer-making process, we have been fortunate enough to work on a number of Charlie Kaufman films and he does something that is extremely brilliant with the fascinating worlds he creates but one of the things I am always thankful for, as a trailer maker, is that there is always a moment in the film where the main character explains what is happening – whether it is John Malkovich in *Being John Malkovich* who explains – "there is a door in my office and it leads you right into John Malkovich's brain" – Perfect Trailer Line! I could have spent minutes and multiple lines of dialogue trying to figure out how to convey this point. The same thing with *Eternal Sunshine of the Spotless Mind*: "There is a machine that erases memories of past relationships." Whenever there are clear lines of exposition, they are a trailer maker's dream.

THE EXECUTION BY GENRE

Once the story directions are settled on, your advertising agency will create a number of versions of the trailer with different emphasis on the narrative, the stylistics and the cast. And each type of trailer has a unique style to appeal to its core audience:

- Horror: Fast cutting, strong sound design, antagonist reigns.
- Dramatic: Extended scenes, focus on performances, story is key.
- Romantic: The initial romantic meeting/set-up, the risk to the relationship, and get out – important not to give too much away in this genre
- Tentpole: Big scope shots, heroic setup, cliffhanger, incredible, action packed montage to close.
- Independent: Many choices here – mood, character relationships, quirky situations emphasized, tone.

- Comedy: Highlight the talent, the one line jokes that can be shared socially, the story exists only to insert the right jokes and of course, the comedic button (the joke at the end of the trailer).

COMEDY PRESENTS ITS OWN SET OF CHALLENGES

David Schneiderman: It's really hard to be funny, and it's really hard to sustain the funny. We create so many versions of trailers and TV spots when we're working on a campaign, and we present all of those versions to our clients (the studio marketing executives). There's a sort of ennui that sets in when you see the same joke over and over again in a presentation, and invariably our clients will say, "I don't think this is funny anymore." Of course, in reality, it's going to be funny to people who are seeing the trailer for the first time. But that's not always going to fly with the executive who will press us to find new ways to cut the same joke. That's when we go to outtakes, which we find when we comb through the dailies. Outtakes can be the reason someone will have seen a trailer and liked a particular scene, line, or joke, and then discover it's not in the movie they see in the theater. Ironically, when I tell people I make trailers that's the chief complaint I get – second only to, "Why do you have to tell me the whole story?!"

ADDING THE MAGIC

Voice Over and Narration

A tried and true method used in the structure of trailers and television spots is the use of voice over, or narration, as a means of setting up a storyline given the short parameters of time. A lot can be told with a few lines and/or with some carefully placed story cards cut in between scenes. Both of these methods help propel the key narrative moments in the trailer.

More recently, the use of voice over and narration has fallen out of favor in the past few years. What has replaced it is a greater focus on dialogue lines that are written for and recorded by the main characters, even if they don't exist in the actual film. In many cases, the vendors working on the content will actually write these lines knowing how they want to tell the story.

Marketing will then work with the production to either have the talent record them during principal photography or at a later point after the spots have been cut. The whole idea here is to create a more seamless way of setting up and telling the story of the film the words coming out of the mouths of the characters rather than a disembodied voice. It is also another instance of how marketing works with filmmakers to create the most effective advertising materials possible.

Watch trailers closely; if you hear a line of dialogue from a character that is delivered when their back is facing the camera or their face is hidden, chances are that is an ADR line recorded long after the principal photography was complete. Likely, this extra line was needed to clarify a story point, express the title of the film or succinctly explain the concept of the movie. If the actors are not available for recording, studios will sometimes record sound-alikes who can seamlessly mimic the voices of famous actors.

If a production company is working with a studio and somebody from marketing calls them to say "we need this stuff for the campaign – the trailer company has put together a piece and they really need these lines" – can you talk about why it's really important to cooperate?

David Schneiderman: I think filmmakers should trust the people who work in marketing and view them as partners. Making trailers and TV spots is all we do and we have years and years of experience. Do you tell a seamstress or suit maker how to sew? Filmmakers are so creative and know their movie intimately, but can often get stuck on a certain notion or idea, which makes them become very myopic. A successful marketing executive or creative director can help a filmmaker think beyond their film. If we do our jobs right, we can help the film reach as broad an audience as possible. But it's also important to engage a research firm to help strategize and test whether what we're doing with any particular trailer or spot is attracting or polarizing potential audience members.

THE MUSIC SOLUTION

The role of music cannot be overemphasized in terms of how it impacts short form works in multiple ways (remember trailers are two minutes and TV spots are just 60, 30 or 15 seconds long). Music defines emotion, genre, sets up expectations, and generally serves as the heartbeat of the trailer.

As filmmakers, you know and value the importance of music in your movies. On the creative advertising side, there is perhaps nothing that has such as profound impact on a trailer or piece of short form content than a music cue. There are scores of companies with massive libraries available to the vendors who cut these spots in addition to most of them having their own in-house music coordinators. The job of staying abreast of the latest music and finding unique compositions that help propel the story or set the mood is a full time gig.

Mark Woollen: Music is 70 percent of the process. We look for that one piece of music that really conveys the tone and drives the trailer. Trailers are really about rhythm and a piece of music can really drive the rhythm and can really be a great guide for us.

137

Trailers also tend to be an emotional experience, or at least with the kind of work that we do and it's about trying to find that piece of music that can really help underscore the emotion and drive things forward. Of course, there is the main issue of story telling but the music really inspires us.

Why do so many trailers have popular songs in them and what added value does that bring to the marketing campaign?

MW: There is value in placing songs in trailers that have a sense of familiarity and using music that is inherently popular and sometimes reworking that song or juxtaposing it in a different way.

People have a connection with a recognizable track that helps the trailer seem inviting. Music also serves to bring a sense of familiarity when a music cue is used that is known by some or all of the audience.

Any advice for graduating students who are interested in the creative advertising field or filmmakers?

David Schneiderman: Well, I always tell everybody to become an editor. I swear it is like the greatest field ever. Think about it, you could do editing for television, you could do editing for commercials, you could do editing for movies, you could do editing for trailers and promos … if you can cut, you can cut your own film. I just think it's great. I feel like a lot of kids are just loading up the software on their computers and they're cutting. My kids are cutting. My kids did a little outtake reel, they did a little movie and they did an outtake reel. I couldn't believe it. Now they happen to have a father that is in this business but I see this all the time and I find these great kids that come out of school and they are editing already. So I recommend learning how to edit because that is a skill, like you're learning how to build a house or you're learning a craft. I remember one of my mentors said to me, "if you edit, what you do is a skill that people will always pay you for. You can always make money."

SPECIALIZED CONTENT

The multitude of ethnicities and religious affiliations in the US create opportunities for movies to be produced and targeted to specific audiences outside of the mainstream. The Latinx, faith based, Africa American, Indian and other religious or cultural audiences all tend to over deliver at the box office based on their movie-going attendance as a percentage of the overall audience.

BEHIND THE SCENES

These are short form pieces that highlight the filmmaking process and are usually a compendium of interviews with the talent and filmmakers with video footage of the production process. This can also include pieces on the post-production, musical performances or editorial process as well.

PODCASTS AND RADIO SPOTS – THE NEW AUDIO

Radio spots are an excellent way to reach audiences and drive up awareness. They are particularly effective during holiday weekends when people tend to have the radio on during road trips or BBQs. Plus, with the ever growing popularity of podcasting, the audio track is very much back in favor.

INTERNATIONAL TRAILERS AND TV SPOTS

Similar to the print campaign, the audio visual (AV) materials for a movie will need to be localized and tailored for the different international markets. Each country has their own restrictions on content that can air in theaters or on television.

Additionally, the lines of dialogue, themes, tone and music that work domestically may fall flat in other territories. The international marketing team will work to create content that connects with global audiences outside of the United States. Generally, the domestic and international campaigns are in synch as content easily travels globally once you place it online. But sometimes, distinctly different pieces are cut for marketing abroad.

Each piece of international AV marketing will also need to be "subbed or dubbed" (subtitled or dubbed with actors in the local language). This process requires a huge amount of coordination with the foreign markets and extra time. There are actors in each country that typically "play" the roles of the major US stars and audiences are used to that voice accompanying that actor and these well-known local actors then become the stars of the film.

If there is a signature song in the movie, marketing may also opt to re-record it in major territories with a musical star from that country and in the local language. They will then use this across the campaign in that country.

THE MOTION PICTURE ASSOCIATION OF AMERICAN CODE AND RATING ADMINISTRATION

CARA is the branch of the MPAA that addresses content and gives your movie both its rating and decides whether the advertising materials can be shown to all audiences or more specific ones, such as R-rated films only. The studios are all members of the MPAA who agree to abide by CARA's decisions, as are most of the independents. While it is not necessary to be a member to have your film and advertising materials "rated," all of the exhibitors look to these ratings to decide when, where and even if, they should play your movie.

The procedure for getting the proper rating is sometimes an arduous one. Many of the suggestions from CARA may seem arbitrary particularly when it comes to rendering decisions on sexual content versus violence. We all know which gets away with more.

Each and every TV spot that is created will be vetted by the MPAA and either approved or sent back with notes and restrictions. Certain spots are not allowed to air in "prime time" when children may be watching.

Nonetheless, CARA is an important influencer in the creative advertising world and while some consider it a necessary evil, it has to be dealt with both respectfully and firmly. It is an ongoing dance between the studios trying to push the envelope as far as they can and the MPAA pushing back and restricting the content in the commercials and trailers.

And a special note: *everything* created must be run through them including posters and web sites.

CASE STUDIES

Philosophy of War

Print

This movie lends itself to a lot of exploration and design but given the star quotient, you can rest assured that the final poster will be a version with all the key talent in some grouping. While this can be a predictable and over-used look, a really good design person can still make it stand out.

There will also be a teaser poster that will serve to establish the look of the film and while this may very well be a symbolic graphic – probably a military one – it should serve as a haunting setup for the movie. Given the importance of this movie, there may be multiple posters each featuring a character of the movie as there are always plenty of places to situate these in the digital universe. Further, the amount of special interest websites that may be interested in this film will be a great repository for themed different looks.

The final (payoff) poster will prominently feature reviews and critical acclaim for the film as this will be a major driver of interest. The film will also garner one exceptionally positive review from a major publication and marketing will blow up that review to poster size for display at art house cinemas domestically. The international poster will significantly downplay the American military aspect of the film and instead will highlight the family dynamics. Posters in each major territory will feature reviews by well-respected critics in that country.

AV

The best version of the trailer will convey the following: Star driven. Important. Relevant. Emotional.

What will be hard for the trailer to impart will be a sense of entertainment, which is what most audiences want when they go to the movies. Assuming the film had a few high profile screenings at the fall festivals like Toronto and New York, the trailer vendors will be able to build a visual campaign based on reviews, graphics and story.

The positioning test we discussed earlier found that the best sell for the movie focuses on the drama but does have some thriller/mystery elements surrounding the car crash that will build intrigue. The trailer will be cut to highlight the cast performances and key dramatic scenes and it will also pose some questions to the audience such as, "what actually happened with this car crash?" and "will this family be able to pull through this extraordinarily difficult time and make it together?" The price of admission is coming to find out what happens.

TV Spots

Since this is a very high profile movie geared to a 35+ audience, television advertising will still have a prominent place in the marketing spend. We will cut probably five differently themed spots: a trailer cutdown, a review driven high impact "big picture" look, a spot for males that will focus on the war experiences, a "family" spot that will focus on the soldier's inner battles and how he tries to relate to his family, and a female spot where we see the story unfold from the wife's point of view.

Internationally, in line with the print campaign, the military element will be more background to the family drama. Here the thriller and mystery levers will be dialed up even further to try to push the theatricality of the film. However, the A-list stars and the major director in this movie both have what is called "creative review" privileges. This means that they have the right to view the materials before they are finalized and to okay them. The trailer that international marketing wants gets a "no" from the actors because they don't feel it conveys the film accurately. Despite research and some attempts to negotiate from marketing, the cast will get their way on this and a compromise trailer will be cut that plays up the drama more and highlights the credits of the stars and director. In the end, it's going to make the film a harder sell in certain territories and marketing quietly lowers their box office estimates in some territories and pulls marketing budget back. This is a prime example (and an incredibly common one) of when filmmaker interference in the campaign can hurt the film. Yes, audiences will be well prepared for the film they are showing up for … but the problem is getting them to show up in the first place!

The Tunnels

Print

As we have seen, movies like *The Tunnels* are best visualized as a single image – either a possessed child, a faint image of the evil in the film or a graphic representation of the tunnels underneath the town.

There are many versions of this look, and one that would show both the older sister in a protective hold with her younger brother as if they are facing something evil could work as well. Colors would be blues, dark, shadows and beams of light illuminating our subjects. Depending on the extent of the distribution commitment, a teaser poster introducing the evil part of the film could work as well.

This genre is not cast driven, it's much more about succinctly conveying the horror and the promise of the premise. Marketing will likely use a still from the movie for the poster that features the characters at their most desperately frightened. There is little need for a special shoot on this poster with the cast as that would look too posed and safe for this kind of campaign.

AV

Trailers for this movie will incorporate the basic three-act structure: The young boy's discovery and setup (source of the fear), older sister sees something is wrong and sets out to investigate (heightening of the fear), and the third act is a montage of showy effects shots inside the cave as they fight back or as the town turns rabid (promise of fear). Also after the title comes up, there will be a "button" which is a "jump scare." This is when tension builds and quick scare happens to startle the viewer. It sends the trailer out on a bang and gets audiences' hearts pumping.

The big challenge on this movie is the one that research identified very early: It might feel more like a "rental" than a "theater movie." In other words, with so many of the scenes taking place in the claustrophobic tunnels, the movie can look small and dark – especially in television spots. The creative team and the trailer house will have to comb through the movie and look for as many outdoor and wide scope shots as they can find. This is a case where they may also cut in some stock footage of a cornfield or ask the filmmakers to grab some additional, above ground, establishing shots of the small town just for the campaign. Marketing will need to open up the movie and make it feel bigger and worthy of a movie ticket purchase.

Internationally, the sell will be very similar to the domestic trailer except that the devil worshipping and possession elements will be dialed up for some markets (especially Mexico and South America). Remember we said there is a major Mexican star in this movie as well, so there will be custom materials cut for that market that feature him prominently in TV spots and print. The filmmakers gave marketing a big leg up with this casting choice and it will lead to not only a great opening in Mexico, but also a strong turnout of Latinx moviegoers in the United States who are fans of the actor.

TV

Television spots for horror movies are also a tricky line to walk with the MPAA. This film is rated PG-13, which helps. It's forbidden to advertise R-rated movies on television during certain hours of the day when children may be watching – including prime time. This really limits the amount of exposure you can generate through a TV campaign.

In this case, the scares in the movie are primarily startle or jump scares and the violence is very minimal. This helps a lot when trying to get spots cleared with the MPAA. However, Marketing will get pushback for showing the little boy in the movie in peril or too frightened. He's a big part of the scares and will need to be used sparingly, which is a challenge. There is one scene where the sister character delivers an excellent line of scary dialogue, but she happens to be covered in blood when she does that. That's a no-go from the MPAA so Marketing will either ask the filmmakers to film the scene two ways, or if not possible, they will record the line from the actress and cheat her saying it in a different scene. Sometimes, we can get away with darkening blood and we try to argue that it's some other substance … but that doesn't always work!

The lesson here is to work with marketing early and make sure to keep theatricality (need to see in a theater) in mind while filming. If there are excellent lines for the marketing team to use, make sure they are covered in filming in a way that will clear the regulations.

K2TOG and Sugar

Both of our smaller films will have limited budgets to work with in order to create unique poster, trailer and web materials. Most of the smaller independents have a host of vendors that they select based on both their strengths with the genres they work in as well as the budget ranges they are comfortable in. Having said that, it is not uncommon for big companies to work on smaller titles if they feel the movies are unique enough and they can use them as examples of work for future clients.

K2TOG

Print

This film lends itself to unique graphics coupled with a two shot of the twins. It will be important to highlight the two of them to ensure their fans are aware of them in the film and also the juxtaposition of their expressions could tell a lot about the story.

By the time we make the poster for this film, we will have convinced the filmmakers that we need to change the title. Still, even the new title, *Knit Together*, will require some help graphically. Marketing will work with the print vendor to create a title treatment using knitting yarn and needles. A really creative designer could even take this one step further and draw the two girls' faces in yarn. The poster is all about highlighting the twins, the comedy and the hook of arts and crafts. The same print look will be used for international markets as well, except for those territories that may have been pre-sold at a film market. Those countries will likely create their own campaign with their own creative partners.

AV

The trailer should not only set up the story but also establish the twins' different personalities early on. And given their web presence, a lot of smart banter would

signal to their audience that the game is on between the two. Dialogue driven and a shorter length feels right with this title and not giving too much away about what happens when they arrive in Texas for their grandmother's funeral. Some strong early reviews will be cut in to show audiences the film is good and the sell will focus strongly around the comedy. The location between the two cities – East coast and small Texas town does not feel that relevant for a poster, but certainly this should be highlighted in the trailer as this speaks to the story unfolding in both a big urban market and a small middle American one, i.e. a movie accessible to all audiences.

TV

Television spots for this movie will consist of a trailer cutdown to put the story out in a succinct way, a review spot will highlight the comedic and great interaction between the twins, and a "sisters" spot which will focus on why the twins even made the movie – this will serve as a behind the scenes short story. However very little television will be used for this movie unless we feel it is on the cusp of breaking out to a wider audience.

Sugar

Print

As a documentary, this star of this movie is the subject matter and the people who are being profiled. This movie is being self-marketed, so the filmmakers aren't going to have access to some of the major print vendors at this stage. They will likely create the poster themselves and it will be all about finding that one perfect still frame in the movie that captures the promise of the whole film. In this case it is: Pastries, a sorry looking storefront and a bunch of ladies having good laugh together. It's a sweet, compelling and enticing image that invites you in and makes you want to experience the film.

The filmmakers will also include positive local reviews in the poster but they will make sure the overall look is uncluttered and attention grabbing. Also, they wisely hire a graphic designer to create the title treatment, which ups the professional look of the poster considerably.

AV

The trailer for *Sugar* will also be cut by the director and editor and here is where things get a little tricky. It's very important for them to take off their filmmaker "hat" at this stage and to think like a marketer. Namely, this is not a trailer that is meant to showcase the most beautiful or successful shots in the film. It's not about highlighting the great work of the director. It's about creating a desired emotion in the audience and compelling them to buy a ticket. The filmmakers will have to think about their core audience, older, arthouse moviegoers and determine what

they will want in the film. The best version of the trailer will set up the women and their talents and it will deliver the promise of seeing some extraordinary baking. It will touch on the issues in the wider community and promise audiences a truly inspiring and feel good experience. The filmmakers will keep the "talking heads" interviews to a minimum in the trailer unless someone delivers a truly great line. The idea is to make the film feel like a theatrical experience with lots of movement and funny beats. Some well placed critical praise will help as well. In the end, the director and editor will wisely show their trailer to some impartial acquaintances, get feedback and refine. Bottom line, our filmmakers are better off trying to get a good trailer company to cut the trailer for a small fee and for the kudos of working on a super indie film. There are companies that will do this.

TV

None to speak of with this film, as there is no budget. We will discuss in Chapter 13 how short form content could work with this film.

EXERCISES

Creative advertising is a lot of fun to explore. You can start with the terrific poster site impawards.com, which has every domestic – and many international – posters over many years. You can search by movie, by director, by year, by cast member, and by vendor.

Then look at the trailer vendor sites and see what movies they have made trailers for. Some sites to look at are trailerpark.com, seismicproductions.com, moceanla. com, wearebond.com, conceptarts.com, arsonal.com, coldopen.com

Here are some things to try:

1. Take a really bland title, something like *Boulevard Nights*, and create three completely different posters based on three different genres.
2. Look at the studio releases for the past five years. Analyze what are the key elements of trailers for each genre – are all the tentpole movies incorporating a lot of characters and scenes? What are the common themes running through the comedies? The horror movies?
3. Look at an independent trailer for a well-known academy award nominated film from the past few years. Since many of these movies are character driven, is there anything unique in their trailer structure?
4. Pick a trailer that you like and break it down. Where are the first and second acts breaks and what is the setup for each? How is the third act dealt with – montage, more plot?
5. Pick another trailer – you will notice many of them are two minutes 30 seconds or around that. Do you think the trailer is too long? Gives too much away? Would it work better if it was under two minutes?

12

Publicity

Controlling the Message

Aside from the movie itself, it can be argued that there is no area of marketing that has a greater impact on the public. While there can be heated discussion about whether publicity does or does not "open" a movie, it is certainly a major contributing factor. Now, more than ever in the digital age, publicity has become so important and at the same time more fraught, with potential minefields.

Publicity has evolved dramatically "from a one-way conversation to a two-way conversation" says Elissa Greer, who has held senior publicity jobs at Blumhouse, Tilt, Focus Features, Film District and New Line Cinema. What Elissa is alluding to is that you can no longer dictate publicity, you have to be in the conversation and manage it as best you can. Elissa also was an enormous help for us in crafting this chapter.

Publicity is considered the second form of media – owned. As you will see below, there are many ways to create content, all of which is at the disposal of the Publicity and Marketing team to make available to the target audience in multiple ways.

Publicity is about generating awareness and interest for your film and accomplishing that through strategic positioning – a blueprint if you will– that brings every asset to the foreground while anticipating issues or circumstances that may pop up which could alter the conversation.

As a reminder from Part One, there are a number of ways that publicity is active during the production of a movie but in this chapter, we're going to focus on how publicity kicks in to enhance and support the marketing campaign for the film.

Campaign publicity consists of all the elements that go into supporting your release date. In many ways, this is the most exciting area because you are really working with a ticking clock leading up to the first public exhibition of your movie, whether it is in a movie theater or on television.

PRE-EMPTIVE MESSAGING

In our extraordinarily fast moving media world, there is little room for mistakes and an even smaller window exists to right them. For movies that have sensitive subject matter, or if a cast member may have something negative in their past that could come out and be an embarrassment potentially damaging the release where the issue overwhelms the movie, it is important to prepare for these eventualities by pre-emptively getting these messages out there, or being well prepared to respond should they come up.

The proper handling of talent is one of the surest ways to control messaging. Since these are the people who become the "face" of your movie, it is important to make sure your talent embraces your talking points and stays on message when talking to the press.

This can be further reinforced with the talent's handlers – agent, manager, lawyer and personal publicist. Getting everyone on the same page as early as possible is an arduous task but a great deterrent to any surprises that may come up as you prepare for release.

TALENT CONTRACTUAL OBLIGATIONS

Most talent contracts have clauses that obligate the talent to support the film by doing a predetermined amount of publicity and engaging on social media with their followers. While everyone has the best intentions of supporting your movie at the beginning of production, many factors may come up later as you near release where the talent may decide not to support the movie. These could include:

- The movie is not being well received by the press and the feeling is that maybe it's not worth defending.
- Other shooting commitments interfere with scheduling.
- The representatives may feel that the movie is not being adequately supported through marketing. This happens more in the indie arena where budgets are tighter and the talent is less concerned with their relationship with the mini studio.

This is why it is so important to get as strong a commitment from the talent as early in the production cycle as possible. And even though you may have it in writing, it is not always easy to enforce.

SOCIAL MEDIA ACTIVITIES

Some talent embrace these activities – Twitter conversations, Instagram posts, live Facebook chats, etc. with full knowledge that this is what drives audience engagement. On the other hand, other talent might shy away from these activities and it

becomes incumbent on the publicity department to get these folks as involved as possible. Most studios even cast talent based on the extent that they pursue and utilize social media.

The studio publicity department will coordinate closely with the publicists for the talent and each seemingly "impromptu" post will be carefully planned and strategized.

OFF THE ENTERTAINMENT PAGES

In the ongoing search for audience and how to engage them, content branding, where brands are woven into unique storylines in subtle ways to give a sense of verisimilitude to the product, has become all the rage with advertising agencies. The same idea also applies to getting your film off the traditional entertainment pages, both online and offline, so the themes of the movie can come to more targeted audiences in different areas of the print or website. For example, a dance movie may have an article in the traditional entertainment section on the director and how the movie was financed, but an equally and perhaps more actionable story would be one in the dance section that focused on the choreographer and how she adapted her movements to work within a two dimensional frame. Or, the last summer's hit and Oscar nominee, *Dunkirk*, which was about the British rescue during World War II would be equally at home on the entertainment page with an interview with the director (Christopher Nolan), but also in the book section where an eyewitness account may have been published, or as a podcast describing in great detail the strategy of the retreat, etc.

FILM FESTIVAL STRATEGY

While not every film is destined for a film festival launch, certainly those that are critically driven like our case study title, *Philosophy of War* and our indie special, *K2TOG*, which needs the attention to help promote awareness, are perfect examples of the types of films that could greatly benefit from a festival. A few of the A-list festivals like Toronto Film Festival, Sundance, Telluride, Cannes and Berlin all serve their entrants well, but for the thousands of films that do not get into these nationally recognized festivals, there are local smaller festivals in many towns around the country where these films could find a home. While their benefits are more on the local level, they are all part of publicity's strategic game of getting attention.

SCREENING PROGRAMS – IS YOUR FILM WORTHY?

Every filmmaker thinks their film is great, and they should, that's their job. However, as you near release, it is possible that what you wrote, produced or directed is not everyone's cup of tea and this puts the publicity team in a bit of a quandary. If your film is not getting good advance reviews at some early screenings, is it worth it to keep screening the film for critics and risk bad word of mouth or a low Rotten Tomatoes

score prior to opening? Sometimes it is an easy answer with most horror films or lower budget action films; the answer is certainly not. The Marketing team should try to sell the movie with great creative materials and the publicity team should focus on how to exploit the talent on television or through social media. For other movies, it is a trickier conversation that has to be had with the filmmakers and talent. At the end of the day, it comes down to what is the best way to protect the investment.

TRAILER AND POSTER DEBUT

The idea of offering a television show or website a first look exclusive of a trailer or poster remains a very viable one for helping to launch your movie. While television shows like *Entertainment Tonight* or *Good Morning America* still serve the largest viewership of people who may be interested in your film, these types of shows usually only want the big blockbuster titles. Which is actually fine, because you want to debut your materials where the eyeballs are best served. The goal of publicity is to offer the exclusives to the best programs and websites for the film.

If you are on a more restricted marketing budget, you might pursue an exclusive trailer premiere on a local news channel, local websites or a cable access morning show. Any exposure is worth it and many times local media will be game to help support a film that was filmed in the area and features themes of regional interest.

SPECIAL EVENTS

These are specific events tailored to your film and happen as "one offs." They may range from a presentation at Comic-Con to a script reading at the 92 Street YMCA in New York. These events are geared to expand your movie's universe by taking it out of the comfort zone of traditional publicity and creating bigger impressions for a larger audience.

The famous "Hall H" presentations at Comic-Con see all the major studios trotting out their film slates, sneak peeks and their major stars to wow the crowd. This is a win-win for studios as they galvanize several thousand tastemakers at Comic-Con to get online and begin generating buzz for their films. But, this is also a major publicity event. The studios know that press is covering each of these presentations and there will be a healthy amount of coverage for any announcement made at the convention.

Even if you are self-marketing your movie, you can create an event on a local level around your movie. Host a screening with a Q&A (question and answer session) with the filmmakers and cast. Invite local media and try to generate as much regional coverage as you can.

FIELD PUBLICITY, TOURS, PROMOTIONS

One of the bedrocks of publicity and an essential part of any campaign is taking the film to the people with the local television, radio and web presence in every area.

While the A-list stars of the studio films will mainly focus on the national press junket discussed next, if your film has less recognizable or even soon-to-be-discovered talent, then field publicity is the road is for you and your movie! Local stations are always looking for content and by having personal appearances, it boosts their image in their own city and helps promote your actor on this very important grass roots/local level. Many independent films will set up a travel schedule that could cover 15–20 markets.

As part of this local push, films will tie-in with local restaurants, theaters or clothing boutiques to help cross promote the film. Here again, the lack of nationally recognized stars is actually an advantage for these local businesses as it helps identify themselves with something unique and new. The degree of participation, however, rarely includes the transfer of money but the goodwill generated from these tie-ins is more than worth it.

NATIONAL PRESS JUNKET

This is the gold standard for most films released on both the studio and independent level. By taking a day or two at a well-known hotel either in New York or Los Angeles, your publicity team will bring in press from all over the country for two to three days of intensive interviews with television, radio, promotional partners and web folks. This is an extremely effective way to get a lot of work done in a relatively compact time without having to take the talent across the country. The press people who are invited to attend this junket are then given a thumb drive of their interview to take back to their local station to be broadcast around the time of the film's opening.

National press junkets usually happen two to four weeks before the release date and include a few screenings of the finished film. The presenting distributor or studio pays 100% of the fee – including travel and hotel for the attending press.

It should also be noted here, that the "A-level" press rarely attend these junkets as they have a no expenses paid policy. Most of the newspaper and magazines along with their digital versions have had this policy for decades and they still adhere to it. This is not to say the press that attend junkets are not important, they are generally respected entertainment reporters who are very important to the campaign.

SATELLITE TOURS

These are both television and radio based and are a variation of the national press junket. Here the publicity team will book a television studio with satellite feed and place the talent in one room and they will proceed to do live interviews with press people across the country. A typical schedule would be to arrive at the sound studio at 5 a.m. EST and go across the entire country in 15-minute to half-hour intervals so the last interview on the West Coast could be at noon EST. The same "tour" happens on radio where the talent sits in one room and does live interviews with radio hosts across the country. This is a great way to augment both the national press

junket and any field publicity work for markets or second and third tier stations that did not make it to the other events.

SPECIAL SCREENINGS/Q&A/COLLEGES

Special screenings, whether they are for colleges, churches or special interest groups around the country are effective in a number of ways: They bring the film to a very targeted group, which usually results in strong word of mouth. These groups are made to feel special as they are among the first to see the film weeks before it opens in their market and can become evangelists on behalf of the film. Bringing the talent to attend these events further heightens the importance of each event. College screenings, while sometimes a risky maneuver, also help spread the word among the younger moviegoers who are so difficult to convince.

CLIPS, EXCLUSIVES AND PRESS KITS

Content, content, content. With all the outlets that exist for showing content from video streaming services to websites to traditional television and radio outlets, the demand for content has never been greater. But to what value? Is simply showing more going to help launch viewership? Yes and no. Since promotional efforts can start as early as a year out or as close to release as six weeks out, the important piece of this puzzle is to make sure there is enough fresh content to put out there so your movie doesn't become stale. If you are asking your audience to engage with your movie, then you'd better have new and fresh stuff to keep them on board or they will move on to the next movie. Likewise, in the case of a trailer as we saw in the creative chapter, multiple trailers help tell a larger story while providing new glimpses.

The strategic key to this content is to release it in a compelling way that continues to build story while it offers new material. Clips refer to scenes taken from your film, exclusives or maybe a themed piece geared to a specific audience. For example, with a period film, it may be about the costumes or a historical frame of reference. Press kits are the sum total of interviews with the director, producer and talent and background information on the making of your film.

PARTNERSHIP PROMOS

With movies that have a more commercial appeal, and the advertising budget to support it, promotional pieces are great ways to show off your film through the eyes of established YouTubers, cast members from a reality TV show, or with a brand that may sponsor a behind-the-scenes look at your movie. Or how about Ben Stiller and Owen Wilson taking part in a real fashion runway presentation in their *Zoolander* characters?

It was an extremely effective PR stunt when Ben Stiller and Owen Wilson showed up, unexpectedly, walking the runway for Valentino during Paris Fashion

week in 2015. They were playing the part of their characters from the comedy *Zoolander*.

It was a wonderful integration of art meets life and there was a huge amount of press coverage, which, of course, all helped the movie build awareness.

STUNT PR

Many of you probably remember the *Carrie* coffee shop stunt. To promote the remake of the classic horror film, Sony Picture's division, Screen Gems took a regular coffee shop and rigged it so shelves would rise, books would fall off the shelves, the lights would shake and even a wall would fall down. The idea here is for unsuspecting patrons to be suddenly shocked into watching someone who they thought was just another customer having an argument with another actor and then going on a "possessed" rampage to destroy the place. This stunt garnered more than 65 million views on YouTube and is still considered a classic.[1]

Virtual Reality has been used to create a number of experiences and stunts to promote TV shows and movies. Specifically, *Stranger Things* set up a 360° VR experience of the house in the show.[2] Also, Fox created a fully immersive VR experience to promote their Matt Damon film, *The Martian*.[3]

If you're currently sitting in a cubicle reading this (get back to work!), just know that it could be a lot, lot worse. At least you're not suspended in the air, stuck inside a 12-by-12 foot plexiglass cubicle overlooking Times Square. Yes, you heard us right. To promote the film *Office Space*, a comedy about the monotony of everyday work life, Fox marketers placed a man inside a glass cube for an entire week, where he had to file TPS reports and answer phone calls – all the while being photographed by spectators.[4]

PREMIERES

Whether your movie is a Disney film and can spend $1M taking over Hollywood Blvd with a parade or you are working with a significantly lower budget of a few thousand dollars to rent a theater in downtown Manhattan with a party in the latest, smallest and hippest enclave on Tribeca, premieres still have a purpose. Besides making the cast happy and giving the producers something to invite their investors to, premieres are all about what kind of publicity they can generate and where it appears the next day. Sure, your Soho premiere may not make the gossip section of the *New York Post*, but someone who attended the premiere may know someone who knows someone. And that's how word of mouth travels even on the super indie circuit.

Bigger movies will also feature at least one if not several international premieres. Even though a premiere is technically supposed to be the very first screening – studios get around it with monikers like "domestic premiere," "world premiere," "European premiere," etc. If a movie has a strong local tie-in, was filmed in a certain country or features a local celebrity – chances are strong the studio will hold a

premiere in that country to generate as much publicity as possible. They may also invite press from neighboring countries to come cover the event.

REVIEWS

We all know the power of good reviews and the withering effect they can have if they are not positive. While you may think your film is worthy of multiple screenings for the critics, your publicity team may not agree if they feel the content and sell is more important than a mixed critical response. Delicate stuff for sure, but in this media world where social media rules, word of mouth travels faster than ever and screening a film that may not have a strong response can doom it.

A significant change in the impact of reviews has occurred in the past few years with the rise of "Rotten Tomatoes." This website aggregates all the reviews and assigns a score accompanied by a red "fresh" tomato or a green "rotten" splat. The clean score and simple iconography allows the site to permeate widely and audiences are exposed to the score on everything from Google searches to ticket buying websites. While there is a good deal of debate in the industry around whether or not the Rotten Tomato scores impact box office, positively or negatively, there's no question that marketing is left scrambling when the score comes in rotten.

CRITICS TEST SCREENINGS

There are ways to get an advance reading from some press to determine if your film should be screened aggressively or sparingly. That process goes like this: Once a film is near ready, the publicity team may reach out to what they call "friendly critics" – critics who are willing to give a response to your film without making their responses final and publishing them. This gives some indication of how a film could play when it gets to the critics en masse. This is a very interesting tool that most of the independents use to rate their new productions or acquisitions.

There are also two companies that presently do these "critic's test screenings: Screen Engine and Franchise Entertainment Research. Their methodology is to recruit ten working critics who anonymously rate the movie on a scale of 1–10 and give comments similar to a review they may give the movie when it comes out.

We talked to David Gross of Franchise about how his company does this and why they are unique among others.

How does your process work?
David Goss: These early research screenings give the producers and distribution companies a window of time to anticipate the critical response to the film and prepare accordingly.

Based on the feedback from these research screenings, the distribution company and producers might show the film to certain kinds of critics and journalists – big city, mainstream, high-brow, fan boy, certain interest groups, etc. – whoever might be especially interested in the

film, to build interest in the movie and help it find its audience. This is an important piece of the publicity and marketing strategy.

Does part of Franchise Entertainment Research's analysis involves forecasting a film's Rotten Tomatoes score?

DG: While some movies become hits without a strong critical response and others fail with outstanding reviews, and while certain types of movies are more sensitive to reviews than others, every distribution company prefers positive over negative reviews. It is impossible to put an exact figure on it, but the swing in box office between positive and negative reviews appears to be in the neighborhood of plus or minus 15%. That's a lot of audience and a lot of money for any movie.

LONG LEAD SCREENINGS

Long lead screenings is another way of testing the critical waters early. These screenings usually happen two to four months before your release date and are geared to those publications with early closing dates for their issues, or promotional partners, TV, web or the like, looking to create content.

If it is determined by the publicity team that the reviews should not break over an extended period of time, or they are mixed, then publicity would initiate an embargo on releasing the reviews. This does not prevent the critics from seeing the film, it just sets a date when they can release their reviews, normally the week of release. This somewhat protects the film and at the same time honors the critics and their work.

Of course, there are any number of films that are never screened prior to opening – those are the reviews you see that break on Saturday or even after the weekend. These movies are usually genre or teen movies that don't need reviews to support them. They live or die on their stars, concept and how original their advertising campaigns are.

Bloggers are an interesting group and this brings up the whole issue of Rotten Tomatoes and how important this website has become. Normally, RT puts its score together as a compendium of all critics who weight in, whether it's a blogger with their own website that RT recognizes, or the head critic from the *New York Times*. This has shifted a lot of influence to the ranks of the movie bloggers.

When it comes to pulling quotes to use in the advertising for your movie, then the credibility factor all goes out the door. In the need to validate a movie, the Marketing department has no qualms about using quotes from *anyone* as long as the pulled quote speaks glowingly about the film. How many times do you see reviews quoted that say something like "The Best Movie of the Summer" or "The Funniest Film of the Year" but have no idea of the source? Or the source on the ad is so small you can't even read it? Welcome to marketing! However, audiences are getting wise to this trickiness now, and it's becoming increasingly necessary to use legitimate quotes from trusted sources – or face moviegoer rejection.

OPENING WEEK REVIEWS

At this point, everything is fair game and your movie is no longer protected so hopefully you have a good Rotten Tomatoes score, the important critics give you a thumbs up and word of mouth kicks in. With independent movies, critics are still extremely important and definitely drive audience interest and awareness, particularly if the cast is not known.

BUT KEY CRITICS STILL MATTER

Rotten Tomato score aside, the critics from the major publications like the *New York Times, Los Angeles Times, Wall Street Journal, Rolling Stone, Chicago Sun Times, San Francisco Chronicle, Time, The New Yorker* and really every key critic in every large city still have tremendous sway over a movie's success. These critics *really* matter when the film has an upscale appeal or could be become an awards contender.

One only needs to look at the glowing reviews of some films over the past few years – *Dunkirk, Manchester by the Sea, La La Land, Moonlight, Three Billboards Outside Ebbing Missouri, The Shape of Water* and a host of others, to best understand how the predominantly stunning reviews these movies garnered helped drive box office – and awards buzz, which led to nominations.

OPENING WEEKEND SPIN

There are many times when a movie does not open well, or comes in below expectations. At this point, the publicity spin-meisters get to work and start feeding the head of distribution, who will be doing the interviews, some key phrases to give to the press.

One phrase that is often used: "While we are a bit disappointed with the weekend result, we are fully confident the film will over-perform internationally and will make up for any potential shortfall." Sometimes this is actually true, where a film will do better overseas.

Nonetheless, a bad domestic opening is still a bad domestic opening.

And here's another one: "With strong exit polls, we expect the film will be in theaters for a long time and will eventually earn its way to profitability." This usually refers to films that have an older demographic where that audience does not always rush out to a movie the first weekend, but over time they will find it. A good post opening spin.

And one more: "While we had hoped for a stronger opening, this is the kind of film that should perform beyond expectations in the home video arena." Almost always this is never the case. While it is true that some films do over perform on home video because audiences did not feel it was important to see them in a theater, in more cases than not, a weak opening usually translates to weak home video numbers. Most people can see right through this one.

CRISIS MANAGEMENT

Probably the fastest growing area of concern and attention for publicity is crises management. As we have seen from actors behaving badly, to illegal offshore financing of some major motion pictures, to the present political climate, to the new exposes of sexual harassment seemingly happening every day, all of which are a crisis that has to be dealt with.

There is a very big difference between anticipating a crisis and being prepared to deal with it and having to face a crisis once it breaks out through the press. While it is hard enough for a publicity team to manage a movie release, given all the things that can go right, wrong or awry, the area of crisis communications has reached new heights of sensitivity given the always prying press and flash points that can ignite a story which years ago would probably never have never come to light.

This is an all hands on deck emergency as anything negative that comes out has the potential to turn off the movie-going public and therefore your audience. There have been thousands of transgressions ever the since movies began, including the Fatty Arbuckle murder story from the 1920s. Recently, the most damaging publicity crisis that came to light was the scandal of Nate Parker, the writer and director of *Birth of a Nation*, and the rape charge he faced while a student at Penn State in the mid-1990s. Even though he was never found guilty of the offense, the news of it, when it was broken by a *New York Times* reporter, was such a surprise to the public and eventually Academy voters, doomed what was a huge critical hit at the 2016 Sundance Film Festival. The resulting box office was significantly below what was projected based on the sale price in Sundance, and what was once a forerunner to a Best Picture nomination failed to secure anything. By the time the story came out then, it was impossible to contain.[5]

Of course, we are in the years of calling out Sexual Harassment and embracing #MeToo and Times Up watershed moments in the righting of so many wrongs and hopefully the establishment of more gender equality across the industry.

There are many times when a publicity team successfully manages a potential crisis for talent. Years ago, when the well-known British actor Hugh Grant, who at the time was at the height of his fame, was caught and arrested on Sunset Blvd for partaking in a lewd act with a prostitute, he went on *The Tonight Show* with the host at that time, Jay Leno, and owned it.[6]

At the Academy Awards presentations, it is the custom that the previous Best Actor winner present the Best Actress Award for the new year. In 2018, Casey Affleck declined to do so, as he was on record for sexual harassment charges, which he apparently settled with a payoff. To be a presenter at the 2018 awards show would have most probably brought him jeers and boos if he stepped on stage. And what could the Best Actress winner possibly have said after receiving the award from him?[7]

This was a real publicity crisis. how would you handle it?

In 2006, New Line produced and set for release a retelling of the *Nativity Story*. The film featured the New Zealand actress Keisha Castle Hughes, fresh off her nomination as Best Actress for *Whale Rider*, and the youngest female ever to be nominated. The film was directed by the highly regarded director of young adult stories, Katherine Hardwicke (who went on to direct the first *Twilight*) and was also the feature debut for actor, Oscar Isaac.

The story was meant to be a retelling of the Nativity story and staying true to the biblical version and was squarely targeted at the faith-based community.

Keisha, our Mary at the time, was also 16, close to the real Mary's age in the Bible as well. The film was set for an early December release to anticipate the Christmas interest that usually accompanies the story of Jesus' birth.

Six weeks before the movie was set to open, we received a call from Keisha's agent that she was pregnant! And from her 19-year-old boyfriend of six months.

So if the original Mary was a virgin, how were we now going to sell our Mary who was no longer! What would the Christian community think? Would this be considered some kind of Hollywood joke of a movie that rejected true religious value?

Of course, we were also thinking of our actress who was going through a difficult moment in her life. We wanted to protect her privacy and be sensitive to her feelings in all of this.

So here the company was, six weeks out, with a pregnant 16-year-old sitting in New Zealand about to come to America and do a press tour.

What would you do?

- Do you still have her come and do press?
- Can you really keep this a secret?
- If she doesn't come, what's the point of releasing the movie?

A lot of solutions swirled through the Marketing department – all seeking a way to frame a publicity crisis that none of us could ever have imagined while trying to respect the privacy and well-being of our young star.

As you think this through, remember some of the areas we talked about with crisis management. We decided to lean into the best publicity rule, which is: Tell your story before someone else tells it for you. We offered an exclusive to a national publication, which was *People Magazine*. They put the story out in print and on the internet. After the article hit, there was no pushback from the Christian community as they embraced the fact that this young mother was going to keep the baby. We also announced that Keisha would do no further publicity for the movie, which she was grateful for. *Nativity Story* went on to gross $46m worldwide and Keisha has continued her strong career, most recently appearing in *Game of Thrones*.

SPECIALTY PUBLICITY

As we've seen, movie audiences are basically interested segments of the whole, with each demographic target having its unique traits, habits and personalities. Faith-based audiences tend to support movies with a spiritual message, Latinx and African-American audiences will also over-perform on content that connects with them. While not many of the movies that are targeted to these specific audiences travel well internationally, they can do 80–90% of their box office domestically and each of these segments represents a thriving aspect of the film business, outside of the studio mainstream movies.

One other phenomenon that has grown exponentially over the past few years are movies that appeal to a subset targeted audience, but one that is spread out throughout the world also known as their diaspora. For example, the extremely large audience for Indian films does not just lie in India, but in different communities situated in many countries throughout the world. These audiences, who are far from their homeland, nonetheless are great fans of their culture and eagerly attend films that feature stars they are familiar with or have read about. In 2017, the Indian production, *Bahubali 2: The Conclusion.* went on to set massive box office records in India and throughout the Indian diaspora, grossing US$120M on 9000 screens in the first six days of release. This, then, was not an Indian phenomenon, it was a worldwide one. And a worldwide marketing push was responsible for its enormous success.

And the same can be said of movies from Korea, Japan and even China though the East Asian audience seems to be especially prolific in supporting their local cinema regardless of where they live.

The publicity teams that work on these movies target these special audiences are generally smaller independent companies who have the relationships with the specific publications and press that will drive interest. If your movie is specialty targeted to one of these audiences, you will probably come into contact with a studio representative who solely focuses on this audience in consort with an outside publicity and promotions company.

THE POWER OF THE FIELD

Field publicity has always been a significant part of a movie's national campaign. These are publicity efforts that happen on a local or regional level, rather than national. For example, field publicity might include college campus promotions, sponsoring a holiday parade or press with local radio and television stations. While the Marketing department of the studios and independents set the tone and framework for the national look and feel of a campaign, it is on the local level where the messaging becomes most resonant.

We spoke with Kymn Goldstein, Chief Operating Officer of Allied Global Marketing, one of the leading marketing agencies focusing on entertainment, culture and lifestyle. Allied has strong DNA in field publicity and promotions and has been working with the studios and independents for many years. But while the functions in many ways have remained the same, the methodology has changed dramatically.

How would you define field publicity and marketing?

Kymn Goldstein: Field publicity provides the opportunity to take the national strategy as it is defined in large and broad concepts, and curate and distill them on a regional and local level in a way that will resonate with people who live there.

How has the digital landscape impacted the world of field?

KG: What we are seeing is the evolution of field marketing. In the past it was about market specific tactics on a local level, but now with the overlay of digital, it is about understanding the impact you have when you take a local strategy and execute it across multiple markets.

For example, take an event like Coachella, the three-day rock concert in Palm Desert, or the South By Southwest Festival in Austin. You can actually spend your whole regional budget on various promotions and tie-ins with a specific event like these, but they do not remain localized.

You have enormous opportunities with social impact beyond the event itself, whether that means live streaming it to a number of locations across the country, creating Instagram stories, or pushing out fresh content over a period of time. It has completely changed how we approach our campaign strategy where a local footprint can now become a national one.

Does that mean there is a whole culture of local influencers that you work with?

KG: We do, but always remember our niche is engagement, not followers, since a lot of who we are doing deals with are micro influencers. For example, we have always had relationships with local media personalities, organizational contacts, mayors, etc. and this is the next lane of that – being able to develop relationships with these micro influencers. In some cases, it is a pay and play situation similar to the way it may work with a national YouTuber, but more commonly, since these micros function primarily on a local level, they are willing to work with us without a fee structure because it helps build their own followings.

The general nature of publicity has evolved from traditional television and press outlets to traditional online outlets and now there is a level of influencers who have crossed over and have themselves become an extension of the press. I don't think you can have a campaign without them.

For example, with a recent project we managed to get placement on a small outlet that no one had really heard of. On paper, in the normal course of doing business, people may overlook it, but when we ran the numbers on engagement, suddenly this smaller

person that no one had ever heard of was very important in their market.

That's what is exciting about what we do now, because it is no longer a cookie cutter approach, but about what you are marketing and who you are marketing to and what are the right approaches.

Do you have any advice for emerging filmmakers?

KG: For the most part, there is a "mystery" about the marketing process for people on the filmmaking side. I think it is essential to ensure that you make a marketable product so that you can be informed and be a smart collaborator during the process.

INTERNATIONAL PUBLICITY

This is from the MPAA website:

Worldwide box office in 2017 was $40.6 Billion broken down as US Domestic box office of $11.1 Billion and International box office at $29.5 Billion. For that year, international accounted for 63% of worldwide box office. This is an astonishing number which has been very consistent between and may even go higher as more and more screens are being added in China and other emerging countries around the world.[8]

In most of the major countries the studios have branch offices; for independent films bought and sold territory by territory, there is a local distributor who handles the release and the international numbers vary greatly depending on genre, subject and star quotient.

Publicity's biggest concern then is how to manage all the numerous requests for premieres, interviews, personal appearances from many different countries or distributors. For the studio releases, this has to be coordinated within a few weeks period to take advantage of the worldwide release date, which also helps thwart piracy. For the independents, a movie can open over a six-month period around the world so the issues are not as profound.

The studio side of international is a machine pretty much the way it is in the States. At least five to six major cities might have premieres – London, Paris, Beijing, Sydney, Moscow and Tokyo would be the norm for a big blockbuster and these premieres and the attendant press schedules that happen around them are similar to their domestic counterparts. Talent certainly understands the value of a worldwide press tour, as it works on behalf of the film and enhances their own personal brand – so who wouldn't want to jump on that train?

Tom Cruise is a mega star, not only because of the type of internationally friendly movies he makes, but he because is a tireless worker going from city to city promoting his latest adventure film. It is not unheard of for him to visit ten cities over a

two-week period. Will Smith, Robert Downey Jr, Leonardo DiCaprio, Tom Hanks, George Clooney, Brad Pitt, Dwayne Johnson, Jennifer Lawrence, Scarlett Johansson, Sandra Bullock, Charlize Theron and Meryl Streep – all of these stars have major international followings and work globally to promote their films.

CASE STUDIES

Here's how our four films would handle publicity given their budget and production funding.

The Tunnels

Production Publicity

Assuming this is a low double digit budget probably financed by a studio or bigger indie, is the perfect kind of film for on set publicity and visits! A young cast with social and television visibility will be willing participants for press visits. The only question will be if the cast is strong enough to attract quality press. But not to worry as there are any number of press ideas that can be employed, and here is where the world of bloggers and influencers come in. By bringing in these people who have their own followings (and of course they will have to be paid!), the social followers of these people will translate to interest in the film. Couple this with the cast doing a set event or promotion with their followers will more than amp up interest. Also the look of the cast and feel of the settings will invite strong photography from both the unit and the special photographer and provide a treasure trove of usable material for blogs, fansites, and creative advertising ideas.

One of the stars is also a very popular actor in Mexico and he will galvanize his friends by posting frequently from set. All of his posts will be coordinated with the PR team and vetted ahead of time. They may even shoot several different pictures and posts in a day and bank them to post over the next few weeks to keep the followers engaged.

On the video side, this movie is ripe for on set promotions with branded content partners or simply creating behind the scenes theme pieces. For example, a piece on the urban mythology of tunnels or the history of demonic worship in small-town America will lend itself to help build awareness and interest in the movie.

Publicity Release Campaign

We have already looked at the strengths and challenges of *The Tunnels* in our introductory chapter for Part Two of our book. The messaging is what is important here and to emphasize that this movie is not about drug trafficking through tunnels. Rather, we are concerned with the mythology of the tunnels and the dark history of this town. So it will be important to give talking points to our cast that talk about the urban myths

of tunnels, how scary they can be if you are caught in one and cannot find your way out, and, of course, what lies at the end of the tunnel, be it horrific or a startling reveal.

Our cast is ready and willing and looking to this movie to boost their careers into the mainstream with its success, so they will do everything they are asked to do – from social messaging two to three times a day to attending premieres well in advance of opening, to live online chats – all to garner fan interest. They will happily travel across the country, attend college word-of-mouth screenings, partake in every local promo event the local publicity teams can come up with, they will feast on the national junket, promote any article of clothing thrust into their hands, and hang out with the YouTube stars who are supporting the film. It's a dream scenario for the publicity group here as they have active and eager partners in marketing the film.

However, the cast will *not* be involved with any stunt promos because any association with these unique events will immediately telegraph to the audience that this is a move promotion, not something organic.

Stunts and Promos

Many opportunities here given the studio willingness to support a film like this with a significant budget, i.e. a VR tunnel experience would be a natural to create, they will hold one or two special screenings in an underground tunnel – even a subway one – or a mine, and they will have the digital agency create a viral experience perhaps tied to the cult that is discovered inside the tunnel, etc. This can be applied internationally as well as mysterious tunnels underneath cities are something you can find virtually anywhere and/or build a stunted screening around that location.

Specialty Publicity

Since this film is a genre rooted in cultism and, by association, exorcism, and we have a Latinx star, this audience is ripe for promotions and publicity. There will be an additional press junket in Miami, home to many Latinx broadcast outlets, and special local attention will be paid to cities with large Latinx populations like Los Angeles, Houston, San Antonio and, of course, Miami.

Premiere

The studio will likely hold a small cast and crew screening and after-party but not a full blown premiere with red carpet. The stars of the movie aren't going to attract enough A-list press to justify the cost of a full-blown red carpet. With movies like this, which are genre themed and lacking name talent, most premieres are set up as radio promotions in conjunction with a popular local station. These radio-promoted screenings usually happen a few days prior to the opening release date and have the benefit of on air publicity, a very targeted radio audience, and the premiere tickets are given away through the station to an incredibly appreciative group who never

get a chance to go to a premiere. Responses are usually quite good and everyone goes home after the party feeling great.

Opening Week Reviews

Critics are often tougher on genre films and the horror audience is typically more concerned with the reviews from sources and blogs that cater to the genre. It's rare that a genre film gets reviews or an RT score that is strong enough to drive an audience that is not already thinking of going, but when it happens it is wonderful thing.

Remember the movie, *Get Out*? – a $4.5M dollar budget with unknown leads, directed by Jordan Peele, who had a considerable following as a comedian on his show, *Kay & Peele*. This movie managed the unthinkable and became a critical darling, a cult phenomenon, a huge box office grosser ($255M worldwide) and is probably considered the most successful film of 2017. Oh, and it also got a best original screenplay Oscar, which is a rare accomplishment for a horror film.

We can't expect this with *The Tunnels*, and we may not even decide to show the film to critics prior to opening date. If it comes out well enough, then there is really nothing to lose as we are not depending on critics to drive box office, but certainly not something to prioritize when the publicity tour is so much more important.

International Publicity

The Tunnels will have a spotty trip overseas – there will be a few markets where the film can be expected to work – possibly the UK and Germany, but the movie is not unique enough to grab the attention of the large potential box office of an international release. It is also not a scary thriller with a real evil antagonist but a movie about spirits and ghosts, a topic that many local productions also invoke and based on their own urban mythology.

Also, it is entirely possible the studio who made this movie may sell off the international rights territory by territory, with the exception of Mexico and South America where we know these stories will work with the help of our Mexican actor, now thrust into greater prominence in his home country

Philosophy of War

Production Publicity

Given the intensity of the dramatic sequences in the filming and the level of star power here, the director doesn't want to allow on-set publicity. This is a set-back for marketing, who were hoping to generate some early awards buzz with curated set visits from key press and exhibition partners. After some negotiating, marketing

is able to convince them to at least allow visits and banked pieces from one or two chosen press like *Vanity Fair* or *The New Yorker*. These presses will write articles with more of an editorial than entertainment slant, the better to put this film on a pedestal.

There will also probably be a Golden Globes visit in the mix as well (members of the HFPA – Hollywood Foreign Press). This is allowed as everyone associated with this film knows its success will lie in a robust awards run, and what better way to seed that than with an early group of manageable, usually very friendly, international press correspondents.

Photography is a given as is the special unit photographer since the cast portraits both in and out of character could provide the necessary imagery to indicate its importance. However, given the caliber of the cast, they will select their own unit photographers and have complete approval over all shots taken.

Film Festival Strategy

Since our film is considered awards worthy, a film festival strategy is a must. The Venice, Telluride and Toronto Film Festivals all happen within two to three weeks of each other in early September and at least two of these are considered important stops. Here critics will be able to screen the film under the friendly circumstances of a culturally important event, and the filmmakers will be screening their film to an adoring audience of cineastes in a cloistered environment of important and new and emerging filmmakers.

There are, of course, inherent risks of screening a film at a festival a few months before release. What if the reviews or audience reaction is muted? What will your distributor do – will they support the film with as much vigor as they had originally planned? Will all those award nomination dreams start to fade? Luckily, *Philosophy of War* is well received.

The value of a film festival is similar to a national press junket except even greater. With hundreds of domestic and international critics mixed in with a normally very sympathetic audience, a lot can be accomplished over a few days of screenings and press interviews that will begin to fuel word of mouth and start the "buzzability" of our film, weeks, if not months, prior to its release. With our Fall festival strategy, we overcame the potentially first major hurdle on our way to release – and came out of the festivals with good reviews and most importantly an excited cast.

As we get nearer to our release date, there are a few more festivals that are also extremely important including the New York Film Festival and the American Film Institute Festival, not to mention a number of local city festivals that serve their own purposes as well.

The cast and director will travel to the higher profile festivals for the premiere. Photographs of them together looking glamorous on the red carpet are circulated widely online and awareness about the film is starting to grow.

Pre-release Publicity

This movie will probably have a platform release for the first few weeks. This means a few theaters will initially show the film in a very limited amount of cities. Over the ensuing weeks, more cities and screens will be added until it reaches a good saturation point, but perhaps, not saturated to a tentpole studio release of over 3000 screens. The idea with this film is to go slowly with the release strategy so that audiences, who may have an initial aversion to seeing a film based on a story currently playing out in the real world, will discover it and talk about it over time. Certainly, the press about the film should be considerable given the star and director power assembled, and many times the sheer amount of interest a film like this can generate in the press is in itself a great driver of interest.

Publicity

The cast and director will be expected to give this film an enormous amount of support in the press beginning with the festival exposure. As the film gets closer to release, the publicity team will book the talent on as many of the daytime and evening talk shows they can to feature someone from the film. As part of the awards release strategy, the cast will be expected to partake in a large number of events, but we will detail this further in the Awards chapter.

However, this turns out to be a significant issue for *Philosophy of War*. The cast has all moved onto other projects by the time the publicity machine is gearing up and they will be largely unavailable in the weeks leading up to the opening. Marketing will pay another studio to get one of the stars released for a day so they can do as much press as possible at a junket and hopefully cover a major talk show.

However, if there are a few hiccups in the manner of soft reviews, even after the positive Festival response, our cast will become even more reluctant and while they will do the essentials to keep the studio happy, they may not go the extra mile. Fortunately, this has not happened.

So, this is a prime example of filmmakers not working in tandem with marketing on the film. Availability for press was not built into the stars' deals in advance and now it's a problem. It doesn't mean so much to have huge stars in your film, if they don't help promote it.

Promotions and Special Stunts

This is a film that does not lend itself to stunting with its serious themes of war, PTSD and the like. However, it very much does lend itself to theme pieces that could be considered off the entertainment pages, whether they are articles about the current state of war, returning from war, or a chronicle of a real life soldier with no association to the movie, trying to adjust to civilian life. Most of these are not happy tales but they speak to the importance of the subject and the movie, which will hopefully drive interest.

Marketing will use these sparingly however, as they want to keep the focus on the performances and keep reminding audiences that the film is an enjoyable experience, albeit an difficult one.

Review Strategy

A crucial piece in our strategy is to convince audiences to go to the theater, and to send a message to awards voters that this is a serious contender. Long lead screenings are also an important building block for our campaign particularly as a lot of these will be published as editorial pieces in prestigious magazines or websites. With this movie, it is all about positioning. Long lead screenings will also allow the studio to collect some key quotes and accolades that creative marketing can cut into trailers and spots.

The same idea will apply to opening week and day reviews. Since our film is well received by the critics, the resulting box office in the small number of theaters it opens in initially have an impressive per screen average. This in turn will engender more interest from exhibition to want to play the film, and because the limited number of theaters could have sold out opening weekend, interest will definitely be piqued and set up for expansion over the coming weeks. In fact, high per screen averages and sold out opening weekends are a piece of publicity in their own right and the studio team will make sure to get the word out.

Specialty Publicity

In this movie's case, it will be about screenings for special interest groups – veterans, military families, etc. There will be many who will want to see this film for other than entertainment reasons and as many of these groups should see the film as possible. But publicity will want to keep these screenings separate from the mainstream screening program and not open to the public or critics.

K2TOG

Production Publicity

With the assumption that this film was financed piece by piece and completely independently, the odds of being able to attract any press interest are quite low. Which in many ways is all the better, as the film's success story will be told in the coverage it receives after it is finished when screenings start. No reason to push for it this early outside of a few local articles about the film shooting in such and such location.

However, like all films in this category that will be looking for an eventual distribution deal, every set needs a photographer and behind-the-scenes footage and interviews. Getting as many set-ups, cast and location shots as possible is very

important to an eventual sale. The associate producer can become the videographer but every production, even at this level, should try to get a publicist on set for at least a week to gather all the necessary information so they can write and compile it all later.

It will also be very important to contact any guilds that are associated with knitting to help promote the movie while it is being shot and certainly as it enters release. The Knitting Guild Association and the Craft Yarn Council, to name two, would be very interested in helping to promote the movie, and you get an opportunity to start building your community around the subjects of knitting, chapters and clubs around the country and with publishers.

Festival Strategy

Hopefully, our film lands a distribution deal with a strong independent company, like A24, Annapurna, Focus or Roadside Attractions. The distributor will then begin to plot a festival strategy. These companies excel at selling these types of movies and the first step for their publicity teams would be to submit the film to a prestigious festival. Here again, the most important for American independent films are Toronto, New York and Sundance and any of these would be a way to launch our film. A festival strategy for movies like this allows for the discovery of a new director and talent, compresses the intensity of interest in the movie inside a tight two to three day time frame before all the press move on to the next item of interest, and puts the film on a world stage of critics, exhibitors and international distributors.

The reviews coming out of the festival are strong and when the film goes on to win an audience award, so much the better, and everybody feels great about the impending release.

Release Publicity

Now that the film has had a successful launch at a festival, adding a few more local festivals would be in order being careful not to overload the number. All of this allows the movie to work for itself through publicity efforts and a lot of money is saved in having to buy expensive media, traditional or digital, in order to launch the film.

The same categories of publicity are relevant here, albeit on much smaller levels – a national press tour, local screenings for special interest groups, and even a national press junket if possible. This depends on how much "heat" the film has coming out of its Festival runs.

While the two leads of *K2TOG* are not yet big enough to book as guests on a major talk show, they are well-respected comediennes with a big following particularly in the digital space. Consequently, publicity is able to score a slot for them to do their stand-up on one of the national late shows followed by a quick sit down with the host to plug the movie and release date.

Reviews

The distributor is confident that the movie will get good reviews, but they will make sure it is framed correctly for critics. It's a sweet, rather small story with great comedy and heart.

Opening Week

This film will also have a platform release. The first release date may include only New York, Los Angeles and perhaps a Texas town where the movie is set or where it was shot. This could also be a place to have a stunt premiere – and while it would not garner any national publicity, it could very well be picked up by the syndication services if it is interesting enough. Over the ensuing weekends, more and more cites are added, so there are really many "opening weekends" beyond just the first one. We will get into this in more detail in our Distribution chapter, including how per screen averages affect exhibitor and the public's interest, but suffice to say that a slower rollout for a movie with unknown talent is essential for word of mouth to kick in over a period of weeks.

International Publicity

Our film will be a difficult sell overseas and, in all likelihood, there will be only a few sales even based on the audience award at a major festival. While there are smaller independent distributors all over the world, the issues will be subject relevance to each market and the fact that the twins are not at all known outside of the States. It would behoove the producers to make a worldwide sale to a streaming company and let the publicity and awareness emanate from the online work the twins do in the States to help create awareness overseas.

Sugar

Since this documentary absolutely works for its intended audience, there are a number of opportunities in the publicity space. Besides a publicity tour itself of the talent, featuring our 80-year-old star, the prevalence of a number of recent movies dealing with seniors (*The Book Club*, the *Going in Style* remake) has set the stage for numerous tie-ins and promotions to this still very dedicated movie going audience. Also recent documentaries like, *Won't You Be My Neighbor?* about Mr. Rogers and *RBG*, the story of 85 year-old Supreme Court justice Ruth Bader Ginsberg, speak to a harkening back to a time of more innocence that many still yearn for. *Sugar* can serve as an opportunity to rally seniors to reinvigorate themselves and take up activities that are both social and healthy. Opening up a bakery is certainly one of them!

Since this movie is being self-marketed by the filmmakers, they are going to have to be strategic and proactive on generating these publicity hits for the movie. The best bet for them is to start locally with Detroit press and work to set up interviews, featurettes, profiles, etc. Then, they may set their sights bigger and see if they

can pitch a write-up or feature about the movie to a national cooking or baking magazine.

AARP is also a great partner on movies like this and they have a huge subscriber base who receive their magazine. The filmmakers are able to snag a great profile in that circulation which instantly puts *Sugar* on the national radar.

Production Publicity

Despite being incredibly busy during the production phase, the filmmakers here made sure they were covered with the basic marketing tools – photography, cast and production interviews, bios and production notes. Other than some local press, there was little opportunity to have people come watch the production, but the nature of documentary shooting does not really allow for traditional on-set visits. The most important part of this phase is to get enough interesting footage that will cut into the story you are trying to tell. The filmmakers hired an on-set PA who they charged with collecting tons of photography, B-roll and candid moments with the documentary subjects. The PA even took the initiative to film several "how-to" videos where the ladies in the documentary give step-by-step instructions on how to bake their signature pastry. These videos will be a hugely valuable asset later when the filmmakers are doing everything they can to generate publicity for the film. These can be given to local press or featured online, all while promoting the movie.

Festival Strategy

Best case scenario is the movie premieres in the documentary section of a prestigious festival like Sundance or South By Southwest. There are also number of festivals that only feature documentaries so do the research and submit to them all (The Documentary Film Institute, Hot Docs, AFI Docs). Without a doubt, any of these festivals will provide the proper opportunities for exposure and hopefully a sale to an indie distributor or a streaming service, since the odds are long that some company would acquire the movie beforehand.

If you decide not to go with a distributor based on the offers on the table, then you are entering self-distribution, and in the case of this chapter, the self-publicity option. Here the director and producer become the focus of attention and if your subject is compelling enough, then she will join the bandwagon as well. Assume you have no budget to do any publicity outreach but again, it is about anticipation and making sure you still build whatever part of your marketing toolkit you can. We will discuss this further in the Alternative Distribution and Marketing chapter (Chapter 17).

Release Publicity

If the movie ends up with a distributor willing to take a theatrical risk, then the publicity opportunities are quite good. Of course, the movie has to garner reviews

that are strong enough to help book the talent and continue to expand upon the social media community you started to curate during production.

International Publicity

While the likelihood of international sales of our movie facing many hurdles, one thing about the movie that may help its sales potential is the food aspect. Certainly, bakeries are a staple of the worldwide desert and coffee house scene, so a series of television sales would be in order. Theatrical would be unlikely and there would be no need for the cast to travel.

EXERCISES

1. What is the most important aspect of publicity? Describe it. What aspect of your movie does publicity have absolutely no control over?
2. Describe how you would get your cast to talk about your movie
3. What are the most important elements for helping to sell *The Tunnels*? How do you publicize a movie like *K2TOG* when it has a completely unknown cast, or does it? *Sugar*, being a documentary, also does not lend itself to a traditional publicity campaign. What is it about the subject matter that will still give the Marketing team a lot to work with?
4. Create a publicity plan for your film that includes the following: List of assets you will collect on set to use in publicity later, list of on-set visits you will try to secure, list of publications (especially specific or niche) that you will pitch articles to. Also, consider if your film will have a screening/premiere and what kind of press that might generate. Finally, consider the cast and you the filmmakers, what can be promoted here and is anyone able to book radio or TV interviews?

NOTES

1 https://www.boredpanda.com/telekinetic-coffee-shop-prank-carrie/
2 http://www.hollywoodreporter.com/lists/10-best-marketing-campaigns-movies-939307/item/mr-robot-usa-best-marketing-939337
3 https://www.forbes.com/sites/davidewalt/2016/11/14/fox-releases-the-martian-vr-experience/#1bf276e83f94
4 https://www.safra.sg/articles_library/outrageous-film-publicity-stunts
5 https://www.nytimes.com/2016/10/28/movies/nate-parkers-past-surfaces-in-prose cutors-investigation-of-penn-state.html
6 https://www.theguardian.com/film/from-the-archive-blog/2015/jun/26/hugh-grant-arrest-prostitute-divine-brown-20-1995
7 https://www.reuters.com/article/us-oscars-caseyaffleck/actor-casey-affleck-with draws-as-2018-oscar-presenter-idUSKBN1FE2Z7
8 https://www.mpaa.org/wp-content/uploads/2018/04/MPAA-THEME-Report-2017_Final.pdf

13
Social Media and Digital Marketing
Where the Buzz Begins

As a filmmaker, digital marketing is one of the most accessible forms of marketing you can leverage the moment you begin thinking about your project. Not only is it affordable (at least some of it!) but it also provides real-time insights that can be valuable in the decisions you are facing as a content creator.

Digital marketing has evolved so quickly over the past five years that any chapter written about it is in danger of being be out of date by the time this book publishes. In order to avoid this inevitability, we have focused on the basic tenants of digital marketing, all of which have grown out of the traditional theatrical marketing model yet each having its own unique characteristics.

Nicole Butte who has had a stellar career in the digital marketing space working on a wide variety of movies from the studio to the independents currently has her own company called Digital Pep. She was also a great contributor to this chapter.

DIGITAL MARKETING DISCIPLINES

Every digital marketing campaign for a theatrical release incorporates a number of set disciplines:

- **Digital media**: Advertising purchased to run in the digital space, inclusive of both desktop and mobile inventory.
- **Digital publicity**: Editorial and earned media placed in the digital space.
- **Social media:** Marketing within social communities encouraging interactive dialogue on various platforms.
- **Digital promotions**: Extended programs that connect potential audiences with the themes and messages of your brand beyond a basic ad.
- **Digital creative**: Artwork designed and programmed for the online space.

Digital Marketing Disciplines for a Theatrical Release

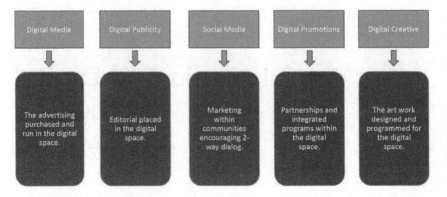

Figure 13.1 Digital disciplines

Image created with the help of Nicole Butte

If we drill down further, each discipline has a number of subsets that are the essential building blocks of the larger categories:

DIGITAL MEDIA

Video

Video ads can be purchased online, similar to TV advertisements. From pre-rolls (ads that show up before the chosen content starts) to mid-rolls (ads that show up in the middle of the chosen content), video is one of the best ways to give audiences a glimpse of what your content is. Video ads can be purchased on desktop and mobile.

Display

Display is also known as banner ads. They are typically labeled on websites with an "Advertisement" designation and are at the top, middle or bottom of the page. There are various sizes in which they are sold; popular sizes include 728 × 90 pixels, 300 × 600 pixels and 300 × 250 pixels. Although video is a great way to tell the story of your content, display gives you more flexibility to run next to non-video content. Display ads can be purchased on desktop and mobile.

Contextual

Contextual advertising is when the content of the ad is in direct correlation to the content of the web page you are viewing. Advertisers identify keywords and phrases associated with the content, and contextual advertising serves the ad adjacent to

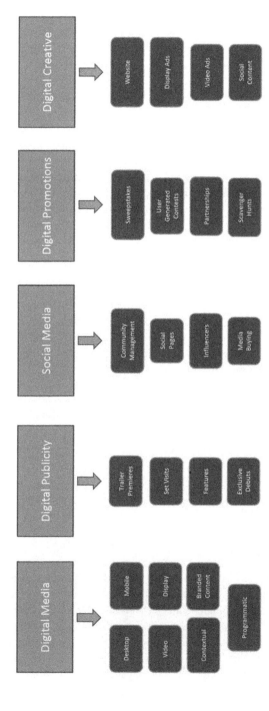

Figure 13.2 Digital media sub categories

Image created with the help of Nicole Butte

content that contains the keywords and phrases you select. Contextual ads can take many forms – from a keyword hyperlink within an article you are reading, to a result on a search query you run on Google.

Vibrant Media is one of the leading companies providing contextual advertising and you can find examples here: https://www.vibrantmedia.com/.

Sponsored Content

Sponsored content is sometimes referred to as advertorials or native ads. They provide advertisers with more "real estate" to promote their content, and can also be themed with a specific audience in mind. Sponsored content can be written articles, branded video, or even branded "hubs" containing both. Many leading publishers have established "Sponsored Content Studios" whose sole job is to write and produce content for advertisers, ensuring that the content is built through the lens of the publisher's voice and audience. Branded content is a type of sponsored content that is growing in popularity, especially with the rise of social influencers and content creators who make money when developing content for an advertiser. A good piece of branded content is engaging and entertaining, while thematically weaving in elements you are trying to sell (story points, characters, settings, etc.). Branded content is often a subtler type of advertising, but the thinking is if people like the story and trust the source it's coming from, they will show more interest in seeing your film.

The film *This Is The End* worked with MTV to create a branded content for the film themed to MTV's show *The Real World*. The cast created a parody episode of the show alongside a waitress from Hooters and a Playboy model. The conceit was a version of *The Real World* during the apocalypse. The partnership advertised both MTV's program and the movie.[1]

One of the original branded content examples, and which still holds up surprisingly well, is the BMW Films series of eight short movies produced in 2001 and 2002. Certainly groundbreaking at the time and a harbinger of things to come, they all starred Clive Owen as The Driver and were directed by eight of the hippest directors at the time including John Frankenheimer, Ang Lee, Wong Kar-Wai, Guy Ritchie and Alejandro Gonzalez Iñárritu. In this way, they created content that people wanted to watch but also tied it thematically to the brand.

Programmatic Advertising

Programmatic advertising has blown up in popularity with the rise of first party databases built by marketers and publishers. Technically, programmatic is the use of data and technology to purchase and deliver ads. One of the large benefits of programmatic is that you can buy and serve your ads based on audience behaviors, regardless of where they are. That said, programmatic is more prone to ad fraud and decreased viewability. Additionally, you are limited with the type of advertising you can buy. For example, publisher and homepage takeovers cannot be purchased through programmatic.

Taking *Philosophy of War* as an example, instead of buying ads with sites like MilitaryTimes.com and WeAreTheMighty.com, through programmatic advertising you can buy ads targeted to people who were or are serving in the military, people who have purchased books and products that are about war, people who enjoy psychological dramas, and so on. Your advertising is not contained to specific military websites, but instead you are building a "psychographic" of your target audience, and buying ads to this audience wherever they are on the Internet.

DIGITAL PUBLICITY

Set Visits

We talked about this in our publicity chapter and for the digital side, inviting digital-first publications, bloggers and/or influencers to the set to meet the talent or get an exclusive look at what's going on usually pays dividends. Digital publications don't have to worry as much about editorial "real estate" since there are no fixed pages or fixed air time – unlike print and TV. This can often result in multiple stories and features for your project, from one set visit.

Trailer Premieres

For decades the premiere of a movie trailer was reserved for the network television shows during either early morning or late night. They were then followed by availability online a few hours later and on the coming weekend, they would appear in theaters. While this practice still works for tentpole or heavily star-driven movies, the majority of the trailer premieres are now done online as many of the established magazines or network shows have stronger digital footprints now than their live viewership or readership base. Additionally, we know the younger generation is accessing entertainment content through online sites like YouTube and Facebook, over shows like *Entertainment Tonight* and *Access Hollywood*.

Exclusive Debuts

In the same vein as an exclusive online trailer launch, exclusive debuts can include pieces like scenes from the movie, a featurette about the film, photos from the set and more. In exchange for exclusivity, digital publishers will promote it to their readers and their social followers.

Features and Think Pieces

Similar to how publicity works in traditional mediums, features can be pitched in the online space to web editors, podcasters, influencers and more that tie into the overall themes of the film while connecting with larger world issues happening now.

SOCIAL MEDIA

Social Pages

It was less than ten years ago that Facebook rolled out pages for businesses. Since then, filmmakers and marketers have grown to understand the value of creating pages early for their projects. Whether it be Facebook, Instagram, Twitter, Pinterest or a host of other smaller sites, these platforms provide filmmakers with an easy way to engage with fans and provide them with content, which is then amplified through the fans and their own followers. Pages are usually maintained by the community management team in marketing and this group is making content that is expressly aimed at digital use. Consequently, there's been a growth in "social-first" content such as short videos in square or vertical dimensions, captions for sound-off viewing, and cuts that start immediately with the heart of the content in order to capture attention when someone is scrolling through their social feeds.

Community Management

Refers to the ongoing content posting and two-way dialog with fans. One of the biggest mistakes a marketer can do is to think of their social pages as a one-way channel to push out information to the fans. Not only is it critical to keep them engaged with new content but it's important to respond to them so they know they are being listened to. You can also learn a huge amount from the analytics and conversations happening on your page. For example, through platforms like Facebook, you are able to see the demographic and geographic breakdown of your fans, as well as other pages and brands your fans consume. You can also conduct polls and informal research surveys to learn more about them, what they like and whether your instincts are correct. Social is also a great place to start building a fanbase and engaging people at very early stages of your project.

Universal's *Mamma Mia 2* knows that keeping the franchise's fans engaged is important during off-marketing windows, as seen in this album of photos from the set that they maintained on their Facebook page. There is an engagement call to action with the headline, "go behind the scenes of Mamma Mia Here We Go Again with photos shared from the cast."[2]

Influencers

The importance of influencers has skyrocketed with the rise of social media. The reason we put them within the social discipline is because one of the main ways to evaluate the potential impact of an influencer is by how large their social following is. The larger the social following, the more money they charge – as seen by top influencers like Kim Kardashian West and Selena Gomez making six to seven figures for one social post. As social algorithms shift (most recently Facebook deprioritized business page posts getting served in fans feeds), the value of having an influencer

speak on behalf of your project goes up as it has more potential to be seen in a person's news feed than your business page. And as mentioned in sponsored content, if the post is produced well, it will feel less like "advertising" and more authentic from the person you follow and trust. Additionally, it's important to find influencers who are not attached to your project, providing a third-party validation from trusted sources.

Media Buying

Although digital media has its own category, it's important to note that social media also includes media buying. As mentioned earlier, algorithm shifts in recent years have started to prioritize friends and family posts in newsfeeds and de-prioritize business page posts. This means that marketers need to start buying their way into a fan's newsfeed. There was a time when anything you posted on your page would be seen by over 50% of your fans. Today the percentage is closer to 1% and continues to decrease. The only way to ensure your content gets in front of your fans is to spend money promoting it, which is what a media buy will do for you.

DIGITAL PROMOTIONS

In much the same way that promotions are negotiated for when your distributor buys traditional media space, the same idea applies here in the digital world where a strong media buy would reap additional opportunities to promote your brand. Digital promotions are not always linked to a media buy and can be negotiated using in-kind marketing or a fixed fee.

Sweepstakes

A prime example of one of the oldest promotional gimmicks now transformed to the digital world. These include "enter to win," participatory contests, gaming contests and more. The content and brand being marketed is often integrated into the artwork, the copy and the prizing.

Omaze is a popular company that cleverly combines Entertainment/Celebrity sweepstakes with cause-related programs to build awareness and generate good-will for the film. Movies frequently partner with the site and record videos of the cast encouraging people to donate to a cause in exchange for set visits, walk-on roles or premiere tickets. An example is the *Star Trek Beyond* campaign, which was heavily promoted by Paramount.[3]

User-generated Content

There is nothing more fun that seeing your movie being embraced by your community of followers who take it upon themselves to create their own posters, trailers, reviews or post feedback and comments. This implies a sense of *ownership* on behalf

of your movie's fanbase, which is perhaps among the strongest selling elements you can earn.

Additionally, you benefit from authentic endorsements that are shared with the users' own personal followers. User-generated content isn't always developed organically, and a good marketer can blend tactics like contests and media buys to activate more participation.

The music video mash-up for *Pitch Perfect* is a great example of a marketer combining the power of an influencer to induce user-generated content. The video edits together fan-made clips of themselves singing the song and combines them with footage of the cast. The effect is brilliant because not only does it highlight individual users allowing them to share and promote the video, but it also ties in thematically with the movie.[4]

Love, Simon developed a tool to make the creation of user-generated content easier for fans to develop and share with their followers. On their film website, there is a fill in the blank format where you address a message to a friend and pick from a variety of things you'd like to say. Once completed you get a moving postcard with a sweet message that you can share on social or download.[5]

Partnerships

Digital partnerships can take on many different forms, but it's usually when several of the above tactics are activated on, triggering a larger partnership.

For example, films and car manufacturers are often a marriage made in heaven. When Lexus and Marvel's *Black Panther* partnered up, they created everything from product placement in the film, commercial spots on air and online, and an entire website dedicated to the partnership.[6]

DIGITAL CREATIVE

Digital is a unique medium, in that not only can it be both static and moving but it's also interactive and sharable.

Website Design

While many movies only have a small website that functions more as a landing page for basic information about the movie, the bigger tentpoles have extraordinarily elaborate websites that function as immersive worlds on their own. Unless you are a tentpole movie that can command visitors to your site, it's smarter to put movie content where there is an already established community, rather than try to push people over to the movie website. This is one of the reasons there's been such a growth in social media for films – from the development of brand pages to the dedication of community management as a full-time job at studios.

Display Advertising

Both animated and static, these typically are based off of assets like the key art and trailer, trans-created into display ad sizes that are purchased on sites. For premium price tags, takeovers, roadblocks and skins can further brand your content and are fixed on pages typically in a 12- or 24-hour increments. Movie studios often do this with sites like IMDB and Fandango.

Video Advertising

From 5 sec to 60 sec and beyond, the use of video as a sales tool greatly increases the likelihood of engagement on behalf of the casual visitor, and is one of the best ways to show off your content in its original format.

Social Content

As the development of standalone websites decreases, more and more time is being dedicated to creating original content for social media. "Social-first" creative best practices are evolving, but include tactics like shorter form video, captions on top of videos, and square or vertical video to control more real estate in a person's news feed.

Wes Anderson is a great example of a filmmaker who is always thinking about marketing and capturing content as early as the pre-production phase. From this introduction shot announcing the start of production for *Isle of Dogs*[7] to these set tours and behind the scenes featurettes for *Moonrise Kingdom* created using content secured during shooting[8] and[9] – these were all pieces produced and developed for online.

Jumanji is another example of a film that thought beyond standard trailers and TV spots. Leveraging musicians Nick Jonas and Jack Black from the film, they created this funny music video spoof that Nick Jonas debuted on his social pages to his millions of followers.[10]

DIGITAL MEASUREMENT AND DATA ANALYTICS

A rapidly growing area in web based research is the use of data analytics. The web provides a great way to research and track who your target audience is, to understand how they are responding to your content, and to get early insights into whether they will pay to see it. There are several ways to measure this. We talked about this in greater detail in Chapter 9 on market research but here is a brief recap:

Research Companies

Companies like Screen Engine employ online surveys to help studios research for various elements of the marketing campaign. From target audience to media consumption,

these companies recruit a large sampling of participants from the web and then generate reports based on the responses that can help shape the marketing campaign.

Social Listening

With dialog going both ways in social (studio to fan; fan to studio), there's a lot that can be gained from listening to your fans. Whether helping to pivot a specific theme that is getting negative traction, or leveraging off of something that is trending, social listening companies like "ListenFirst" and "Fizziology" can help track social conversation and provide ongoing reports and benchmarks against comparable films and themes.

Proprietary Reporting

Almost all the major digital platforms have their own proprietary reporting tools that can be incredibly useful in understanding what your audience is doing. From "Facebook Insights" where you can dive into the type of people who are engaging with your content, watching your videos or sharing your posts, to "Wikipedia Web Statistics" where you can see how many people are searching for your film page or the themes of your film, this can be incredibly useful data to help shape or pivot your marketing. And using Google Search Trends, marketing can identify which areas around the country have been high density searches for a particular movie or subject. These search trends also illuminate where interest is resonating with local audiences.

To cap off this chapter, we spoke to Amy Spalding, Senior Manager, Digital Media, at the Sheri Callan Advertising Agency. Later in the day and in the evening, Amy writes, performs, and pets as many cats as she can. She is also the author of five young adult novels, including her latest, the bestselling *The Summer of Jordi Perez (and the Best Burger in Los Angeles)*.

Video is all the rage now as the basis for online engagement. It has replaced the whole idea of static advertising. Is there a new form of engagement in the future? Perhaps something more interactive?

Amy Spalding: Digital media changes more quickly than one could keep up with it, to a huge degree. As time progresses and technology advances, there are sure to be new ways to advertise and new ways for your potential audience to engage with ads. That said, in no way do I think video has completely replaced static advertising. A stunning image or artfully designed one-sheet can still make an impact. I've seen beautifully designed static ad banners make a huge impact because of the synergy of their design, the film being marketed, and the environment in which they were being advertised. Studios still spend huge dollars on out of home ad campaigns featuring static images. Video is big but that doesn't mean it's the only game in town.

When is the most effective time to begin a digital campaign for a movie? How many weeks out and why?

AS: This really depends on budget. If you have a major tentpole feature with at least an eight figure budget, you may be dropping teasers six, nine, even 12 months out to build anticipation. For smaller films, there isn't the luxury of a buildup, and the campaign may likely be marketing a title that hasn't yet been heard of the way a Captain Marvel has. In these cases, advertising is typically started only a week or two out, with maybe a brief trailer boost using social media (as well as publicity) when the trailer goes live initially. There is no "most effective time" because depending on budget, timing, cast, etc., it's always a moving target. The most important thing is to look at budget and goals and spend effectively so that the campaign has a chance to make an impact.

CASE STUDIES

Philosophy of War

The important thing to remember with this movie is to hold it up and keep it on the pedestal in respect not only to the subject matter but to the talent that joined in making this difficult to market movie. And with studio backing, we would anticipate a strong budget to support the efforts.

Digital Media

With a striking poster that works on a desktop or a small mobile device, the message of the movie should work at any size. This will be coupled with banner review ads that will showcase the great reviews the movie will have received which will continue to remind audiences how important the movie is and that it should not be missed.

Digital Publicity

With the willingness of the cast to participate in any number of online discussions and chats from Facebook to Reddit to curated community groups, the dialogue about the issues the movie represents will always remain at the forefront. While this poses a bit of a risk that audiences may be turned off by the "importance" of the movie versus the entertainment value, good media training of the cast should allow them to navigate these perceptions.

Placement of behind the scenes making-of content pieces as well as short form stories that will embrace the themes of the movie will be placed on and promoted to selected sites where the psychographics of the audience will be matched.

Remember that we learned in the Chapter 12 Publicity that our cast in this film is reticent to do much press. That is a serious issue for the traditional publicity team.

Here, there is some potential wiggle room as online Q&As are easy for cast to do and can be done from wherever they are currently.

Social Media

The cast for *Philosophy of War*, while A-listers, are not active on social media. They will not be posting or tagging content for the studio, which is another challenge. But here is where the movie's web presence can shine. The socially active groups that will embrace this movie should be very varied and include war veterans, organizations dealing with the effects of PTSD (post traumatic stress disorder), self-help and healing groups and a host of others. A number of the conversations inside these groups could include the talent as well. On the entertainment side, the awards sites should fully embrace this movie as a potential nominee and will continue to track the film's fate at the box office and as it is measured against other competing films opening during the crucial fourth quarter of the year. Movies like this will generally create a strong community that will rally around it.

Digital Promotions

While there is the potential to employ user-generated content in the marketing – shared real life stories – the studio will be careful not to use any cheesy promotions that could undermine the importance of the movie. At the same time, ticket-giveaways and special screenings for interested groups would be in order.

Creative

The movie will have a strong sense of time and place from home to the battlefield and these images should all lend themselves to interesting online creative. While there will always be a central image that defines the film, the use of unit photography will all serve to locate the movie as special and not to be missed.

The Tunnels

Digital Media

If there is any of our four case study movies that is ripe for digital advertising, it is this one. Considering that the target audience has fully embraced all things digital, the challenge in placing media on this movie is where *not* to go, as there are a plethora of sites where the content and story of this movie will resonate. Such classic websites as "Bloody Disgusting," "Dread Central," "HNN (Horror News Network)" and scores of others will all eagerly welcome paid media on behalf of *The Tunnels*. At the same time, given the subject matter of the movie and the focus on a female teenager as our protagonist, many general interest teen-targeted sites would be ripe for placement. And last, with its pagan ritualistic themes, the movie lends

itself to editorial content and advertising on the many sites devoted to these practices and mythology all of which are essentially "off the entertainment" pages and should attract even non-movie fans due to the subject matter.

Digital Publicity

With the line between editorial and advertising not as clearly defined as it is with major news and opinion maker sites, many of these sites will happily embrace publicity turns in exchange for advertising. And since most of these sites are entertainment oriented, being able to host a cast member, regardless of how well-known or not they are, is usually considered a coup. The bigger issue of course will be to convince the actor's publicist that an interview with the site is worth doing!

Social Media

As we outline in our positioning statement on *The Tunnels*, a few of the actors already have strong social media followings based on their television work so being able to help migrate their existing fan base to the movie genre should not be too difficult. Fan bases are eager to follow their stars wherever they go, particularly younger ones, and the issues of change of genre and character won't be an issue. The world of social exists for movies like this as do the social media agencies that will be working on your film.

The filmmakers wisely worked alongside the studio to capture a plethora of assets on set that could be banked and used later. They scanned the tunnels set to create a VR experience and a mobile game. The cast posted during shooting and gave their fans a sneak peak of the film. When it's time to release the first trailer for the film, the cast puts it out on their social channels first giving their fans a "first look." The trailer spreads quickly from there as fans post and share with their friends.

This movie is also perfect fodder for a clever stunt. The studio takes over an abandoned train tunnel in New York and creates a haunted house of sorts full of jump scares and spooky encounters. They bring random people down and film them going through the tunnel on night vision cameras. The stunt is then edited to highlight the funniest reactions from terrified people and put online. The cast of the movie also helps to push it out and it's quickly picked up by the genre press and shared as well.

Digital Promotions

With a considerable of dollars committed to ad placement, this will open up many doors on these sites for promotional opportunities including chats, and special screenings for sweepstakes winners and cross promotions with radio and their digital extensions.

The studio sets up multiple special event screenings around the world (held in actual underground tunnels) and they use digital to push out the sweepstakes and

get people to enter. Not only are they exciting people about the movie, but the studio is able to track who is entering and start to get a peek into their audience for the film. They use this information to specifically target like-minded people with a social media buy on Facebook.

Creative

Here again, the use of strong images online will root the film to its potential audience. As we discussed in the creative chapter, horror/thriller movies whether they are PG-13 or R lend themselves to striking creative. The digital creative team creates a series of page take-overs and digital ads that feature the iconography from the small town cult and position it as a mystery.

They encourage fans to click to learn more and direct them to a site built just to profile the history and details of the cult as if it were a real thing.

K2TOG

Digital Media

Given the smaller nature of this release, the movie will have a gradually rolling media buy that will increase with the number of screens from week to week based on success. With the hope this movie will be driven by reviews initially, the more film specific sites like IMDB, ComingSoon.net, etc. will be targeted. Once the movie establishes itself the push will be to widen the audience outside of the traditional art house crowd to include knitting communities, Pinterest, seniors and certainly the AARP membership base. Another big surprise will be the hipper younger female audience who at first may shy away from the film, but eventually they will embrace it as well as at its core it is a story about two sisters. The buy here will be very strategic and very targeted.

Digital Publicity

Not the easiest sell here, but certainly our two twin web stars should be great company to have on chat sites, Facebook, and the digital extensions of some of the morning television talk shows and magazines including *People, Seventeen* and *US Weekly*. The creative team will use the funny banter and natural chemistry between the leads to try to set them up with interviews. They distributor also targets websites that have a dedicated crafter following like, "Apartment Therapy" and they set up an apartment tour for the stars to show off their Brooklyn home.

Social

With their already established social media presence from the followers of their webcast, the twins are able to ramp up their fanbase into a frenzy. Certainly not

necessarily the traditional art/specialized crowd but we do see a lot of female college students suddenly paying attention and this would be fanned by live streaming of some selected college screening events. The distributor is pleased to see that audience is broadening for the film and they expect that the movie will probably play out 70/30 female to male, which will be just fine.

This film isn't necessarily something that lends itself to a viral stunt. However, it does create great opportunities for knitting tutorial videos hosted by the two leads and superstar knitters. The filmmakers create these videos and roll them out on YouTube every couple of days. The videos get a great response and both endear the stars to new fans as well as get the word out about the movie.

Promotions

Another stretch here because the movie will take time to get going and any commercial tie-ins with knitting, fabrics companies, etc. could be too late but you have to try and see if anything comes up. However, once the movie starts to go wider, the distributor is able to set up in-theater promotions, radio promotions, even a selected cable station like AMC or IFC can throw something together rather quickly once the movie even goes modestly wide.

They also use the knitting tutorial videos to create a contest where people are asked to knit the craziest thing they can think of and send in a video. The winner will get tickets to a private screening of the film with the two stars.

Creative

The digital media buy on this movie is small and carefully targeted. The distributor knows that they will need to grab people's attention quickly. They create an eye-catching title treatment for the new title and short, very funny video clips to promote the comedy and the heart in the film. This isn't a big, splashy tentpole or the sort of film where people will seek out the trailer, so the distributor knows they will have to grab people's attention quickly.

Once the reviews start to come in, they cut those into the digital spots as well to laud the positive response to the film.

Sugar

Digital Media

This documentary will be self-distributed, which means a very limited media budget, probably in the area of $200K. This precludes all television with the exception of some geo-targeted cable buys based around the zip code of the theaters playing the film. Instead, the advertising will be a mix of digital and even some radio, like NPR. Expectation levels have to remain low and the theatrical release has to be looked at as simply setting up an awareness platform for subsequent windows,

185

which we will have pre-negotiated. Among the digital sites we would look at are ones devoted to cooking, baking, seniors, etc. as well as prestige/lifestyle sites that will likely have an art house following, like *The New York Times* online or Goop.com.

Publicity

Here we have some excellent opportunities to augment our hard media dollars with chats and posts featuring our cast on multiple platforms. The filmmakers cleverly scour Facebook and Instagram for superstar baker bloggers and they reach out to ask for help promoting the movie. They don't have a budget to pay the influencers, so many will decline to promote. But, due to the wonderful message in the film and it's life-affirming tone, there are some online baking stars who voluntarily will cross-promote the film. They invite on the ladies from the documentary for a special baking lesson and post it on their channels. The reach is major and it will drive audiences to watch the film when it is available on streaming.

Promotions

This is a documentary so brand integration is not on the filmmakers' minds. However, there is potential to partner with a local news channel to hold a small baking contest where the winners will be able to attend the Detroit premiere. The contest is filmed by the local news and judged by the women in the movie. It's a clever piece of publicity for the film on a local level (and it's free)!

Creative

A small budget will mean a dedicated agency that simply loves the project and will want to contribute their resources for a low fee. The filmmakers create a very small package of online ads that simply focus on *Sugar* and the other women in the movie. The ad buy here is very local, so they only need one or two pieces of workhorse creative.

The filmmakers take to Etsy to find a graphic artist who will create a poster and title treatment for the film at a very reasonable cost. They will provide these assets as well as clips and stills from the film for the agency cutting their digital spots.

EXERCISES

1. *K2TOG* has the look and feel of both a millennial sell and an older audience sell depending on where you want to focus. What are the individual marketing strengths of each direction with this film and how would you exploit them online? With the two leads coming from the web/podcast world, how do you tap into their existing audience as a way to start building the target and how do you expand upon this small fan base?

2. *Sugar* has a number of themes that could appeal to multiple audiences. Name three of them and how you would find the audiences for each online?
3. Come up with a stunt for the movie *The Tunnels* that you think could go viral. How would you set it up and get it promoted online?
4. Make a list of websites and YouTube personalities that you think would align well with your own film. Why do you think these would be good potential media and creative partners for your movie? How will you pitch them on doing interviews or a cross-promotion?

NOTES

1 https://www.youtube.com/watch?v=R9ZRIFNRdsk
2 https://www.facebook.com/pg/MammaMiaMovie/photos/?tab=album&album_id=10154715855 332665
3 https://www.omaze.com/campaigns
4 https://youtu.be/JYtYCNkR1Yo
5 http://www.dearworldlovesimon.com
6 http://www.lexus.com/blackpanther/
7 https://vimeo.com/196374066
8 https://youtu.be/j8z6b1SRJzU
9 https://youtu.be/HAZS6WRtvbk
10 https://www.facebook.com/nickjonas/videos/10154801512741642/

14

Media Planning and Promotions

Delivering to the Right Audiences

This chapter is about the third area of media, called Paid, and refers to content that your Marketing team will pay for to place creative advertising, sponsored and branded content in all the different outlets available including television, online, outdoor, radio and in-theater. The value with this type of media is that you can place as much of it as you can afford. Micro distribution companies including those of you who decide to release the movie yourself could pay as little as $50K for some social media exposure, while the studios average $40M for each of their releases. Everyone wants to control the amount of media they advertise with, but the marketing budget will determine how much will be bought.

The ability to pay for awareness is the dream of every Marketing department because paid media is the only media they can *control*. The bigger independents and studios certainly have the wherewithal to buy what their research dictates, but downside to paid media is precisely the same reason that the Marketing department uses it. You, as a part of the film-going audience, have become increasingly skeptical of the messages put out by corporate America including film companies and audiences know that because marketing people can control it, it is probably not as trustworthy as other types of messaging they have come to rely on.

As we go through this chapter we will see how Marketing departments have evolved new methodologies to give more credence to the marketing message.

Gail Heaney is currently a consultant specializing in entertainment media planning and buying for advertising agencies and studios and was enormously helpful in writing this chapter. She was formerly Head of Media for Summit Entertainment working on such films as *Twilight* and *The Hurt Locker*. She previously worked for J. Walter Thompson, The CW Network and Universal Pictures. She is a graduate of University of Texas at Austin.

She has a great perspective about the state of the media buying industry today:

> If movie marketing is a restaurant then creative is the food and media is the service. It's my job to serve the right message to the right people. If they don't like the food, they are never going back. And if I may take it a bit further, media is becoming more and more self-serve. There are few opportunities where we get to say if you want to get served, it has to be at this place and time.

What Gail is getting at here is there is no longer the ability to dictate to an audience what they should see even with the best laid-out media plan. The creative "food" is now the driver more than ever and if audiences aren't buying the creative, they aren't going to the film.

Gail goes one step further:

> I don't think finding reach is harder [eyeballs and awareness] today than when I started my job over 30 years ago. The marketplace has shifted and so do we. Our creative needs to be shorter and more interesting. That's hard. But really the hardest part is convincing filmmakers we don't need to buy the Super Bowl. We can reach more people for less money with Facebook and Instagram every day of the year.

The question then is why buy television when digital seems to be doing such a great job?

> Facebook does have better daily reach but TV is still the best way to use a :30 spot. The biggest issue is getting marketers to have shorter messages (like :5 second ads) and taking advantage digital's reach.

WHAT GOES INTO MEDIA PLANNING

Media planning involves a lot of the same tools that the overall Marketing department employs in order to come up with the proper media mix.

The Media Agency

Studios and distributors rarely buy or place their own media. Most of them partner with a media agency to negotiate the best rates, leverage relationships and handle trafficking the spots. It makes sense as the media agencies have a range of other clients and a major purchasing power that they can wield in upfronts.

The media team at the studio will oversee the agency but the relationship is truly a partnership. The agency will receive tracking reports, have access to research and

will join some strategic marketing and creative meetings. The plan for the campaign will be a constantly evolving target and both the in-house team and the agency team will have to react quickly to unexpected events (like cancellations or suddenly available events). Some of the big firms include MediaCom USA, Omnicom Media Group, Mindshare, Starcom, Wavemaker, Initiative and Horizon. Many studios or distributors partner with full-service agencies that can provide logo design, branding, research, creative and media planning.

Determining the Spend

Every movie is assigned a budget for the media spend and this is no arbitrary number. There isn't a set formula for determining marketing and media spend. Rather, distributors look at a number of factors to come up with the number.

1. The SWOT Marketing Analysis (Strengths, Weaknesses, Opportunities and Threats) run by the Marketing department gives an overall valuation of the film's potential.
2. Research – including the results for the test screenings, trailer and TV spots.
3. Assess size of target audience (does your movie appeal to a broad audience or only one segment such as young females)
4. Gauge role of geography – is the movie being distributed nationwide or is it a slower platform launch, market-by-market over a period of weeks.
5. What are the box office goals that have been set by the green light budget process and, through evaluation of similar films, how much was spent to reach those box office goals? There are a number of companies that are available to supply this information like ISPOT or Nielsen AdViews.
6. What is the range of the overall available funds? This speaks to how much of the entire budget should be spent to open the film and how much should be held back to continue to support it. The rule of thumb is wide releases spend almost 100% of their media budget to open, while platform releases spread it out over time to support the subsequent weeks as the screen and city count builds. At the same time, it is very important that the first weekend is sufficiently supported to deliver a high per screen average at the box office, assuming all the other factors work out including reviews and strong word of mouth.
7. For wide releases, determine cost of awareness based on comparable titles launched during the same time of the year. This is extremely important as the cost of media varies from season to season and calendar quarter-to-quarter. The fluctuations in the cost of media could be as much as 25% of the overall budget depending on the opening date. From most expensive to cheapest, the media quarters look like this: Q4, Q2, Q3, Q1. We will cover this more in our distribution chapter, but suffice it to know here that holiday periods and school vacations greatly impact the cost of media.
8. Budgets are then evaluated to make sure they are able to deliver the targeted Reach (how many eyeballs will see the campaign) and Frequency (how many

times will the audience be exposed to the campaign) through television and what are the targeted number of impressions on digital.

Defining the Target Audience

After budget is determined, the next step is to figure out who, specifically, we're going to try to reach. Furthermore, we need to figure out *how* we're going to reach them.

1. Start with the marketing objectives. (Who is most likely to be interested and recommend your film?)
2. Determine who are the frequent movie goers that are interested in your films and likely to attend opening weekend (younger audiences, African Americans, Latinx moviegoers and those who live in NY and LA are most likely to attend opening weekend). Look at past box office performers, research screenings, trailer tests and TV testing.
3. Discover if there is the secondary target that is interested in your film (who is the most likely person that the primary audience will bring along).
4. Evaluate the interests of the target audience. (Are they parents, dog owners, live-theater or concert-goers?)
5. Discover where they live. (Look to genre or comparable title box offices results.)
6. Dig deep to see if there is a segment of the target audience that can be defined as an "influencer", also known as avids – an audience segment that not only is definitely going to see the movie but will talk about it online through social media to their followers.

Just like you will spend time getting to know and understand your characters when writing and developing a script, so too must you know your audience. A media executive needs to understand everyone who may potentially buy a ticket for the film and not just their basic demographic data. We need to know where the audience lives, what they do for fun, how their lifestyle looks, what they watch, listen to, love, wear, eat and drive. The more you know about your audience, the easier it is to find them and serve them advertising for your film.

Setting Geographical Guidelines

We talked about the idea of a wide or platform release, but now the geography of the movie has to be taken into account.

1. Is the theme of the movie more conducive to big city markets like New York, Los Angeles or San Francisco or is there is a heavy up in the middle of the country where faith-based or car enthusiasts live?
2. Evaluate if the genre has a history of over-performing in certain markets. For example, family and horror over-perform in markets like New York, Los Angeles, Chicago, Dallas and Houston.

Determining Seasonality, Timing and Opportunistic Buys

Media executives will look at the time of year when the movie is released and determine opportunities that can be leveraged in that timeframe.

1. Most movies begin advertising with a trailer of the movie usually launched three months weeks prior to release and, budget allowing, a second trailer six weeks up to release.
2. Compare flighting of films from competitive studios releasing on the same date. [Note: The duration of media unfolding is referred to as a "flight" so the entire campaign is called a "media flight."] This analysis is helpful in determining the SOV (Share of Voice). You may find if the budget is limited, concentrated digital and TV schedules closer to the release date is the best decision. Or you may find that if budget permits, getting ahead of the competition may work best. Whatever works best, it is crucial not to plan media in a vacuum. You have to look at the other movies releasing around you, especially those targeting the same audience, and plan how you will capture those moviegoers. In the current atmosphere, it would also be wise to be aware of any major debuts on the streaming services as well as significant videogame releases.
3. Radio tends to air three days before the release of the movie to create a sense of urgency and to get the title stuck in people's minds so they remember it.
4. Newspaper tends to run in New York and Los Angeles markets the Sunday before opening weekend and on the Friday, Saturday and Sunday of the opening weekend. However, more and more, newspaper advertising has pretty much gone away except movies that may appeal to an older audience who still read newspapers or during special times of the year like the awards season when older voters are targeted in print.
5. As we already said, seasonality can affect pricing. The 4th quarter tends to be the most expensive for television buys.
6. Opportunistic buys can be defined as special programs that are only available on an annual basis – a season premiere or finale, the Super Bowl or a special music show. These usually come with a high cost premium but are considered very valuable if the audience is right as the ratings are huge. Of course, with independents who are more involved with smaller platform releases, these are way too expensive to consider.
7. Some movies hold dollars in a reserve to support their movie after opening weekend. This is called "holdover" or "Boost" advertising.
8. Political windows can affect advertising pricing. The law requires that political candidates receive the lowest prices in broadcast (TV and radio). Ads may not run as scheduled as political advertisers also have priority of available inventory insure equal opportunity to get their messages across. A movie advertiser in tough political markets may find looking for local alternatives in heavy political months such as October and early November.

Ways to Buy Media

Media of all types can be expensive and there are lots of ways that studios and distributors acquire this real estate.

1. Upfront – This is an event that occurs every year where the TV networks roll out their show slate and try to woo advertisers. Studios will commit a certain amount of media dollars during upfronts which they will split-up among their films. The prices are better to buy during upfronts rather than waiting to buy individual ad units on shows later in the season. Furthermore, higher profile programming will sometimes sell out in the upfronts and buying ad space here is the only way to secure a spot. Dollars are leveraged for the year and broken out by each film's needs. This upfront method can be done for all media including TV, outdoor, digital and radio. Media companies and the studio agree to a certain level of spend to firm commitments and limited cancelation options. In exchange, the media company provides guaranteed delivery, added value (integrations, time exchange for exclusive content), preferred programming and time slots.
2. Scatter – This is a term that means buying national media outside of the upfronts. Here you are picking individual programs or events and buying spots, rather than pre-negotiating a slate of media placements. Dollars are leveraged on a quarterly or per-film basis allowing for flexibility. Independent distributors who do not have a full year-long slate usually buy media this way – it is more expensive since it is bought throughout the year and not in advance as in the upfront, and not all programs that they may want to add to their play could be available.
3. Spot – Each local affiliate of the bigger networks has its own time slots which it can sell. So, if your budget is too low to buy across the country, you can also buy media market-by-market. Spot buys are frequently used in awards campaigns where the studios only really need to reach people in New York and Los Angeles (Academy voters). It would be a waste of money to run a national ad in this case.
4. Opportunistic – This means that something has become available and you can jump in to buy it. As with scatter, this method can be more expensive. However, the studio receives the most flexibility and ability to spend dollars when needed. On the indie side, there may be some big shows that become available throughout the year which may not have been available in the upfronts. For example, let's say the Los Angeles Dodgers unexpectedly make it into the playoff race. This is an opportunity to buy a massive game with a hard-to-reach male, 18–49 audience. Most (if not all) of the studios will be fighting for a spot in that game. You might have to pay more, but the reach is worth it.

The Role of Tracking in Media Planning

We discussed research and theatrical tracking earlier. To recap, tracking services survey an online audience three times a week to gauge their awareness, interest and if

the movie is considered a "first choice" against all the films coming in the market-place over a rolling four-week period. Media planners use this four-week period to build interest for a movie as it relates to putting paid media into the marketplace and scale it by a percentage of the media budget over this period.

You may ask why is the four-week period such a magic amount of time – why not ten weeks or two? Tom Donatelli, Vice President of Media Services at S Callan Advertising, has this to say:

> Traditional advertising campaigns for non-blockbuster films often begins 3–4 weeks prior to the release in order to allow for tracking of awareness and intent to see the film. Significant early awareness would come in the form of trailer plays in theater and trailer launches online. During the course of a 3–4 week flight, a distributor can learn more about who the film is really starting to appeal to and potentially adjust the media mix and creative messaging accordingly. Additionally, talent publicity appearances, film reviews, and news stories about the film can begin 3–4 weeks out, allowing the paid media to impact the publicity and the publicity to impact the paid media.

Over the years, research has shown that this is the period when audiences start to focus on their movie choices and while tentpole awareness and tracking can be huge from the start, many other movies need a shorter and more concentrated run-way to spread their budgets in an efficient manner.

Media Rotation

In a movie campaign, the media doesn't hit all at once; rather, it has to roll out in waves. Usually this rotation begins with a :30 and/or :60 second TV and digital burst prior to the movie coming on tracking four weeks prior to the release date. This initial burst helps ensure that amount of media is put out earlier to establish awareness and in effect set a benchmark from which to grow awareness and interest. The role of these early spots is to establish story, cast and promise. As the release date gets closer and usually inside the last ten days, the content moves to :15 seconds and even :10 second spots, both on TV and online, which serve more as a frequency reminder that the opening date is close. These spots are known as "closers."

Some advertisers say the :30 second spot is dead but most distributors think otherwise. Also, there are so many ways to re-purpose a television spot digitally, that it will never go away as its main purpose is to contain the essential building blocks for shorter versions.

A typical media percentage of weight that drops over this four-week period is 25% four weeks out, 20% three weeks out, 25% two weeks out and 30% during opening week.

Another important part of the rotation is serving up the right spots to the right people. Using the research results, the creative team will identify TV spots that

work better for this or that audience. For example, one ad might perform well with younger males while another one moves the needle for older females. The media, research and creative groups will coordinate to make sure the right spots get in front of the ideal audiences.

Promotions and Added Value

1. This is where buyers (studios or distributors) negotiate beyond the cost of the media. They may ask for additional inventory to run a screening program (standard procedure in a radio buy) or ask for time to run a "sneak peek" for a content piece like a trailer or sweepstakes.
2. Media vendors tend to offer more value or better placement if the studio provides an exclusive look.
3. Other added value opportunities may include a research study (such as a YouTube Brand Lift Study), sponsorship of a program or an event with subscribers and viewers (such as a Comic-Con party featuring the movie).

Joe Whitmore was formerly the EVP, Worldwide Marketing and Creative Content at Paramount Pictures. This was a very unusual division as most of the studios have three or four people who do this job, and located in different departments as well. Joe has since segued to Co-President of Marketing at Sony Pictures/Screen Gems. In his role at Paramount, Joe worked on many of these high-profile promotions, integrations and added value opportunities.

Joe Whitmore: At the upfronts, when the studio does the big media buy, the promos are big bonuses that the networks throw in. So the promos are technically free, but we pay the production costs and negotiate where we want to put it – one or two weeks out, week of release, etc.

I concentrate on three buckets:

1. All the publicity stuff that we have always done – Electronic Press Kits, film clips, behind the scenes footage, sound bites – all the publicity content that we give to journalists around the world so they can cut pieces on our movies
2. Broadcast Promotions – once media has done all their buys and get the added value of promotions, they hand the promotions to me and I do the creative for them. This is my favorite part. I work with Bravo, ESPN, MTV, etc. to create customized spots. For *Baywatch*, we had Olympic Gold Medalist swimmer Michael Phelps do an audition for the movie with Dwayne Johnson. It was a lot of fun. Where this has the most opportunity now is international where channels haven't done that, but it is starting to happen now.

> Sony (Pictures) has a deal with Manchester United, the soccer club, where they do three spots a year. They don't pay the channels like we do here, but they pay the club directly. This type of branded content is now getting bigger all over the world

3. The third bucket is the creative content bucket. We do special shoots for every department including exhibitor relations, publicity, all the digital content we do for Instagram, Facebook, viral videos, etc. If the departments use the movie, then they do it themselves and if it is using special shoot footage, then we do it.

When you do a special shoot you feed everybody so there is no reason for digital to have a special content person, for exhibitor relations to have a content person, for home entertainment, or any of the other departments.

The direct-to-camera talks that talent does looking at the camera are very effective – those are the types of things you put on Snapchat, put in theaters, etc. That is the one thing that filmmakers should push to get done.

My favorite spot was the one we did for *Arrival* – which was really hard to get women interested in because it is male science fiction, but it is really about family and communicating. So we found people who didn't speak the same language and locked them in a room – and I didn't know what was going to happen. They had to figure out what they had in common. Some women realized they were both pregnant, another two realized they both played the piano and towards the end, a Japanese man and a Chinese woman could not figure out what they had in common – we knew what it was – finally after a little while, we rolled a white board in. The Japanese man drew his family and crossed out his dad and the Chinese woman started to cry.

And that's where we transitioned into the (message) that the ability to communicate is a matter of life and death. So the whole beginning of the spot had nothing to do with the movie – it was just people in a room trying to communicate – and then it went into footage from the movie at the end.

Post Buy Evaluation

Media buyers and planners conduct a post buy evaluation to make sure the buy was executed as planned.

1. For TV, buyers compare delivery of the target rating points (TRP) vs. the planned TRPs. If the buy is guaranteed as part of the negotiation the buyer will receive Audience Deficiency Units (ADU) in exchanged for the under-delivered TV time. In basic terms, this means that when we negotiate a deal we are guaranteed a certain number of eyeballs. If the show/network fails to deliver they make it up to us by giving us ad units in other shows.
2. For digital, any missed impressions would be rebated or "made good" during or at the end of the flight.

3. For radio, buyers require affidavits to ensure the radio commercials aired on the correct days and time of day.

So, let's assume you have delivered your film to your distribution partner, and the media department has begun to build a media plan to support the release. Here are the key media areas:

Broadcast Television

The most obvious one is broadcast television during pre-scheduled programming of national shows. These are the "appointment television" shows that people tune into on a weekly basis and are generally found on the traditional networks: CBS, NBC, ABC, and Fox. And while millennials and other "cord cutters" have significantly cut into this, the amount of news that is being watch has soared in 2017 across all platforms including broadcast, cable and radio.[1]

The most popular shows are watched by a large segment of this audience at the time of broadcast, through DVR ownership and recording have made it far less important for these shows to be seen at point of broadcast. Nonetheless, this is still by far the most expensive media that can be bought as it has a national footprint. This kind of buy is usually called a "shotgun" approach to media since it reaches a very wide audience that many not much in common other than a particular show. The studios and bigger independents buy network on a regular basis for their releases as they are made to appeal to the largest audience possible. Smaller companies and independents tend to shy away from broadcast as it is too wide an audience reach and is a prohibitive cost on their media budgets.

Local Broadcast

These are television shows that are broadcast in local markets by independent stations or stations that are affiliated with one of the major broadcast networks. Their broadcast schedule is a mix of local programming and national shows broadcast during their own time zone. Local broadcast has real value as it augments awareness in a specific market. If, for example, your distributor was going to open your film in a small number of theaters at first, they would not buy national, but only local, as a more effective way to find their audience.

Cable

The huge number of stations that you pay for to receive and incredible variety of programming. The enormous value that cable provides to media planning is that the channels can be targeted to more specific audience interests – sports, food, reality, gossip, etc. – and are a much more effective type of media buy for movies that do not have a wide audience appeal. It can be said that cable was the first public "community" arena as it represented a way for people to

watch shows with common interests, in much the same way now that social media works.

While each channel may reach a significantly smaller audience, cable is also a much cheaper alternative to broadcast television and is the go-to option for a number of reasons:

1. Smaller companies that are releasing more specialized and upscale films can target their audience on such channels as IFP, Sundance and Bravo.
2. The studios and larger independents will use cable to target their genre fare – you can reach a horror/thriller audience on such stations as FX or MTV, or a teen audience on Comedy Central, or romantic comedy fans on Hallmark Channel.

Local Cable

In much the same way that local broadcast works, so does the option for local cable. Here a media planning team could just buy the cable network for the west side of Los Angeles, or the Time Warner network in Manhattan, or the local cable provider in any city across the country. They can further dial this down to individual shows on these cable networks. So the ability to fine tune demographics and psychographics provides a very cost effective method of buying awareness.

Syndication

The last of the standard television standard bearers is syndication, which are shows produced by any number of suppliers, including the networks themselves and offered to national and local broadcast networks to augment their programming. Think of all the late morning and afternoon shows that permeate television and you get syndication. There are no specific rules as to when they are broadcast, and certainly the local networks put them into their schedule on a regular basis. But think of *Judge Judy* and the myriad of legal related court shows and the soap operas and you start to get the idea

PBS

We mention this as a unique option and even through it is considered a broadcast network (though also available on cable), it is specific to itself in how it treats advertising. Media cannot place commercials on any PBS show. However, they can sponsor a program with a banner at the head and tail of a segment. In the case of the radio counterpart, movies can sponsor a particular show (e.g. *All Things Considered*) but the message can only be a summation of the story with cast. No reviews and no critical accolades allowed.

Out of Home

The purchase of billboards and bus shelters has always been a controversial buy for some marketers. The studios abide by it while the independents look at it as

additive depending on budget. There are arguments on both sides. On the "buy it" side, outdoor usually exists in an unfettered space – along a highway, on the side of a bus, inside a bus stop shelter, next to a phone kiosk, atop a taxicab, inside a restroom, at your gym, etc. The list has become quite long. So here you are seeing an ad for a film or television show that is not lumped together with other ads from similar platforms like it is in television, radio and even digital. When you are at a traffic light, you notice it. Animation companies really embrace outdoor because of the huge and bright imagery, which is very attractive to children, particularly those sitting in the back seat of a car browsing out the window. Outdoor is also not a measurable spend and it is similar to the "shotgun" approach of a national television spot – you are hitting a lot of people, but not all of them are your target. Further, it is impossible to say how many eyeballs are actually seeing your material other than what the agency tells you about the traffic ratio. But outdoor does linger and it adds to the overall impression that your film is "big."

A fun fact to be aware of, marketing people also tend to buy their outdoor in those areas where they know their talent lives (i.e., the west side of Los Angeles, Manhattan, Chicago, San Francisco) and even in some instances where their bosses live to show they are taking a "no stone unturned" approach.

Russell Schwartz: When I worked at New Line Cinema, the owner of the company firmly believed that outdoor was a profound waste of money. Knowing how important the outdoor campaign was to the talent, agents, managers and publicists of one of our movies, instead of buying billboards that I knew he would see on his drive home, I had to buy them in the *opposite* direction of where he lived.

On the 'don't need it" side, an outdoor buy is a luxury for the independents. Some companies buy just New York and Los Angeles to give their films a bigger feel, but the decisions on a limited budget is usually a forced choice between more cable television or that digital promotion that is directly targeted to their audience.

The New Outdoor

With the rise of digital outdoor billboards, outdoor advertising has been radically transformed so that one of the oldest forms of advertising has suddenly become the newest tech darling, used by both studios and consumer products to great effect.

Most forms of conventional advertising – print, radio and broadcast television – have been losing ground to online ads for years; only billboards, dating back to the 1800s, and TV ads are holding their own. Such out-of-home (OOH) advertising, as it is known, is expected to grow by 3.4% in 2018, and digital out-of-home (DOOH) advertising, which includes the LCD screens found in airports and shopping malls, by 16%. Such ads draw viewers' attention from phones and cannot be skipped or blocked, unlike ads online.[2]

Billboard owners are also making hay from the location data that are pouring off people's smartphones. Information about their owners' whereabouts and online browsing gets aggregated and anonymized by carriers and data vendors and sold to media owners. They then use these data to work out when different demographic groups – "business travelers", say – walk by their ads.

That knowledge is added to insights into traffic, weather and other external data to produce highly relevant ads. DOOH (Digital Out of Home) providers can deliver ads for coffee when it is cold and fizzy drinks when it is warm. Billboards can be programmed to show ads for allergy medication when the air is full of pollen.[3]

Radio/Audio

Audio, which now includes radio and podcasts, is another of those budgetary decisions. Certainly, broad commercial movies tend to make significant tie-ins with the hottest local rock stations and syndicated platforms like "I Heart Radio." But for independents, and this will go for pretty much every one of you, NPR, National Public Radio will be the only radio that your distributor will buy on your behalf.

The advantage of buying the NPR national station reach is that this station has an extremely dedicated audience, many of whom support and attend independent film. So having your film be a presenting sponsor for a show like "All Things Considered" is a big plus.

However, on the advertising front, NPR does not allow advertising in the traditional way. Your distributor cannot create a :60 second radio spot full of reviews, music, and scenes the way they would for a digital or television spot. In order to advertise on NPR, you can only be a sponsor of a segment and your description of the film must be as dry as possible.

For example, here's a text of a sample ad on NPR:

> This portion of *All Things Considered* is being brought to you by *Three Billboards Outside Ebbing, Missouri*, the story of a search for an elusive killer starring Francis McDormand, Woody Harrelson and Sam Rockwell, written and directed by Martin McDonagh. Now playing at select theaters nationwide.

Ads like this are designed to create awareness for the film and are betting on the hope that the arthouse audience will be intrigued enough to pursue more information about the film and will be exposed to trailers and clips that way.

Special mention also to the satellite radio company, Sirius, who not only accepts advertising on certain stations, but will even go so far as to create specially placed content that may be exist for a short period of time which is relevant to your film. Of course, getting your audience to find it is another matter entirely, but it's all about targeting.

While podcasts have been around for a while, they have become increasingly popular with younger audiences who are drawn by the old radio "soap opera"

qualities and deal in a wide of variety of subjects from murder mystery, true life crime, news, personalities and web series.

How do you determine the media mix?

- By genre.
- By budget and by impact (i.e., studio vs. indie).
- By strength of social media reach (includes the cast, influencers, etc.).

TYPES OF CONTENT

The length and scope of adverting content has evolved significantly over the years, but at the same time it is all audio visual and firmly rooted in the DNA of your movie logic. For decades the go-to advertising format was the :30 and :15 television spot. The :30 second spot was the workhorse and helped set up the characters, story and plot, while the :15 second spot was more of a recap of the first two. Normally the :30 second, and even :60 second, spots begin to air starting four to three weeks out from opening date. The :15 second spots ran closer to the opening date, the assumption being that by a week to ten days out audiences knew the significant plot points and having a shorter spot to run closer allows for the advertising to run more frequently for a lower cost per spot. These spots are known as "closers." Additionally, the use of: 5 second "bumpers: or spots that appear either in a corner of a program or immediately above or below the frameline has become increasingly important as part of a media mix.

Let's now discuss what the objectives are for each type of media spend:

What a Network Buy Accomplishes

Buying media on a national level means blanketing the country with a spot that will reach an enormous number of eyeballs. Network television is only viable when a film is opening in a wide release or it enters wide release territory after a few weeks if it starts slower. The network shows that are bought are usually all highest rated ones and therefore the most expensive. It is not cost effective – the cost per eyeball is the most expensive. It gives the perception that your movie is a big deal and important to take notice of.

What Local Broadcast Accomplishes

These are all the affiliated network stations as well as many independents who operate in a specific market. These stations always have their own advertising space to sell in addition to carrying the national advertising, so studios use these stations to augment their national programming, for example, if they want to heavy up in some of the larger markets like New York or Chicago. Independents also tend to buy local broadcast specifically when they are only opening their films in a limited number of markets at first.

What a Cable Buy Accomplishes

Buying cable television allows you to pick and choose the most effective networks and their specific audience demographics as it related to your movie.

- Targeted demographics and psychographics, for example, dog lovers, heavy movie goers, horror, comedy or action fans, fans of a cast member, the subject matter, etc.
- While a cable spot will be seen by substantially fewer people, if the stations are chosen correctly by the media buyer, those people who are watching should have a vested interest in seeing your movie. So fewer people but a high desire to buy a ticket.
- Cable television is the medium of choice for smaller independent films not looking to reach a wide audience.
- Cable can be bought on a national or local level and can even be geotargeted by neighborhood by market. For example, if your film is only opening in one theater in lower Manhattan, then your distributor would only buy a few mile radius from the theater, determined by zip code.

What Out of Home Accomplishes

Out of home is not a media that can be measured, like a television rating or digital view or share. Rather, it serves a more strategic purpose.

- It enhances the perception that this is an important film. Even now television series from HBO and Netflix use out of home to call attention to their latest offerings.
- Out of home usually sits in an uncluttered environment – a billboard on a major thoroughfare, a digital display in a train station, a backlit oversized poster inside a bus stop shelter, etc. People are stopped at a light, waiting for a train or simply walking past an outdoor poster where there is a longer chance it can resonate.
- Out of home can be expensive. To rent a billboard on a well-travelled boulevard in West Los Angeles could be $50,000 per month, plus the cost of installation. On Sunset or Hollywood Blvd where a company make take over a side of a building, that price easily goes to $150,000+ per month.

What Audio Accomplishes

Works in many of the same ways as cable, but with an even more targeted audience.

- Terrestrial radio like NPR, satellite radio like Sirius, and the thousands of podcasts that are available all have very dedicated audiences that are quite affordable to reach.

- It allows you to run many ads per day and hammer listeners with your title to build up awareness and name-recognition.

What Digital Accomplishes

Digital media buying augments traditional media and depending on the genre really drives the audience awareness and interest.

- Digital includes social media, publicity, paid and promotions centered around your movie, some specific content or subject matter.
- Very targetable.
- Interactive – the only way to engage audiences through all the key platforms available including Facebook, Instagram, Snapchat, Pinterest and Twitter.
- Identifies and builds communities through psychographic criteria as they relate to your movie.
- For some demographic groups like young tweens up to millennials, this is in many ways the only way to communicate with them.

AVERAGE MEDIA SPENDS BY GENRE

Studio Tentpoles – 4 quad movie, all audiences, IP driven

$75M Total budget
- 40 Television
- 15 Digital
- 12 Outdoor, audio, promotions, branded content
- 5 Promotions
- 3 Audio

Studio non-tentpole, 2–3 quad

$35 Total budget
- 10–20 Television
- 10–20 Digital
- 5 Outdoor, audio, promos

Independent aggressive platform single target, 1–2 quads

$20 Total budget
- 12 Television
- 5 Digital

1 Outdoor, audio, promos
1 Print

Independent specialty art film single quad only

$7–15 Total budget depending on how success
3 Television
2 Digital
1 Print
1 Outdoor, etc.

Super indie/limited theatrical/VOD/DIY sub quad

$150–500K
100K cable television
100 digital

INTERNATIONAL MEDIA BUYING

Buying media is very much dictated by the allowable and most prevalent types of media buying recognized in each market. For example, in France there is no television advertising allowed for movies, so the poster and outdoor campaign are extraordinarily important. In most other countries, television advertising is allowed but the length of spots are sometimes 10 and 20 seconds.

In Nigeria's "Nollywood," which produces over 2000 movies per year, there are no movie theaters and all the produced movies are sold in street kiosks. The advertising for these movies is very dependent on the trailer and the DVD artwork. The trailer is available online as well.

Digital advertising is a prime marketing component throughout the world. In China, there is virtually no television advertising and pretty much all of the marketing is done through social media and entertainment websites. This is pretty extraordinary considering it is the second biggest movie market in the world behind the US.

CASE STUDIES

Philosophy of War

Assuming the film has a platform release towards the end of the year (we will detail this in the Distribution chapter) it will be important for the studio to have pre-bought in their upfronts, selected specials and end of the season television shows. Usually these shows are broadcast on either network or cable and happen in November and they become the perfect media real estate to start building awareness for movie.

Audience media target would skew older male programming but women should be courted as well, though perhaps more through the talk show circuit with the film's talent. As the movie widens out January, the media plan will expand accordingly and depending on when the film hits its widest release, which for this film would be pegged to the awards nominations around the second or third week of January, the media spend would be at full strength on both the broadcast and cable levels. Local television network would also be used to augment the national buys wherever the film is playing.

Out of home would start at the beginning of November and could be a combination of big billboards, bus stop shelters and subway advertising in the major transit cities like New York, Los Angeles, Chicago, San Francisco, Washington, Boston, etc.

Audio is also a great way to take this film into other areas that are relevant to the storyline. These could include historical, self-help, psychological stories dealing with illnesses like PTSD and trauma podcasts. Radio would fit into this perfectly on both news stations and NPR. Ultimately, the challenge in presenting this film will be a combination of emphasizing the quality and importance of the story while keeping it entertaining so the choice of programming to advertise on has to reflect this.

The Tunnels

With the younger audience demographics the important element here is targeted media and this film should be a wide release supported by an almost equal mix of television and digital media. Other than a few special event prime time shows, the television media buy will be targeted to a younger female and Latinx audiences through cable and local broadcast. The broadcast shows would be the latest ones on the CW and the cable would push on such networks like FX and SyFy and USA Networks. This film will have a hard media dollar spend of around $18M to ensure maximum awareness for a film that may or may not last long in the theaters so the opening weekend is paramount to its success.

Outdoor would point to the singularly arresting image we will create and which will be used extensively on billboards and transit spaces.

Audio is a flashpoint for *The Tunnels* with multiple podcasts devoted to the supernatural and urban mythology available for sponsorship opportunities. Radio also becomes a strong medium to reach our young females through promotions with Spotify, custom programming on Sirius and the more traditional radio networks like I Heart Radio which would also sponsor a series of advance screenings around the country on the day before we open.

K2TOG

Our super indie title deserves all the love it can get on the editorial and publicity side as there won't be a lot of media dollars to push awareness. But while broadcast television is out of reach, even with a limited budget we will make sure to have a

cable presence on all the relevant networks like IFC, Lifetime, Comedy Central and TBS. And digital will, of course, be a big part of our sell on this film. If the film catches and our audience does expand, then all bets are off and we could introduce some relevant broadcast but cable will remain the primary driver.

Outdoor is probably not going to happen on this film other than some strategic wildposting on construction sites in New York and Los Angeles. "Wildposting" means posters that are hung up out in the wild of the city on construction sites, building sides, fences, etc. – done with permission... usually. However, promotional items like post cards could be used extensively in coffee shops and other appropriate venues.

Audio does present us with a wealth of opportunities particularly with the small but avid fanbase of our female stars. Comedy is king on radio and given the hip quality of our film, we envision many opportunities on satellite and the music streaming sites for interviews, playlists and comedy routines.

Sugar

Documentaries usually rely on their subject matter to rally a fan base and with our movie this is certainly the case. We will assume there is only a very small media budget, which we will spend beginning from ten days out of our platform release in a few markets and while this will not necessarily drive an audience, it will help create a small amount of awareness particularly if we place the cable media on a geographic basis in proximity to our theaters.

There will be no outdoor for *Sugar* but audio will present opportunities given its subject matter including podcasts and discussions on seniors, baking, second and third chance bites of the career apple, and social networking as a means of staying healthy. There can also be some clever content built with the cast, which could be placed on the air as public service announcements.

EXERCISES

1. Research and look for examples of high profile studio "important" awards movies like *The Post, Bridge of Spies, A Star is Born* and *Zero Dark Thirty*. Take a look at their range of TV spots and see if you can guess which specific audience each was targeting. Next, make a list of shows or networks where that spot would ideally run to reach that audience.

2. Both of our two smaller movies, *K2TOG* and *Sugar*, do not have big media budgets, with the documentary being significantly challenged due to the limited upside.

 A. What are the key audience demographics for *K2TOG* when buying targeted media

 B. Research the media spends for other small movies like *Little Miss Sunshine, Eighth Grade* and *The Florida Project* to better understand how media works with indie titles

C. The media that can be bought to support our two films can be very different. Why is that? Do documentaries need a different kind of media mix?

D. *Sugar* has a lot of sub-topics that support its storyline. Identify three of them and research where you would buy the media.

E. What is the theme in *K2TOG* that could create a breakout success? How would you support it with media?

3. Considering the audience for your own film, make a list of network, cable and local networks that would make sense. Would you invest in outdoor? What would your radio strategy look like?

NOTES

1 http://fortune.com/2017/04/03/nielsen-news-report/
2 The Economist, "Signs of the times Billboards are an old but booming medium" November 8 2018
3 The Economist, "Signs of the times Billboards are an old but booming medium" November 8 2018

15
Consumer Products and Licensing
Monetizing the Property

This department is supremely important, not the least of which because they are the only group in marketing that actually earns money. While everyone else is spending money to make money, Consumer Products and Licensing is the group in charge of monetizing your film. They expertly look for each and every angle to do any of the following:

- Place products or brands in your film seamlessly, which provides exposure for the brand and gets you free product or financial support.
- License your film brand to third parties so they may create products like games, pajamas, toys, collectables, posters, shot glasses, etc.
- Partner with companies to develop toys and games based on your film.
- Find like-minded companies who would like to use your film to sell their product which creates ad support for the movie.

Essentially, these are the very important people who make the t-shirts, the stuffed animals and everything else. They begin their work earlier than any other department (except maybe research) and start trying to sell a movie before even a frame is shot.

LICENSING

Remember the last time you visited a department store and saw stuff from the latest tentpole franchise everywhere? The logo was plastered across kids' pajamas, t-shirts, videogames, school supplies, greeting cards, toys, party favors and even pet accessories. This is the work of Licensing.

This department at a studio will work with a huge network of partners nationally and internationally. The "licensees" specialize in many different areas, but the

end game is that every one of them makes products based on movie brands and sells them for profit.

TOY FAIRS

There are a number of major toy events every year where major companies come to show off their newest product lines. The two main events are Hong Kong Toy Fair and New York Toy Fair, both in the beginning of the year. These events are also an opportunity for studios to pitch their upcoming product and try to win a collaboration with a major toy maker.

FAST FOOD TIE-INS

You might kid about your movie being a "Happy Meal" toy, but that is actually no joke in the world of consumer products. McDonald's is extremely choosy about whom it selects for an elusive global partnership. It looks for (mostly familiar) family-friendly properties with at least 8–12 discernable characters that can be turned into toys. Locking down a partnership like this is a huge coup and will bring serious money, ad support and exposure to the film.

GAMING

Gaming is an excellent way to sell a movie experience to audiences and there are multiple ways this can be produced:

- An elaborate game for a popular console
- A streaming game sold on a platform like Twitch
- An app available for download
- A mobile game embedded in a social platform
- A website with game experiences
- A VR or AR game experience.

BOOK TIE-INS

Family films will often generate a "novelization," which is a middle grade or easy reader book that lays out the plot of the movie with stills from the film. This will come out before the movie opens and give kids a chance to meet the characters and read about the world of the movie.

Importantly, these books end on a cliffhanger without revealing the ending of the movie. If kids want to know what happens, they'll have to get their parents to buy a ticket!

There are also frequently "making-of" books produced with a partner, such as Taschen. If a movie involved a lot of technical advancements (such as *Avatar*) or artistry (like animated films), these books serve as wonderful companion pieces.

Sometimes a version is created that includes the full screenplay alongside production art, storyboards and other ancillary materials. For example, *The Dark Knight* released the full shooting script in a book alongside production art and director's notes. These books are aimed at fans and cinephiles and are usually sent to press to help promote the film.

THE BIG RETAILERS

Having a great relationship with the major retailers is extremely important in this competitive industry. Walmart, Target and Best Buy are probably the three most crucial partners and studios will spare no expense to court them. Walmart headquarters are in Bentonville, Arkansas, and you'd be hard pressed to find a senior executive in the industry who hasn't made a pilgrimage there at some point. The studios will host screenings for the retailers and bring out talent to promote the movie.

Why is it so important to court them, they're going to carry the DVD regardless, right? Yes, the major retailers will usually stock most movies that are released on Home Entertainment. But, the question is how much will they support it? There are certain coveted spots in the stores where there is heavier foot traffic and visibility. The ends of aisles are called "endcaps" and studios vie for those or for prominent cardboard displays. The major retailers also send out mailers, emails and promotional materials and the studios want to be featured in these materials as well. These are extremely important relationships that can help support the licensed merchandise and the DVD/Blu-ray.

THE STYLE GUIDE

The Consumer Products and Licensing team will create this for any film where they are going to be licensing out merchandising. It's a given on an animated movie or franchise. The style guide will include all of the information that a toy or licensing partner will need to create merchandise that fits in with the branding. There will be stills of all the characters, information about the color palette, the costumes, typefaces, icons and graphics in the film. Essentially, the style guide includes everything that could end up on t-shirts, pajamas or shot glasses.

TOYS!

This is not just for family films – certain properties can also spawn collectible toys and games (especially horror franchises). But, toys are a massive part of franchise marketing on tentpole films. Any superhero movie, sci-fi adventure, animated property or fantasy epic is going to have a toy program. The Consumer Products group will find a toy partner to create all of the toys for the brand, which will scale up and down depending on the property. CP executives will talk a lot about "play patterns" in their brands. This basically means – how will children play with these toys? For example, if the property involves spaceships battling, then there will be toys that

include the characters, the ships and will encourage playing out the space battles. Conversely, if the property is a princess animated franchise, the play pattern may be more aimed at girls buying dolls of the characters and changing the outfits and playing with props and sets.

Plush is another significant category, which basically means stuffed animals. Interestingly, characters that are squat and more round make much better plush than long and skinny characters. Cute, fluffy and round makes for an ideal stuffed animal. The Consumer Products team will watch a film and look for these types of characters. If they aren't in the film, they may work with the creative team to help influence design on some of the secondary characters.

Toys are such an important revenue stream for studio tentpoles, movies will actually rearrange their release dates to make sure that they hit theaters in time for the toy program to unfold over the holidays.

PARTNER ADVERTISING

One of the big advantages of a brand partnership on a film is that the brand will create and pay for additional advertising. These are often called "tie-ins" and they can beef up a movie's media plan considerably. Usually, the brand will create an ad campaign that sells both the brand and the movie. They will feature the movie's stars and find a way to cleverly link the two brands together. These spots will run alongside advertising for the movie in the main media flight window. Although they are also selling a car, watch, alcohol, etc. they also get word about the movie and build awareness at no extra cost to the studio – a big plus.

INTERNATIONAL

Bigger movies will also have a robust international consumer products and licensing push. They will work the marketing groups across the world in the studio's offices in each market to set up local partnerships. Sometimes these collaborations will occur across an entire region like Europe or South America, or they will be targeted to a specific country. Either way the combined efforts of the international Consumer Products and Licensing outreach will bring in a great deal of revenue and exposure for the movie globally.

CASE STUDIES

Philosophy of War

This film will have very little, if any, consumer products or licensing tie-in. The subject matter doesn't lend itself to advertising brands and might even be seen as insensitive.

However, the team will create a beautiful making-of book that shows behind the scenes, sections of the script, production artwork, storyboards and stills from the

film. They may also partner with a national non-profit doing work in the PTSD space to create guides and materials, but this will not be a profit play. Rather, the studio will do this to show that they respect the subject matter.

The Tunnels

This film lends itself to some fun licensing opportunities. The program won't be very robust, but there will be a few clever items created. Licensing will make items aimed at college students like shot glasses and drink cozies. They will create a "spell book" based on the cult in the small town in the movie. There are no product placement opportunities in the movie, so this avenue is not explored.

K2TOG

This low budget movie isn't working with a Consumer Products and Licensing team, so the filmmakers will have to arrange for their own product placement. However, this happens organically because they need to show the characters selling yarn and using it. The filmmakers reach out to a major yarn brand and arrange for a partnership. The company will provide all the materials for the film so long as there are a few key shots that clearly show the brand. This is an easy win for the filmmakers, as they can do these shots subtly and get all these props paid for by the yarn company. Down the road, they will expand the partnership and create some co-branded advertising as well as include the yarn company in the movie premiere.

Once the movie is acquired by an indie distributor, their Consumer Products and Licensing executive will reach out to knitting how-to stores in all of the cities where the film is playing. They will create micro-partnerships with these stores, holding screenings, putting up signage and reaching their customers directly.

Sugar

This movie is self-marketed, so licensing off the table. The filmmakers just don't have the reach to set up those deals and documentaries don't lend themselves to toys and products anyway.

The filmmakers know their movie is super feel good and life-affirming, with very charming people featured in the story. They cleverly identify a major sugar company (part of a global food distributor) and reach out to inquire about some sort of cross-promotion. The agreement is that we will use your sugar in the film and feature it. We'll also get the film's charming ladies to do an advertisement where they vouch for that sugar. This can be run online in targeted buys. The sugar company loves the association for their brand and agrees to provide some cash for the partnership, which the filmmakers can use toward their marketing budget. This is an excellent play by the filmmakers as they would have used those scenes with that sugar anyway ... why not make it work for the movie?

EXERCISES

1. Pick three tentpole movies from the past year and research the brands that they partnered with. Were there TV ads, print and online?
2. Take a field trip to a major retailer and make a report about the presence of all movie properties in the store. Where are they sold? What movies are featured more than others?
3. Think about your own film. Are there any brands or products that are part of the concept that you could reach out to for a partnership?

16

Distribution, Exhibition and Windows

Finding the Perfect Release Date

There are no two disciplines that are more closely aligned once a film is finished than marketing and distribution. While each has distinct responsibilities essential to the overall success of a film's release, they also overlap in a number of areas like research, the all-important release date, in-theater marketing, national exhibitor conventions, awards marketing and, recently, the ongoing dialogue about windows, Netflix and how they impact a release. Each department has a profound mutual respect for each other and recognizes each one's particular territorial focus. At the same time, if a film does not have a successful opening, the responsibility for the failure could be borne by either: A failed marketing campaign or the wrong release date.

DISTRIBUTION OVERVIEW

To say that size matters in the world of distribution and exhibition would be an understatement. In the beginning, almost 100 years ago, there were seven major studios (which now include Lionsgate and Sony): MGM, Walt Disney, Warner Brothers Pictures, Universal, 20th Century Fox, Paramount and Sony Pictures, and RKO Pictures. The sustaining power, with the exception of MGM, which was bought and sold a number of times and ultimately broken up, is a testament to the power, enduring brand and diversification that these companies were able to accomplish while controlling a significant portion of the business. However, MGM has recently combined with Annapurna to create United Artists Releasing, so everything that is old is new again in Hollywood.

By the time this book is published Fox will have become a part of Disney so it will be back to six. Here's another fun fact – during Christmas, 2016, when the latest *Star Wars* film came out and Disney had two films in the top ten, Disney, with its imminent acquisition of Fox, was responsible for 92% of the box office on opening weekend. Does this bode well for the industry? We shall see over time.

Rank	Distributor	Titles	Date Range Gross	Market Share
1	Disney	12	2,410,448,444	21.68%
2	Warner Bros	31	2,034,888,951	18.3%
3	Universal	33	1,689,013,152	15.19%
4	20th Century Fox	38	1,431,508,301	12.88%
5	Sony	23	1,057,058,778	9.51%
6	Lionsgate	31	885,089,076	7.96%
7	Paramount	18	534,273,892	4.81%

Courtesy of Comscore Inc.

Rank	Title	Release Date	Rating	Dist.	Locs at Widest Release Locs	Opening Weekend Locs	Opening Weekend Gross	Cume
1	Black Panther	Feb 16, '18	PG13	Disney	4084	4020	$202,003,951	$700,047,537
2	Avengers: Infinity War	Apr 27, '18	PG13	Disney	4474	4474	$257,698,183	$678,815,482
3	Incredibles 2	Jun 15, '18	PG	Disney	4410	4410	$182,687,905	$608,581,744
4	Jurassic World: Fallen Kingdom	June 22, '18	PG13	Universal	4485	4475	$148,024,610	$417,719,760
5	Deadpool 2	May 18, '18	R	20th Century Fox	4349	4349	$125,507,153	$318,491,426
6	Dr. Seuss' The Grinch	Nov 19, '18	PG	Universal	4141	4141	$67,572,855	$240,490,550
7	Mission: Impossible – Fallout	Jul 27, '18	PG13	Paramount	4395	4386	$61,236,534	$220,159,104
8	Ant-Man and The Wasp	Jul 16, '18	PG13	Disney	4206	4206	$75,812,205	$216,648,740
9	Solo: A Star Wars Story	May 25, '18	PG13	Disney	4381	4381	$84,420,489	$213,765,308
10	Venom	Oct 5, '18	PG13	Sony	4250	4250	$80,255,756	$212,969,264

Courtesy of Comscore Inc.

The seven major studios usually account for 90% of the gross North American box office for any given year. In 2017, their market share was this based on the annual calendar gross box office of $11.12 billion.

Fox Searchlight's numbers are included in 20th Century Fox's overall reporting, whereas Focus, a part of Universal Pictures, reports separately as does Sony Classics. And for the year 2018, the top ten box office releases were these, which alone represent $3.611 billion or almost 33% of the entire year!

What accounts for this longevity? It started off with massive amounts of production, which created huge libraries and value, then the companies diversified into radio, television, music and eventually owning chains of movie theaters, which they had to divest in the late 1940s per a government court consent decree. Beginning in the 1970s, the studios became the object of desire for corporations, both international and domestic, seeking to get into the entertainment business to create additional value for their shareholders as well as harbor content for their evolving distribution platform needs. Now, the only independently owned companies are the Walt Disney company and Lionsgate, but in the case of Walt Disney, they also own so much more.

The independent distributors, which account for the balance of the 10% of the annual box office, are many and constantly fluctuating. Some of the bigger ones over the past 20 years were New Line, Miramax, Summit Pictures and smaller ones like Broadgreen and Relativity.

And, finally, there are the Specialty Distributors, many of whom are in the awards race every year.

What about this annual box office number? Every year you read or hear about how the annual box office has gone up or down by a percentage point or two, based on what huge blockbuster in any given year may have moved the needle, but overall it has essentially remained the same at around $11 billion. While most of the industry looks at this as a good sign of a mature and stable, business, the numbers do not tell the whole story. In fact, for the past 10 years or so, the box office has remained the same (at around $11 billion) but what has kept this a stable number for so long, is not the number of people going to the movies every year – that number has gone down every year – but the rise in ticket prices, which has created this myth of stability. The United States is one of the few countries in the world that operates on a ticket price system, which allows for the industry to always look good. Most other countries measure their film industry performance by admissions, which is a much more realistic look at the health of the industry.

EXHIBITION OVERVIEW

On the exhibition side of the industry, the "size" issue is the same. There are 6000 theater locations in North America representing 43,000 screens (source: Comscore). A considerable amount of the box office is accounted for by the Big Three exhibitors – Regal Cinemas, AMC Theaters and Cinemark Theaters, each of which has a national footprint, with Cinemark mainly concentrating in the south and

southwest. The rest of the screens are controlled by a large number of independent chains, some of which, like Landmark Theaters, are spread nationally, but most are concentrated in a small region of a number of B (medium) and C (small) markets orbiting around an A (large market).

While the Big Three tend to play every film that is distributed by a reputable distribution company – assuming they think they will perform at the box office – some of the smaller companies tend to specialize in certain types of films. Landmark is a perfect example of the opposite of the Big Three. Sure, AMC, Regal and even Cinemark have dedicated screens in their complexes to a more arthouse or specialized film, but they are predominantly in business to serve the seven majors. On the other side, Landmark is not averse to playing a portion of the bigger Hollywood titles, but they are developed their own audience over the years that care about quality, sophisticated independent cinema. Every Academy Award worthy title will play on a Landmark screen at some point. That cannot really be said for any other chain in the country.

HOW MARKETING WORKS WITH DISTRIBUTION

The size of your distribution company doesn't matter – whether it is a 10 person or 500 person operation – your distributor basically performs the same functions. In addition to being a member of the greenlight committee as we discussed earlier, the distribution head is responsible for the coming up with the proper release date based on a large number of factors which they take into consideration:

1. The production and post-production schedule.
2. Analysis of the upcoming release schedule.
3. A competitive analysis of upcoming titles in and around the best case release date, usually by quarter.
4. If the film is thematic specific, like Christmas for example, then it will be important to pick a date after November 1.
5. If the film is strong enough to compete in the summer – either capable of going head to head with other blockbusters, or to work as counter-programming against the bigger films.
6. What is the genre and is there a best time to release films of that nature? Romantic comedies, for example, usually perform best between Valentine's Day and the end of April when the competition is not as fierce. They rarely work in September, which is when mothers – a prime driver for this genre – are busy with school, shopping and the like.
7. Horror films have predominantly opened in September and October taking Halloween into account, but the genre has proved so successful over the years, and with production and marketing costs certainly somewhat lower than most other titles, they have become a year round staple. The only issue has been to make sure there is enough separation between them and they don't pile up against each other as was the case in the Fall of 2017 where *It* opened to enormous numbers and was then followed the next week by *Mother* and the

following week by *Friend Request*, one psychological and one YA horror both of which under-performed.

8. Is the film an awards contender? Normally these films are released between September and December in New York and Los Angeles to keep them relevant and in the minds of awards voters and critics. More on that later.

9. Your distributor even has to take into consideration the talent and what other films they may be starring in that could be competitive during the same period, as well as their availability to promote the film in general.

10. Once a date is picked, your distributor keeps a constant eye on the ebb and flow of the overall release schedule and unless they are a major with a very specific date picked for their tentpole, many times the independents will have no hesitation moving their original date if something lands on their date that they don't feel they can compete with.

11. If the film needs a bigger presentation with IMAX as a key appeal in the marketing, it will be important to know when these theaters are available, as there are not a large amount of them (as of this writing, there are fewer than 400 nationwide). Most theaters can play 3D, but this format has been losing its appeal over the past few years.

12. Even if you are working with a small distributor, they will want to make sure that their release slate is scheduled out over a 12-month period (in the studio cases it is usually at least 24 months ahead), so besides the competition from outside titles, there may be conflicts inside the company as well which prioritize one title over another. For example, a high profile acquisition where the company has committed to a release strategy as part of their deal.

HOW MARKETING WORKS WITH EXHIBITION

For decades, exhibitors were all about depending on the success of the movies they played as a driver for concession sales. Over time they realized it was important to up their game and provide a more pleasant environment to entice people to keep coming regardless of what films were playing. Now you can pre-buy a reserved seat, watch on a recliner lounge chair and order a meal, sit at bar with a burger and choose from a very wide assortment of snacks including health bars and drinks, thought it remains true that popcorn is still the most important item theaters sell.

What the exhibitors do to increase their earnings is not a matter for this book. What is, are the new forms of in-theater marketing, which includes the variety of signage and trailer placement opportunities now offered to distribution companies, as long as they are willing to pay. The real estate rental proposition is now alive and well at concession counters, in lobby and hallway displays and even bathroom mirrors and urinals. As part of the distribution team, there are a few exhibitor relations people who work with their counterparts in exhibition to maximize these efforts. In addition, the ticket-buying services like Fandango, usually offer weekly promotions, though unfortunately these are mostly reserved for the big studio films.

The independent distributors have a tougher road when it comes to these budgetary items, where every poster or lobby standee has its price. Nowhere is this more apparent than when it comes to trailer placement. Everyone acknowledges that the trailer is still be best form of advertising for a movie and what better place than in a movie theater in front of a demographically or psychographically aligned audience? But this comes at an even steeper price.

A Very Costly Secret

Those trailers that you see in front of every movie at the theater? Most of them are there because the studio or distributor bought a slot. Over the past ten years, trailer placement has become a budgetary item and for exhibitors, this has become a welcome income opportunity as they now offer independents the opportunity to bid on the placement of their trailers with the right kind of film. Theaters tend to play an average of six trailers in front of the main feature, and the distributor whose film is the main attraction gets to place two trailers of its own. The rest of the trailer play comes with a price, or pay-for-play as it is known.

A distributor can bid, for example, on 50% of the screens of the Regal theater chain of a high profile film for the first weekend and the bidding can be between $100K and $400K depending on the popularity of the film. While the studios engage in this process of pay for trailer placement, their deals are based on an annual payment but the producers will never see this as a line item. It is simply the cost of doing business and remains a bit of a secret in their world.

However, not every theater chain charges for trailer placement. Landmark Theaters, for example, welcomes trailers (limited to four per movie) for the films they have coming as they are playing to a very specific audience target of upscale predominantly over 35-year-old filmgoers and there is no reason a distributor would want to place a trailer in their chain that didn't appeal to that demographic.

Landmark and some of the other specialized theater chains, like the Arclight Cinemas, also offer "Q & A" talks with the director and talent on opening weekend depending on their availability. This is great publicity for the film and these particular shows tend to sell out, thereby increasing the per screen average, which we will discuss below.

The "20"

This is a programmed time of 20 minutes prior to the playing of trailers in anticipation of the feature presentation. The largest company that sells this time is NCM (National CineMedia), which sells this time to anyone who wants the movie going eyeballs. This time can be bought from anywhere from 30 seconds to two minutes. Usually you see television shows, commercial products like soda and candy, and even cars. This screen real estate is solely owned by the exhibitors and has provided then a strong source of revenue.

Theater Promotions

These are usually done on a chain wide basis where audiences are offered a chance to enter a contest tie-in with a specific movie, the chain offers a movie ticket program, and even done on a local level where the manager of a specific theater arranges a tie-in with a local retain outlet.

The Release Strategy

In addition to the release date, marketing and distribution also collaborate on another very important aspect, which involves how the film is introduced into the marketplace. Movies are released in a number of scenarios, two of which are traditional while two others are part of the new world of digital distribution.

The Wide Release involves putting the film in the maximum number of theaters on the first weekend. Normally this is between 2000 and 4000 screens depending on a number of factors:

1. How commercial is the film?
2. The number of quadrants it appeals to (i.e., 4 quadrant titles usually mean 3500–4000 screens).
3. The time of year the film is released and screen availability.
4. The genre – for example, traditional horror films rarely are released over 2500 screens.
5. The rating – G, PG, and PG-13 usually account for a higher screen count than R-rated films as they don't always play in the smaller markets.

The advantages of this type of release are the maximization of opening weekend box office through a marketing and promotion spend close to 100% of the budget. The aim – hopefully becoming the number one film with all the bragging rights that come with it. As far as their grossing potential after the opening weekend, the genre usually determines the drop off.

1. The typical wide release, for example a big adventure or tentpole film with very recognizable stars usually drops 50–60% the second weekend and continues on a similar trajectory throughout the course of their theatrical run.
2. Horror films tend to gross 2 to 2½ times their opening weekend – they have a very dedicated fan base and they usually all come out on the opening weekend.
3. Four quadrant family films titles can do 3 to 3½ times their opening weekend.
4. Films that appeal to the 40-plus audience can do 4 times their opening weekend since this demographic doesn't necessarily rush out opening weekend but tends to go over the first three or four weekends. So while they may not open as strongly, the ones that work have stronger "legs" to hold on.

Regardless of the type of film, the net result of a wide release is to generate a great deal of awareness, which sets the film up for the subsequent windows of

Rank Title	Rating	Dist	Release Date	Locs At Opening Opening	Wknd Gross Locs At Widest Release		Total Box Office Gross
1 Black Panther	PG13	DIS	2/16/18	4020	202,003,951	4084	700,047,537
2 Avengers: Infinity War	PG13	DIS	4/27/18	4474	257,698,183	4474	678,815,482
3 Incredibles 2	PG	DIS	6/15/18	4410	182,687,905	4410	606,467,855
4 Jurassic World: Fallen Kingdom	PG13	UNI	6/22/18	4475	148,024,610	4485	416,611,525
5 Deadpool 2	R	FOX	5/18/18	4349	125,507,153	4349	318,485,133
6 Mission: Impossible - Fallout	PG13	PAR	7/27/18	4386	61,236,534	4395	218,488,098
7 Ant-Man And The Wasp	PG13	DIS	7/6/18	4206	75,812,205	4206	215,876,567
8 Solo: A Star Wars Story	PG13	DIS	5/25/18	4381	84,420,489	4381	213,765,308
9 Quiet Place, A	PG13	PAR	4/6/18	3508	50,203,562	3808	188,024,361
10 Hotel Transylvania 3: Summer Vacation	PG	SNY	7/13/18	4267	44,076,225	4267	166,146,774

Figure 16.1.

Courtesy of Comscore Inc.

streaming, DVD/Blu-ray sales and television and syndication. Per the chart below of films released through August 2018 (Figure 16.1), one can see that the top 20 movies grossed $4.9 billion. If one assumes that this year the annual box office will be in the area of $11.5 billion, then these movies have alone accounted for 43% of the total box office. So, no surprise the studios are leaning into the tentpole business.

The disadvantage of a wide release, of course, is the distributor has spent all its advertising dollars against the opening weekend and if the film doesn't work, there is no way to cut back on the campaign.

When is wide too wide? While it is always the desire of the studios to release their movies on as many screens as they can on a given weekend, in one particular way, there is a major inefficiency to this strategy.

Let's take any big studio film, and for these purposes we will look at *Black Panther*, released in February 2018.

Opened: February 16, 2018 Opening weekend: $194,724,657 Number of theaters: 4160

Rank	Theatre Name	DMA	Weekend Box Office	Cumulative Box Office Total	Percentage of Box Office Total
1	THEATER #1	ATL	690,987	678,987	0.34%
2	THEATER #2	NY	678,098	1,369,085	0.68%
3	THEATER #3	NY	578,817	1,947,902	0.96%
4	THEATER #4	LA	565,621	2,513,523	1.24%
5	THEATER #5	LA	512,456	3,025,979	1.50%
597	THEATER	DAL	115,765	100,586,897	49.79%
598	THEATER	ATL	110,125	100,697,022	49.85%
599	THEATER	DAYTON	110,449	100,807,471	49.90%
600	THEATER	NSHV	102,100	100,909,571	49.95%
601	THEATER 601	NY	100,043	101,009,614	50.00%
1224	THEATER	PHNX	59,876	141,300,754	69.95%
1226	THEATER 1226	HOU	58,234	141,418,944	70.01%
1227	THEATER	LA	57,078	141,476,022	70.04%
1894	THEATER	SEA	31,680	181,743,556	89.97%
1895	THEATER	CLEV	30,696	181,774,252	89.99%
1896	THEATER 1896	MIL	30,198	181,804,450	90.00%
4020	THEATER 4020	BOISE	35	202,003,951	100%

Figure 16.2.

Courtesy of Comscore Inc.

The film was released on 4020 screens and grossed a $202M opening weekend. But 50% of that opening weekend box office was on the first 601 screens! 70% was at 1227 screens and 90% was earned with 1896 screens. This means that the last 10% of that opening weekend box office, or $21M was earned by the bottom 2100 screens or so, or roughly *half* of the total number of screens. So why would you book that last theater in Boise or any theater at the bottom of a theater list if it only did $35 on the opening weekend when it is not nearly enough to cover the cost of the digital hard drive sent to that theater? And if you did this calculation on any big studio release over the past ten years it would look close to this. The only fluctuations would be a hundred screens or so at the 50% mark depending on the four quadrant and family appeal of the title.

What, then, is the logic behind taking all these additional screens? Logic is perhaps not the right word, but here are some reasons:

1. Over the past 20 years, as exhibitors have strained to increase their market share, many theater complexes have been built in both the major and minor markets.
2. Many of these screens are in C, D and E markets – cities and towns with smaller populations.
3. Each exhibitor has a number of prime locations that account for a high percentage of the box office for the specific chain.
4. In order to fill up their additional screens, their "soft negotiation" technique is to tell the distributors you can have my prime theaters but you have to take my subprime ones as well. The distribution companies then usually spread their titles around the top three, particularly when they are in competitive markets and eventually.
5. At the same time, distributors want to have as many screens as possible in order to make the film an event. It perpetuates the myth of being biggest and therefore best.

The platform release is usually employed by smaller companies seeking to stretch their advertising dollars through publicity, reviews and word of mouth. Many of the films released by Focus, Searchlight, A24 and Sony Classics normally start with a very limited number of screens in New York and Los Angeles. The advantages of this type of release are many, both marketing and financially driven.

1. An initial four to five screen can turn out an extremely high per-screen average, which makes the press, the public and the exhibitors take notice that this movie is something special. While this type of pattern is used year round by these companies, when it comes to the awards season of October through December, these films need to do in excess of $40–60,000 per screen to be noticed in an extremely competitive environment. The rest of the year, an opening per screen average of $25,000 is considered strong.
2. With films like these, which usually don't have star appeal, the publicity and reviews surrounding the film are critical tools for success

3. Most of these films have tricky, or not overly commercial subject matter, and by going slower and adding theaters and markets week after week, the public has a chance to catch up to them.
4. Word of mouth is also essential for these types of releases as it still remains the single most effective sales tool after trailers.
5. If the film does not work after the first few cities, distributors can then cut back on their advertising expenses to save money and rethink their whole distribution pattern. This is known as the POW model – where these movies Pay their Own Way – and it is a great option for smaller companies with limited budgets.

The disadvantages of this type of pattern is the importance to reach a maximum number of screens within a few weeks before the next buzzed about movie comes along. The trap of this kind of release is to widen out too fast before the word of mouth has had a chance to catch up and spread around the country. When the pressure to widen comes from the producers, the exhibitors or senior management, this can be a big mistake and it will usually result in a low per screen average the exhibitors will lose interest and move on to the next one. Every independent company has been guilty of this maneuver at least once – when the pressure and belief that the film has more potential than it actually does drives an overly optimistic response.

International Release Strategies

The seven major studios distribute their own films throughout the world via offices in the major cities and countries. Lionsgate has deals in place with a number of independent distributors who heavily rely on their relationship for their important titles. In addition, the independents have their own overseas relationships but are rarely in a position to provide content on a continual basis, so their overseas partners also deal with a number of other independents to fill their slate. Let's look at the four main ways a movie is released:

Worldwide

This is the standard pattern utilized by the studios when a film is released simultaneously in a large number of countries on the same date or within a few days of each other. The number of screens involved could be 25–35,000. This strategy works for a number of reasons:

1. It helps thwart piracy of these big budget titles by making them available to audiences around the world at the same time.
2. The studios use the web to publicize their movies months in advance and with the immediacy of experience that the web offers, the studios are wise to take advantage of this fastest method of communication. This is eventizing a movie.

3. Global phenomenon are what continues to drive the entertainment industry and attract new investors into the business.

Regional

Where a movie is released in a particular region first, for example Europe, before it is released elsewhere. This is used for movies that may have a common theme, actor, or tone that is best received in specific countries first.

National

County by country release is mostly reserved for independent films and distributors who have their own schedule and will tailor their release and campaign to best appeal to their local audience. In situations like these, local customs and censorship play a significant role and one only has to consider the Middle East and China as examples of countries where becomes a major consideration.

Ethnocentric

This relatively new and more sophisticated release pattern will appeal to certain diaspora ethnic groups who may be scattered throughout the world but who have pockets of cities and theaters that perform well. Here again, the web is an incredibly useful tool to disseminate the information to these communities directly. The Indian and Nigerian diasporas have been particularly effective in the success of a number of their locally produced films.

THE CASE FOR (AND AGAINST) WINDOWS

No matter how you get here, through a one-week theatrical run of your film in ten theaters in ten cities, or if your film has great success with strong support from your distributor and had an extensive theatrical run, the rubber hits the road when it comes to how your film does in the post theatrical world of digital streaming, rental, sales and television windows. This is where you and your distributor will hopefully see how all the hard work in publicity, awareness building and creative advertising on behalf of the theatrical release will translate to success in this huge aftermarket. And it is also the arena where you could earn real money with very little additional support.

Here is a snapshot of the life of a movie and all the various window permutations a movie can go through beginning with its initial theatrical release. While all of these are subject to change, per the heading at the bottom (There Are No Rules), when it comes to a movie's release, let the chess game begin.

So the rules and windows are constantly evolving and being renegotiated from the legacy ancillary studio deals that have been in place for many years. But rather

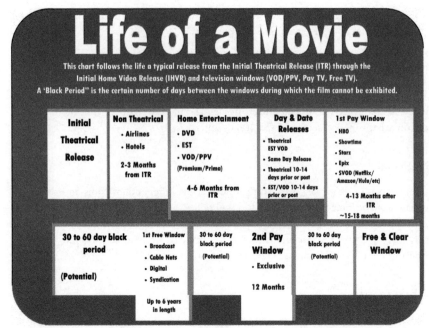

Figure 16.3

Source: David Spiegelman lecture

than put these in a chronological order as the diagram above, it is best to just understand how marketing applies to each area regardless of where they will fall in the window waterfall.

From a marketing standpoint, it is rare for a distributor to substantially change any of the artwork associated with the original platform look as consistency of the brand is very important as your film travels through the cycle.

Many times, the marketing team of each platform will re-purpose material created for the theatrical or first window release though the one request usually goes to the talent to help support the film for its initial ancillary launch. What we will focus more on here is how these windows work and also talk about the business in general with someone who lives in this world every day.

INITIAL THEATRICAL WINDOW

This is the original window from which all other windows emanate. It is still the most coveted, the most respected, and definitely offers the widest potential for creating awareness for your movie. However, as we have seen, it is also the most expensive, the most risky, and has the least chance of recouping the marketing dollars

spent to release. This doesn't mean that the theatrical release has no value, quite the contrary, as awareness creates interest and interest in many cases can mean a click through to rent, stream or purchase.

The VOD/day and date release remains the more controversial method of releasing a movie. Here, streaming services like Netflix champion a short theatrical release coupled with a streaming availability on a day and date scenario or a few weeks after. The thinking behind this strategy is to take advantage of the publicity that a theatrical release affords with reviews, editorial and the like, and at the same time make it available for a potentially wider audience than would be found through a standard release.

Another issue is the steadfast refusal of the "Big Three" exhibitors, AMC, Regal and Cinemark, to play any movie that is designated for a shorter window release under 90 days, which has been in place for decades. They firmly believe that having the title available in both a theater and at home at the same time, or within a short time of each other, will severely undercut the revenue at the box office and that people will simply stay at home for a few weeks until the latest movie comes to their home screen. On the other side of the argument are the studios and independents who believe that these films will find a whole new audience that was not going to the theater in the first place, young families, for example. This has become a hotly debated topic and as it now stands, exhibition is as much on the opposite side of the streamers like Netflix as our two major political parties are from each other.

Filmmakers are actually quite torn by this situation because, on one hand, a company like Netflix is giving them opportunities to make movies in the $35–50M range, a mid-level budget scenario that the studios have all but abandoned. Yet, these same filmmakers all desire the treasured "theatrical window," which of course is why they make their movies in the first place – big screen, big spends, awards recognition, etc.

Alfonso Cuarón, the director of the highly acclaimed film, *Roma*, offers a split decision, and a sentiment that is probably shared by most filmmakers who want the budgets and the creative freedom, yet recognizing that things won't be the same as they move into the future.

"Of course, I'm a big defender of the big screen," the director told *The Los Angeles Times* in September of 2018. "The film was made for the big screen. But I'm also a big defender of options."[1]

Meanwhile there are many plans afoot for taking on the Big Two – Netflix and Amazon. OTT (Over the Top) channels are the latest evolution in platform delivery systems and consist of curated content by interest and based on specific programming, like sports, history, manga cartoons, sci-fi, etc. This category also includes the new studio subscription channels as they will have specific types of programs available on a tiered level. This is what Walt Disney, Warner Media (ATT) and Apple all plan to be offering in 2019. It should be a very interesting year.

Also, we can't forget about the all-important original staple of post theatrical sales after all these initial versions of electronically offered windows play out, and

that is the world of broadcast, cable and syndicated television. Putting all these together usually means a movie can have a minimum of ten years as a revenue producer.

Let's conclude with two views of the existing state of the windows debate: David Spiegelman has a very pragmatic approach – he has been in the ancillary markets business for many years and has worked or consulted with a large number of companies including New Line Cinema and Europacorp as well as a number of independent producers. David sells the rights of the films he represents to all the services from streaming to broadcast to cable.

The windows are constantly evolving on when movies are becoming available. Do you think there will be a time when one window will satisfy all?

David Spiegelman: I do not. I believe the windows are very important yet they are constantly changing. The one rule that we follow is that there are no rules when it comes to windows, however the most important aspect comes down to good programming and the opportunity to manipulate these windows based on the kind of programming and the need that the buyer has.

Will there come a time when exhibition gets involved in creating the windows time frames?

DS: Distributors seem to be partnering more and more in the world of post-theatrical windowing and I think it is inevitable that some of these windows will shrink down to nothing and there are already so many examples of that with day-and-date releases. It all comes down the content and the needs of the different platform providers.

Is there a tipping point between when movies become theatrically worthy versus when it does not matter where they are seen?

DS: Again it comes down to the content – for example, I am representing a movie that cost over $50M to make yet the production company made the decision that it was not strong enough to spend an additional $25M to market it, so now it will have a limited theatrical release and at the same day go out on VOD and all the different digital platforms.

So for young filmmakers, would you consider this a Golden Age?

DS: There has never been a better time to produce content, there has never been a better time for distribution for long form and short form. But the most important thing is it has to be really good and someone has to like it. If you and I don't like it, but there is an audience out there for it, that's all that matters.

Ted Mundorff, the President of Landmark Theaters, the pre-eminent boutique specialty theater chain in the United States, has had a wide range of experience working in the exhibition business for the past 25 years. He also has a stellar reputation and the taste to match.

How do you see the coming year with all the window shuffling?

Ted Mundorff: Until now we have not seen a true consolidation of two studios. We had Comcast absorb Universal, and AOL and Time gobble up Warner's. Years past the usual buyers of these entertainment properties were existing non-entertainment companies. Seagram's bought Universal and Coke bought Columbia. Then Sony (a hardware company) bought Columbia from Coke. National Amusements, a theater company bought Paramount. Now Fox is being swallowed by Disney. Two companies that do the same thing. They produce product and distribute through their companies which include television outlets. This will be a game changer. Prior to the Reagan presidency neither of these companies could own television outlets or theaters. Today they can not only own TV stations but each other. We enter a new world.

I fear with this merger will hasten the shortening or elimination of windows allowing people to see anything they want, when they want and where they want. This will have an impact on existing theaters and movie making. Remember that film distributors who have already worked in the day and date and SVOD world such as Magnolia, IFC and Radius (now defunct) do know the impact of day and date vs. straight theatrical and do adjust their release patterns to straight theatrical if they feel it has theatrical merit. Theatrical increases awareness of a movie, which in turn helps it downstream find an audience. They have years of data and experience doing both types of release and know the consequences of each.

CASE STUDIES

Philosophy of War

As we have said from the beginning of our book, *Philosophy of War* was a labor of love for our director and the cast signed on not only for the opportunity to work with their director, but for what the movie represents and its message (plus a shot at an Oscar, let's be honest). The studio is on board for an equal number of reasons, but the most profound is wanting to keep strong director and actor relationships with

this group and are willing to risk a significant budget and marketing campaign to achieve its multiple goals.

The studio has decided to platform our movie – namely to open it in a few cities in mid-December, hopefully taking advantage of the fall festival buzz, the Golden Globe nominations and kudos from critic groups, all of which come out throughout December. Our movie is now on a pedestal and an awards qualifier.

The following distribution pattern is set:

December 13	6 screens	
December 20	250 screens	(post-Golden Globe noms)
January 10	800 screens	(pre-Golden Globe wins)
January 24	2500 screens	(post-Academy Award noms)

This entire release strategy here is to use nominations and awards as the fulcrum for adding screens and upping audience interest in seeing the movie.

How Did It Play Out?

In its initial opening weekends, the film performed quite well, and the studio was smart to keep it in a relatively small number of screens through the Christmas and New Year holiday period.

Everyone, including the talent, took part in the first wave publicity blitz as a commitment to both the director and the studio, but that was pretty much it as they were all on to new projects. The per screen remained high on both coasts and in a number of middle American towns the film played in as well including Texas, Arizona, Colorado, Washington, Utah and parts of Southern California.

The movie did receive Golden Globe nominations for Best Dramatic Film, Best Actor and Actress in a Dramatic Motion Picture, and Supporting Actor, which helped bump its box office up over the January 10 but it was not sustained. Interestingly, the director was snubbed.

The Marketing department breathed a sigh of relief that their first wave worked, and things were humming. Everyone had a relatively relaxing holiday break knowing that the real work was yet to come.

In January the movie did not win any Golden Globes at all. To make matters worse, it did not fare well at the Academy Awards nominations either, only picking up Best Supporting Actor and Best Screenplay nominations.

This significantly hurt the movie's chances of breaking out and inside the studio there was talk of reducing the screen count and letting the film play out to a lower level. So, this was a classic case of a movie needing awards recognition to break through the audience reticence of seeing a movie with a difficult subject matter. Perhaps because it was too rooted in current events, but the audience didn't come to the levels anticipated.

At the end of the day, the movie grossed $35M at the box office and an additional $25M internationally. With a $50M budget and a $35M domestic marketing spend, the film was a financial failure for the company but certainly something that

they could absorb quite easily. Also, they held true to the talent, which was also extremely important. When the film went onto the streaming services, word was that it received a lot of subscriber attention, but since these streaming deals are tied to box office, it was not relevant to the studio's bottom-line loss.

The Tunnels

Our movie will be released wide from day one on approximately 2500 screens to make it available to all audiences at the same time and particularly to the young females who tend to flock in packs on the first Friday if they deem the movie a "hot" title. Hopefully, the film is considered good enough to attract couples and dates, which would account for a solid Saturday. The Latinx audience who could be attracted by the supernatural elements will possibly pick up the Sunday slack.

The Tunnels may not have a long run in theaters as these kinds of movies tend to drop off rather quickly unless there is something that is startlingly unique about them or they come out beyond expectations. As a traditional horror movie about a possessed child, this movie will probably deliver 2½ to 3 times opening weekend.

The Tunnels also lends itself to some fun materials to be placed in theater lobbies from oversize posters to even a VR walk into The Tunnel, which were placed in screening pods in the lobby, and installed into an empty storefront near the entrance to the theater in the mall.

How Did It Play Out?

The Tunnels opened to a surprisingly solid $72M weekend over the Easter break four-week rolling season where schools across the country are out of session at different times throughout this period of four weeks.

Exit polls were stronger than anticipated, which really helped word of mouth. The film actually hit its core audience and then expanded to an older audience over the second and third weekends, intrigued with the subject matter. Another factor, and one that no one in the marketing or distribution department could have anticipated, was that the main competitive film was pulled a few weekends before by a competing studio, who cited they were going back for more reshoots. Obviously, the other film did not test well and the studio panicked, which left a much clearer path for The Tunnels to perform. At the end of its run, The Tunnels grossed $72M, a financial win for the mini-major that released it.

K2TOG

Even though the film had its debut at the Toronto Film Festival the company that acquired it did not feel they had sufficient time to prepare it for release later that year. Also, there was no reason to assume it would be an awards qualifier, though they did talk about the Independent Spirit Awards as a reason to go with a Fall

release. At the end of the day, everyone agreed that Spring was a better time for the movie and the release date was set for mid-March, after the Academy Awards, and a time when critics were looking for new movies to write about.

Our movie will be handled with kid gloves by our distributor knowing full well that going too quickly after an initial platform release before word of mouth catches up could be the end of the film in theaters rather quickly.

With success, our film will slowly widen out and cross over from the traditional specialized "smarthouse" audience (arthouse + smart audiences = smarthouse) into a more mainstream audience of 35+ who will latch on to the themes of family, small town life and the knitting craze. There is no star quotient driving this movie, but, as a movie like *Little Miss Sunshine* illustrated, if a movie is good the more mainstream audiences find it.

How Did It Play Out?

K2TOG, with a new title, did a surprising gross of $20M at the box office, which is terrific for a low budget movie with no recognizable talent. The success was attributable to the slow-release strategy, which allowed a number of special interest communities to catch up to the film while it held in its exclusive runs in the major markets. Over time, the film did cross over to the audiences that we felt could embrace it if it worked. And who knew how many knitting and quilting organizations and groups there were in the country – all of whom embraced the movie as their own and pushed it out to a much larger audience that was achievable through a traditional media campaign!

Sugar

Our documentary will not only be opening a few screens to get started, but these screens must be chosen from exhibitors who will "get" this movie and be willing to stick with it until it finds its audience. Exhibitors like Landmark Theaters, Harkins Theaters, even AMC, which devotes a certain number of their screens inside commercial venues to specialized movies will be important allies for the film to achieve success. If AARP gets behind the movie with a screening program for its 55+ subscribers, then the chances of its success improves greatly.

We decided to go in the Fall of the year to help it qualify for Best Documentary at the Academy Awards. It turned out that there was just too much competition at that time and a documentary with real life and no known stars was buried in the cascade of important arthouse movies that normally come out at the time.

How Did It Play Out?

Because of budget limitations, there was no way to go beyond 75 prints and while the movie did a respectable number over the few weeks we were able to hold

screens, the movie then faded rather quickly. So, an overanxious producer/finance team played the Academy card and lost.

However, all was not lost. While the movie only ended up with a gross of $1.5M, midway through the run, the producers were approached by Apple who wanted to produce a television series based on the movie! So even though the release turned out to be a mistake given the choice of release date, the post theatrical life of the movie was assured. End of story – a success but not for the reasons we thought.

EXERCISES

1. Both *K2TOG* and *Sugar* are traditional platform releases, that is, the number of screens and cities will increase each week based on the film's success. Research similar movies and see how wide they were able to get to.
2. What are the most important cities used to launch movies like these two? Is it better to use an independent exhibitor or a chain to help promote these films. Why?
3. Look at the release pattern of a two successful documentaries and indie movies and try to establish a playout pattern for our two films
4. Wide releases usually earn 2½ to 4 times their opening weekend at the box office. Come up with an example of a movie that earned 2½ times, 4 times, and 8 times their opening weekend and explain why.
5. What are some of the dangers of a movie opening too wide?

NOTE

1 What Netflix's release of *Roma* says about its movie business strategy. By Ryan Faughnder and Josh Rottenberg, *The Los Angeles Times*, Dec 03, 2018.

PART III
KNOW YOUR MARKETING SPECIALTIES

17

Marketing for Alternative Distribution

Taking Matters Into Your Own Hands

Warning: This chapter is not for the faint of heart

As a filmmaker, reality will eventually set in. Sometimes it's when the terms of your financing deal leave you with the chance to make your movie but not much chance to see any profits from it. Sometimes it's during production when you fall behind schedule and have to scratch scenes, including ones you thought were pivotal to the storyline. Sometimes your post schedule goes longer and your budget shrinks and that all-important music score you thought you were going to have goes away. Sometimes, after the elation of getting into a prestigious film festival, your film doesn't get the great reviews you were expecting. Sometimes, even with great reviews and distributor interest, you are disappointed with the offers that are put on the table.

What to do? First off, prepare your investors with the ins and outs of distribution and explain the potential for profitability.

Dan Mirvish, the co-founder of the Slamdance Film Festival has this to say about how distribution fits into your Business Plan:

> You talk realistically about what will happen when the film is done. You'll describe film festivals, producer's reps, foreign sales agents and how most distribution deals are with small companies who barely give you a theatrical release on the way to Video on Demand (VOD) oblivion. But it's also a good time to talk about how your particular history may apply to distribution of your new film. DO you have a track record with critics and festivals? Do you have a million subscribers on YouTube? Have any of your investors ever broken your kneecaps, or are they as pleased as punch with your last film's success?
> I usually throw in about three distribution scenarios, each featuring bullet-point descriptions of the timeline and financial waterfall of how

that distribution will affect the equity investors. I usually do a Best-Case Scenario (think Oscars and a 5,000 percent return on investment), a Zero-Sum Scenario (nice festival run, good advances and everyone paid back initial investment but no actual profit) and a Grim Case Scenario (the film tanks critically, gets a lousy distribution deal and not even the investors' original money gets paid back). By the way, this Grim Case Scenario is what happens to over 95 percent of indie films made today. So, better your investors laugh about it now than get shocked later.[1]

If you can't get the right amount of love for your project, then your options are simple: Take what you can and hope for the best in terms of distributor overages and profit participations, or, sacrifice that small advance offer against distribution rights and keep full creative and distribution control of your movie. And by going this route, you keep all rights and license each "right" whether it be TVOD, SVOD, DVD, or television.

As daunting as this may sound, it is a perfectly viable option for many filmmakers who work in the world of high-end art movies or documentaries where these movies are appreciated by specific audiences but don't fall into the business model of a distributor. Most importantly, these filmmakers instinctively know they will be better at maximizing the returns to their investors through a comprehensive marketing campaign that they control, and not relying on a third party distributor who will give the film its one shot and then move on.

These are movies that have very targetable community-based audiences, don't need the full court press of television or heavy media advertising, and can be launched on a small platform basis supported by a heavy dose of social media, publicity, reviews, the right kind of exhibitor support and, hopefully, strong word of mouth.

The only thing these movies need, besides a modest budget, is another almost full-time commitment from your producing team that could last as long as it took to finance and shoot your film, in other words, be prepared to live with your project for at least *another 8–10 months.*

You have now entered the scary, frustrating, and highly rewarding world of Alternative Distribution, also known as Self, Hybrid and OMG-What-Have-We-Gotten-Ourselves-Into super independent distribution.

There are a number of factors to consider if you decide to go this route:

1. You firmly believe that at the end of the cycle you will have earned more revenue than the original distribution offer you rejected (or was never offered) and be closer to recouping and paying back your investors.
2. You want complete creative control over the marketing.
3. You feel that the lack of substantive offers from the existing distribution companies is not an indictment of your movie's potential, but based on their own profitability models, and through self-distribution, you see a window to success that cannot be attained otherwise.

On the flip side, the commitment is challenging, can be overwhelming and requires a steep learning curve but at the end of the day will be an exhausting yet exhilarating experience.

1. The time commitment is long and intense – as in months and months.
2. You must assemble a team of consultants to help market and distribute your film and be able to devote the proper amount of time to manage them. You cannot do this yourself or with your producing group alone. There are many independent consultants who provide the services you will need to generate your plan, and their own personal contacts in their specific areas are indispensable.
3. You will have to raise additional funds to execute your marketing plan.
4. This also means getting your initial investors to sign on to this plan and maybe provide the additional funds. They will also have to understand the revenue stream will have a long tail. Sometimes your investors will want out based on the offers that are on the table, even if it means a loss for them. Or they may choose to stay with you and continue to support your new plan, particularly if their investment is less about a simple profit motive, but about supporting you as a filmmaker, your subject matter and content, which may have been an initial reason for their involvement, or a cause or topic that you have made your documentary about.
5. You will have to become quickly schooled in the business aspects of theatrical distribution, media buying, ancillary window licensing and how that windowing impacts your release if you decide to go day and date, VOD or maintain the standard 90-day window. This knowledge will support all your future decisions as you continue your career.

While there are many ways to raise financing, and build and execute your plan with a sales and marketing team, a great example of this has recently been established by the Sundance Institute and can be seen as a potential template whether you decide to apply to them or not.

THE SUNDANCE INSTITUTE CREATIVE DISTRIBUTION FELLOWSHIP

The title of this Fellowship sounds like it is a Distribution option only; in fact, it is a grant-based wealth of resources and licensing deals that allows you, in consort with your own fundraising capabilities, to build the necessary assets to control your own destiny.

Here is an excerpt from their mandate: "We help independent storytellers build audiences and sustain careers through innovations in marketing, distribution, and data transparency."[2]

As of this writing, the Fellowship has supported two films, the fiction feature *Columbus* and the documentary *Unrest*. Their full case histories can be found here: https://www.sundance.org/programs/creative-distribution-initiative. By the time this book is published, there will probably be at least two or more added.

Here are the opening paragraphs from the *Columbus* case study that set the stage for the producer's next round of decision-making (quoted with permission from Sundance).

> You make the film, you get into a great festival, it's super exciting, you have all of the highs and lows, you have the premiere, it's the best day of your life … and then what? *Columbus* producers Danielle Renfrew Behrens and Giulia Caruso approach the Sundance Film Festival like most of their peers: hoping for a distribution deal that would enable them to pay their investors back, turn a profit, and reach and inspire audiences.
>
> Their film—a lyrical drama by first-time feature writer/director Kogonada, starring John Cho, Haley Lu Richardson, and Parker Posey—premieres in the 2017 Festival's NEXT section.
>
> It is an exciting time for the entire team, especially for Kogonada, making his feature-length debut. Having garnered a cult following through his captivating visual essays, buzz circulates around Kogonada and *Columbus* leading up to the Festival, and the producers, along with their domestic sales team led by Cinetic Media, are optimistic.
>
> Going into the Festival, the filmmakers hope for a worldwide all-rights deal with an advance in the range of high six figures to $1,000,000, which is not uncommon for an American fiction film premiering at the Sundance Film Festival. For international sales, the *Columbus* team hires Visit Films in case they only receive domestic all-rights deals. Their preference is to secure a theatrical release in North America, since the team is committed to Kogonada's cinematic vision, but they are willing to consider foregoing theatrical release if they receive an offer that recoups the film's budget (e.g., a big Netflix buyout).
>
> The film was financed entirely through equity for $700,000. To support their Sundance Film Festival premiere, the film team uses nearly $30,000 from their contingency budget to cover PR (publicist and pre-screenings for press), condos for filmmakers and talent, film team travel, ground transportation, and poster printing, bringing their total budget to $730,000.
>
> By the end of the Sundance Film Festival run, *Columbus* has been seen by nearly every distribution company. Still, despite exemplary reviews and a prominent international premiere at the International Film Festival Rotterdam in February, the best offer the team receives is a North American all-rights distribution deal with a $150,000 advance—far lower than the high-six-figure advance they hoped to receive.
>
> The filmmakers weigh their options: Take the all-rights deal for less than expected or pursue self-distribution?[3]

More recently, and as their project started to wind down to more manageable oversight, we had the opportunity to talk to Guilia Caruso and Danielle Renfrew

Behrens, the two lead producers on *Columbus*. While their extensive comments are part of the case study, we did have a few additional questions based on their experience.

What was the biggest takeaway from your marketing experience?

Guilia Caruso and The marketing process was a deep learning curve. One of the
Danielle Renfrew: big things we had to learn was having to always be thinking about the macro to the micro, from which tweet or post to keeping the overall picture of the campaign in mind. Each part of the process had its own campaign and we had to keep track of the small pieces as well as the longer picture. Everything was relevant.

How much impact do you think the social media campaign had on the success of the film?

GC and DR: We will never really know but we put a lot of energy into the (social) campaign. But the success was still driven by traditional means – press, quotes from the press – and our publicity team worked hard on this. We used Facebook as the primary platform. For example, people saw the trailer and read reviews on Facebook, not on TV. Each piece of press coverage became its own link and all the digital press provided content.

Can you speak to the value of self-generating publicity and the *Columbus* premiere in Indiana?

GC and DR: What we were happy to find out and embrace was how the *Columbus* premiere was going to be a big deal. The event we created (in Indiana) generated a lot of publicity that resonated in other parts of the Midwest.

What happened after the theatrical release? Did you have to keep the marketing going?

GC and DR: The movie has a long life and you have to keep coming up with ideas. The hope is down the road you can create mini events over a long time. For example, the film was in Sundance in 2017 and around the time of Sundance 2018, there was a spike in sales because the Festival highlighted some of the films from their previous festivals.

A key subject of the movie is architecture, and yet according to the case study, this was not a driver for your social advertising, that is, the cost to promote that content to fans of architecture came in very high and did not resonate.

GC and DR: This is what our digital person found out. At the same time the most efficient audience buckets were arthouse audiences and modern art audiences, with a small group aided by Asian celebrity interest, as one of our stars was John Cho. But after

the movie opened, we heard through word of mouth that people were suddenly more interested in architecture, so this was great to hear.

Having now gone through an exhausting yet exhilarating process, do you think art films can survive?

GC and DR: We realized there is a world between the two coasts where these kinds of movies are important.

And for each market, we created a unique localized marketing campaign including specific tweets and posts, ads and screenings. That we were able to tailor to each market's needs was very important to our success.[4]

The Sundance Institute also introduced us to Jim Cummings, the writer/director/star of *Thunder Road*, which won Best Narrative Film at the 2018 SXSW Film Festival. Having just gone through an experience at SXSW where *Thunder Road* won the top prize for best narrative feature, and subsequently went through the whirlwind of distributor love, interest and passes, he realized that you have to constantly remind yourself that as much you may think the cavalry is coming, sometimes it never does, and you have to do it all.

Jim does not feel he is too crazy to be doing this. As a six year Redditor he has learned the power of the web and how you can monetize it through YouTube and other venues. Sure, his rapper friends have a lot of influencers attached to them, but there's no reason the concept can't work here as well. "I learned how to do VFX when I made this film, so to me this distribution thing is just another thing to learn."

Ultimately, he thinks that transactional will lead the day. Create a trailer and put it up online with links to rent or buy and do the publicity and whatever else it takes to promote awareness – festivals, etc. This, of course, presupposes that the film will not have a theatrical release in theaters, something that many filmmakers still opine for, but certainly for a wide variety of low budget films, Jim has a good point.

The only thing you have going for you is your basic instincts and audience-building skills, just like you had when you made your movie. And the marketing concepts we discuss in this book all apply to self-distribution as well.

A big final note – this is not for the faint of heart. Many young producers who we have talked to, once they got an understanding of the intricacies and time commitment in self-distribution, opted to take whatever deals were available, hire a sales agent to cut the streaming deals and forgo the theatrical piece unless it came as part of a commitment from one of the ancillary companies.

They are neither right or wrong in their decision process – it all depends on your commitment to yourself, your subject and message, and your investors.

EXERCISES

1. Read some of the stories from producers about their choice to release their movies themselves. A great blog to read is Dearproducer.com.
2. How do you determine the reasons for self-distribution?
3. Research some of the small independent companies that you can hire to help market and release your film

NOTES

1 Dan Mirvish, *The Cheerful Subversive's Guide to Independent Filmmaking*, Focal Press 2017.
2 Excerpted from the Sundance Institute 2018 Distribution Fellowship Application.
3 Excerpted from Columbus Case Study, © Sundance Institute.
4 Source: phone interview 6/4/2018.

18

Awards and Festival Marketing

The Art of Winning and Why it Matters

"I'm here at the Academy Awards – otherwise known as the White People's Choice Awards," said Chris Rock hosting the 88th Academy Awards.

That was the blistering commentary from the host in 2015 as he, and global viewers, called out the lack of diversity in the awards with #oscarssowhite. In 2017, viewers around the world watched in shock as *La La Land* was incorrectly announced as Best Picture, stealing the thunder from rightful winner, *Moonlight*. In 2018, the industry was rocked by the #metoo movement and a strong call for female representation in key leadership positions in studios and behind the camera. And for 2019, after choosing Kevin Hart to be the host, he pulled out after it came to light that, in the past, he had made a number of homophobic jokes online.

However, outside of these events, there have been some notable gains: The 2018 Oscar nominations class had more diversity than ever and the voter ranks have reached over 7000. For the first time, a female was nominated for a cinematography award, an African American woman was nominated for best adapted screenplay, and there was a diverse group of best director nominees including a woman (Greta Gerwig), African American Jordan Peele and Latin American Guillermo del Torro. There was also a black, transgender filmmaker nominated for best documentary feature (Yance Ford).

And while there were certainly some groundbreaking nominations, there were also some controversial omissions like *Wonder Woman*, directed by Patty Jenkins or festival favorite, *The Big Sick* for Best Picture.

The bottom line is that there is never a season that is more scrutinized, analyzed and theorized about all year. With all the scrutiny of Hollywood on television, the web, and publicly, everyone remains drawn to the same thing that has allowed movies to endure for over a hundred years – entertainment, escapism and quality story telling.

Welcome to the awards season where egos are served, millions are spent, back-stabbing is more the norm than people admit, hosts' jokes go viral, movies are put on a pedestal, political relevance is at an all-time high, both presenters and winners can't help themselves from commenting in front of hundreds of millions of people around the world, and everybody wants to know – what are you wearing and what is the food being served at the latest Academy function?

A quick note: This chapter is not about how to enter your film into a film festival or what you should do to prepare for it (a great book on that is *The Complete Film-makers Guide to Film Festivals*, by Rona Edwards and Monica Skerbelis). Nor is it a primer on a DIY awards campaign, which you simply cannot do alone – not only is it too costly, but the voters lists are closely held by the consultants who are protecting the key to their livelihood and only available for a hefty fee. But more about this unique group later. First, a key question:

Are you a contender? Maybe – you finally completed your first feature and you are really happy the way it turned out. Congratulations to you, the cast and everyone involved in making the movie! At this point in the film's life, you have reached Nirvana – it doesn't get any better than this because nothing has gone wrong, no one has rejected you, and the critics haven't seen it yet.

Your next step is to try to secure distribution and if you are successful in that endeavor, it becomes incumbent for you and your distributor to create the best and most profitable scenario to return the distributor's investment followed by your financial backers.

Russell Schwartz: At one of my marketing classes in Chapman, I asked the creative producing students when they thought their producing job was done. Some said when the film was sold, others said once it is released and gone through all the windows (the correct answer!) and another one blurted out "when you win an Academy Award." While this got a nice laugh in class, it is not unusual for many film-makers to believe that they have a movie worthy of an awards campaign, whether they have a feature or short. Of course, if the film contains some of the right elements, an awards run may in fact be the best way to launch your movie.

Be forewarned however – there is a not so fine line between doing what is best for the movie and getting sucked into the circling drain known as The Awards Push. Your distributor must decide whether an awards push is the best thing for your film or if is there a better time of year for it to open without the added pressure and expense of chasing, what for many, will be a rainbow. And let's not forget the very important question – what are the best chances for profitability?

Opening your movie in the spring, for example, with less competition and more eyeballs available, could be the road to a much more profitable scenario. This is also not to say that releasing earlier in the year is impossible to be nominated. The work to do is make sure the movie is remembered when the fall comes around, and supporting it with a full awards campaign even though the film will be available for streaming and rental.

During the last quarter of the year is when 95% of these award contender movies open, and the competition is beyond fierce as every movie being pushed has the

same boxes checked – glowing reviews, a slow platform release geared to making sure the film has the staying power to last in theaters, a robust screening program, talent more-than-eager to work, and the incessant desire of the critics and editorial people to analyze, postulate and predict.

Further, in order to qualify for an Academy Award, your movie only has to open in Los Angeles before December 31 and run for seven consecutive days. While this is not the case for the stronger indie or studio titles that have a higher profile and open according to a predetermined release strategy, many producers of smaller films have the option of doing their seven-day qualification.

While the entry bar is quite low (including filling out all the correct forms, of course), you get a good idea of how many smaller films are fed into the increasingly narrow funnel of October, November and December. It is quite common for these films to cannibalize each other particularly when the audience in many cases is the same – sophisticated moviegoers who generally set the box office tone for films that get a strong critical response. While this audience is a very loyal one, it is older and not very large so there are just so many films they can see over the short window of these titles' release. And, of course, there are the commercial holiday titles they will want to see as well, which are also vying for awards recognition.

A nice exception throughout the summer and fall of 2018 is how the documentary contenders were released over a long number of months, and not just in the fall where most would surely have gotten lost.

The awards "season" ends with the Academy Awards in the end of February or early March depending on the year. It unofficially begins with three late August/early September festivals –Venice, Telluride and Toronto. All three have become early showcases and litmus tests for a large number of films with awards in their headlights. Venice usually spotlights a mix of commercial and specialized films geared more towards a European audience and is not heavily covered by the domestic press. Telluride, the first official fall American festival, is much smaller and showcases a select number of titles that are considered contenders, either auteur driven or original breakout titles. Films that do well critically at Telluride are considered on their way to awards recognition.

The festival cycle begins with the Sundance Film Festival in January. While this is not where the studios bring their award contenders, it has always been a source of new and emerging filmmakers and their movies, of which a small amount are acquired through intense bidding wars and then properly dressed and attired to join the festival circuit in the fall. In the middle is Cannes; however, less a bellwether for English-speaking movies and more a highlight for future foreign language contenders. While the first fall festival is technically Venice followed by Telluride, these two coupled with the Big Kahuna known as the Toronto Film Festival in early September are a mix of studio and independent titles as well as a large number of international films that have hopes of foreign language nomination recognition. These festivals are also the first place that a film can stumble in its aspirations, either through mixed critical or audience response. So, while distributors and filmmakers love going to Toronto, for example, since the city and its population are so

supportive, a bad review is a bad review and a tepid audience response is very difficult to recover from. Toronto is also the first time we see the armies of publicists and awards consultants converge in mass to start pitching their clients and setting up whirlwind publicity days and nights.

As the fall season revs up to include festivals in New York, Boston and a number of other cities as well as the American Film Institute in Los Angeles in early November, a multitude of self-sanctioned awards groups start to announce their own nominations and predictions in an effort to become the early harbingers of what's important and what's not. The majority of these groups are about self-promotion and the ability to sell television rights, but no one does it better than the Golden Globes.

The Globes' membership is an odd assortment of 90 independent international journalists whose nomination choices include picks from both the dramatic and musical/comedy categories, (the more nominations, the better the show looks!) as well as a plethora of television nominations as well. The Globes announce their nominations in early December with their televised awards show in early January. While the Globes themselves are not really considered an awards predictor, they can certainly claim that role since so many movies and shows are put into contention. They have been around a long time, over 50 years and through various mini scandals. At the same time, they have been referred to as the best party in town with their table layout and easy camaraderie between television and movie folk.

Among the many other groups in the fray are the Critics' Choice Awards, representing mostly broadcast critics, the National Society of Film Critics Film Society, the Los Angeles, New York and 50 other city critics' groups, The Gotham Awards and Independent Spirit Awards in New York and Los Angeles respectively, which honor fiercely made indies, and special mention to the National Board of Review – a group that announces very early in November, but given their eclectic membership, it is said that if you win Best Picture from this group, you are doomed to win anywhere else. But you didn't hear that from us.

Also weighing in are the more seriously taken guild associations including the Directors Guild of America, the Screen Actors Guild and all the craft guilds, which have a significant impact on the Academy nominations as most are members of both. In other words, the Oscar nominations and winners are voted on by the members of the Academy. Most members of the Academy are also in the acting, directing, producing or writing guilds. This makes these awards quite predictive in the big race.

As we said above, between October and December, most of the films that have the potential to be nominated are released and fight tooth and nail not only for their own screens but against the mighty studios who jump into the fray occasionally, but are equally concerned with milking the huge box office potential in November and December.

During this time, armies of consultants are brought on board, many of them competing with each other and in some cases even themselves in some of the bigger categories where they handle multiple titles, but the fees and bonuses are too great

for them to play nice. Even the studios and independent distributors don't seem to care as they all believe they have the best chances with their film.

So what makes these awards consultants so special? And why can't the regular publicity team of your distributor handle this? In many cases they do work hand-in-hand and the consultants are able to focus on specific awards related activities, like screenings, events and talent handling, updating membership and critics lists, etc. while the publicity team works on the overall release strategy of the movie in consort with the full marketing department. For a lot of the independents who have a small publicity staff, or producers who want full control over the process, the consultants are a much welcomed asset in terms of taking on the awards responsibility.

The game has also changed dramatically with the advent of DVD screenings and now the introduction of streaming some awards titles well in advance of their street dates. With so many titles released in the fourth quarter, it is virtually impossible to go to a theater to screen every contender, and the stacks of DVDs being sent out has complicated this even more. Assuming I can't get to the theater, I know I will receive it at home and will more readily make the time to screen it.

Russell Schwartz: As an Academy voter, for example, I receive over a hundred DVDs per year, and the timing of when I receive what and when will determine where it falls in my stack of unwatched titles. Naturally, I have my choice titles I will see either in a theater or when they arrive, but there is a big middle ground of wannabe contenders that have to time it just right to be early enough but not too early in advance of their opening to miss the publicity push that would get me to put the movie in my player. At the same time, distributors must make sure they don't open too late in December unless they have a high profile contender or they will miss being in the conversation.

By the way, every DVD I receive, I am required to destroy at the end of the awards season. They are not keepers, but loaners as they remain the property of the studio. Does everyone destroy their loaners? Probably not and if you are thinking about loaning them to friends and family, the risk of lending them out, when most are watermarked and coded to each voter should they be found online, is not worth it.

SO WHAT ARE THE DNA ELEMENTS OF A BEST PICTURE?

By opening up the number of pictures that can qualify from five and up to ten, there are a much more diverse number of titles that now end up on the list from the extremely low budget *Moonlight* to could be one of the biggest budget nominees in 2019, *Black Panther*.

The wide and very different personalities that make up the Academy membership means the voters can no longer be considered as a "block" as their individual tastes and their desire to support new and original stories and filmmakers and producers has accounted for a very unique mix over the past 15 years.

Interestingly, the classic, impeccably crafted story like *The Post* is almost always nominated but rarely wins.

It is the hot button issues where voters can vote with their heart, content with their conscience, the throw-back celebrations to either the industry or an older Hollywood, like *La La Land*, and the smaller "must see" titles like *Three Billboards...* or *The Shape of Water* are the films that usually end up on the podium.

RULES OF THE AWARDS CAMPAIGN

An Academy Awards campaign can cost anywhere from $500,000 to $15M depending on the scope of the movie and the pockets of your distributor. This includes an extraordinarily large number of items to be covered from sending out those all-important DVD screeners (usually 15,000 of them), millions for media advertising depending on budget, events which could include screening followed by a lunch or dinner and discussion with the filmmakers afterwards (one Academy member said he decides which movie event to attend based on the menu being served), travel, hotels, printed brochures extolling the virtues and critical response of the movie, and an endless procession of parties, presentations and awards events where the talent has the opportunity to interact with the voters.

So what are some of the myths of Oscar and awards campaigning?

Festivals Matter

As we've discussed, these are important bellwethers on the path to awards recognition but your distributor and you must be super confident that any early exposure will only yield positive results.

Campaigning

This is the crazy one – the publicity teams will tell you that you can never do enough, but most talent abhors the process and seek to make their own schedules with what they perceive as important. And there is no way to gauge whether any of it matters at all.

There Will Always Be a Surprise

There will come a time when an actor in a CGI costume will win. Up until *Lord of the Rings*, a movie based on fantasy had never won a Best Picture.

For years, fantasy was always mentioned as the "F" word before the breakthrough.

Peaking

One of the biggest fears is for a movie to peak too early – meaning it is a shoe-in for the Best Picture win over a number of months, but then a smaller movie comes along that everyone embraces and all of a sudden the sure-fire winner ends up in second place.

Such was the situation when *The King's Speech* beat out *The Social Network* for Best Picture and more recently *Moonlight* beating the front runner, *La La Land*, very much towards the end of the awards cycle.

But *The Social Network* vs. *The King's Speech* is a most interesting case study. Here's how *The Social Network* looked on October 1, 2010 when it was released and went on to gross $96,962,694 domestic and $224,922,135 worldwide.

- Early frontrunner.
- October release date meant the film was top of mind for five months.
- Great reviews across the board.
- Very hot book with terrific screenwriting, production and directing team.
- Hip soundtrack featuring the rock stars of the day.
- Sony Pictures seemed over eager to grab the prize – hosted many lavish dinners in Hollywood throughout the fall.

And then things went awry. What happened?

Right after *The Social Network* won Best Picture at the Golden Globes, the mood on both films changed dramatically. Voters, not journalists like those who comprise the HFPA, started to weigh in on their choice and soon every nod went to *The King's Speech*. As opposed to *The Social Network*, which was essentially about a not very likeable, misogynistic lead character, *The King's Speech* offered an emotional story that resonated with most of the older members of the Academy. And, of course, it was British, which is always a plus with this demo voting group. And the back story elements only added more fuel to the sympathetic fire – the screenwriter was a stutterer, and the director's mom told him he must make this movie.

Most importantly, the lesson to be learned is you never want to be the front runner because there is no way to go but down. Every movie that opens after yours is gunning to take you down a few notches.

Big budgets and studio backing don't guarantee anything. Just look at the nominees over the past few years and see how different their distributors are – from small indie to big studio.

So what's more important – the nomination or the win? For the distributor, the nomination is by far the most important as this is the bait that brings the public in – wanting to see the contenders before the winner is chosen. On the average, movies will do up to 90% of their business through the nomination phase. The actual win is much less important when it comes to factoring in new audience interest.

For the talent – you could say the win as this will have the greatest impact on the actor's salary for their next film or television show. However, even a nomination puts you in rarefied air and is a pretty sure guarantee of continued work and demand over the next few years.

This then, is where the all-important discussion between producers and distributor begins to take place – when is the best time to open the movie? Do you do what's best for the awards potential or what's best to maximize the film's chance of success?

THE ROLE OF CREATIVE ADVERTISING IN AN AWARDS CAMPAIGN

The design and audio visual content that are produced for an awards campaign can be quite different from the campaign created to open the movie to the general public. Here, we are dealing with a very targeted group of awards voters, whether they be members of the Academy, guild, Golden Globe or critics groups.

Most advertising is placed in the industry trade magazines, like *Variety*, *The Hollywood Reporter*, *Deadline*, *The Wrap* and *Screen*, which is the international trade magazine, and the specific publications of the guilds whether it be the producers, cinematographers, editors, hair and make-up etc. And most importantly, if you are seeking a nomination for an actor, then *Back Stage* is the magazine that most Screen Actors Guild members read. Each of these magazines has its own digital extensions where advertising is essential as well. If you add in more national publications like the *Los Angeles Times* and *The New York Times*, two cities where most of the awards voters live, then you are pretty much covering the territory.

Gail Brounstein has been an awards consultant for a number of years and has worked on the creative advertising campaigns for many award winning films including *The Lord of the Rings*, *Moneyball*, *Argo*, *The Theory of Everything*, *The Danish Girl* and worked on *Bohemian Rhapsody*. She believes that every movie has its own strengths that must be evaluated and brought into focus:

Gail Brounstein: When we approach an awards campaign, we look at a number of areas where we feel the movie has a chance of voter recognition. We are after scope, performance, craft and emotional resonance. As the film earns responses from the festivals, critics and any awards groups, we incorporate these into our print, digital and television campaigns.

How is the look different from the normal theatrical release campaign?

GB: It is rare to use the theatrical campaign for an awards campaign as they serve two different purposes – one is for the general public to entice them into seeing the movie, and the other is to celebrate those accomplishments that went into making the movie a success. We focus on specifics – actors, costume designers, production design, directing, etc. depending on which group we want to reach.

Where is the advertising placed?

GB: The advertising dollars are primarily spent in the geographical locations where most of the awards members preside, namely Los Angeles, New York, San Francisco and London. We are dealing with a very small and extremely targetable base.

Once a campaign is decided upon, do you then just run with it or are there changes you make as the campaign moves along?

GB: I wish! These ads are perhaps the most scrutinized of any campaign. We have to satisfy the talent, the publicists, the managers, the agents, and anyone else who feels entitled to voice an opinion on behalf of their client. Many times, we are up until way past midnight tweaking a last-minute new quote line or scourging for one more line to fill out an ad right before an early morning deadline.

CASE STUDIES

So what about our case studies? How are we going to do with the Critics and Awards groups?

The Tunnels? Forget about it.

This movie was not made for the awards but for the public and will not be the type of movie that your distributor will want to spend money on for a campaign. Be happy about that as the advertising spend should be at opening, not months later.

Philosophy of War? Definitely a contender.

On the opposite side of *The Tunnels* lies this movie with its made-for-awards-contention characteristics. A compelling story, strong talent, a director with previous awards cred and a studio willing to spend the necessary amount to push this film into "must-see" status regardless of if it starts off slowly at the metroplex.

No expense will be spared to promote this movie to Academy members. Best to list some, but certainly not all, of the campaign checklist:

1. Special screenings and selected lunches or dinners with cast members.
2. Premieres in a few major cities – New York, Los Angeles and possibly Washington DC.
3. Q & As during the opening weekend in New York and Los Angeles.
4. The industry trades like *Variety* and *The Wrap* host a screening series for the public and Academy members.
5. Participating in *Deadline*'s The Contenders Saturday presentation usually the first weekend in November.
6. The cast making themselves available to attend awards ceremonies and other premieres.
7. A 30–40-page full color insert placed in the trades. A number of years ago the Academy ruled that promotional material could no longer be sent to the members directly. While the Academy rule was applauded as an effort to level the playing field, the trades were more than happy to take the advertising revenue and send to their own Academy list.
8. Participation in numerous photo gallery shoots that a number of magazines like *Vogue*, *Entertainment Weekly* and the trades do to highlight the contenders.
9. The television circuit from early morning to late evening talk shows are exhausting but a necessary evil to not only promote the opening of your movie but to sustain it afterwards to keep it in the voters' minds.

10. Creating new and focused message radio and television spots, usually only running in *New York*, *Los Angeles* and *San Francisco* where the majority of the voters live.
11. Making sure the international voter is romanced and accounted for.
12. Sending the all too important screener to anyone who has influence. This number is usually around 10,000 DVDs that are sent to Academy members, critics' groups, the Golden Globe members, the online critics group, selected guilds depending on the potential nominee's affiliation and last and certainly not least, the Screen Actors Guild nominating committee, which in itself is around 2200 screeners. Remember the SAG Best Ensemble award is usually a harbinger of the Best Picture winner.
13. Hire any number of awards consultants to concentrate on both individual nominations and the overall campaign. As we noted, these people are usually not exclusive so they may end up not only competing with other consultants but with themselves if they are handling two different actors, for example, in the Best Actor category.
14. Not to mention, of course, how important it is to fill out all the application forms and get them in on time!
15. Look for selected end of the year film festivals like the AFI Fest, which is considered a harbinger for contenders.
16. About 100 other boxes to check.

K2TOG? Could be a surprise for original screenplay or stand-out performance.

Your distributor will not want to devote too many resources to this awards campaign as they will be working with a limited budget from the start. And if they feel your movie is not going to be a contender for best actress, director or picture, the benefit to the box office is meaningless.

However, there are some awards groups where the movie could shine, particularly in The Gotham Awards or the Independent Spirit Awards where the vibe is considerably more laid back and a win from either of these as a picture, breakout performance, first feature or the myriad of non-Academy Award type awards, all help position the movie as the hip film you and your distributor will want to ensure attracting the contemporary millennial and older crowd. And let's not forget all the free publicity your cast may get from television, radio and digital interviews all geared to the public and by extension, the awards audiences.

Sugar?

Definite Best Documentary contender because of its feel-good nature.

But this is not a category you have to spend on. There is a committee that narrows the films down to 15 and then five and these are your contenders. Further, the Academy, like it does with the foreign language and short films, has established a streaming service as well as a DVD package that is sent to each voting member. Sure,

your distributor should take a few ads in the trades and put your director and stars on the publicity circuit but these are not very expensive items.

EXERCISES

1. Name two examples of each category of Best Picture nominees over the past few years.
2. Come up with "comp" titles for both *K2TOG* and *Sugar* (doc category of course) in terms of their award worthiness.
3. What do you think are the most important criteria for *K2TOG* to be considered an awards contender? Reviews? Box office? etc.
4. When is the best time of year to release independent specialized movies?
5. Find other two to three other movies that are similar to yours and study their awards strategy. Did they advertise? Were they successful and garnering nominations? How did that impact box office?

19

Marketing for Animated Movies

Marketing to the Kid in All of Us

While the basic principles still apply, marketing an animated movie is also a unique challenge with a different set of tools. The most important thing to know about marketing an animated movie is that you absolutely must plan ahead. The animation process is slow and very expensive. It's a form of filmmaking where everything that ends up on screen is created from scratch and, therefore, there's a great opportunity but also a new set of challenges for marketers. If the Marketing team works with the filmmaking team strategically, they can create all sorts of useful assets that can unfold during the campaign.

WHY MARKETING IS DIFFERENT

First of all, the audience for an animated title is very unique. These movies, in general, are very expensive to produce and therefore the studio has major expectations for them. The marketing group needs to target kids, parents, grandparents, tweens, teens and general audiences. Each of these audiences will respond to the movie in a different way and will require a different sell. This is exactly the same situation as marketing tentpole movies and these animated films are expected to be on that same box office level for the studio.

Of course, there is also a robust industry of independent animation being created outside of the studio system. Many countries have their own major animation industries, such as Japan, France and Spain. There are artists who create lower budgeted two-dimensional animated movies or stop motion animation. But, even though the budgets are lower than a CG tentpole, they are still not low. It's expensive to create animation and it takes a ton of people. While indie animation may distribute via festivals, streaming and VOD, there is still a lot of pressure to reach a wider audience.

ANIMATION PROCESS

This is a very simplified summary of the process, but it's important to understand that CG animation happens in phases.

- **Storyboards:** Once the filmmakers have a script that they are happy with, they bring in a team of very special artists who hand draw frames of the film. The Editorial team then takes all of those drawings and stitches them together to create scenes that can be screened – an "animatic."
- **Layout:** Next, another team moves these drawings into a computer program to start to block out the movement and basic sets.
- **Animation:** This phase takes the characters from layout and starts to add real movement and facial expressions to them. Animators talk about creating a skeleton for the characters that allows them to move – this is called the Rig. The characters start to come to life.
- **Lighting:** These artists add textures, light and shadows to the surfaces of the sets, characters and props.

There is an excellent video on the animation process created by DreamWorks Animation and posted on YouTube, titled "Penguins Show us the Pipeline of DreamWorks Animation Studios."[1]

TRULY INTEGRATED PLANNING

Given the many stages of animation, it is both costly and time consuming to make changes when a scene has moved past storyboards. Therefore, it is key that the marketing department reads the script and screens the movie at the storyboard stage. Animators call this, "putting the movie up" and they will hold a number of storyboard screenings before they start approving sequences to move through the pipeline into Layout. Marketing should work with the filmmakers to identify key scenes that they would like to see finished earlier so they can be used in the campaign.

REACHING KIDS

The first-and-foremost goal on the mind of a marketing exec working on an animated film is, "How am I going to get kids ravenous to see this movie?" The rule of thumb with kids' marketing is that you have to start a little earlier than marketing for a general audience. Whereas a typical marketing campaign really ramps up in earnest about three weeks from release, a kids' campaign can begin four to five weeks out. The reason is that it takes a bit more repetition to get the attention of younger audiences. They are inundated every day with advertising for everything from toys to snacks to television animation. Breaking through

the noise and grabbing their attention takes a longer media flight and a higher frequency of ads.

Furthermore, a major tentpole animated movie will typically release a teaser trailer up to a year ahead of release and multiple trailers in the months leading up to the opening. These movies need to feel like events so the campaigns begin early and are intended to create a lot of awareness and buzz.

In terms of the content, there are a couple of specifics here too. Children respond very strongly to the following:

Comedy

Kids love to laugh and it's important for a campaign to show off the comedic goods. Physical comedy, silly characters and, let's face it, fart humor, are usually a big driver of kid interest. That's not to say that a movie can phone it in; the characters and jokes need to be genuinely funny. It's a big mistake to underestimate how savvy and discerning kids are. They can tell right away if something is pandering. But, it is true that they love a good fart joke.

Not all animated movies are overwhelmingly funny; certainly, Pixar movies tend to be more adventure than comedy driven. But, there will still be comedic situations and funny sidekicks to feature in the campaign.

Kid Point-of-view

It's surprising how many movies aimed at kids actually feature adult characters with adult problems. If the main character is struggling to succeed at work or to keep his marriage together, it's a good bet that kids are going to be bored and uninterested. Kids want to see kid characters with conflicts they can relate to: Belonging (*Wall-E*), dealing with change (*Inside Out*), sibling rivalry (*Boss Baby*), accepting yourself (*Frozen*), etc. Even though the movie *Up* had an older male lead character who was dealing with things like grief and fear of the unknown, it's no mistake that a lonely, young boy joined him on his adventure. That character, Russell, was the kid point of view.

Kids also aspire up, meaning that they often tend to like characters and storylines that are a little older than they are currently. This is why you see so many 12–15-year-old protagonists in animation. It's a bit of a death nail in animation to hear 9-year-olds say in the research screening that this "looks like a movie for kids younger than me." The slang term for those titles are "baby movies" and it means the audience is much more limited. That said, there have been examples of films that were specifically aimed at younger kids and did great business. For example, *Curious George*. But, a studio sets out to target that audience specifically ahead of time and the movie is budgeted accordingly. When a CG tentpole that is supposed to appeal to everyone is being read as young, it spells trouble for the movie and a challenge for the marketing team.

Cute and Cuddly

Kids respond very well to characters that are cute. This usually means some combination of little, big eyes, fluffy and cuddly. These characters are usually secondary or tertiary characters in the movies, but they end up becoming beloved.

Notable Quotables

Kids love a catchphrase and it makes for marketing gold as well. Anytime a character delivers an instantly memorable and funny line, kids love to repeat it back over-and-over … and over, which makes the movie top-of-mind for both them and their parents. In general, if kids are running around quoting the commercials and trailers for an upcoming animated movie, that's a strong sign it's going to be a hit. Here are some well-known examples of notable quotables (also known as "one-liners").

> "No capes!" – Edna Mode, *The Incredibles*
> "The claaaaw" – The Green Men from *Toy Story*
> "Da da da dadadada circus da da da dadadada afro circus afro circus afro polka dot polka dot polka dot afro!" – Marty, *Madagascar 3*
> "Squirrel!" – Dug, *Up*

NAG VS. DRAG

Another common expression in family movie marketing is the concept of "nag vs. drag." This expression refers to the tendency for animated movies to fall in one of two categories:

Nag Movies

This is where kids are nagging their parents to take them to the film, but the parents are more likely to see it as a movie they will endure rather than enjoy.

Drag Movies

These are films that parents really want their child to experience and therefore are planning to drag them to the theater. These movies often have a nostalgic appeal, an educational element or a strong moral message that parents wish to impart on their children.

It's always preferable to be a "nag" movie rather than a "drag" movie, if you can't be both. Tickets and movie snacks are expensive and if a kid isn't begging their parents to see the film, it usually means it becomes a rental rather than a trip to the theater. Of course, a movie that both parents and kids want to see equally is the best case scenario.

Convincing Gatekeepers

While it's incredibly important to win over kids in animation marketing, you also must acknowledge that they cannot drive themselves to the theater or purchase a ticket. You can get kids white hot interested in a movie, but it doesn't matter unless you also convince the gatekeepers: Parents, grandparents, guardians and teachers. Put it another way, you must convince adults to bring the children to the movie and buy them a ticket. How do you do that?

Two-level Comedy

Adults really appreciate it when a family movie works on two levels. There's slapstick and kid-friendly comedy to keep their little one rolling in the aisle, but also an adult layer with more sophisticated jokes that sail over the head of kids. A best case scenario is when the comedy keeps both parents and kids laughing and engaged. But this is really difficult to pull off, so at least be ...

Tolerably Entertaining

When their kids are begging to see a movie ("Nag" factor) parents will assess how tolerable it will be for them to sit through and whether that is worth the price of a theater ticket. Remember, the gatekeepers hold the ultimate decision for "yes" or "no," so make sure your film is at least entertaining for adults.

Positive Message

Parents will look for the message that the film is peddling and this is an important factor in their decision. If the film has a good message for kids or teaches an important life lesson, that is bound to help convince then to take their kids. Conversely, if the film features kids behaving badly or celebrates a negative message, that's going to be a much harder sell for parents.

The marketing campaign will rely on heavily on the positive message in the spots they cut for the gatekeepers. They will also give the message to the cast to work into their talking points in publicity appearances.

Mommy Bloggers/Vloggers

There are a large group of bloggers and vloggers who specialize in advice on parenting. They have loyal followings and their readers trust them.

Studios will court these gatekeepers with special screenings and early access. If they will post a favorable review for the film touting its family-friendliness and good values, this will really help the movie and can be used in advertising.

Whole-family Sell

For tentpole animation, it's important to send a message that the movie is great for the whole family all the way from little kids to teens to parents to grandparents. The campaign will feature customized advertising aimed at each group and we will also sell the idea that the family can come and enjoy the movie together. This is especially crucial during the Christmas season, when "compromise" moviegoing is at its peak – meaning, this is the time of year that families get together and decide to see a film and the one that everyone can agree on is the winner.

General Audience Marketing

General audiences, that is teens and adults without kids, cannot be excluded from the marketing on these films. These are not easy audiences to get on these family titles and marketing will need to find a way in for these moviegoers. One of the most surefire ways to reach a broad audience is to highlight plenty of comedy. Everyone likes to laugh and animated films have a strong tradition of being remarkable funny. Whether it's the slapstick of the *Minions*, the sarcasm of *Wreck-it Ralph*, the buddy comedy in *Madagascar* or the pop culture parody of *Lego Movie*, there are many examples of animated films that broke through with general audiences.

Another way in, and one that Pixar has perfected, is to create films with universally relatable emotional stories. The opening scene of *Up* is a masterclass in emotion and it's hard to find an adult who had a dry eye during the conclusion of *Toy Story 3*. When a film delivers a satisfying emotional experience, word spreads and people who might normally opt out of an animated film will come to see it.

Another tool for reaching general audiences is the power of nostalgia. There are some franchises, like the aforementioned *Toy Story*, that have had a long history in cinemas. The first *Toy Story* came out in 1995 while the next installment of the film will open in 2019. A kid who was ten years old for the first film will be 34 years old when the next film comes out. Even if they don't have children of their own, they may still flock to the theater to see that characters they have grown up with. Nostalgia is also activated when studios make animated films using beloved characters or toys from decades past. Adults may be drawn to the title simply to revisit these beloved worlds and characters. It's no accident that there are so many animated or hybrid animated films based on nostalgic properties like *Trolls*, *Smurfs*, and *Garfield*.

CUSTOM ANIMATION/TOOLKITS

In animation marketing, a big part of the sell is something called the toolkit. This is a set of little vignettes and shorts that are entirely custom (created outside of the movie), which are used across the campaign. The toolkit is used by the creative advertising, promotions, media and digital teams. Some examples of toolkit assets:

Lower Thirds

These are little, funny beats with the characters which are meant to run along the bottom of programming. They are placed in partnership with network partners. For example, the characters might jog along the screen and interact with the network logo. They might pop up with a quick message or do something funny leading into the commercial break.

Seasonal Promos

The studios might create little customized animation pieces for holidays (Valentine's Day, Thanksgiving, Christmas) or events like the Super Bowl or the Olympics.

No Talking/No Texting

These little announcements are common in movie theaters now. Characters come on screen and in a funny and creative way, let audiences know to turn off their cell phones and refrain from talking and texting during the movie. These are a win-win because the studios get to promote their film and the exhibitors get to remind audiences to silence their phones in a funny and unique way.

The toolkit is something that needs to be created many months in advance. It follows the same process as the film, starting with storyboards and progressing to animation and lighting. It is important for the Marketing department to plan for this well in advance and request the toolkit assets while the film is still in production so that it can be created seamlessly and efficiently.

SHORTS

Many animation studios, like Pixar, Disney, Blue Sky and Illumination create short films to run before their features. This serves a dual purpose for the studios. It's an entertaining way to start a movie and a bit of a throwback to the earlier days of cinema. But also, it's a way to test new technologies, break in new directors or launch new characters or storylines. It's also a way to remind audiences about the worlds and characters that they love, like the *Olaf's Frozen Adventure* short for the *Frozen* franchise that played before *Coco*. If a studio plans head, the short film can be a powerful tool to launch a new franchise, filmmaker or technology. But these shorts take a very long time to create and a sizeable investment, so they are a major undertaking.

LIP SYNCH

Often, the Marketing team will come up with a funnier punchline for a joke set-up in an animated movie. They will splice various lines together and then end with a character saying something funny that they've written. But there's a problem – the character on screen is saying something else and his or her lips don't match the new

line. This is when Marketing will reach out to Production and ask for a new lip synch shot. The animation team will re-animate the character so it looks like they're saying the new punchline. Then Marketing will bring back in the actor to record the new joke line. If the actor is no longer available, sometimes Marketing will use an actor who is a "sound-alike." Because it's just one quick line, there are times when an actor who sounds a lot like the main cast can cover the recording. But, it's always ideal and preferred to have the cast record these new lines.

STILLS/PHOTOS

In a live action film, the photo department will send a photographer to set to capture photos during production. They will also pull "stills" from the footage (still frames from the shot). But, in animation everything is created from scratch. In this case the photo department needs to run through the finished (or nearly finished film) and select frames to represent the movie in magazine spreads, newspaper articles, etc. They will usually need the animators to clean up the frames, which means rendering them in a higher resolution, removing the "motion blur" where characters are moving, making sure all the characters have their eyes open and adjusting the lighting. This is also a process that requires advance planning as cleaning up and re-rendering these frames is a slow and costly process that is best completed when a film is still in production.

ART AND ASSETS

During the planning and pre-production of an animated film there is a lot of research and exploration. The production will hire artists to begin creating sketches and paintings to inform the look of the film (called "visual development"). Key filmmakers may take a research trip to explore real-life locations in the film. Artists may spend time with real animals and study how they move so that they can be drawn realistically. Props may build models of sets to use as reference. 3D models of the characters are created that are called "machettes." On a stop motion film, there will be character puppets, tiny costumes and props.

All of these artistic assets can come in very handy for marketing later. They can interview the artists and use the art in the EPK and in making-of featurettes. This can turn into extra DVD content and or use the art and props to dress the lobby at a special event screening. Contests might give away original signed pieces of art and it's very common to create lovely hardcover coffee table books called the "art of..." books. These are commonly distributed to press to help promote the films. All this to say, that just like in a live action movie, everything that is created in the making of a movie can later be an asset used by the Marketing team.

Overall, animated movies are a long and complicated production process with many people involved. They are potentially very lucrative properties due to their ability to reach wide audiences from kids, parents, teens to general audiences. But, when a studio invests in one of these expensive and work-intensive films, the

pressure is on for the Marketing department to find the elements in the film that will generate the broadest possible sell.

EXERCISES

1. Watch the special features on the DVD for your favorite animated movie. Write down all of the different creative assets that the Marketing team used (art, filmmaker and cast interviews, etc.).
2. Pick a recent animated film and find the trailers and TV spots online. Write out the strategies that the spots are using to appeal to kids, parents (gatekeepers) and general audiences.
3. Select a popular folktale or fairytale and imagine this is the basis for a new animated title. You are in charge of marketing this film to all audiences. Write out a plan for how you will use elements from this story to appeal to all audiences.

NOTE

1 https://www.youtube.com/watch?v=5CbG0d_tnSg

20

A Marketing Tale with Pivot

When You Have to Rethink
Your Strategy

Throughout this book we have emphasized the necessity to make the best film possible while always keeping an eye on the intended audience and marketing opportunities. When you start early enough and take this guidance into account as you develop your movie, then the result usually plays out the way you want it to.

However, in the world of acquisitions, where companies acquire finished movies and then have to fashion a marketing plan, the result isn't always as clear cut. As we have seen, distribution companies acquire movies for a variety of reasons – there is the festival hype where a movie is put on a pedestal and becomes a must-have, the company has a desire to work with the director or producer on future projects, a company feels so strongly about a movie that they may outbid everyone else to secure the rights. Or, it may be a combination of all of these factors that drives an acquisition.

WHEN MARKETING GOES ONE WAY BUT THE TARGET GOES ANOTHER

As we have discussed throughout this book, defining the audience is one of the most important areas to identify early on in the marketing of a movie. Once you know your target audience, your creative team can craft the messaging accordingly. However, sometimes the audience that you thought was your target, turns out to be quite different. And while this is certainly a rare occurrence and while Marketing usually knows it is best to follow their instincts, sometimes things just flip over and do a 180. Such was the lesson we learned in the marketing of the movie *Chappaquiddick*, a movie that Entertainment Studios bought in a daring pre-emptive move right before it had its premiere at the 2017 Toronto Film Festival.

A movie about Ted Kennedy would be a slam dunk pitch to a liberal audience of his and the family's supporters. While many people aged under 50 had never heard

of Chappaquiddick, the older audience certainly lived through it and most came away dissatisfied from the whole event with a slight feeling of unease that maybe Ted should have been more severely punished.

However, given the popularity of the Kennedys in the 1960s, most looked people just wanted to move on.

The movie itself is a very clean telling of the event where Ted Kennedy accidently drove a car off a small bridge on the island of Chappaquiddick in Massachusetts resulting in the death of his female companion, Mary Jo Kopechne. To make matters worse, it was a full ten hours before Kennedy alerted the police to the accident.

The film's strength, as anchored in Jason Clarke's brilliant performance as the senator, illustrates how a family dynasty rallied around one of their own and was able to manipulate the facts and the law enforcement community and engage in a coverup that essentially got Ted off on an extremely light sentence.

SWOT ANALYSIS

One of the first strategic documents a Marketing team usually generates is a SWOT analysis, where the Strengths, Weaknesses, Opportunities and Threats categories speak to the overall potential and speedbumps the film will face as it moves to opening day. Here is the original SWOT analysis that was created for *Chappaquiddick*:

Summary

Chappaquiddick recounts the tragic events of the 1969 fatal car accident involving US Senator Ted Kennedy and a young, female campaign worker who died at the scene. What happens over the ensuing ten hours before Kennedy actually reported the incident to the authorities, reveals how one of the most powerful and influential political family dynasties in US history orchestrated the facts and the real reason for the death of the campaign worker. With Kennedy poised to be a candidate for the next presidency, this incident became the defining moment in his career, and he ultimately must put his future in the hands of the American people to be his jury and conscience.

Strengths

1. Strong performances and potential awards recognition for Jason Clarke, screenplay, possibly more.
2. Target audience 40+ who are familiar with the event but intrigued to revisit and learn the truth behind the headline.
3. Very editorial worthy – a lot can be written about the position the movie takes.
4. Straddles the line between demonizing him and casting Kennedy as a tragic figure.
5. Stories about rich powerful family dynasties are always intriguing.

6. This can be sold as a behind the scenes scandal– very in vogue with *House of Cards*, etc.
7. This is a drama with new information and an exposé of sorts.
8. Cast will be willing and available for significant television and online appearances
9. Critics will be positive.
10. Putting the film into awards contention raises its profile in the industry and the public eye.
11. Conspiracy theorists will love this. The film could appeal to the alt-right as well.
12. Mirrors our political climate of misinformation and coverups.
13. First-time writers could be bridge to younger generation who would appreciate the film.
14. They can also become press darlings.
15. Festival worthy.
16. Director pedigree/ensemble sell.

Weaknesses

1. Story not known by the younger audience so challenge is to engage them.
2. Very crowded release period. Many films appealing to same audience could cannibalize each other as we have seen in previous years.
3. Is this movie theatrical? Will people want to pay to see it in the movies or is it an extended *60 Minutes* or *Crime Stories* reportage?
4. First-time writers not known.
5. Booking the cast could be difficult given all the competition during Q4 with higher profiles.
6. Release plan could make it go wide too quickly so have to do a lot of work on the local levels to advance the narrative of the movie before it opens.
7. Does the liberal core want to see a movie that shows a darker side of the Kennedys?
8. Period story creates its own obstacles and there is no period music to help us through it
9. Best Actor nomination does not drive box office.
10. Kennedy malaise.
11. The title (also a strength).

Opportunities

1. Add a few key 1960s songs to better set the mood. Is there a Beatles song?
2. If not for the movie then, can use for advertising materials?
3. Tie in with similar themed very high-profile Spielberg film *The Post* for editorial think pieces.
4. Establish film as ensemble cast for SAG nomination.

5. Pitch exclusive piece on the facts behind the movie to *Vanity Fair* and one of their key socialite writers. (Where is Gore Vidal when we need him?)
6. Editorial on and off the entertainment pages.
7. Cast could be award show presenters.
8. Data analytics to find older audience and be very targeted in digital media.
9. Capitalize on nostalgia via social media. Remember that weekend? Where were you? etc. That was an important weekend with this happening and the first people on the moon.

Threats

1. Ultra-competitive release period – Q4.
2. December 8 release good as long as we go wide – stay ahead of *Star Wars*, etc.
3. December 8 also helps hold through Christmas.
4. If the movie gets no awards nominations does that hurt its box office potential?

This analysis went through a number of iterations over the first few months while the Marketing team watched and listened how the film was being perceived but most of the topics held as correct.

The film had a very successful world premiere at the Toronto Film Festival and initially the release date was set for December of that year, but after careful consideration of the amount of time needed to mount the campaign and against all the fourth quarter competition, it was decided to move the date back to the spring of 2018.

The liberal festival audience raved about the film and this certainly seemed to be the defined audience that we should target. The only disconcerting thing we saw early on was when we looked closely at the first round of reviews we saw a pattern start to emerge – that the critics who were from left-leaning newspapers, television and websites – were mixed to negative about the film. Some were even dismissive and made us start to think that they just wanted the movie to go away:

Compare these quotes from two very well respected entertainment trade entities. This rave review from *Variety*:

> The movie is avidly told and often suspenseful, but it's really a fascinating study of how corruption in America works. It sears you with its relevance and, for that reason, has every chance to find an audience. "Chappaquiddick" is exactly what you want it to be: a tense, scrupulous, absorbingly precise.

And this dismissive quote from *The Wrap*:

> I'm not entirely sure why anyone chose to make this movie right now. We hardly lack in narratives that debunk the Kennedy mystique. Indeed, the Kennedys' moral failings are hardly what ails our democracy at this time. Many of us wish there was a Kennedy-esque figure to offer leadership in place of the moral chasm that faces the nation right now.

As the screenings played out, liberal audiences continued to embrace the film. But we started to get the unsettling feeling that they may not really want to go.

When we released the first trailer of the movie in December of 2017, our target audience started to define itself, and that was the audience and press on the right. For decades they have been waiting for an exposé on the Kennedy myths, and while this movie is not really that, it was widely embraced as the first really honest look at *Chappaquiddick* and how unrelenting the coverup was on behalf of Ted. An extremely popular commentator on Fox News said, when she first heard about it, "This is my *Star Wars*."

A step backwards here: If you look at the SWOT analysis under Strengths, note #11 where we raise the possibility that this film could also appeal to the alt-right. Now suddenly, #11 was being vaunted to the top of the list!

So yes, in these highly excitable times when the country is split into many different parts, this movie became a rallying cry for the right. It was raved about by the press and the commentators on Fox News and became a flash point for editorial in many newspapers and blogs. And in a testament to the even handedness of Rotten Tomatoes, the movie rating went from a 63 after the Toronto Film Festival to an 82 at the release date.

Remember, this movie was written by two very liberal screenwriters who were quite taken aback at the response from the right but perhaps more shocked that the audience who they *thought* they had written the movie for, was really not interested in going down memory lane with something closer to the truth. John Curran, the director, said he made the movie so people on the left can examine the flaws of their own heroes, and only when you can do that, do you have the right to go point out the flaws of the leaders on the other side.

However, the issue remained of how to craft this movie as a piece of entertainment and not just a political diatribe that was best seen on CNN or Fox News. How do you make the movie relevant and why now? We grappled with these issues but the conservative press rose up in a wide embrace of the movie, which drove their audience to the movie resulting in a successful theatrical run. Yes, the movie performed equally well in some parts of the country that were considered liberal bastion, Boston in particular, but you could see where the hot spots were going down both the East and West Coasts.

The next obvious question would be – did the advertising support this audience? The answer was yes, because only in the context of a political conspiracy were we able to craft trailers, television and online spots that framed the movie as a mystery with new revelations about what really happened. The most damning of all was the theory from the diver who brought Mary Jo's body up from the car the next morning and declared that she did not drown but asphyxiated from a lack of oxygen, meaning she was probably alive for a few hours while there was an air bubble inside the car before she used it up. If someone had gotten to her inside of an hour or so after the accident, she probably would have been saved.

Interestingly enough, on the ancillary side, the movie performed way over expectations which was probably the original audience that just didn't want to go to the theater to see it.

21
Marketing Trends for the Future
A Look Forward

MARKETING TRENDS FOR THE FUTURE

To conclude our journey through the world of movie marketing, we wanted to a look toward the future trends that are beginning to take shape. We do not consider ourselves in the business of predicting the future of marketing but we do believe this:

It is safe to say that even as the methodologies of marketing evolve, some elements will continue to remain the same. The basic ideas behind trailers, posters, radio and very short form audio visual elements like television and their new counterparts, web-based spots, have essentially remained the same for the past 75 years. While today's digital platforms offer new ways to get the message out, and there is a fascinating amount of content that audiences can consume and pay for, the core elements of paid, owned and earned media will continue to drive awareness and interest.

We spoke with Richard Rushfield, who for many years was a contributing writer to *Variety*, *Vanity Fair* and many other publications and currently runs *The Ankler* a weekly newsletter that describes itself as "the newsletter that Hollywood Loves to Hate and Hates to Love." Richard pulls no punches in analyzing the current state of events in the entertainment industry, with particular emphasis on exposing the many absurdities that inform our business on a day-to-day basis. His most recent column, as this book was being prepped for publication, was "The One Hundred Dumbest Decisions Made in Hollywood in 2018."

There are 500 television shows available right now. Does that mean there could be 1000 in the next few years?
Richard Rushfield: There is no barrier to entry, come up with an app, a show that young girls may like, and then you make another one and you are on your way.

There is so much talk about the Netflix domination. What will happen when all the new studio backed subscription services start coming online in 2019 and 2020?

RR: I don't see how you get to a point where anyone monopolizes entertainment. If anyone did have a monopoly on entertainment, what they would usually do is start cutting back, become complacent, become predictable, and leave themselves wide open. The minute you become predictable you are doomed.

 Eventually it will be we have a billion dollars and you have a billion dollars and we all have a billion dollars to spend and let's see who gets the best results from it.

What about the movie business in general?

RR: It seems like the movie business has gotten to a place where the overhead is so high, and while the movie business is not disappearing, there has to be some sort of consolidation, some sort of restructuring of these giant ancient studios. But movies have a unique positioning in the culture.

What do you think about the streaming companies getting into the $150M movie or series game? Will the marketing departments convince audiences to see these big effects laden movies on the small screen and it will no longer be necessary to go see them in a theater?

RR: I believe that movies are about space and television is about time. TV is about developing a relationship with the audience – characters, etc. over time. Shows like *Game of Thrones* grow and grow from season to season and you can form a relationship with the show.

 Movies are about space, creating a world that overwhelms. But there are some movies in the theaters that look like they were shot on an iPhone and then you have *Game of Thrones* on television. But when you go to the movies you are leaving the house and having a world wash over you in a way that is still a fundamentally different experience than television.

Television advertising will continue to be a strong source of awareness but as it loses its impact, what replaces it?

RR: Television advertising is continuing to decline, earned media opportunities like free publicity, editorial and substantive criticism have become less available as some of these outlets are disappearing or only looking for big name talent to sell covers or book on shows.

 The answer is where to put the $20M – not in Google Ads for sure.

Movie ticket prices are too high and it seems that we have priced out the families. From a marketing standpoint, do you think there should be different price points for movies? For example, you would pay $5 to see *The Shape of Water,* **but $20 to see a Marvel movie in the same multiplex.**

RR: Every time I bring something like the Movie Pass idea up at the studios and ask why don't you do it, the answer I always get is we can't talk to each other about it – it would be collusion. You can't find some level? If that's the level of creativity …

You have so many luxury theaters now so it seems like you could bring the price down on the general side and keep it high on the luxury side.

RESEARCH

Movie research has changed dramatically in even the past few years and will continue to evolve. No one has ever figured out a way to perfectly predict box office ahead of time. Movie tracking is the closest barometer that we have in order to predict the grosses, but it can sometimes miss wildly. Consequently, agencies continue to look for new measurements and technologies to reach consumers.

We talked to Sean Seguin, who, for the past 30 years, has worked in a wide range of roles including analytics, product development, operations and client services for leading research companies NRG and Screen Engine/ASI. Most recently, he has been SVP of Client Services and Operations at Screen Engine. Sean is on the forefront of technology and innovations for the industry. According to Sean, these research methodologies are already evolving and we'll likely see them continue to gain widespread use:

- **Cell phone polling:** Moviegoers aren't answering landline telephones to take surveys anymore and it's increasingly hard to find people willing to take a survey online. But, if you can send a few strategic questions to someone on their mobile phone, which they can answer while standing in line and earn points towards rewards – that is much more feasible. Cell phone research has other strategic advantages as well in that you can also pinpoint where the person is and trigger a survey as soon as they have seen an ad or walked past outdoor advertising.
- **Neuro scanning:** Currently, research relies on asking people questions about how they felt when they saw a particular ad or trailer. This is self-reporting and you have to trust that the person is reporting their feelings accurately. Meanwhile, neuro-testing involves attaching sensors to a person's head and scanning their brain while they watch advertising. This is already being used in research and movie studios are starting to embrace it as well. Using this technology gives you an unfiltered read on a person's response in that you can see when their heart

sped up, when emotional centers in their brain were triggered and when they started thinking (indicating confusion).

- **Holistic tracking:** At the moment, theatrical tracking operates in a bit of a silo where the survey only asks about interested in seeing upcoming movies. But, this will need to evolve as movie studios are no longer just competing with each other. Now, a major premiere on Netflix or HBO can dent box office, as can a significant videogame release. Tracking will have to expand to poll moviegoers on everything they may choose to do on a given weekend.

- **No more definite interest:** In the past the measure of "definite interest" was the most accurate way to assess moviegoers intention to attend opening weekend. But, over time that has evolved and now when people say they are "definitely interested" they mean it more loosely as in – "I'm definitely interested in going to Paris ..." It doesn't mean they actually will go, just that they'd love to. They apply the same language to moviegoing and it makes the predictions much more difficult. Definite interest is still the benchmark measurement in materials testing, but that will shift to more emotional and concrete indicators or attendance.

- **The merger of social and traditional research:** Both types of research have their strengths and challenges, but a marriage of the two is the best way to measure moviegoing. Social research is passive – you just listen and observe behavior. Traditional research is active – you solicit answers and information. The closer they can be integrated, the better.

CREATIVE ADVERTISING

Creative advertising will continue to evolve in structure, length and content. Ten years ago the use of voiceover to bridge story points was the norm. Five years ago everyone shifted to cards to tell the story. While some of that is still used, the majority of the trailers and TV spots are all visceral, actor told and highly intense and emotional.

Avery Blake who is the associate music coordinator at Seismic Productions sums it up this way: "We must break through the clutter and audiences must perceive our content as important and worthy otherwise we will all be lost in the entertainment noise."

So What Is the Next Step?

Short form content is growing as a medium and the :30 second television spot will be gone in the next few years as ad buying continues to shift to digital. Everything will be :10 and :15 seconds – the only way to catch our audiences as they wade through realms of content is with succinct and head turning messaging.

MEDIA PLANNING: HOW TO REACH PEOPLE

As more and more people become "cord cutters" – they unsubscribe to cable televisions and shift their TV viewing online – it is increasingly hard to reach moviegoers through TV advertising.

Netflix and HBO are ad free and Hulu users can pay a bit more and opt out of ads with Hulu Premium. This means that any time moviegoers are watching TV through these media, movie studios cannot reach them with ads. Unless they can integrate directly into programming (like a cross promotion with *The Voice*, for example), they can't break through.

This just means that studios will have to become increasingly clever in how they get their messaging out to consumers. YouTube is a great way to reach young people and as new platforms emerge these will be equally important. As penetration of smart phones and wearables (smart watches) increases, this is another way we might be able to reach moviegoers. Mobile advertising is becoming ever more important.

Furthermore, consumers are now using apps as part of their daily life. Whether they are using them for navigation, ordering food or calling a car, moviegoers are interacting every day with apps. Movie advertisers are already creating promotions within these apps and that practice is only going to increase.

For example, on *Transformers: Age of Extinction*, Paramount partnered with Uber on an integration that allowed people in certain cities to flag down the Optimus Prime semi-truck and get a ride. The app showed the cars as little Transformers masks and the stunt generated a lot of awareness, social media sharing and positive press.

SOCIAL MEDIA: HAS TO BE AUTHENTIC

Audiences are becoming increasingly sophisticated about advertising and messaging. They respond best to authentic, honest campaigns. Spots online or partnerships with online personalities will do best when they are upfront about being advertising. Campaigns that poke fun at themselves, address customers directly or riff outside the movie are also excellent clutter busters. A strong example of this tactic is the campaigns for both Deadpool movies.

Social media also allows for incredibly strategic targeting. You can buy ads aimed at any subgroup that you can come up with, even cat owners who live in Milwaukee! Movie campaigns try to reach as many people as possible, but they are also evolving to strategically target different messaging at different groups.

People are also shifting from posting on their walls to creating "stories." These mini movies are basically a slide show of pictures and videos crafted around a narrative. Movie studios will have to learn how to embrace this new format and use it to sell their movies.

FINAL WORDS

This book has been an incredibly fun project for both of us. What we tried to impart is a balance between classic marketing technique and its seamless integration into the digital space. To our readers, whether you are a director, producer, editor, cinematographer or rising young executive about to get real in the decision making process, we ask you to always keep in mind the one mantra we have always lived by:

MARKETING MATTERS

Glossary

"20" A programmed advertising time of 20 minutes prior to the playing of trailers in anticipation of the feature presentation.

360 Campaign A campaign that encompasses all types of media and includes gaming, merchandise, product promotions, soundtrack, and possible theme park tie-ins. The term suggests that advertising for the film literally surrounds the moviegoer on all sides.

Academy Awards (Oscars) The most distinguished annual award show honoring the best films of the year in various categories.

Acquisitions Companies purchase finished movies and then create a marketing and release plan.

ADR Additional Dialogue Recording. The process of re-recording dialogue by the original actor after the filming process to improve audio quality or reflect dialogue changes.

Alternative Distribution When the producers of an independent film decide to distribute and market the film by themselves and hire a "team" of professionals including publicity, digital and distribution. This is all done without placing the film into the hands of a distribution company.

American Film Market (AFM) A film business event held in Santa Monica, California, every year where production and distribution deals are made for finished films or movies that have packages looking for financing.

Ancillary Non-theatrical markets for feature films such as home video, streaming, television, airlines, and merchandising.

Animatic A screening of the movie in all storyboards with temporary voices, music and sound effects.

Appointment Shows Shows that people tune into on a weekly basis and are generally found on broadcast networks.

Audience Awareness One of the two pillars of a successful marketing campaign that is generated through media, publicity, and distribution. Indicates potential moviegoers who have become aware of the movie.

Audience Deficiency Units (ADU) Additional media spots given when a purchased advertisement doesn't reach the amount of people that it was guaranteed.

Audience Interest One of the two pillars of a successful marketing campaign that is generated through creative advertising, social media and word of mouth. Indicates potential moviegoers that have become interested in seeing the movie in a theater.

Audio Visual (AV) Advertising A category of advertisements that include the trailer, teaser trailer, and web content. Essentially anything that is audio and visual (in other words, all marketing material that is not printed).

Avids An audience segment who will definitely see a movie and also talk about it online through social media to their followers.

Awards Consultant Designs and executes a specific marketing campaign for a film to ensure that film has the best chance of being nominated and winning awards in the most significant categories. They as an extension of the publicity team.

Awards Push Positioning and marketing a film for optimal potential of receiving a prestigious award.

Baby Movies Movies that only appeal to a very young audience making it challenging to make a large profit theatrically.

Background Skin When an advertisement frames a webpage.

Banner Advertising (Display Advertising) A type of digital advertising where image-based ads are embedded into web pages usually in large rectangles along the borders of a screen.

Behind The Scenes (BTS) Short form pieces that highlight the filmmaking process and are usually a compendium of interviews with the talent and filmmakers with video footage of the production process.

Big Heads When the actors' faces, usually known stars, dominate a film poster.

Black Period A period of days between the release windows during which a film cannot be exhibited.

Blockbuster A movie that exceeds all expectations, reaches the widest possible audience, is unequivocally profitable and is generally considered a smashing success.

Bookability How difficult will it be to book your cast on talk shows and schedule them for interviews.

Brand A piece of IP has already established itself in popular culture and when mentioned, it elicits a response of familiarity.

Brand Manager The point person between marketing and production who maintains an open dialog between departments and resolves any conflicts that arise during production.

Brand Study Researching the effect an established brand has on different audiences to gauge awareness, appeal, and interest.

Branded Content A type of sponsored content that is engaging and entertaining while thematically weaving in elements you are trying to sell, such as a specific subject, story points, characters, or setting.

Bumpers Five-second ad spots that appear either in a corner of a program or immediately above or below the frameline.

Business Plan A step-by-step plan that details an executive summary, what the film will cost, how it will be developed, how production and distribution will potentially be structured, and what key executives will be involved in the process, usually the producers, the director and the key finance entities.

Buzzability How well a film's awareness and interest will spread through word-of-mouth or social media activity.

Capability A film's potential for success based on its screenplay and other categories prior to it going into production.

Cell Phone Polling Sending marketing questions to people's cell phones in the form of messages and offering a reward for answering.

Central Conflict The seemingly insurmountable obstacles in the way of what the hero wants.

CG Animation Animated movies that are created with computer graphics as opposed to being hand drawn.

Cliffhanger Moment Usually a trailer will end with a suspenseful scene that will leave the audience wondering what will happen in the movie.

Closers Advertising spots usually lasting from 10 to 15 seconds that are released during the 10 days leading up to a movie being released.

Code and Rating Administration (CARA) The branch of the MPAA that addresses content and gives your movie both its rating and decides whether the advertising materials can be shown to all audiences or more specific ones.

Cold Cut A version of a feature film with the best take from each shot put together. It follows the shooting script as close as possible but does not necessarily reflect the final cut.

Color Palette A series of complimenting colors that are used in a marketing campaign to represent the genre and tone of a film.

Comedic Button A joke at the end of the trailer, that comes after the title of the movie. It is usually the strongest take-away and is very important with comedy.

Community Management Promoting two-way engagement on social media platforms between creators and fans.

Compromise Moviegoing When families decide to see a film and they all have to agree on one choice. This often happens during the Christmas season.

Comps (Comparisons) Films that are similar to each other in terms of budget, potential box office, genre and time of year they were released.

Concept Test Presenting different ways of looking at the story in order to cement the genre and find the most interesting elements of the story to attract the desired audiences.

Consultation Rights Contractually, certain stars and directors get to review and approve all marketing using their likeness.

Consumer Products and Licensing The department that creates financial opportunities for films through product placement, special promotional content and licensed materials (toys, pajamas, calendars, posters, shot glasses, etc.). In essence, this department turns movies into things you can sell in stores.

Contextual Advertising When the content of the ad is in direct correlation to the content of the web page you are viewing.

Copy Line A slogan or brief quote about a film.

Cord Cutters People who no longer purchase cable television.

Cost Per Thousand (CPM) The standard in reporting and evaluating cost efficiency. It is the cost to deliver 1,000 people or homes.

Creative Advertising Creating unique and original content, such as trailers and posters, to promote a movie.

Creative Review Privileges When a high-profile cast or crew member has the right to view the advertising materials before they are finalized and okay them.

Crowd-funding Raising small amounts of money from a large number of individuals using an online platform.

Cut-Around-Editing When scenes from the film are put together differently from the movie cut to enhance clarity of story in a shorter period of time.

Dailies The raw footage of everything shot in a day.

Day-and-Date Release Releasing a movie in a theater and through streaming on the same day.

Day-of-Days A document that lists when each actor will be on set.

Daypart The practice of dividing a day of broadcast programming into several parts. For television they are: early morning, daytime, early fringe, prime, late night and overnight. For radio they are: all day, morning drive, daytime, afternoon drive and evening.

Definite Interest The percentage of people aware of a movie that are also expressing definite interest in seeing your film in a theater.

Demographics The findings and characteristics of certain segments of the population defined by criteria such as age, gender, ethnicity, location, and education.

Development Executive They decide if a project is worth pursuing for the studio or they decide if it's worth recommending to the studio to pursue.

Diaspora Population pockets throughout the world that are very targetable for certain ethnic films.

Digital Advertising Utilizing the Internet to deliver promotional advertisements often through email, social media websites, search engines, banner ads, and pop ups.

Digital Creative The artwork designed and programmed for the online space.

Digital Immigrants People over the age of 30 in 2017. They are typically less familiar with digital media than younger people.

Digital Media Advertising purchased to run in the digital space, inclusive of both desktop and mobile inventory.

Digital Natives People under the age of 30 in 2017. They are typically more familiar with digital media than older people.

Digital Out-Of-Home (DOOH) Advertising Advertisements that reach people outside of their homes in a digital format such as screens on kiosks in the mall or televisions rotating through different ads in cafes.

Digital Promotions Extended programs that connect potential audiences with your brand messages beyond a basic ad.

Digital Publicity Editorial and earned media placed in the digital space.

Distribution The process of selecting a platform to make the film available to the public either through movie theaters, television, or streaming.

Distributor Overages The amount of money left to be shared by the distributor and producer after all marketing costs fees are recouped.

Dubbed Translating foreign-language films into the audience's language using voice actors who speak the native language.

Earned Media Generated when owned or paid media is talked about online or through traditional communication methods such as television, word of mouth and print.

Electronic Press Kit (EPK) A collection of photos, videos, trailers, and interviews promoting a movie.

Elevator Pitch A synopsis and hook of a movie that can be said in roughly 20 seconds. The "elevator" part references having only a short amount of time to get the story across as if you are riding between floors.

Equity Investments Selling interests in the film in exchange for funding to produce the film.

Escalation The stakes are raised to increase suspense and add obstacles to the hero's mission so a happy ending seems almost impossible.

Ethnocentric Release A release pattern that appeals to certain diaspora ethnic groups who may be scattered throughout the world but have pockets of cities and theaters that perform well.

Exhibition The release of a film in theater chains, film festivals and/or streaming portals.

Exhibitor Relations The department within a studio that coordinates with theater owners and oversees in-theater marketing.

Exit Polls Surveying people as they leave a theater to determine their demographics and opinion of the movie.

Featurette A short documentary about the making of a feature film. Its total length will typically be 24–40 minutes, but they are often broken into smaller pods of 2–3 minutes each so the Publicity team can better target where to place them.

Field Publicity Publicity on a local or regional level rather than national. It's taking a national strategy and curating it so that it will resonate with people on individual local levels.

Film Financiers People who put together financing for a film using various sources.

Film Investors People who contribute money or goods to a film.

First Choice Number of people who pick a specific movie out of a list as their first choice to see in a theater.

First Look Deal An agreement between a production company or independent producer and a studio in which the studio pays for the right to be the first to see any material the company or producer acquires or develops.

First Look Scenes Scenes released online and on television before the movie comes out to tease and promote interest in the movie.

Flight The duration of media unfolding in a campaign.

Focus Group A small group of everyday people, specifically chosen based on demographics, to discuss a film or marketing campaign for research purposes.

Foreign Sales Companies These companies try to pre-sell films internationally to each territory individually until enough money is raised to finance the film. If the film is already completed, then they try to sell the film to distributors on behalf of the producers.

Four-quadrant System The division of moviegoers into four groups, or "quadrants": Males over 25 years old, males under 25, females over 25 and females under 25.

Frequency The number of times people will be exposed to a campaign.

Friendly Critics Critics who are willing to give a response to a film without making their responses final and writing them up.

General Audiences Teens and adults without kids.

Geotargeting Analyzing moviegoers and categorizing audiences by regions of the country.

Golden Globes The most notable award show honoring both films and television shows though not necessarily a precursor to the eventual Academy Award nominees or winners.

Greenlight When a production company or studio decides a particular movie idea will be smart and profitable, so they begin to make plans for production.

Gross Rating Point (GRP) A math equation used to determine how many people might have seen their ads. Reach × Frequency = GRP.

Holdover (Boost Advertising) Holding campaign dollars in a reserve to support their movie after opening weekend.

Holistic Tracking Tracking a movie against other things besides other movies that might pull someone's attention away, such as a major premiere on Netflix or a video game release.

Hollywood Foreign Press (HFPA) A non-profit organization of approximately 90 entertainment journalists from 55 different countries. It hosts and determines the outcome of the Golden Globes awards show.

Impression (IMP) One person or home exposed to an advertising message.

In-House When something is created by a team that exists within a company, as opposed to an outside vendor.

In-kind Marketing Marketing that is not paid for with money. The person or company marketing the content is usually getting publicity or some other benefit besides money.

Industry Trades Publications such as *Deadline*, *Variety* and *The Hollywood Reporter* that report entertainment industry news.

Influencers An individual who has the power to affect purchase decisions because of their popularity. Usually, influencers gain their audience and followers through social media or some sort of online presence.

Intellectual Property (IP) (entertainment definition) A term that means a property has built-in awareness and fanship.

Intellectual Property (IP) (legal definition) Anything created that can be trademarked, copyrighted, patented or registered in some official capacity.

Jump Scare When tension builds in a scene or trailer and a quick scare happens to startle the viewer.

Key Image An image that visually represents the logline and hook of a film and is used heavily in the marketing.

Lidar Scan Creates a 360-degree, 3D picture of a film set that can later be used to make a digital walk-through online, a gaming execution, or a VR experience.

Lip Synch Shot When an animation team needs to re-animate a character saying something different after a scene is already finished.

Living One Sheet A finished poster that has an added animated, moving aspect so it draws more attention when posted online.

Local Broadcast Television shows that are broadcast in local markets by independent stations or stations that are affiliated with one of the major broadcast networks.

Logline One sentence that lays out the protagonist, the obstacles, the conflict and the world of the film.

Look Book A compendium of images, words, and even designs, that speak to the mood, place, relationships and tone of their project and usually put together by the director to best express the vision and tone of the movie.

Low-concept A type of film that normally has a smaller budget, fewer and more practical locations, a character-driven plot, and relies on the quality of the script for success instead of a flashy action.

Lower Thirds Advertisements often utilized for animated films, where the characters run along the bottom of the screen during network or cable television. The characters usually do something funny, interact with the network logo, or pop up and give a quick message before the commercial break.

Machettes 3D models of animated characters.

Marketability The ability of a film to attract an audience.

Marketing Consultant Hired to make sure that all potential marketing materials are secured during production and usually communicate with the distributor to ensure the film is properly released.

Marketing Executive The leader of the marketing department who solves problems, communicates with all other departments, and ultimately takes responsibility for the success, or failure, of the entire campaign.

Marketing Outlets The different platforms of a marketing campaign such as digital, publicity, outdoor, in theater, and social.

Marketing Pivot When an audience's reaction to a film in test screenings isn't aligned with the marketing plan so the plan is quickly changed.

Marketing Research The quantitative (numbers) and qualitative (feelings) study of a movie's potential at different points in its life cycle.

Marketing Vision The overall marketing vision about how the film will be positioned in the marketplace.

Materials Testing Researching marketing materials, such as trailers and TV spots, to see how well they connect with audiences.

Media A means of mass communication that helps create awareness often through television, the Internet, outdoor billboards, radio, and stunts.

Media Agency Agencies that partner with studios to negotiate the best rates for advertisement placement, leverage relationships with advertising buyers and handle trafficking the spots.

Media Flight The entire media planning, buying and implementing part of a marketing campaign.

Media Planning and Buying Where and how the media budget is to be allocated between traditional and digital programming.

Mid-rolls Ads that show up in the middle of the chosen content.

Mini-major A studio that markets and distributes its own movies but is not one of the established "majors" (Disney/ Fox, Universal, Paramount, Sony, Warner Brothers).

Momentum When a film builds positive recognition quickly.

Monochromatic Using or containing only one color.

Motion Blur When characters appear blurry in a still frame because they are moving on film.

MPAA Rating Motion Picture Association of America issues a rating for each film which lets audiences know what to expect from the content. The ratings are R (restricted), PG-13 (parental guidance under 13), PG (parental guidance), and G (general audiences).

Nag vs. Drag Used when determining if a family movie is one that children will enthusiastically nag their parents to see, or one parents will drag their kids to because they think their kids should see it.

National Press Junket One or two days at a well-known hotel either in New York or Los Angeles where press from all over the country come to interview the cast. This usually includes television, radio, promotional partners and web folks.

National Release A country by country release that is mostly reserved for independent films and distributors who have their own schedule and a tailored campaign for local audiences.

National Research Group (NRG) The creators of theatrical tracking in 1986 and are still the most respected service used by the studios today for all types of research.

Neuro Scanning Attaching sensors to a person's head and scanning their brain while they watch advertising to analyze their response.

No Talking/No Texting Ads Short announcements played in theaters to remind audiences to refrain from cell phone use during a movie. They incorporate characters from a movie who give the message in a funny and creative way.

Norms The average score a movie could receive based on research screening questionnaire results.

Novelization A middle grade or easy reader book that lays out the plot of the movie with stills from a family film. These books generally stop with a cliff-hanger before giving away the ending of the movie.

One Sheet A 27 × 41 static image that gives the comprehensive message of a film. It is the primary image used in advertising.

One-liners Short, notable quotes from a movie.

Opportunistic Buys Buying media when it suddenly, and usually unexpectedly, becomes available.

Original Content Something created based on an original idea that hasn't been published in the past.

Out-Of-Home (OOH) Advertising Advertisements that reach people outside of their homes such as billboards and bus shelters.

Over The Top (OTT) The delivery of content through the Internet instead of through a broadcast or cable network.

Owned Media Content created to promote a film that is "owned" because you have complete control over it. Some examples are behind the scenes footage or a website.

P&A Budget P&A meaning "print and advertising," is Marketing's approximate cost to sell the movie domestically and internationally.

PA (Production Assistant) An entry level position on a film set who is usually assigned to any small or undesirable task that needs to be done.

Packaging Attaching talent, producers and a director to a script in order to sell it.

Paid Media Generated through the licensing of advertising slots in traditional television, online or outdoor venues. In essence, it is advertising you pay for.

Paper Cut When a trailer is mapped out on paper using lines and moments from the script.

Partnership Promotions When the marketing team works with another company to promote both the film and the other company's product or service.

Passive (Social) Research Observing how moviegoers are reacting to a film and campaign, but not engaging with them or asking them questions directly.

Per Screen Average The total weekend gross divided by the number of screens the movie is playing on. This number tells us how much each screen averaged.

Photoshop A popular image editing software.

Pipeline The overall production process of an animated movie as it moves through stages.

Pitch When a writer, director or producer comes in to present the basic idea and structure of a story to the studio with the intention of getting them to develop and commit to making the movie.

Planting a Flag Setting the release date of a film to make sure any competing films are aware of your date and will hopefully place their film on another weekend.

Platform Release Putting the film in a few cities, usually New York and Los Angeles, for the opening weekend and then slowly rolling it out to other theaters over the following weeks.

Play Patterns A term used in consumer products that refers to how children will play with the toys created to promote the film.

Playability The analysis of how well a film plays to an audience.

Plot Tease A moment in a trailer that hints at a big plot point.

Plush A category of toy meaning stuffed animal or creature.

Positioning Statement A few sentences that define the central idea of the film including the genre, the audience and the allure of the film.

Post-mortem Meeting A meeting held with studio executives and filmmakers the day after a research screening to discuss what people loved in a film and what needs to be addressed.

POW Model When movies Pay their Own Way to be played in each theater.

Pre-emptive Messaging Making sure the information you want to get out to the public is generated internally rather than waiting to respond to a situation that may rise in the public forum.

Pre-roll A promotional video message that plays directly before an online video.

Pre-Sales Selling the right to distribute the film in different territories before the film starts production in order to raise enough money to produce the project.

Press Tour A press tour is when the talent travel to local and international locations to do publicity and help promote the film.

Primary Audience (Target Audience) The subgroup believed to have the strongest interest in the movie and must be initially attracted in order to ignite the box office and create word-of-mouth buzz.

Product Placement When companies pay for their brand or product to be integrated into a film.

Production Rough Cut A version of a feature film cut together before the director signs off on it.

Profile Recognizable cast member.

Profit and Loss Report (P&L) Various budgets go into a report, which breaks down potential low, medium and high box office scenarios and shows that after everything is spent and received, how profitable was the movie.

Profit Participation The amount of money that is clear profit after all the distribution, marketing and production expenses have been recouped. Participation is determined by a percentage of what is available.

Programmatic Advertising The use of data and technology to purchase and deliver ads target to certain demographic groups.

Promo Reel An edited piece that will be used to sell a film or the idea of a film. It may include footage, interviews shots of the locations or other ancillary material to give the viewer an idea of the movie.

Proof of Concept A teaser trailer or scene from a script that is filmed to give a flavor of the film and help generate interest with investors.

Proprietary Reporting Analyzing the demographics of people who are searching for your film and engaging with your marketing materials online.

Psychographics Defining the moviegoing interest of a group of people based on their lifestyle, income, political inclination, religion, interests, attitudes and values.

Publicity (the Concept) Generating public awareness through talent appearances, subject interest, promotions, influencers, print and editorial.

Publicity (the Department) The department that handles all public pronouncements about a film, as well as manages any issues that may evolve into negative press during production.

Putting the Movie Up Screening an animated movie with only the storyboards completed. Temporary voices, music and sound effects are added as well.

Rating The percentage of the target audience that is tuned into a TV program or radio show. Ratings refer to a minute in TV and a quarter hour in local TV and radio. Also could be a movie rating from the MPAA – R, PG-13, PG, G.

Reach The percentage of people who will see a campaign.

Recruit Ratio The ratio of people who were offered an invitation to attend a free screening of a film versus the number of people who accepted. This is an informative measure of a movie's ability to attract an audience based on synopsis of a few lines and a mention of who is in the cast.

Regional Release Where a movie is released in a particular region first, for example Europe, before it is released elsewhere.

Release Strategy The decision to release the film through a platform scenario, wide release, or somewhere in between. It also includes what season or date would be best to release the film.

Rendering The digital process of finalizing a shot in animation.

Research Screening A special screening where regular, non-film industry moviegoers are invited to watch a movie before it's finished to get their feedback on how the story plays, are there any issues with pacing, etc.

Review Copy A few words or a phrase taken from a film review and used on promotional materials.

Rewards Deck A document that details the many different ways an investor may recoup his money.

Rig The skeleton for an animated character, which allows the character to move.

Rip-o-matic Cutting together a trailer using images and scenes from released films in order to show the storyline or mood of a script in development.

Roadblock Advertising (Takeover Advertising) When an advertising campaign takes up every available ad spot on a website layout.

Rotation The placement of creative advertising television or digital spots into specifically chosen programming targeted to the audience most interested in seeing the movie.

Rotation of Schedule (ROS) A daypart that does not include any guarantee that your advertising will land in a particular program but will fall within the agreed time.

Rotten Tomatoes A website that compiles the film reviews of both critics and regular moviegoers and presents two separate percentages of how many people enjoyed a movie.

Satellite Tours When the cast does live interviews with press people across the country in one day via a television studio satellite feed.

Scatter Picking individual programs or events and buying spots, rather than pre-negotiating a slate of media placements during the upfront.

Screener A copy of a film sent to award show voters so the film has a better chance of being seen and remembered during the voting process.

Seasonal Promos Customized advertisements for holidays or big events such as the Super Bowl.

Secondary Audience The group that may have interest in certain elements of the movie or would likely accompany a member of the primary audience to the theater. They are generally considered achievable if the marketing can connect, but will pose some challenge to convince.

Self-reporting People writing or verbally saying what they thought about a film or advertisement when they are asked to participate in a research group.

Set Visits When a studio arranges for press, partners or internal execs to visit a set in the middle of filming.

Share of Voice (SOV) A measure of how much exposure a movie has compared to other films being marketed at the same time.

Shotgun Approach Buying media to reach a very wide audience, many of which probably won't be in a movie's target audience.

Sizzle Piece A few minutes of footage edited together from the movie that is being shot to raise interest from investors or distributors.

Social First Content Content that is designed and edited specifically for people to view when scrolling through their social media feeds.

Social Listening Using digital tools to gather comments from multiple social media sites to assess how people feel about a film and used to help shape a marketing campaign.

Sound-alike A voice actor who is asked to record lines in marketing materials for an animated movie because they sound a lot like a cast member who is unavailable to record.

Soundstage A large, soundproof room that is used to build movie sets so filming can be done in a controlled environment.

Special Photographer They come to set for a day or two and shoot the key cast members in a number of different poses, looks and groupings, all to provide the creative advertising team as many choices as possible.

Special Screening A screening of a film before it is released to the general public. Normally these screenings are for a targeted audience to generate word of mouth awareness.

Special Shoot When the cast of a film is featured in additional material to help market the film such as a cross-promotional music video or a personalized intro

that will be played before select screenings. These shoots are often done by a "celebrity" photographer whose work is known by the magazines.

Sponsored Content (Advertorials or Native Ads) Content created specifically to promote a film, usually created with a specific audience in mind.

Spot Buys Buying media market-by-market instead of nationally.

Start of Production A press release issued by studios when the filming on a project starts. It often includes key details such as the title, anticipated release window, cast and a brief plot summary.

Steal A Weekend When a movie used to be able to spend so much money on advertising that no matter how lacking in quality a movie was, it would have a profitable opening weekend because of the constant media exposure.

Stills Still frames that are taken from a movie's footage to be used as photographs in the marketing campaign.

Stories (Social Media) Quickly posting pictures or videos on social media sites that will automatically delete in 24 hours.

Story The sequence of events that happen in a script.

Story Cards Inserts of text during a trailer to explain the film's plot or main ideas in between actual scenes from the film.

Strategic Positioning Considering the strengths, weaknesses, target audience and main competitors of a film in order to create an effective marketing plan.

Stunt PR An event designed to attract the public's attention and go viral in order to promote a film.

Style Guide A guide that includes all of the information that a toy or licensing partner will need to create merchandise that fits in with the branding such as: stills of the characters, the color palette, the costumes, typefaces, icons, and graphics.

Subbed Adding local language subtitles to a piece of content that is being distributed internationally.

Sweepstakes Contests that are usually entered online and generate buzz for the film and usually offer prizes that also help market the film such as premier tickets or set visits.

SWOT Marketing Analysis The strengths, weaknesses, opportunities and threats a movie has in regards to its marketing.

Syndication Shows produced by any network that have already aired and are being played again on national or local broadcast networks to augment their programming.

Synopsis A straight-ahead description of the storyline and plot.

Table Read A rehearsal where the key cast performs the screenplay start-to-finish at a table with the filmmakers, writers, and producers.

Talent Agency Find jobs, make deals and finalize contracts for directors, writers, producers and actors.

Talking Heads When one person is talking on screen and they are addressing the camera directly.

Talking Points A summary of things the cast and crew should say about a movie to the press in order to best fit the movie's positioning. It also includes things they should avoid mentioning so audiences aren't confused and spoilers aren't released.

Target Marketing A campaign directed at an audience with a specific interest in the film.

Target Rating Points (TRP) The percentage of a movie's target audience that sees or hears the movie's advertisement.

Tax credits When the local government reimburses part of the cost of a film in return for filming in a certain location.

Teaser Poster Posters released very early in a marketing campaign meant to tease the tone of the film and announce the title without giving much of the story away.

Teaser Trailer A short trailer that hints at the concept or tone of a film, but doesn't give away much of the plot.

Tentpoles Very expensive movies, usually made by a studio, that try to appeal to the widest audience possible in order to recoup their investment. These movies are usually made based on existing IP.

Territories Geographical countries or a group of countries where the rights to distribute a film are available.

Tertiary Audience The larger, initially uncommitted audience, which eventually watches the movie after it breaks out and becomes a commercial hit.

Theatrical Tracking A report delivered to film studios three times a week that tracks which films moviegoers are aware of and how interested they are in buying a ticket.

Theatricality The level of which a person has a desire to see a particular movie in a theater as opposed to watching it at home.

Theme The underlying central idea or message that the film is trying to convey.

Tie-Ins Brand and film partnerships where the film and the brand are being promoted in the same advertisements.

Title Treatment The specific size, font and design of the film title on advertisements.

Toolkit A set of little vignettes and shorts with the characters that are created outside of an animated movie and are used across the marketing campaign.

Total Awareness The percentage of moviegoers that are aware of your movie either unprompted or prompted when they selected it from a list of possible titles.

Toy Fair Large-scale events where major toy companies show off their newest product lines and studios pitch their upcoming content to forge collaborations.

Traditional Research Asking people questions and engaging in a dialogue about a film and its marketing. This can happens both on and offline.

Trailer Cutdown Separate television spots will focus on different themed audience segments: A trailer cutdown is a television spot that is a shortened version

of the trailer. It will follow the same structure, but will only be :60 or :30 seconds.

Trailer Moments Moments in the film that can be quickly and easily identified as perfect for the trailer. These are often memorable one-liners, triumphant hero moments, epic action or great physical comedy beats.

Turning Point A moment in a story when the hero does something unexpected or something surprising happens to the characters.

Two Level Comedy A film with comedy that appeals to kids and also contains more sophisticated jokes for parents that sail over the head of kids.

Unaided Awareness A measurement of how many people are aware of your movie without any promoting.

Unit Photographer Someone hired to take behind-the-scenes shots and cast photos during production without intruding on the filmmaking process.

Unit Publicist Coordinates all press interviews, deals with any on set crises that the media might hear about, secures and writes press notes, and arranges on-set visits.

Upfront An event that occurs every year where the TV networks roll out their show slate and try to woo advertisers into pre-paying for a set amount of advertising.

User-generated Content Content organically created by fans such as posters, trailers, art, reviews, or online comments,.

Video On Demand (VOD) or Streaming Content that can be instantly viewed on a television or portable electronic device,.

Visual Development Sketches and painting created before production of an animated film starts to determine what the film will look like,.

Wide Release Putting the film in the maximum number of theaters on the first weekend which is usually between 2,000 and 4,000 screens,.

Workhorse Spots TV commercials that are designed to appeal to everyone.

Workhorse Creative A piece of creative that checks all the boxes, tells the story clearly and tests well in research. It's called the workhorse because it will be used heavily in the campaign.

Worldwide Release The standard pattern utilized by the studios when a film is released simultaneously in a large number of countries on the same date or within a few days of each other.

Index